Contents

● *Agencies with a ● have images on Stock Disk 2.*

The Best of Stock

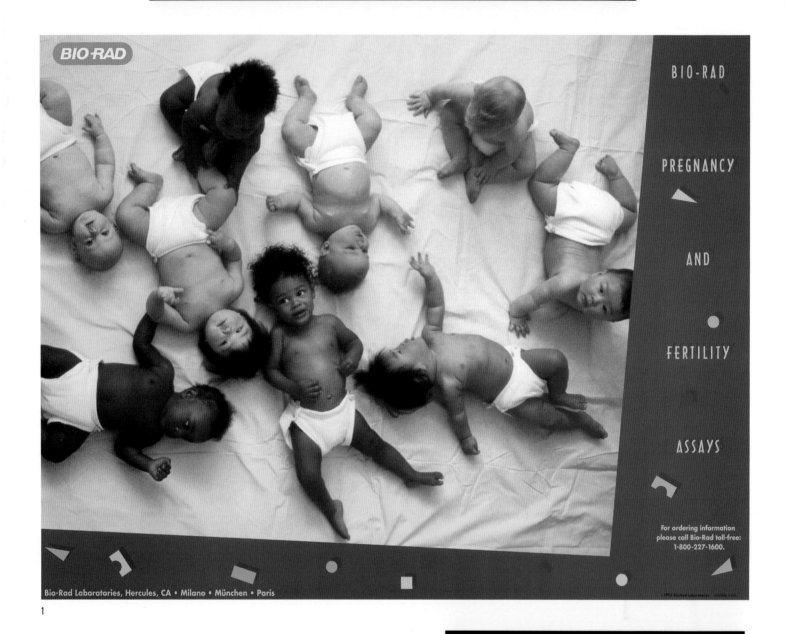

1

1
CLIENT: *Bio-Rad Laboratories*
ART DIRECTOR: *Clelia Bauer*
STOCK AGENCY: *Liaison International*
PHOTOGRAPHER: *Barbara Campbell*

*T*he Best of Stock is exactly what it says. It's what the stock agencies feel was the best use of their images in 1992 and 1993. As you can see, stock can be used in many ways to solve many problems. If we didn't tell you it was stock, we'd bet you'd never know. So here's to another great year of images - both to their creation and their usage.

The Best of Stock

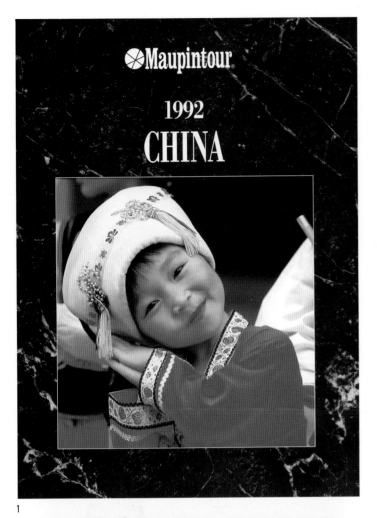

1

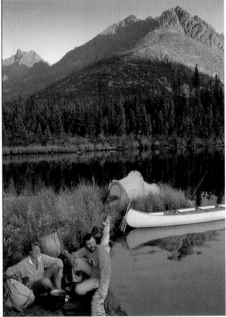

2

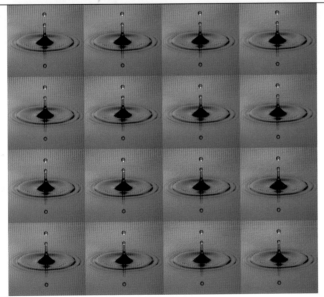

THERE ARE OTHER RESINS...
BUT NONE THAT HAVE THIS KIND OF CONSISTENCY.

It's not a claim we make idly. For more than thirty years, Silmar Resins, part of BP Chemicals Advanced Materials Division, has been manufacturing resins for the cultured marble and onyx industries. Resins that have earned us an unmatched reputation for consistent quality, time after time, lot after lot. Today, Silmar® resins are being manufactured for a diverse group of industries, all of them benefiting from the years of research, experience, and expertise we've put into cultured marble and onyx. To take advantage of this quality heritage and learn how we can apply it to your products, please call 1-800-860-6269.

 BP CHEMICALS

©1993. BP Chemicals, Inc.
Silmar® resin is a registered trademark of BP Chemicals, Inc.

3

1
CLIENT: *Maupintour*
STOCK AGENCY: *H. Armstrong Roberts*
PHOTOGRAPHER: *Joe Gemignani*

2
AD AGENCY: *Wells Rich Greene BDDP, New York*
ART DIRECTOR: *Richard Dieterich*
STOCK AGENCY: *Alaska Stock Images*
PHOTOGRAPHER: *Chris Arend*

3
AD AGENCY: *Martiny & Company*
ART DIRECTOR: *Jim Parrigin*
STOCK AGENCY: *Photo Researchers/Science Source*
PHOTOGRAPHER: *Martin Dohrn*

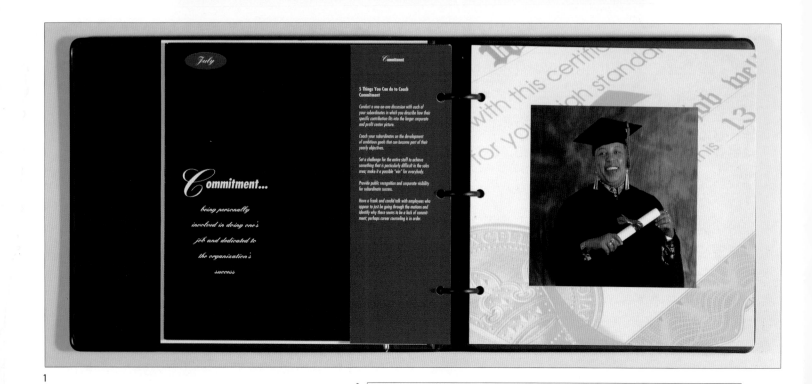

1

2

1
DESIGN FIRM: *Aenigma Design*
DESIGNER: *Brett Clark*
STOCK AGENCY: *FPG International*
PHOTOGRAPHER: *Dick Luria*

2
CLIENT: *Coca-Cola USA*
ART DIRECTOR: *Tom Gonzales*
AD AGENCY: *Germersheim*
ART DIRECTOR: *Paul Krause*
STOCK AGENCY: *F-Stock*
PHOTOGRAPHER: *Sunstar*

The Best of Stock

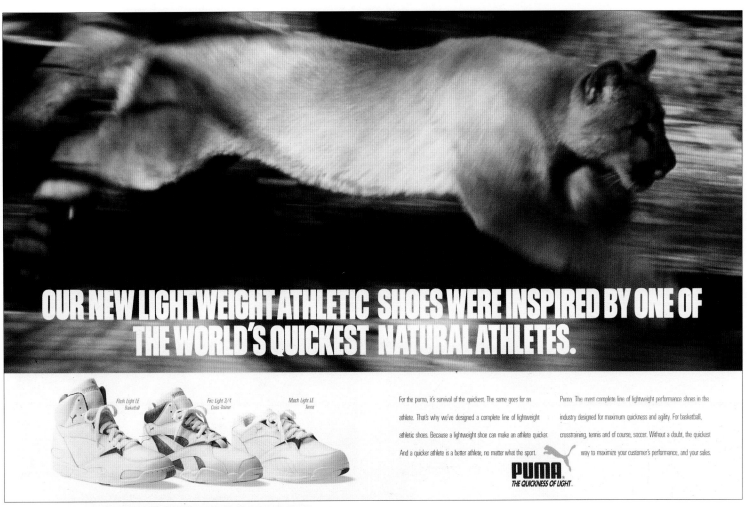

OUR NEW LIGHTWEIGHT ATHLETIC SHOES WERE INSPIRED BY ONE OF THE WORLD'S QUICKEST NATURAL ATHLETES.

Flash Light LE
Basketball

Fire Light 3/4
Cross-Trainer

Mach Light LE
Tennis

For the puma, it's survival of the quickest. The same goes for an athlete. That's why we've designed a complete line of lightweight athletic shoes. Because a lightweight shoe can make an athlete quicker. And a quicker athlete is a better athlete, no matter what the sport.

Puma. The most complete line of lightweight performance shoes in the industry designed for maximum quickness and agility. For basketball, crosstraining, tennis and of course, soccer. Without a doubt, the quickest way to maximize your customer's performance, and your sales.

PUMA
THE QUICKNESS OF LIGHT

1

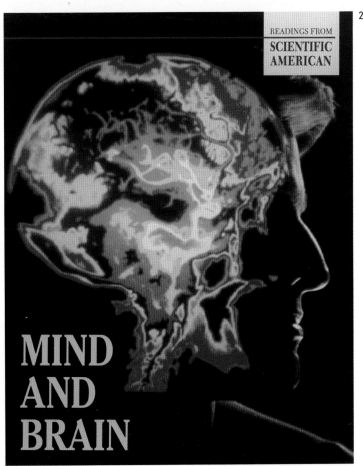

READINGS FROM
SCIENTIFIC
AMERICAN

MIND
AND
BRAIN

2

1
AD AGENCY: *Emerson Lane Fortuna*
ART DIRECTOR: *Nancy Federspiel*
STOCK AGENCY: *Natural Selection Stock Photography*
PHOTOGRAPHER: *Joe McDonald*

2
PUBLISHER: *W.H. Freeman & Company*
DESIGNERS: *Alice Fernandez Brown & Megan Higgins*
STOCK AGENCY: *Medichrome*
PHOTOGRAPHER: *Howard Sochurek*

The Best of Stock

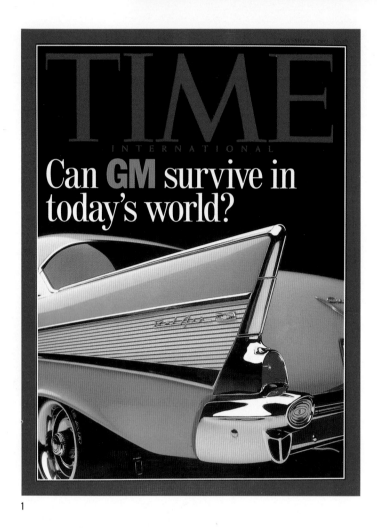

1

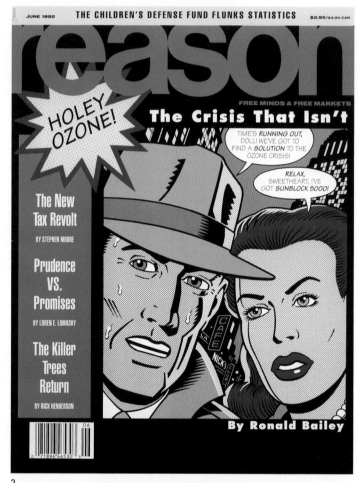

2

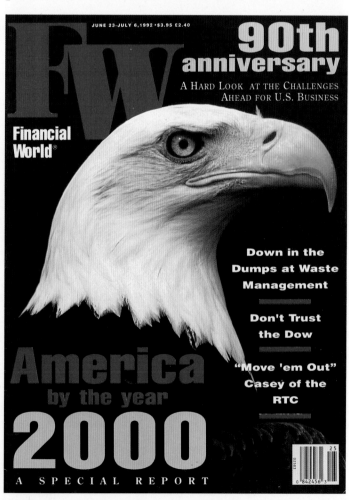

3

1
PUBLICATION: *Time Magazine*
ART DIRECTOR: *Rudolph Hoglund*
STOCK AGENCY: *Ron Kimball Stock*
PHOTOGRAPHER: *Ron Kimball*

2
PUBLICATION: *Reason*
ART DIRECTOR: *Paula Brown*
STOCK AGENCY: *Stockworks*
ILLUSTRATOR: *Steve Vance*

3
PUBLICATION: *Financial World Magazine*
ART DIRECTOR: *Larry Gendron*
STOCK AGENCY: *Peter Arnold, Inc.*
PHOTOGRAPHER: *Kevin Schafer*

The Best of Stock

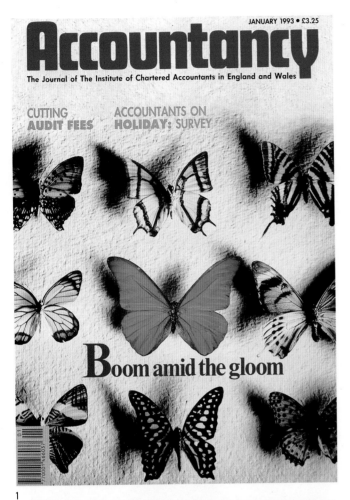

1

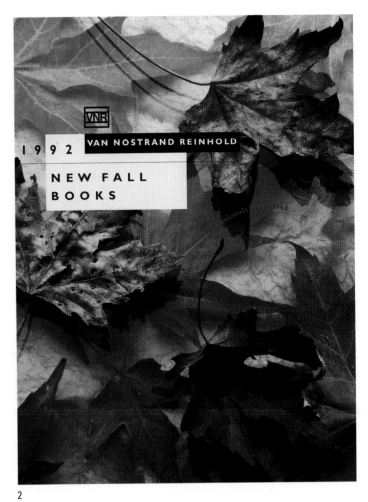

2

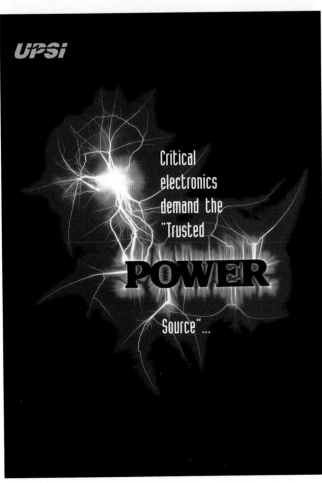

3

1
PUBLICATION: *Accountancy*
DESIGN EDITOR: *Chris Patton*
STOCK AGENCY: *Tony Stone Images*
PHOTOGRAPHER: *Martin Barraud*

2
CLIENT: *Van Nostrand Reinhold*
ART DIRECTOR: *Sharon Jacobs*
STOCK AGENCY: *The Stock Broker*
PHOTOGRAPHER: *Jan Oswald*

3
CLIENT: *Universal Power Systems, Inc.*
ART DIRECTOR: *Mark Abrials*
STOCK AGENCY: *Westlight*
PHOTOGRAPHER: *Gary Bartholomew*

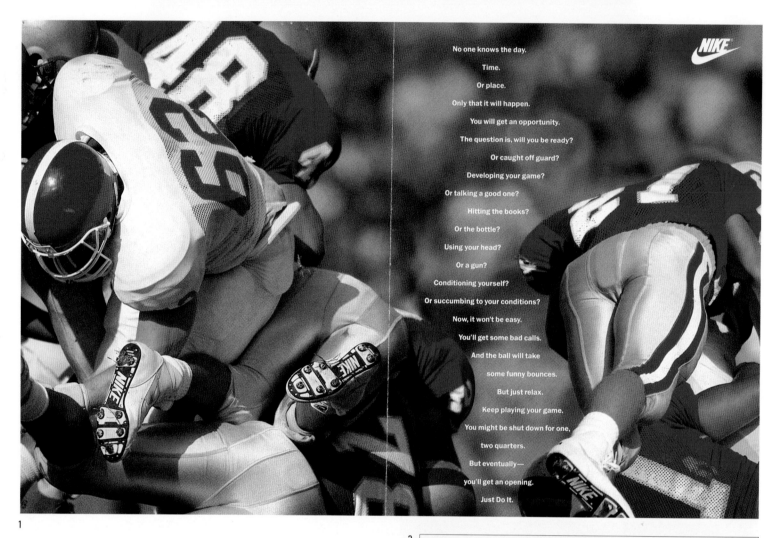

No one knows the day.

Time.

Or place.

Only that it will happen.

You will get an opportunity.

The question is, will you be ready?

Or caught off guard?

Developing your game?

Or talking a good one?

Hitting the books?

Or the bottle?

Using your head?

Or a gun?

Conditioning yourself?

Or succumbing to your conditions?

Now, it won't be easy.

You'll get some bad calls.

And the ball will take

some funny bounces.

But just relax.

Keep playing your game.

You might be shut down for one,

two quarters.

But eventually—

you'll get an opening.

Just Do It.

NIKE

1

WE LOVE OUR COUNTRY

© BRUCE MATHEWS / PHOTOGRAPHIC RESOURCES

KiX Country 104

A ZIMMER BROADCASTING STATION

2

1
AD AGENCY: *Muse Cordero Chen, Inc.*
ART DIRECTOR: *Wilky Lau*
STOCK AGENCY: *Duomo Photography, Inc.*
PHOTOGRAPHER: *Al Tielemans*

2
AD AGENCY: *Louis London*
ART DIRECTOR: *Joe Ortmeyer*
STOCK AGENCY: *Photographic Resources, Inc.*
PHOTOGRAPHER: *Bruce Mathews*

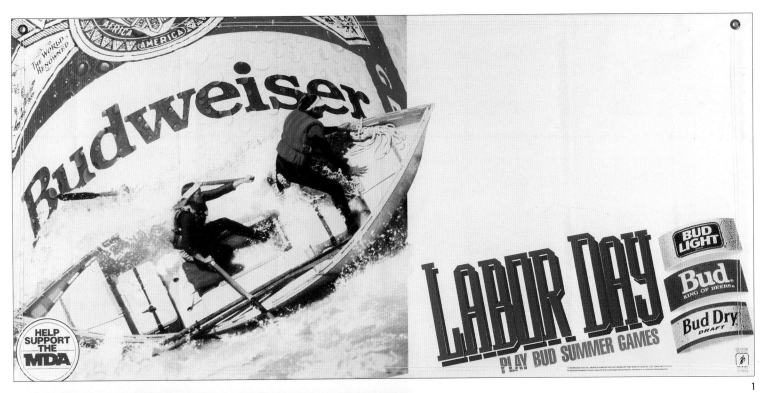

1

2

1
AD AGENCY: *The Waylon Company*
ART DIRECTOR: *Armin Paetzold*
STOCK AGENCY: *Profiles West*
PHOTOGRAPHER: *Wiley/Wales, Ann Wiley & Chuck Wales*

2
DESIGN FIRM: *Carron Design*
ART DIRECTOR: *Ross Carron*
STOCK AGENCY: *Zephyr Pictures*
PHOTOGRAPHER: *Melanie Carr*

The Best of Stock

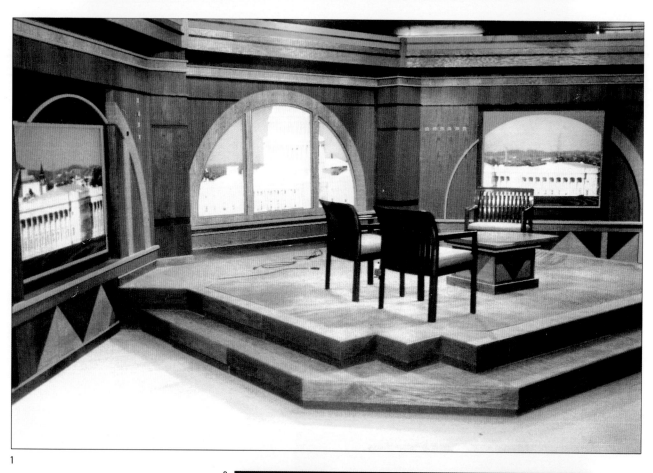

1

2

FEBRUARY 1993

PHARMACY AND THERAPEUTICS
A PEER REVIEWED JOURNAL

VOLUME 18 NUMBER 2

P&T

CARDIOVASCULAR SPECIAL ISSUE
PART 2

A complete update on advances in cardiovascular medications

CALCIUM CHANNEL BLOCKERS
New agents for controlling ventricular rate in atrial fibrillation and atrial flutter

NEW α₁-ADRENERGIC BLOCKERS
A brief review of terazosin and doxazosin

ADVERSE DRUG REACTIONS
Thrombolytic-induced CNS hemorrhage and hepatotoxicity associated with sustained-release niacin

1
CLIENT: *CNN Washington Bureau*
ART DIRECTOR: *Ann Williams*
STOCK AGENCY: *Folio, Inc.*
PHOTOGRAPHERS: *Matthew Borkoski, Rick Buettner,*
 Ed Castle, Pat Fisher, Lilia Hendren, Fred Maroon,
 Evan Sheppard & Michael Ventura

2
AD AGENCY: *Excerpta Medica*
ART DIRECTOR: *Tina Cipriani*
STOCK AGENCY: *Custom Medical Stock Photo*
IMAGE: *Computer-enhanced historical line art*

The Best of Stock

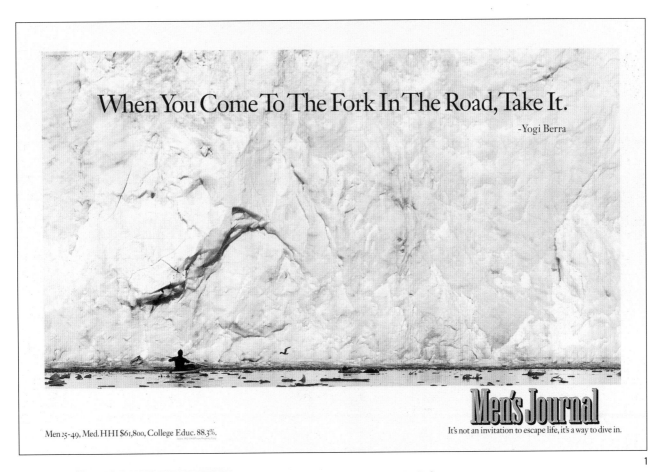

When You Come To The Fork In The Road, Take It.

-Yogi Berra

Men 25-49, Med. HHI $61,800, College Educ. 88.3%.

Men's Journal

It's not an invitation to escape life, it's a way to dive in.

1

2

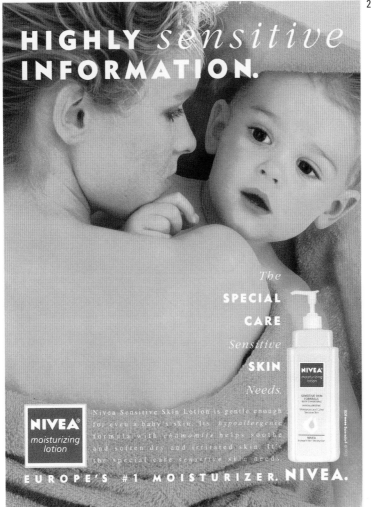

HIGHLY *sensitive* INFORMATION.

The
SPECIAL
CARE
Sensitive
SKIN
Needs.

NIVEA
moisturizing
lotion

Nivea Sensitive Skin Lotion is gentle enough for even a baby's skin. Its hypoallergenic formula with camomile helps soothe and soften dry and irritated skin. It's the special care sensitive skin needs.

EUROPE'S #1 MOISTURIZER. NIVEA.

NIVEA
moisturizing
lotion

SENSITIVE SKIN
FORMULA

The Best of Stock

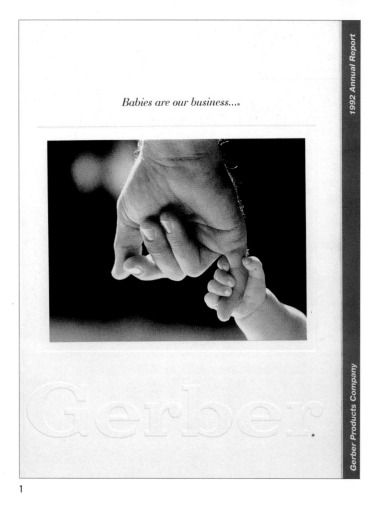

1

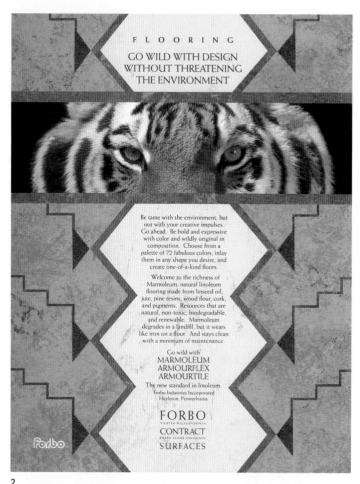

2

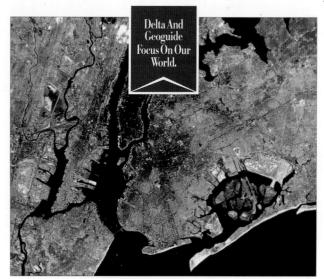

3

1
DESIGN FIRM: *Genesis, Inc.*
DESIGNER: *Jim Adler*
STOCK AGENCY: *The Stock Market*
PHOTOGRAPHER: *Jon Feingersh*

2
AD AGENCY: *Doerr Associates*
ART DIRECTOR: *Ellen Rudy*
STOCK AGENCY: *Photo Researchers/Nature Source*
PHOTOGRAPHER: *Tim Davis*

3
AD AGENCY: *BDA/BBDO, Inc.*
CREATIVE DIRECTOR: *Bob Pitt*
STOCK AGENCY: *Photo Researchers*
PHOTOGRAPHER: *NASA*

The Best of Stock

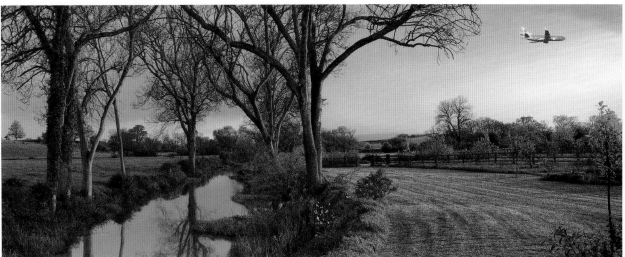

ALL ACROSS EUROPE,
AS THE NEW DAY ARRIVES,
SO DO WE.

West Sussex, England.

It happens in London, Paris and Madrid
just as the cities start to stir. In Frankfurt, Duesseldorf,
Munich and Berlin. In Zurich and Milan.
In Glasgow, Stockholm, Brussels and Manchester.
As the new day arrives, so do we. So call your Travel
Agent or American at 1-800-624-6262 today. And you
could be landing in Europe tomorrow morning.

AmericanAirlines®
Something special to Europe.

| FRANCE | ITALY | SWEDEN | SPAIN | BELGIUM | SWITZERLAND | SCOTLAND | ENGLAND | GERMANY |

1

2

THE LEARNING CHANNEL
TRANSFORMING
EDUCATIONAL TELEVISION
IN THE SPIRIT OF DISCOVERY

TLC
THE LEARNING
CHANNEL®

1
AD AGENCY: *Temerlin McClain, Inc.*
CREATIVE DIRECTOR: *Neil Scanlan*
ART DIRECTOR: *Ed Tajon*
STOCK AGENCY: *AllStock*
PHOTOGRAPHERS: *Will & Deni McIntyre*

2
AD AGENCY: *Discovery Communications Creative Services*
ART DIRECTOR: *Larni Higgins*
DESIGNER: *Debbie Moses*
STOCK AGENCIES: *The Image Bank*
PHOTOGRAPHERS: *Michele Tcherevkoff, Romilly Lockyer,
Randy Nelson, Mitchell Funk & Gary Chapman*

Staff

PUBLISHER/EDITOR
Alexis Scott

ASSOCIATE PUBLISHER
Suzanne Semnacher

EDITORIAL DIRECTOR
Susan Haller

DESIGNER
Craig Butler

ART DIRECTOR/COVER DESIGN
DD Hunter

PRODUCTION DIRECTOR
Paul Semnacher

TRAFFIC MANAGER
Edmond Osborn

ADVERTISING SALES
Marcia Farrell
Michael Masterson

EDITORIAL
John H. Koch
Susannah Olch
Marilyn Walsh

WORD PROCESSORS
Catherine Nielsen
Dave Symonds

PROOFREADER
Gary M. Johnson

WHOLESALE DISTRIBUTION
Jocelyn Kay

PRINT PRODUCTION
Lynn Pile
Don Prust

ACCOUNTING/FINANCIAL SERVICES
Richard Scott

CONTROLLER
Elaine Fahn

PRINTER
Toppan Printing Company, Ltd.
Tokyo, Japan

TYPOGRAPHER
Andresen Graphic Services

CHAIRMAN OF THE BOARD
Heather Milstein

VICE-PRESIDENT
Ashley Butler

ISBN 0-911113-63-0

Specialty Grid

	Page	Agriculture	Animals	Automotive	Aviation	Black & White	Celebrities	Environmental/Nature	Fine Art	Food	General Stock	Geography	High-Tech	Historical	Human Interest	Illustration	Industry	Large Format Color	Medical	Model-Released People	Movie/TV Stills	Natural History	News	Science	Sports	Still Life	35mm Color	Travel/Leisure	Underwater
ADSTOCK PHOTOS	526	•	•		•	•		•		•	•	•		•				•	•	•		•			•	•	•	•	
ADVENTURE PHOTO	81-90		•					•	•		•							•		•		•			•		•	•	•
AIRBORNE	512	•			•			•	•		•	•	•					•	•			•			•		•	•	
ALASKA STOCK IMAGES	361-370		•		•													•	•			•			•		•	•	
ALLSTOCK, INC.	381-390	•	•	•	•	•		•			•	•		•			•	•	•	•		•		•	•	•	•	•	•
AMERICAN STOCK PHOTOGRAPHY INC.	507	•	•	•	•	•	•	•		•	•	•	•	•	•	•	•	•	•	•	•	•	•	•	•	•	•	•	•
ANATOMYWORKS INC.	330		•			•	•	•	•	•				•		•	•	•	•			•	•	•		•	•	•	
ANIMALS ANIMALS/EARTH SCENES	432-435	•	•			•		•			•						•	•			•			•		•	•	•	•
ARCHIVE PHOTOS	508-509		•	•	•	•	•			•	•		•			•	•	•			•		•	•		•	•	•	
PETER ARNOLD INC.	371-380	•	•		•	•		•		•	•	•	•		•	•	•	•	•	•		•	•	•		•	•	•	•
CAMERIQUE INC. INTERNATIONAL	507	•	•	•	•	•	•	•	•	•	•	•		•	•	•	•	•	•	•	•	•	•	•	•	•	•	•	
COMSTOCK, INC.	538-539	•			•			•			•	•				•				•						•	•	•	
JORDAN COONRAD/IMAGERY UNLIMITED	513-514	•	•	•	•			•	•		•	•					•	•		•			•		•		•	•	•
CUSTOM MEDICAL STOCK PHOTO, INC.	179-188	•	•			•		•		•			•	•	•	•	•	•	•			•	•	•		•	•		
LEO DE WYS INC.	440-443	•	•	•	•	•		•		•	•	•	•	•	•		•	•	•	•				•	•	•	•	•	•
DINODIA PICTURE AGENCY	484	•	•		•	•	•		•	•		•	•		•				•							•	•		

	Page	Agriculture	Animals	Automotive	Aviation	Black & White	Celebrities	Environmental/Nature	Fine Art	Food	General Stock	Geography	High-Tech	Historical	Human Interest	Illustration	Industry	Large Format Color	Medical	Model-Released People	Movie/TV Stills	Natural History	News	Science	Sports	Still Life	35mm Color	Travel/Leisure	Underwater
DUOMO PHOTOGRAPHY INC.	217-226																			•					•		•	•	
ENVISION	452-453	•	•					•		•	•	•						•		•		•		•		•	•	•	
EUROSTOCK	476-479	•	•	•	•	•		•		•	•	•	•	•	•			•	•	•		•		•	•	•	•	•	•
F-STOCK PHOTOGRAPHY, INC.	267-276	•	•		•			•		•	•				•			•		•		•		•			•	•	•
F/STOP PICTURES, INC.	450	•	•					•			•	•			•			•		•				•			•	•	•
FPG INTERNATIONAL	51-60	•	•	•	•	•	•	•	•	•	•	•	•	•	•		•	•	•	•	•	•	•	•	•	•	•	•	•
FIRST IMAGE WEST, INC.	510	•		•				•		•	•	•						•	•	•		•	•	•			•	•	
FOCUS ON SPORTS, INC.	454																			•					•		•		
FOLIO INC.	169-178	•	•		•		•	•		•	•	•			•		•		•	•		•	•	•	•	•	•	•	
FROZEN IMAGES, INC.	521	•	•		•			•		•	•	•			•			•	•	•		•			•	•	•	•	
FUNDAMENTAL PHOTOGRAPHS	439					•		•					•					•						•			•	•	
GHOSTS	467				•										•			•									•		
GLOBAL PICTURES	540		•		•			•	•		•							•		•		•	•				•	•	•
GRANT HEILMAN PHOTOGRAPHY, INC.	277-290	•	•			•		•		•	•	•			•			•				•		•		•	•	•	•
THE IMAGE BANK	341-350	•	•	•	•	•		•	•	•	•	•	•	•	•	•	•	•	•	•	•	•		•	•	•	•	•	•
IMAGE FINDERS PHOTO AGENCY INC.	516-517	•	•	•	•			•		•	•	•	•				•	•	•	•					•	•	•	•	•
INTERNATIONAL STOCK	488	•	•	•	•	•		•		•	•	•			•			•	•	•				•	•	•	•	•	•
PETER B. KAPLAN PHOTOGRAPHY INC.	498-499		•	•	•			•		•		•		•			•		•			•		•	•		•	•	
RON KIMBALL STOCK	351-360		•	•				•		•								•		•		•					•		
JOAN KRAMER & ASSOCIATES	493	•	•	•	•	•	•	•	•	•	•	•		•	•	•	•	•	•	•	•			•	•	•	•	•	•

Company	Page	Agriculture	Animals	Automotive	Aviation	Black & White	Celebrities	Environmental/Nature	Fine Art	Food	General Stock	Geography	High-Tech	Historical	Human Interest	Illustration	Industry	Large Format Color	Medical	Model-Released People	Movie/TV Stills	Natural History	News	Science	Sports	Still Life	35mm Color	Travel/Leisure	Underwater
LANDMARK STOCK EXCHANGE	459		•	•	•	•		•	•		•	•		•	•	•	•	•		•						•	•	•	•
LATIN STOCK	481	•	•			•		•			•	•		•						•		•		•			•	•	
LAVENSTEIN STUDIOS	473							•	•		•																•	•	
CINDY LEWIS PHOTOGRAPHY	464-465			•		•						•	•				•	•						•			•		
LIAISON INTERNATIONAL	159-168	•	•	•	•	•	•	•	•	•	•	•	•	•	•	•	•	•	•	•	•	•	•	•	•	•	•	•	•
LIGHT SOURCES STOCK	455	•	•					•			•		•	•			•			•		•		•	•			•	•
MARK MacLAREN, INC.	448-449																												
DAVID MADISON	460-463							•												•					•		•		
JAY MAISEL PHOTOGRAPHY	419-428	•		•	•			•	•		•	•		•	•		•			•							•	•	
MEDICHROME	321-329		•		•	•	•	•		•			•	•	•		•	•	•	•				•	•	•	•		
ABRAHAM MENASHE HUMANISTIC PHOTOGRAPHY	520					•			•		•				•	•			•	•							•		
MON-TRESOR	470-471	•	•			•		•	•		•	•			•	•	•	•		•					•	•	•	•	•
MOUNTAIN STOCK PHOTOGRAPHY & FILM INC.	482-483	•	•	•	•			•	•		•	•		•	•					•		•			•	•	•	•	
NATURAL SELECTION STOCK PHOTOGRAPHY, INC.	149-158	•	•					•			•				•	•				•		•		•	•		•	•	•
NATURE SOURCE	115-124		•			•		•			•									•		•					•	•	•
NAWROCKI STOCK PHOTO	485	•	•	•	•	•	•	•	•	•	•	•	•	•	•	•	•	•	•	•	•	•	•	•	•	•	•	•	•
OCEAN STOCK	445							•																	•		•		•
ODYSSEY PRODUCTIONS	468-469	•						•			•	•		•													•	•	•
OMNI-PHOTO COMMUNICATIONS, INC.	490-491	•	•			•		•		•	•	•			•		•	•		•		•				•	•	•	
PACIFIC STOCK	474-475	•	•					•		•	•	•			•		•	•		•		•			•		•	•	•

	Page	Agriculture	Animals	Automotive	Aviation	Black & White	Celebrities	Environmental/Nature	Fine Art	Food	General Stock	Geography	High-Tech	Historical	Human Interest	Illustration	Industry	Large Format Color	Medical	Model-Released People	Movie/TV Stills	Natural History	News	Science	Sports	Still Life	35mm Color	Travel/Leisure	Underwater
PANORAMIC IMAGES	470-471	•	•			•		•	•		•	•			•	•	•	•				•				•	•	•	•
DOUGLAS PEEBLES PHOTOGRAPHY	458			•				•			•	•						•							•		•	•	•
PHOTO EDIT	536-537	•						•		•	•	•			•				•	•							•	•	
PHOTO RESEARCHERS, INC.	125-134	•	•	•	•	•	•	•	•	•	•	•	•	•	•	•	•	•	•	•		•		•	•		•	•	•
PHOTOGRAPHIC RESOURCES	391-400	•	•			•		•		•	•	•	•	•	•		•	•	•	•		•		•	•	•	•	•	•
PHOTONICA	436-437	•	•	•	•	•		•	•	•	•	•	•		•		•	•		•				•	•	•	•	•	•
PHOTOTAKE	456-457	•				•		•	•	•	•	•		•	•	•	•	•	•	•		•			•	•			•
PHOTRI-PHOTO RESEARCH INTERNATIONAL	496	•	•		•	•		•	•	•	•	•		•	•		•	•	•	•	•	•	•	•	•	•	•	•	
THE PICTURE CUBE	524-525	•	•			•		•		•	•	•	•	•	•		•	•	•	•		•	•	•	•	•	•	•	
PICTURESQUE	518-519	•	•					•	•	•	•	•	•				•	•	•	•		•		•		•	•	•	
POSITIVE IMAGES	486-487	•	•			•		•		•			•		•			•		•		•				•	•	•	
PROFILES WEST	91-100	•	•	•	•			•		•	•	•		•	•	•	•	•		•		•		•	•	•	•	•	•
RO-MA STOCK	438	•	•	•	•			•			•	•			•		•					•		•	•		•	•	
H. ARMSTRONG ROBERTS STOCK PHOTOGRAPHY	189-206	•	•	•	•	•		•		•	•	•	•	•	•		•	•	•	•		•		•	•	•	•	•	•
SCIENCE SOURCE	101-114				•			•					•	•		•	•	•	•			•		•					
SHARPSHOOTERS PREMIUM STOCK PHOTOGRAPHY	291-320							•		•	•				•			•		•					•	•	•	•	•
SHOOTING STAR	451, 489, 527					•	•								•	•					•						•	•	
SICKLES PHOTO-REPORTING SERVICE ARCHIVES	480	•		•	•	•		•		•	•	•		•	•		•			•		•		•		•		•	
FRED SIEB PHOTOGRAPHY	492							•		•	•							•								•		•	
SOUTHERN STOCK PHOTO AGENCY	472	•	•					•		•	•	•	•				•	•	•	•				•	•	•	•	•	•

	Page	Agriculture	Animals	Automotive	Aviation	Black & White	Celebrities	Environmental/Nature	Fine Art	Food	General Stock	Geography	High-Tech	Historical	Human Interest	Illustration	Industry	Large Format Color	Medical	Model-Released People	Movie/TV Stills	Natural History	News	Science	Sports	Still Life	35mm Color	Travel/Leisure	Underwater
SPORTS PHOTO MASTERS, INC.	497																			•					•		•		
SPORTSCHROME EAST/WEST	515			•	•	•					•				•			•		•			•		•		•	•	
SPORTSLIGHT PHOTOGRAPHY	506							•												•					•		•	•	
THE STOCK BROKER	135-148	•	•			•				•	•	•	•	•			•	•		•		•			•	•	•	•	
STOCK IMAGERY, INC.	534-535	•	•		•					•	•	•	•		•	•	•	•	•	•				•	•	•	•	•	•
THE STOCK MARKET	401-418	•	•	•	•					•	•	•	•		•	•	•	•	•	•		•		•	•	•	•	•	•
STOCK PHOTOS HAWAII	530-531							•			•	•			•			•		•		•			•		•	•	•
THE STOCK SHOP INC.	321-329	•	•	•	•		•	•	•	•	•	•	•		•		•	•	•	•		•	•	•	•	•	•	•	•
THE STOCK SOLUTION	528-529	•	•					•		•	•	•	•				•	•	•	•		•			•	•	•	•	
STOCKWORKS STOCK ILLUSTRATION	61-70		•			•		•		•	•					•	•	•							•	•	•		
TONY STONE IMAGES	71-80	•	•	•	•	•		•		•	•	•	•		•		•	•	•	•	•	•		•	•	•	•	•	•
STREANO/HAVENS	494-495	•	•					•			•	•			•		•			•		•			•		•	•	
SUNSTOCK	500-505		•							•	•				•					•		•			•	•	•	•	
THIRD COAST STOCK SOURCE	532-533	•	•	•	•			•		•	•	•			•	•	•	•	•	•					•	•	•	•	•
WILLIAM THOMPSON PHOTOGRAPHS	446-447	•	•		•			•	•		•	•			•		•			•		•			•		•	•	
UNDERWOOD PHOTO ARCHIVES	466					•					•			•	•								•						
VOLCANIC RESOURCES	511			•				•				•	•	•								•		•			•	•	
WASHINGTON STOCK PHOTO, INC.	444			•				•			•	•		•	•			•	•	•		•	•		•	•	•	•	
WATERHOUSE STOCK PHOTOGRAPHY	522-523		•					•										•		•		•			•		•	•	•
WEST STOCK	331-340	•	•					•		•	•		•		•		•	•	•	•				•	•		•	•	•
WESTLIGHT	227-266	•	•	•				•		•	•	•			•		•	•	•			•		•	•	•	•	•	•
ZEPHYR PICTURES	207-216					•				•	•	•			•			•	•	•					•	•	•	•	

Cross Reference Index

Cross Reference Index

Cross Reference Index

C

Cross Reference Index

Cross Reference Index

F

G

H

I

J

M

N

Cross Reference Index

Cross Reference Index

Cross Reference Index

Topic	Page Number
Recreation	52, 92, 93, 94, 97, 126, 156, 190, 200, 225, 269, 362, 374, 450, 460, 477, 482, 488, 491, 493, 500, 503, 506, 515, 529, 530
Recycling	55, 198, 410, 536
Red	122, 143, 146, 158, 191, 196, 201, 203, 299, 425, 479
Red Blood Cells	106
Red Foxes	359
Red Heads	525
Red Square	452
Redwood National Forest	153
Reefs	206
Refineries	198, 243
Reflections	99, 100, 140, 143, 146, 157, 242, 257, 295, 344, 370, 424, 474, 499
Rehabilitation	184, 520
Relaxation	76, 100, 130, 131, 133, 136, 193, 195, 269, 337, 414, 449, 475, 500, 504, 531
Relay	164, 462
Reliable	480
Religion	259, 425, 468, 476, 520
Religions of the World	449
Religion/Temples	325
Remodeling	529
Remote	100
Remote Office	337
Repairmen	324
Reports	197
Reproduction	105, 106, 327
Reptiles	120, 152, 287, 387, 499, 505
Research	67, 106, 112, 113, 198, 328, 329, 378, 396, 397, 408
Research, Geological	511
Research, Industrial	439
Researchers	186
Residents	184, 187
Resorts	133, 136, 210, 447, 449, 474, 531
Restaurants	480
Retired People	317, 427, 493
Retirement	193, 194, 199, 459
Reunion	422
Revolutionary War Re-enactments	486
Rheumatism	107
Rhinoceros	124, 375
Rice	166, 283
Rice Fields	435
Rickets	107
Rio de Janeiro	257
Ripples	146
Risk	82, 84, 93, 137, 340, 483
Rivera, Diego	469
River Rafting	146, 269
Rivers	94, 99, 124, 205, 273, 302, 336, 448
Roads	111, 204, 268, 325, 428, 450, 464, 465, 470, 477, 483, 492, 517
Roads, Night	422
Road Scenes	264, 417
Robotics	54, 521
Rock Climbing	82, 83, 84, 85, 94, 137, 268, 446, 483, 506

Topic	Page Number
Rocks	142, 473
Rocky Mountains	336
Rodents	287
Rogers, Roy	489
Role Models	403
Role Reversals	94, 96
Roller Blades	337
Roller Blading	85, 250, 305, 460
Rolls Royce	354
Romantic	92, 94, 136, 145, 194, 210, 250, 322, 323, 342, 365, 403, 433, 459, 472, 502, 531, 536
Rome	256, 478
Roosevelt, Franklin D.	59
Roping	300
Roses	289, 487
Round	142
Roundup	413
Rowboat	365, 517
Rowing	270
Royal Guard	441
Royalty	67, 509
Ruins	148, 455
Runners	299, 307, 326
Running	52, 70, 164, 192, 211, 212, 223, 253, 268, 269, 326, 343, 432, 462, 483, 497, 501, 502, 504, 506, 509, 530
Runways	244
Rural	92, 95, 203, 424
Rural Landscapes	399, 450, 492, 517
Rural Scenes	290
Russia	165, 176, 444, 452, 476, 477, 494

Topic	Page Number
Sad	193, 520
Safety	193, 198, 200
Sage	289
Sailboarding	348, 458
Sailboats	175, 178, 191, 195, 493, 500, 505
Sailing	136, 170, 171, 172, 177, 427, 445, 450, 454, 501, 504, 515
St. Basil	165
St. Louis, Missouri	165, 205, 215
St. Petersburg	494
Sales	197
Sales Meeting	324
Salmon	364
Sambudu Dancers	134
San Diego, California	215
San Francisco, Aerial	513
San Francisco, California	138, 214, 257, 416, 444, 459, 494
San Juan Mountains	100
Sand	136, 138, 475, 502, 504
Sand Dunes	276, 336, 525
Santiago	448
Satellite Antenna	110

Cross Reference Index

T

Cross Reference Index

X

Y

Z

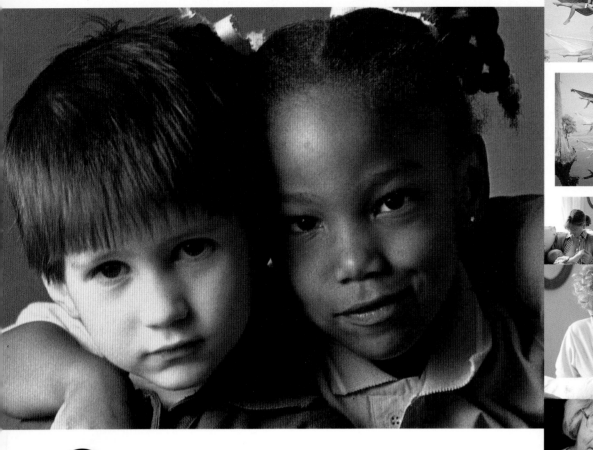

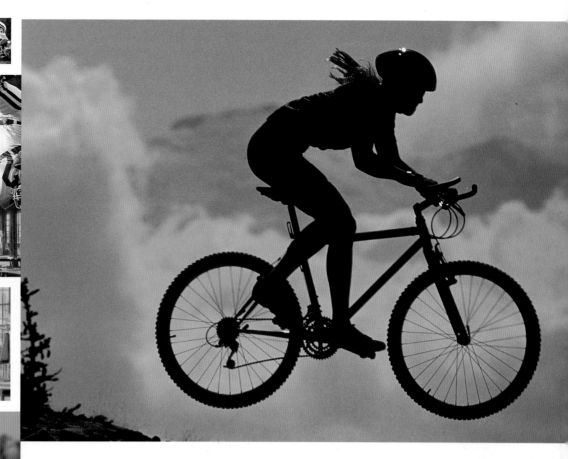

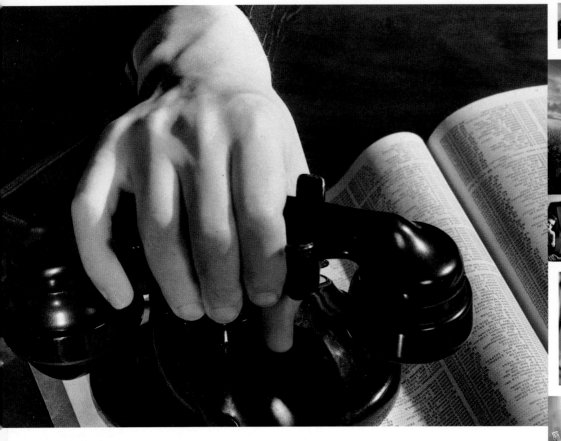

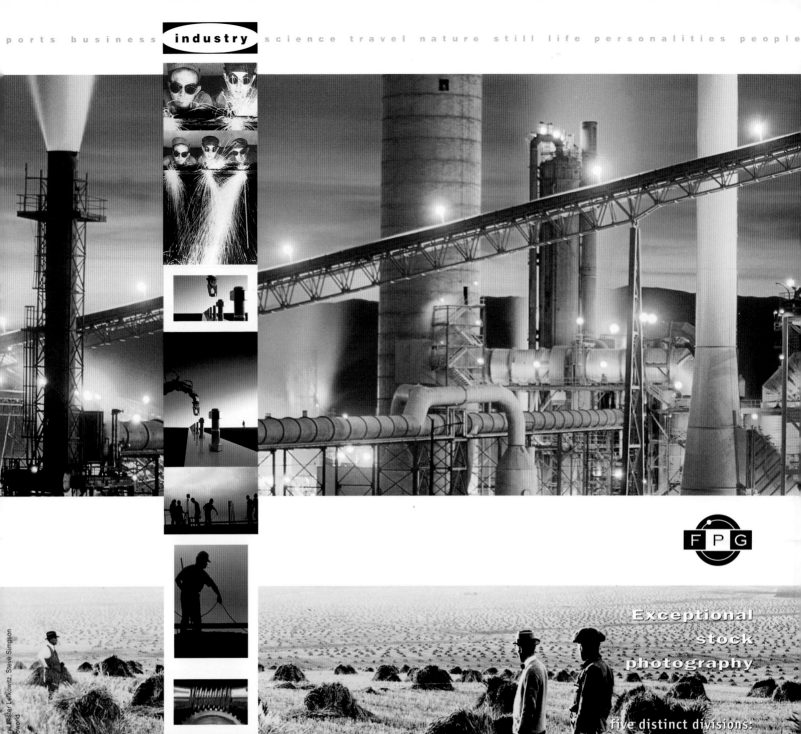

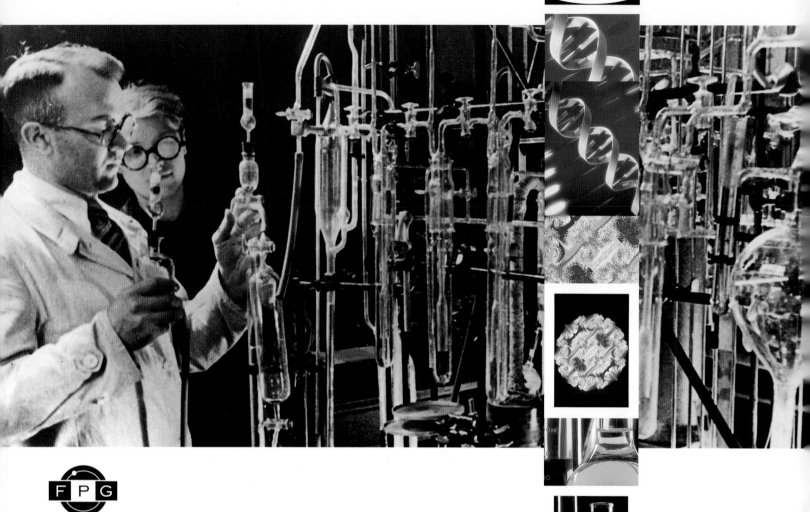
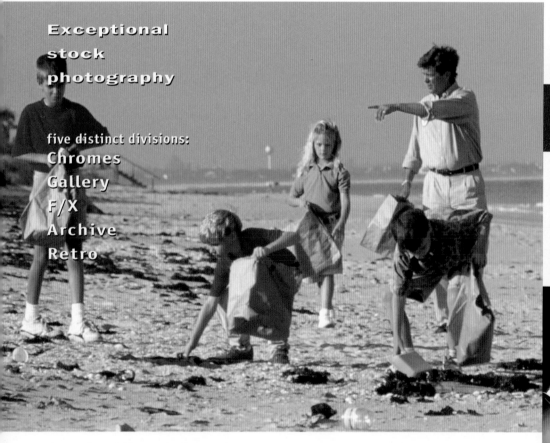

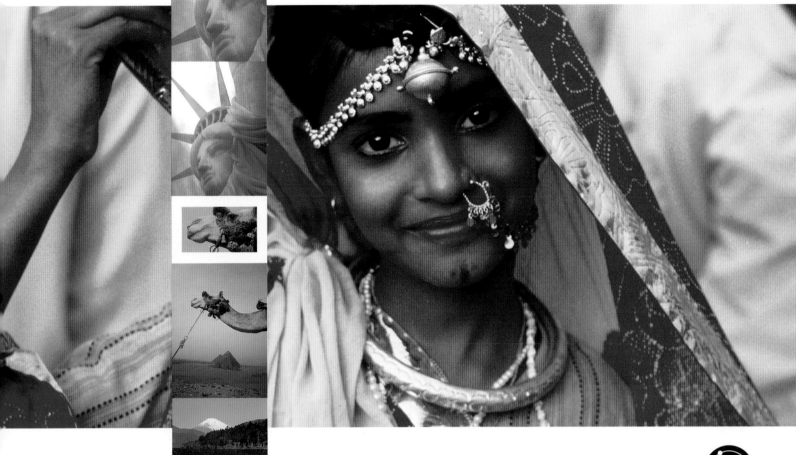

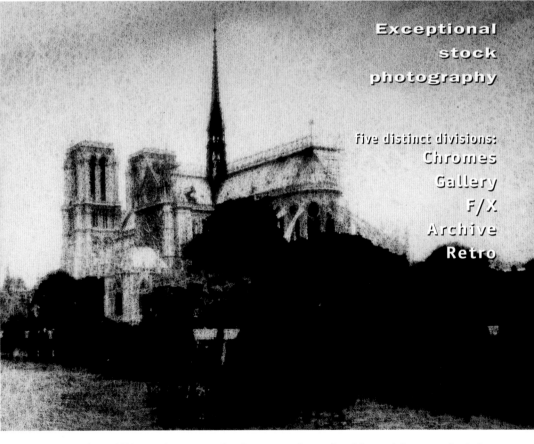

**Exceptional
stock
photography**

five distinct divisions:
Chromes
Gallery
F/X
Archive
Retro

Over six million photographs in every imaginable subject and style.
Call for catalogs and information about FPG's CD-ROM, now available.

212 777 4210 fax 212 995 9652

FPG International 32 Union Square East New York, NY 10003-3295

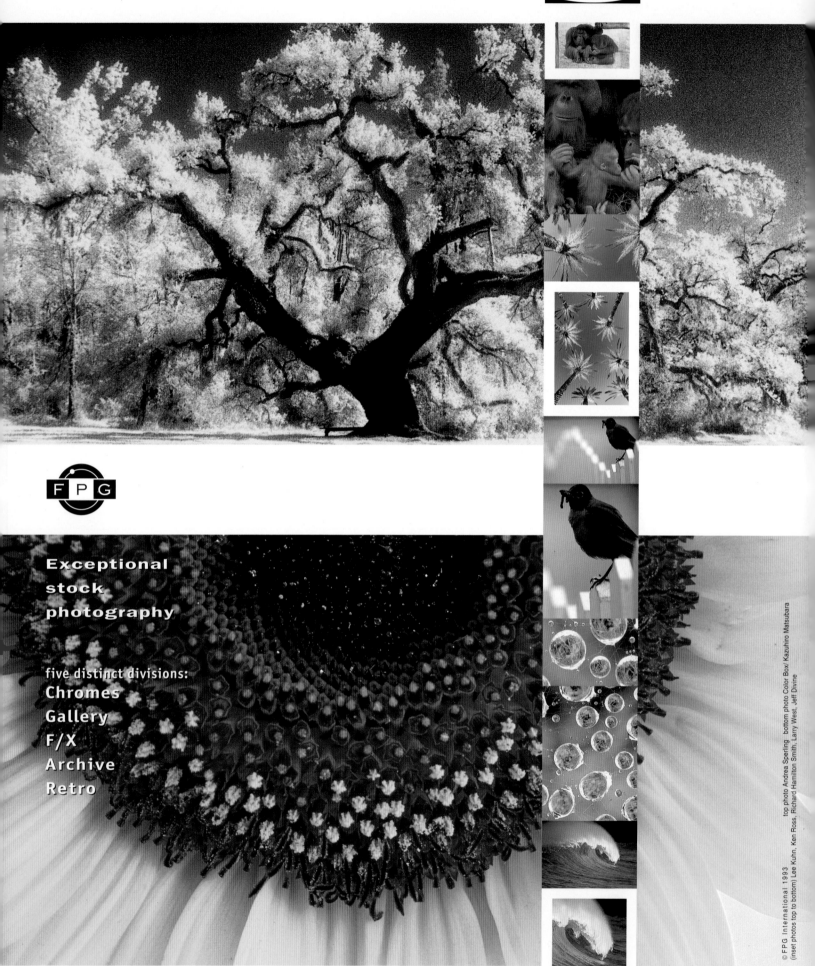

FPG

**Exceptional
stock
photography**

five distinct divisions:
Chromes
Gallery
F/X
Archive
Retro

© FPG International 1993 top photo Andrea Sperling bottom photo Color Box/ Kazuhiro Matsubara
(inset photos top to bottom) Lee Kuhn, Ken Ross, Richard Hamilton Smith, Larry West, Jeff Divine

Over six million photographs in every imaginable subject and style.
Call for catalogs and information about FPG's CD-ROM, now available.

212 777 4210 fax 212 995 9652

FPG International 32 Union Square East New York, NY 10003-3295

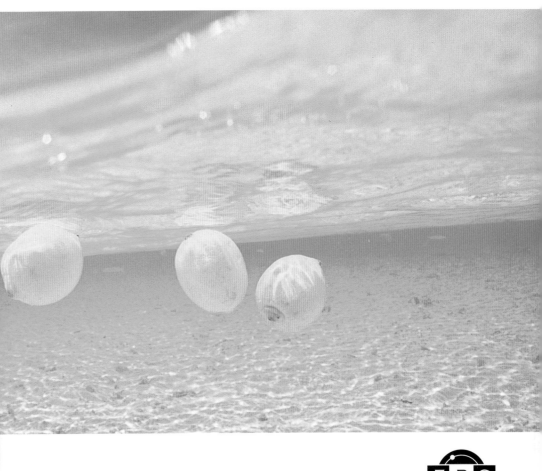

**Exceptional
stock
photography**

five distinct divisions:
**Chromes
Gallery
F/X
Archive
Retro**

Over six million photographs in every imaginable subject and style.
Call for catalogs and information about FPG's CD-ROM, now available.

212 777 4210 fax 212 995 9652

FPG International 32 Union Square East New York, NY 10003-3295

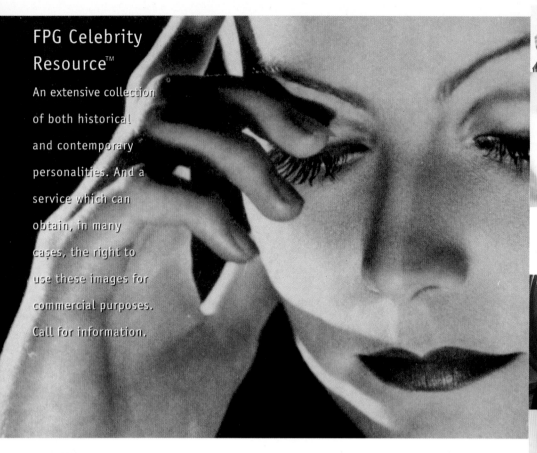

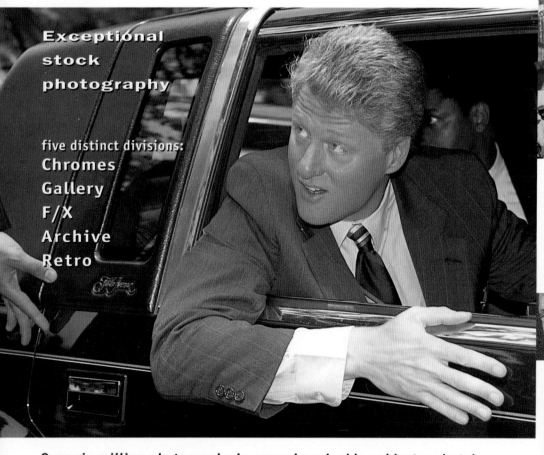

STOCKWORKS

STOCK ILLUSTRATION

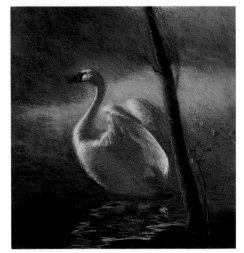

© Allen Garns #1765

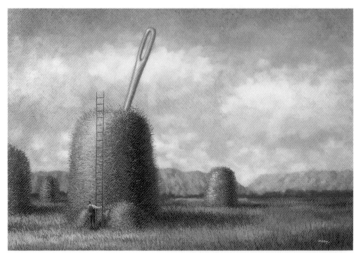

© Rob Colvin #3819

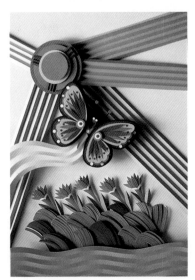

© Gary Hoover #3871

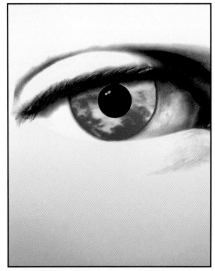

© Alecia Jensen #3892

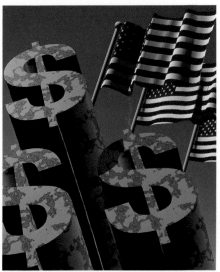

© Steve Keller #3901

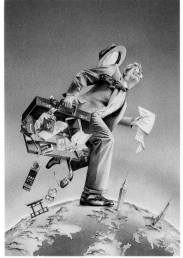

© Cheryl Chalmers #2059

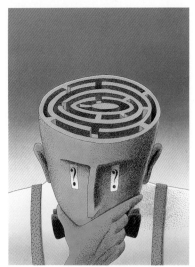

© David C. Chen #4013

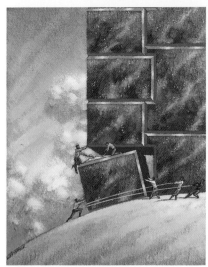

© Eric C. Westbrook #3328

ACCESS TO THE BEST IN ILLUSTRATION—WITHOUT THE WAIT.

THIS IS A SELECTION OF IMAGES FROM OUR FILES. SEE ADDITIONAL IMAGES IN THE STOCK WORKBOOK III THRU VI.
OR CALL US WITH SPECIFIC REQUESTS. ASSIGNMENT ALSO AVAILABLE.

310 204-1774
FAX 310 204-4598

STOCKWORKS

STOCK ILLUSTRATION ®

© Robert J. Jones #3860

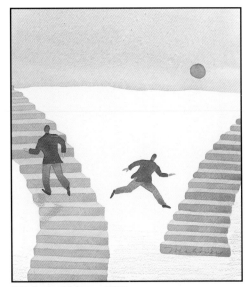

© Katherine Mahoney #4046

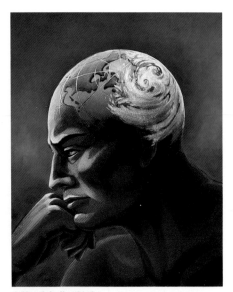

© Kim Scholle #3940

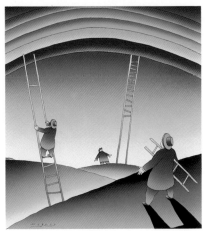

© Michael McGurl #4086

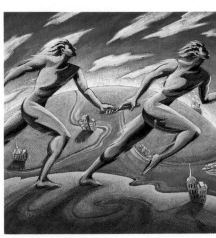

© Kim Scholle #3903

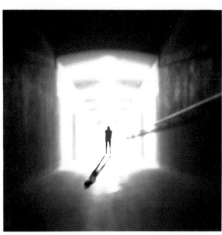

© Alecia Jensen #3893

© Gregory Loudon #3896

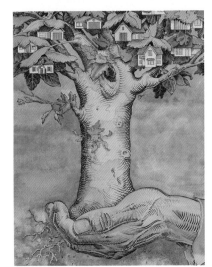

© Roger Xavier #4007

© Steve Vance #4085

ACCESS TO THE BEST IN ILLUSTRATION—WITHOUT THE WAIT.

THIS IS A SELECTION OF IMAGES FROM OUR FILES. SEE ADDITIONAL IMAGES IN THE STOCK WORKBOOK III THRU VI.
OR CALL US WITH SPECIFIC REQUESTS. ASSIGNMENT ALSO AVAILABLE.

310 **204-1774**
FAX 310 204-4598

STOCKWORKS

STOCK ILLUSTRATION

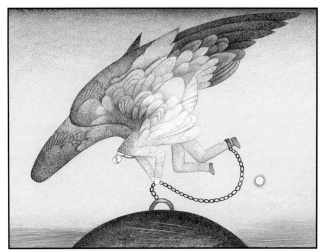

© James Endicott #3240

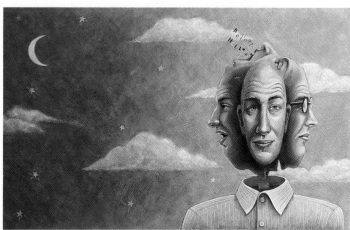

© Kim Scholle #3935

© Rob Saunders #3514

© Steve Keller #3760

© Rob Saunders #4055

© Catherine Leary #4080

© Jim Owens #3995

© Tim Grajek #4051

ACCESS TO THE BEST IN ILLUSTRATION—WITHOUT THE WAIT.

THIS IS A SELECTION OF IMAGES FROM OUR FILES. SEE ADDITIONAL IMAGES IN THE STOCK WORKBOOK III THRU VI.
OR CALL US WITH SPECIFIC REQUESTS. ASSIGNMENT ALSO AVAILABLE.

310 204-1774
FAX 310 204-4598

STOCKWORKS

S T O C K I L L U S T R A T I O N ®

© Jim Owens #3991

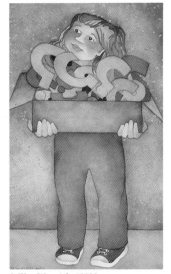

© Elsa Warnick #3922

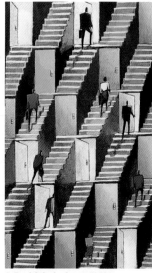

© Paul Schulenburg #3386

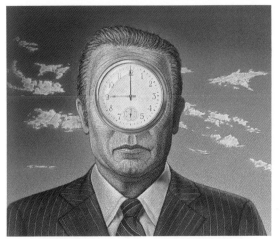

© Ed Soyka #4081

© Alan Brunettin #3805

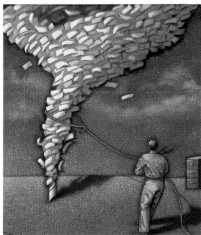

© Katherine Mahoney #4047

© Rich Grote #4008

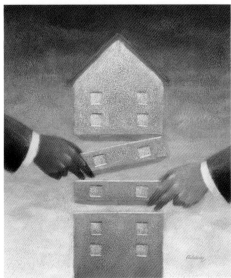

© Rob Colvin #3296

© Pam Wall #4082

ACCESS TO THE BEST IN ILLUSTRATION—WITHOUT THE WAIT.

THIS IS A SELECTION OF IMAGES FROM OUR FILES. SEE ADDITIONAL IMAGES IN THE STOCK WORKBOOK III THRU VI.
OR CALL US WITH SPECIFIC REQUESTS. ASSIGNMENT ALSO AVAILABLE.

310 **204-1774**
FAX 310 204-4598

STOCKWORKS
STOCK ILLUSTRATION

© Robin Jareaux #3900

© Jim Starr #3996

© Richard A. Goldberg #3724

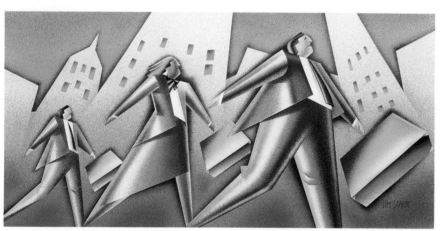

© Jim Starr #3965

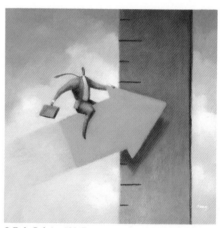

© Rob Colvin #3817

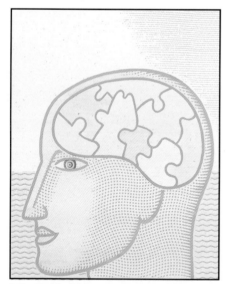

© Tim Grajek #4042

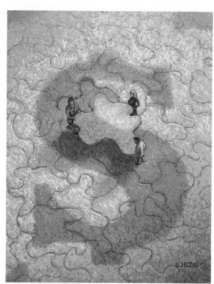

© Michel Bohbot #4045

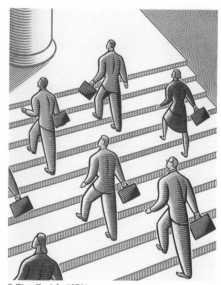

© Tim Grajek #3581

ACCESS TO THE BEST IN ILLUSTRATION—WITHOUT THE WAIT.

THIS IS A SELECTION OF IMAGES FROM OUR FILES. SEE ADDITIONAL IMAGES IN THE STOCK WORKBOOK III THRU VI.
OR CALL US WITH SPECIFIC REQUESTS. ASSIGNMENT ALSO AVAILABLE.

310 **204-1774**
FAX 310 204-4598

STOCKWORKS

S T O C K I L L U S T R A T I O N ®

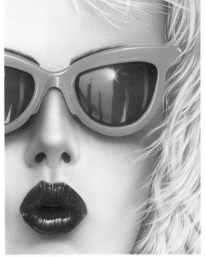

© Pam Wall #4083

© Elsa Warnick #3926

© Rich Grote #3969

© Elsa Warnick #3928

© Michel Bohbot #4044

© Steve Vance #4084

© Rob Saunders #4056

© Pearl Beach #4059

ACCESS TO THE BEST IN ILLUSTRATION—WITHOUT THE WAIT.

THIS IS A SELECTION OF IMAGES FROM OUR FILES. SEE ADDITIONAL IMAGES IN THE STOCK WORKBOOK III THRU VI.
OR CALL US WITH SPECIFIC REQUESTS. ASSIGNMENT ALSO AVAILABLE.

310 **204-1774**
FAX 310 204-4598

STOCKWORKS

STOCK ILLUSTRATION

© Kimmerle Milnazik #3985

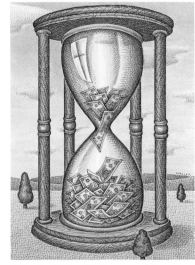

© Charles Waller #4019

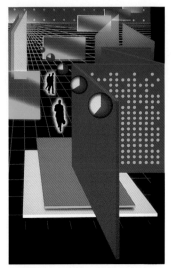

© Bill Morse #3406

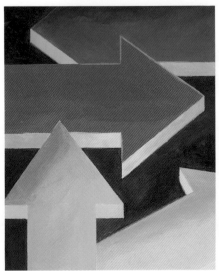

© Caroline Beghin #4058

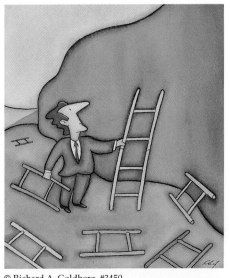

© Richard A. Goldberg #3450

© Eric C. Westbrook #3845

© Tracy Sabin #3961

© Michele Manning #2158

© Paul Schulenburg #3387

ACCESS TO THE BEST IN ILLUSTRATION—WITHOUT THE WAIT.

THIS IS A SELECTION OF IMAGES FROM OUR FILES. SEE ADDITIONAL IMAGES IN THE STOCK WORKBOOK III THRU VI.
OR CALL US WITH SPECIFIC REQUESTS. ASSIGNMENT ALSO AVAILABLE.

310 204-1774
FAX 310 204-4598

STOCKWORKS
STOCK ILLUSTRATION

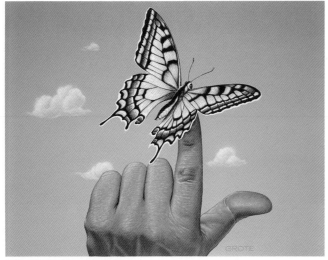

© Rich Grote #4009

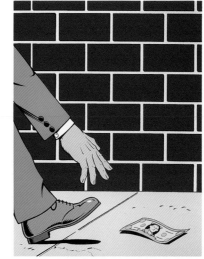

© Steve Vance #4087

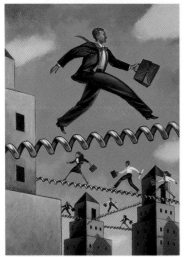

© Rafael Lopez #4001

© Catherine Leary #4088

© Rafael Lopez #4090

© Gregory Loudon #4079

© Dona Whisman #1888

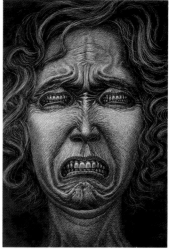

© Ed Soyka #4089

ACCESS TO THE BEST IN ILLUSTRATION—WITHOUT THE WAIT.

THIS IS A SELECTION OF IMAGES FROM OUR FILES. SEE ADDITIONAL IMAGES IN THE STOCK WORKBOOK III THRU VI.
OR CALL US WITH SPECIFIC REQUESTS. ASSIGNMENT ALSO AVAILABLE.

310 **204-1774**
FAX 310 204-4598

STOCKWORKS

STOCK ILLUSTRATION

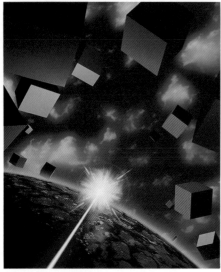

© Rob Magiera #3826

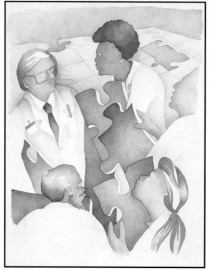

© Elsa Warnick #3921

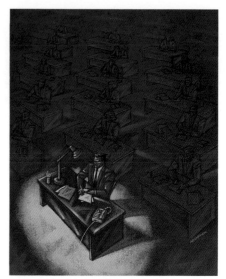

© Eric C. Westbrook #2080

MARATHON

© Mark Jasin #1745

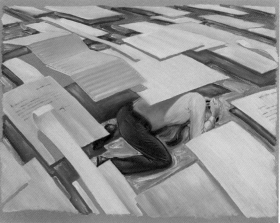

© Danny Wilson #2088

© Lynne Foy #1877

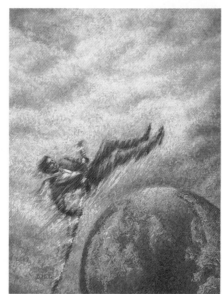

© Michel Bohbot #3491

© Gary Hoover #3867

ACCESS TO THE BEST IN ILLUSTRATION—WITHOUT THE WAIT.

THIS IS A SELECTION OF IMAGES FROM OUR FILES. SEE ADDITIONAL IMAGES IN THE STOCK WORKBOOK III THRU VI.
OR CALL US WITH SPECIFIC REQUESTS. ASSIGNMENT ALSO AVAILABLE.

310 **204-1774**
FAX 310 204-4598

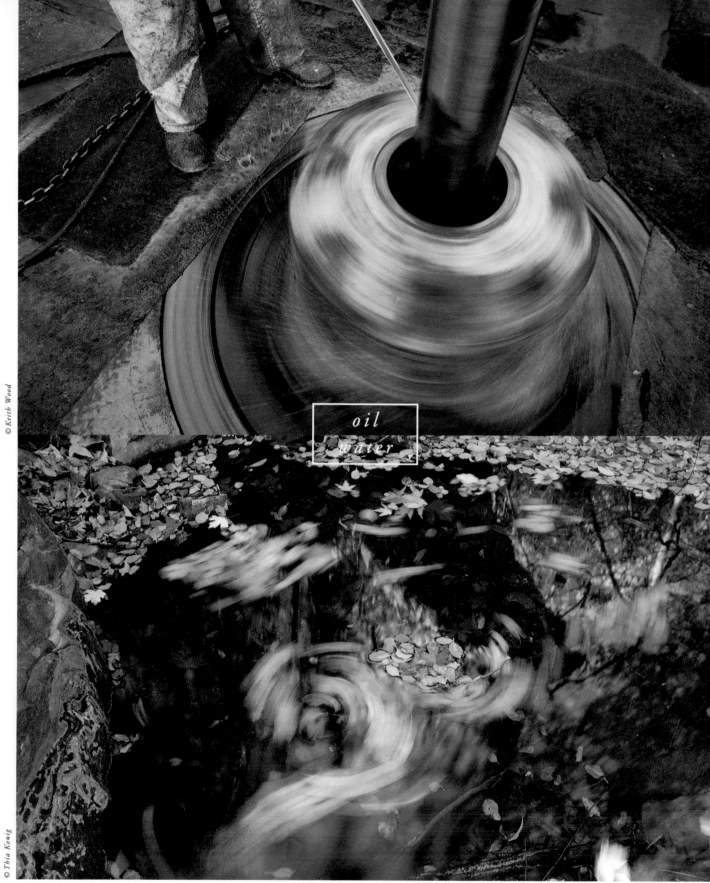

oil
water

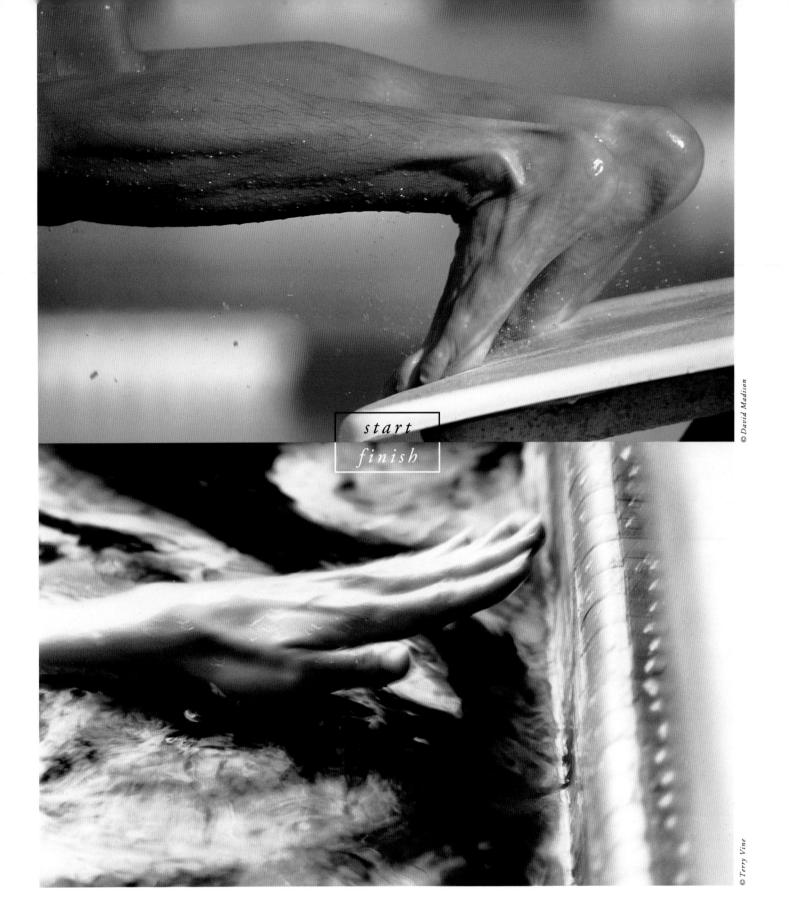

start
finish

© David Madison

© Terry Vine

TONY STONE
I M A G E S

Call for our free catalog Volume 5.
U.S. 800 234 7880 *Chicago, New York, Los Angeles*
CANADA *Toronto* 800 565 3879

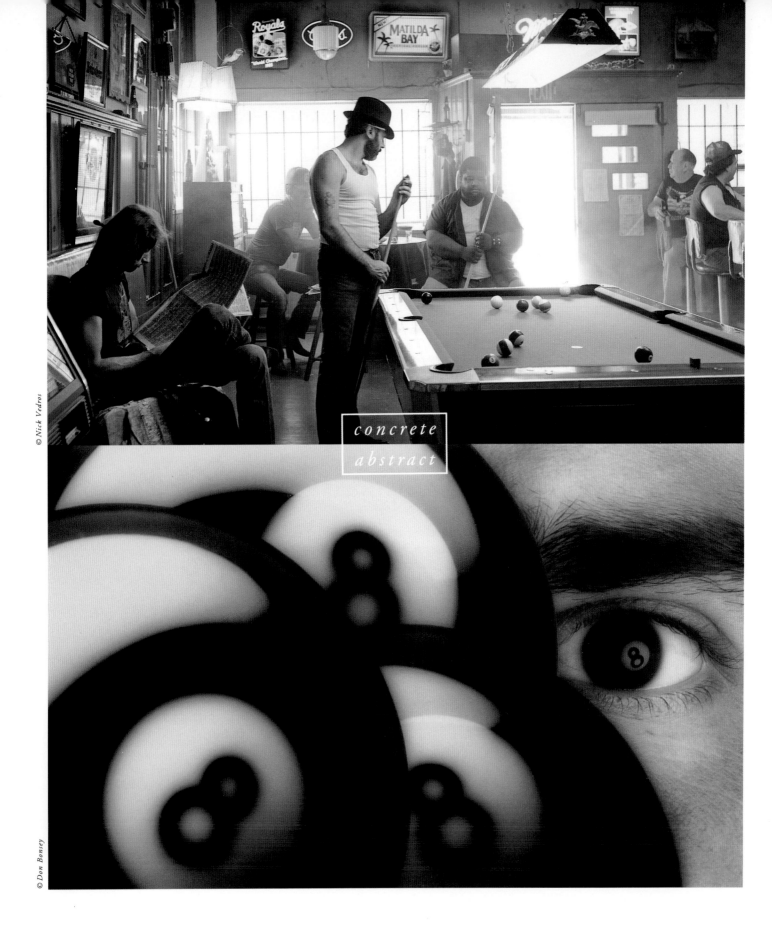

concrete
abstract

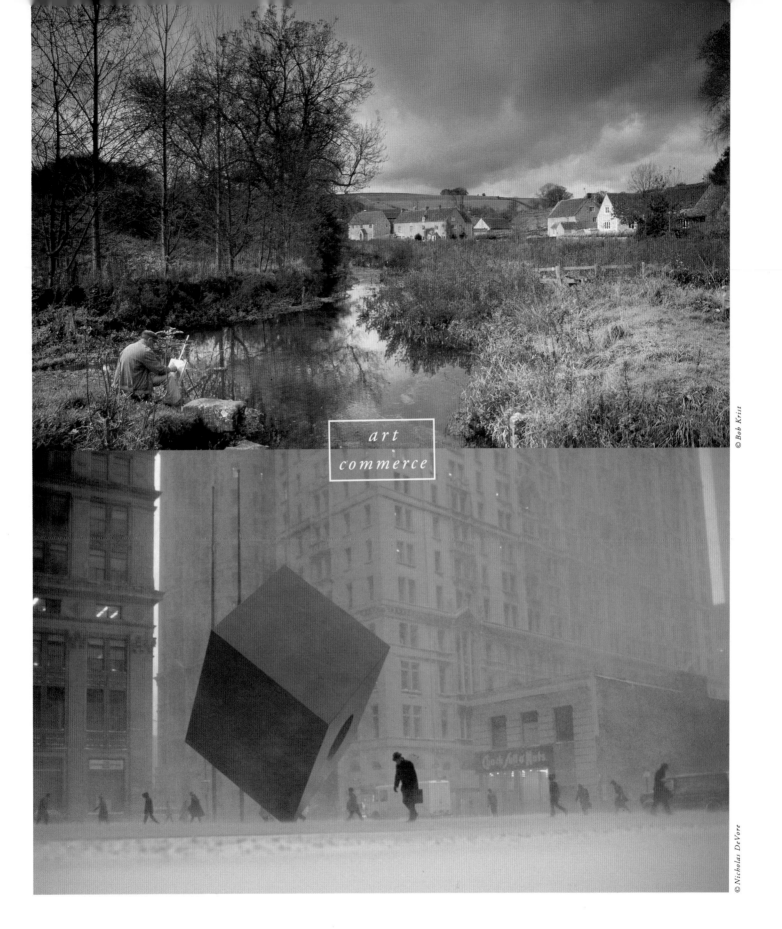

art
commerce

© Bob Krist

© Nicholas DeVore

TONY STONE

I M A G E S

Call for our free catalog Volume 5.

U.S. 800 234 7880 *Chicago, New York, Los Angeles*

CANADA *Toronto* 800 565 3879

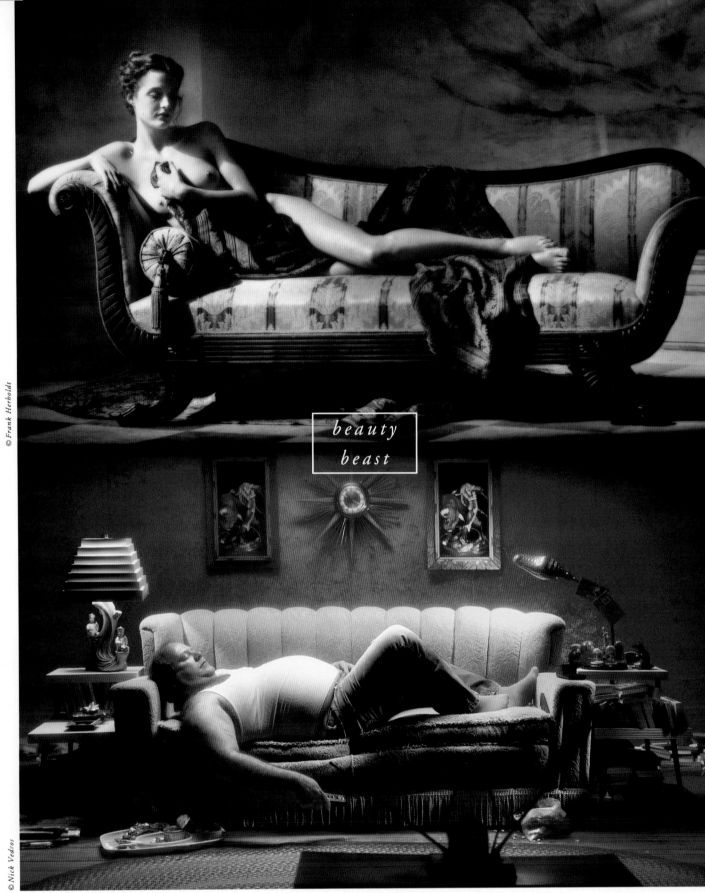

beauty

beast

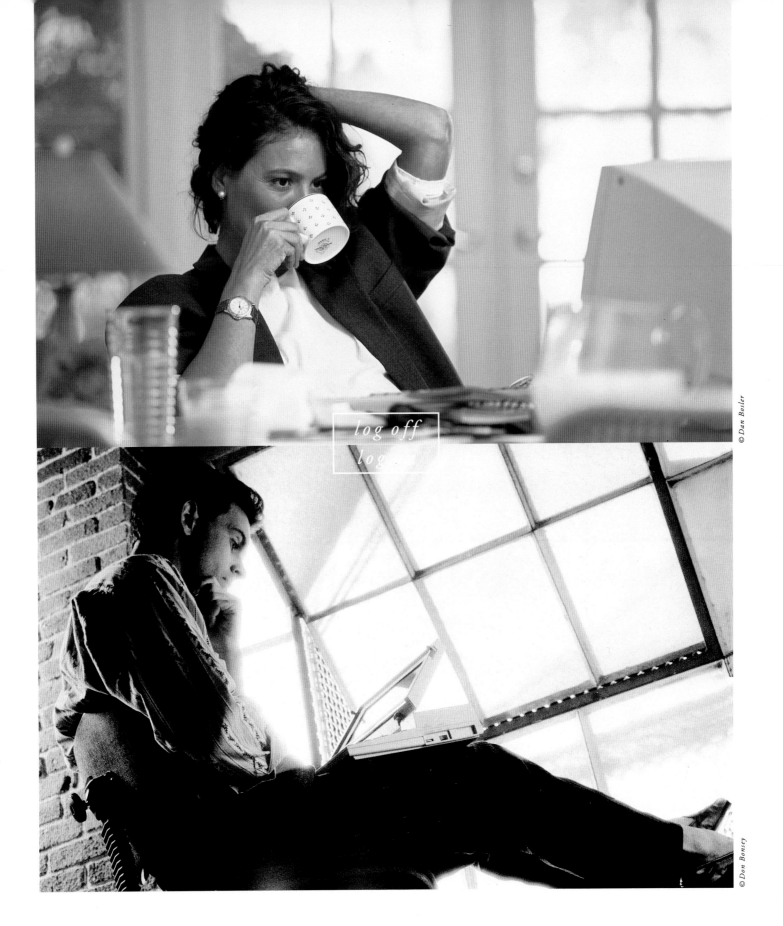

log off
log

© Dan Bosler

© Don Bonsey

TONY STONE
IMAGES

Call for our free catalog Volume 5.
U.S. 800 234 7880 *Chicago, New York, Los Angeles*
CANADA *Toronto* 800 565 3879

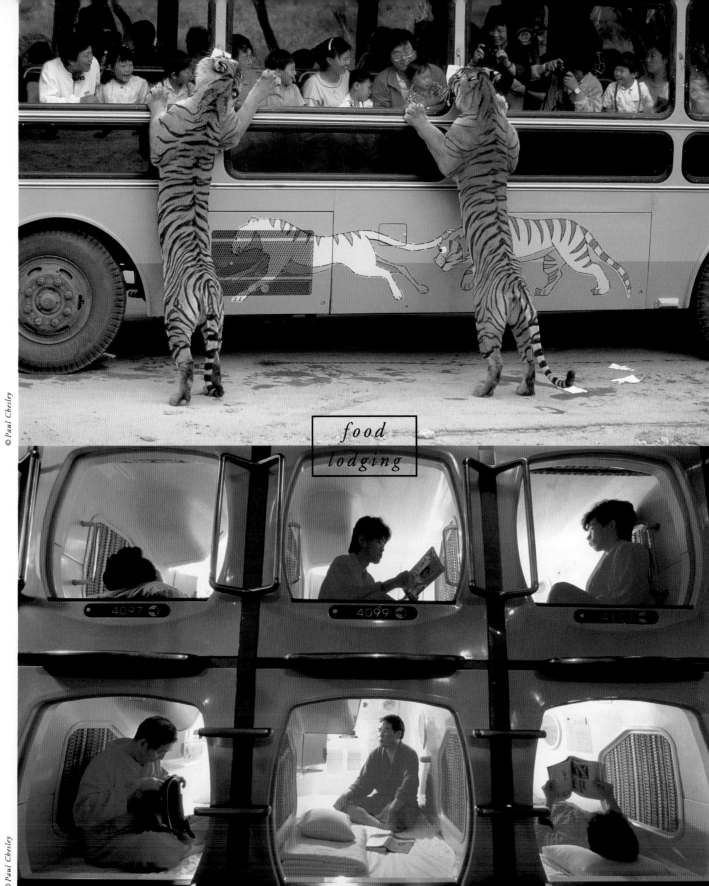

food

lodging

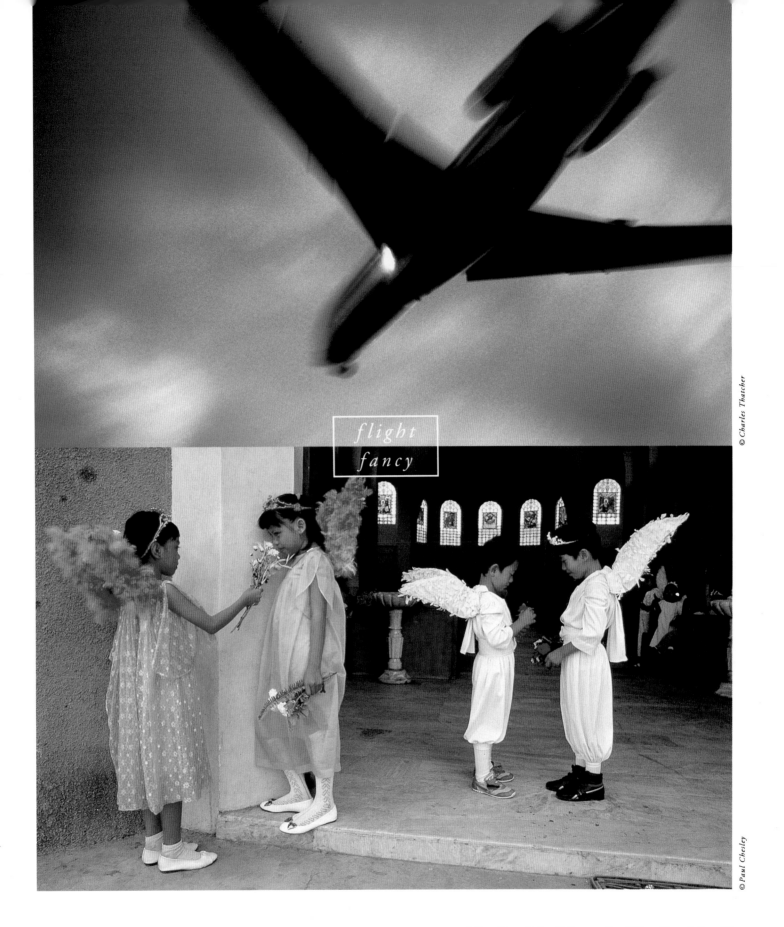

flight
fancy

© Charles Thatcher

© Paul Chesley

79

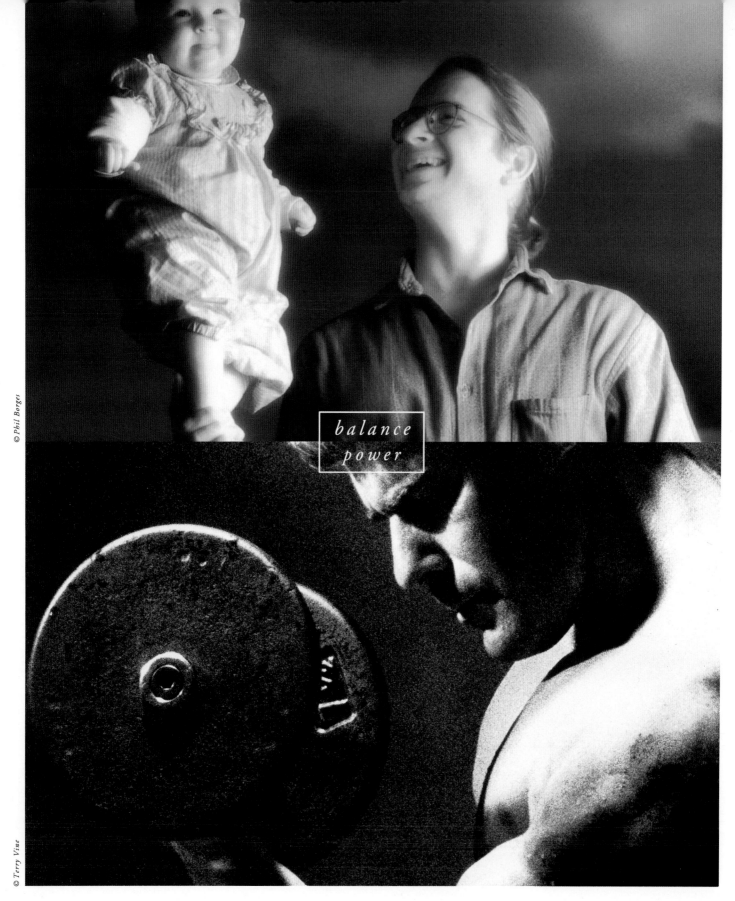

balance
power

© Phil Borges

© Terry Vine

COMPARE AND CONTRAST. YOUR BEST SHOT FOR STOCK PHOTOGRAPHY IS TONY STONE IMAGES.

TONY STONE
IMAGES

Call for our free catalog Volume 5.
Ask about our FREESEARCH[SM] *program and*
our exciting CD-ROM *catalog, too.*

U.S. 800 234 7880 *Chicago, New York, Los Angeles*
CANADA *Toronto* 800 565 3879

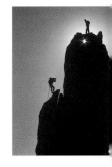

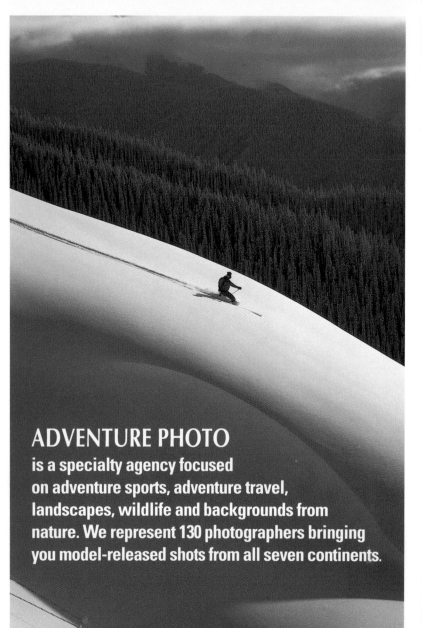
AP 452 Michael Kennedy

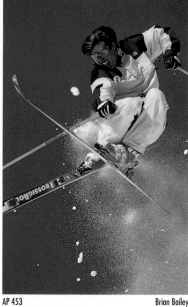
AP 453 Brian Bailey

AP 454 Bill Hatcher

ADVENTURE PHOTO
is a specialty agency focused
on adventure sports, adventure travel,
landscapes, wildlife and backgrounds from
nature. We represent 130 photographers bringing
you model-released shots from all seven continents.

1-800-524-5866
ADVENTURE PHOTO • 56 E. MAIN ST. #202 VENTURA, CA 93001

Printed in Japan

ADVENTURE
PHOTO

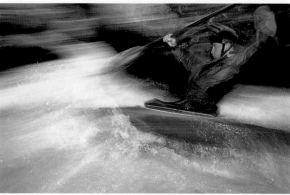
AP 455 Jean-Pierre Vollrath

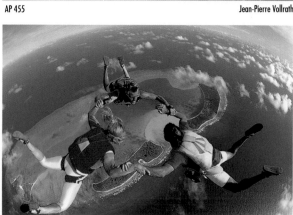
AP 456 Tom Sanders

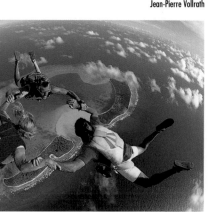
AP 457 Gordon Wiltsie

AP 458 Tom Sanders

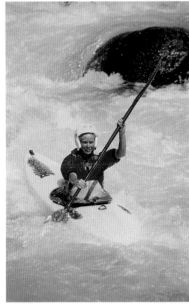

AP 459 Wiley/Wales

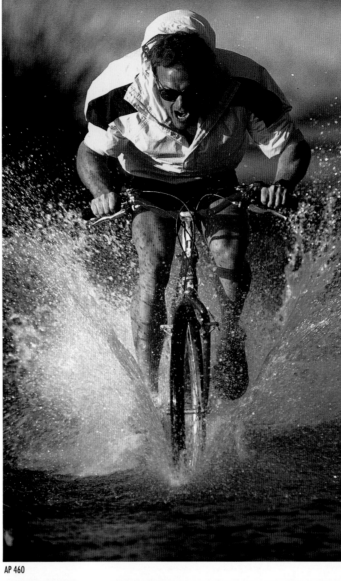

AP 460 Gary Brettnacher

AP 462 David Wheelock

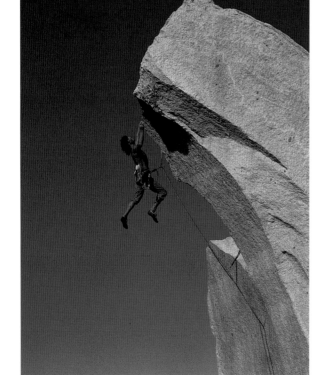

AP 461 Greg Epperson

AP 463 Didier Givois

ADVENTURE
PHOTO

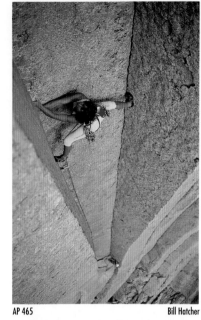

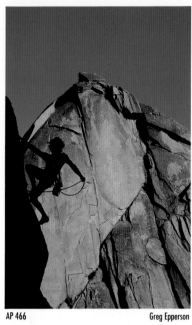

AP 464 Chris Noble

AP 465 Bill Hatcher

AP 466 Greg Epperson

1-800-524-5866

ADVENTURE PHOTO • 56 E. MAIN ST. #202 VENTURA, CA 93001

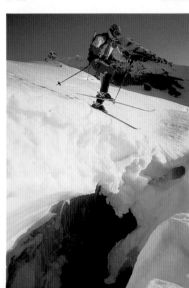

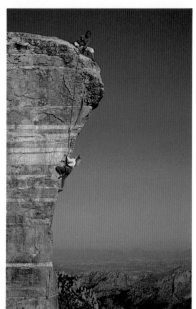

AP 467 Beth Wald

AP 468 Scott Spiker

AP 469 Greg Epperson

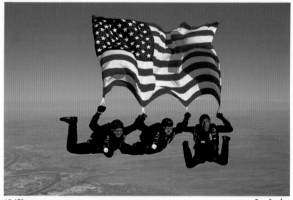

AP 470 Bill Stevenson

AP 471 Tom Sanders

ADVENTURE PHOTO

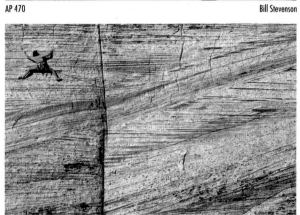

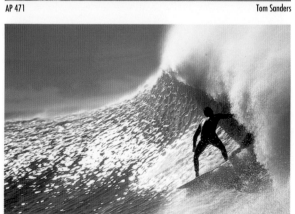

AP 472 Uli Wiesmeier

AP 473 Dan Merkel

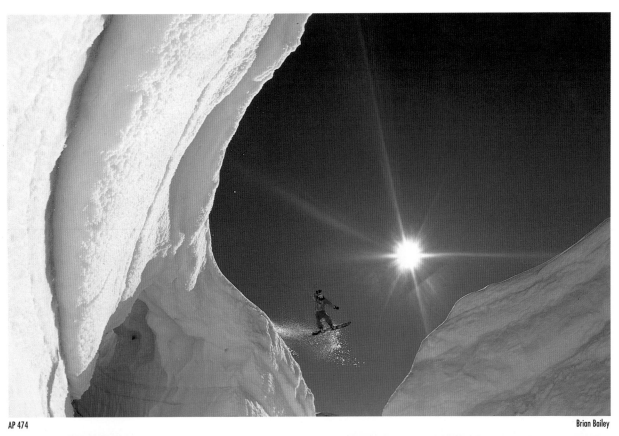

AP 474 Brian Bailey

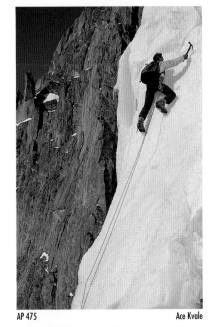

AP 475 Ace Kvale

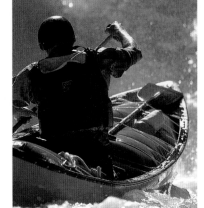

AP 476 Jean-Pierre Vollrath

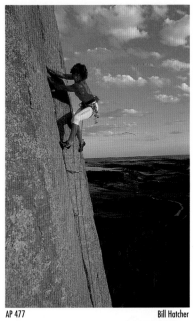

AP 477 Bill Hatcher

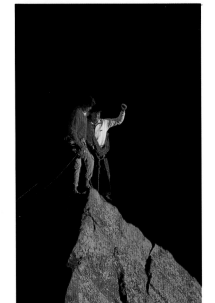

AP 478 Brian Bailey

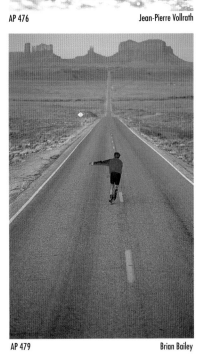

AP 479 Brian Bailey

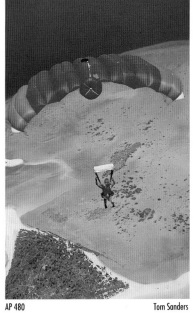

AP 480 Tom Sanders

ADVENTURE
PHOTO

85

AP 481 Gerry Soifer

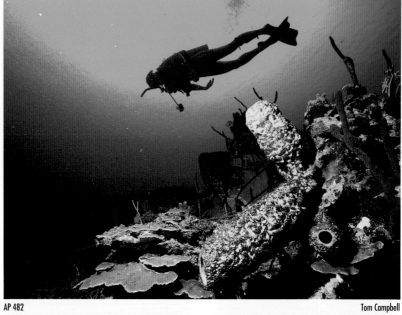

AP 482 Tom Campbell

1-800-524-5866
ADVENTURE PHOTO • 56 E. MAIN ST. #202 VENTURA, CA 93001

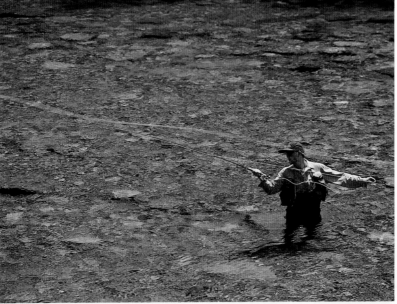

AP 483 Andy Anderson

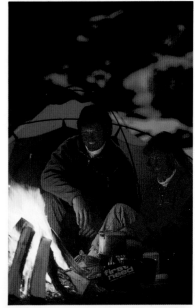

AP 484 Brian Bailey

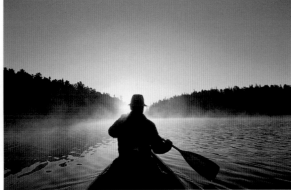

AP 485 Layne Kennedy

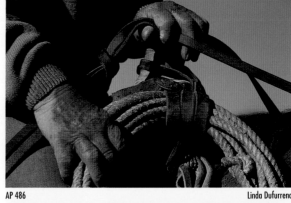

AP 486 Linda Dufurrena

ADVENTURE PHOTO

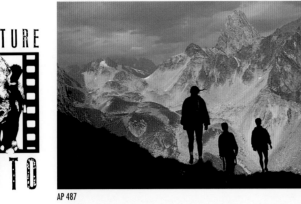

AP 487 Didier Givois

AP 488 Gordon Wiltsie

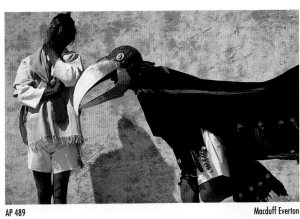

AP 489 Macduff Everton

AP 490 A.M.W.

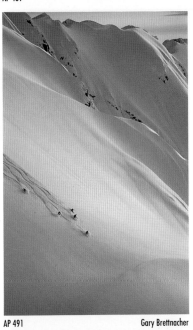

AP 491 Gary Brettnacher

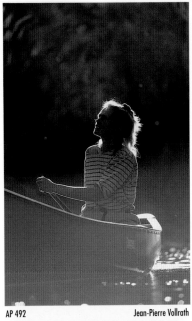

AP 492 Jean-Pierre Vollrath

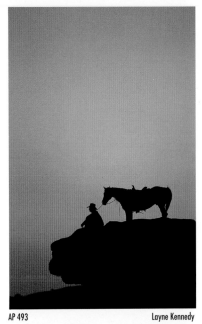

AP 493 Layne Kennedy

AP 494 David Wheelock

AP 495 Kennan Ward

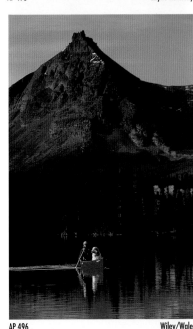

AP 496 Wiley/Wales

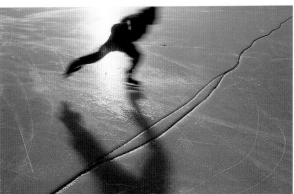

AP 497 Layne Kennedy

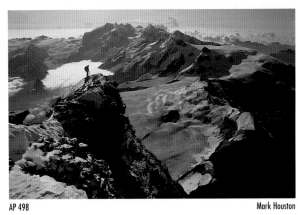

AP 498 Mark Houston

87

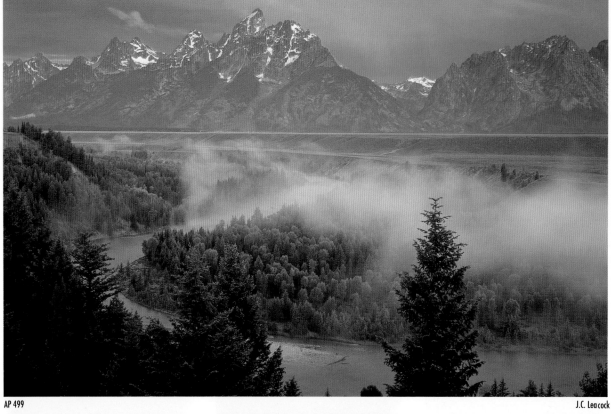

AP 499 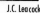 J.C. Leacock

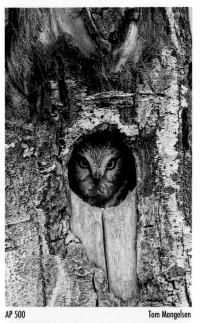

AP 500 Tom Mangelsen

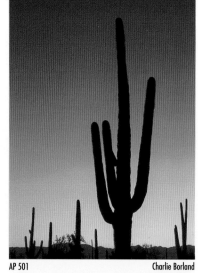

AP 501 Charlie Borland

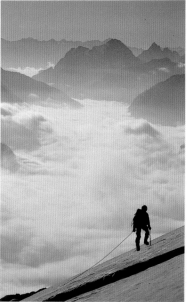

AP 502 Mark Houston

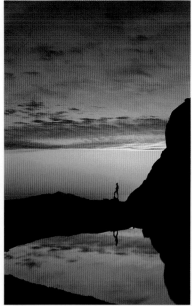

AP 503 Gordon Wiltsie

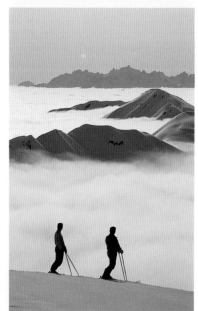

AP 504 Didier Givois

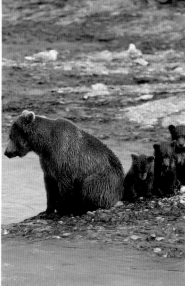

AP 505 Mark Newman

ADVENTURE
PHOTO

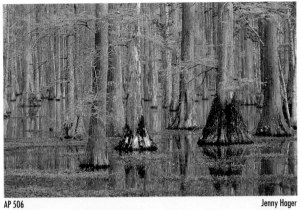

AP 506 Jenny Hager

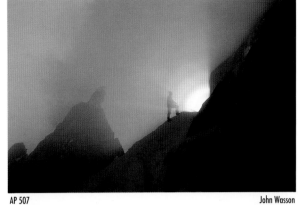

AP 507 John Wasson

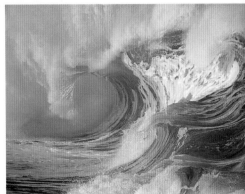

AP 508 Phil DeRiemer

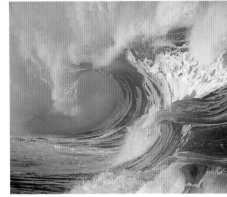

AP 509 Brian Bielmann

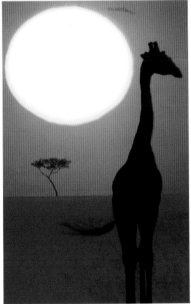

AP 510 Mark Newman

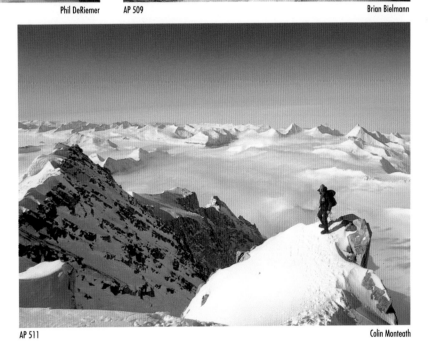

AP 511 Colin Monteath

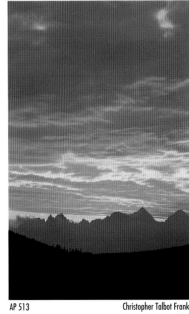

AP 512 Colin Monteath

AP 513 Christopher Talbot Frank

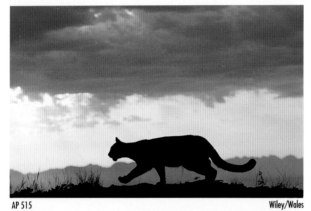

AP 514 Layne Kennedy

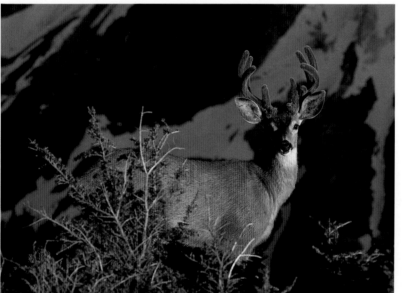

AP 515 Wiley/Wales

AP 516 Tui De Roy

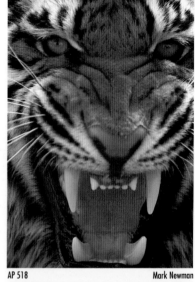

AP 517 Mark Houston

AP 518 Mark Newman

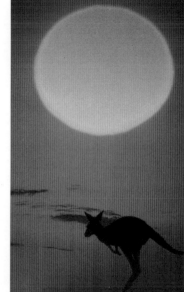

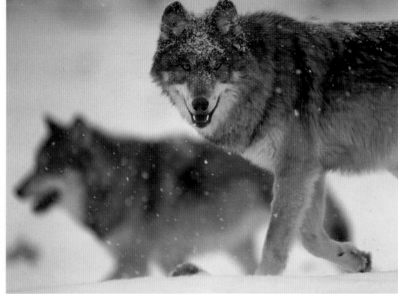

AP 519 Layne Kennedy

AP 520 Mark Newman

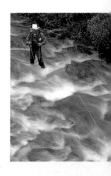

ProFiles West

When you want the West,
Come to the West.
While you're here . . .
We'll also give you the World.

(719) 395-8671

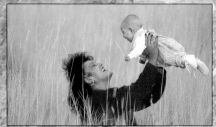
© Brian Bailey

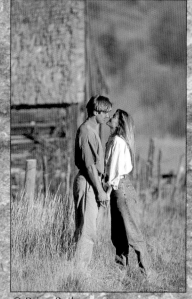
© Brian Bailey

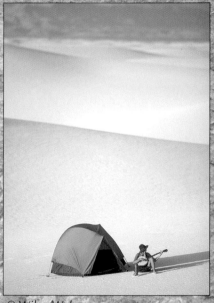
© Wiley/Wales

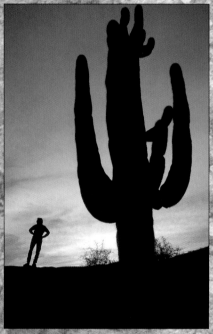
© Wiley/Wales

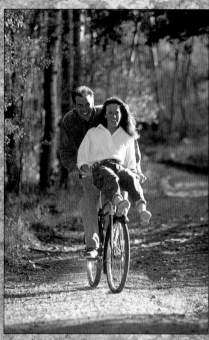
© Bob Winsett

© Bob Winsett

© Allen Russell

© Brian Bailey

All images on the following pages, plus thousands more are available digitally on ProFiles West's CD-ROM Catalog. Call for your copy.

© Wiley/Wales

© Paul Gallaher

© Paul Gallaher

ProFiles West

When you want the West,
Come to the West.
While you're here . . .
We'll also give you the World.

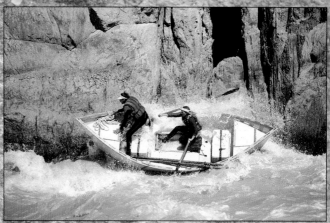

© Wiley/Wales

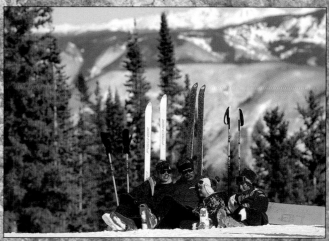

© Brian Bailey

© Paul Gallaher © Brian Bailey © Bob Winsett © Brian Bailey

ProFiles West

When you want the West,
Come to the West.
While you're here . . .
We'll also give you the World.

(719) 395-8671

© Tim Brown

© Tim Brown

© Wiley/Wales

© Brian Bailey

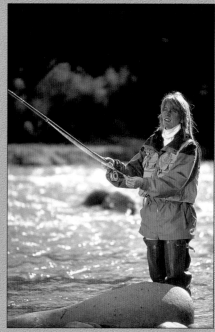
© Paul Gallaher

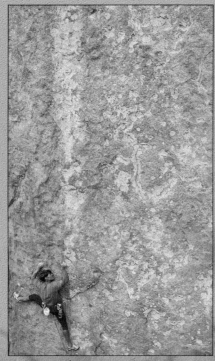
© Brian Bailey

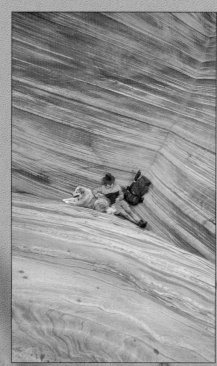
© Wiley/Wales

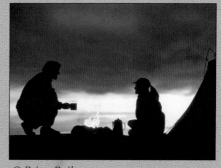
© Brian Bailey

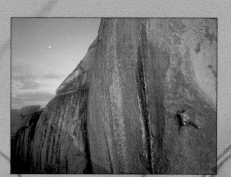
© Brian Bailey

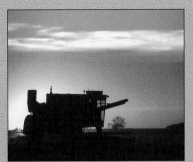
© Allen Russell

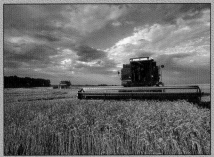
© Jim Bertoglio

ProFiles West

When you want the West,
Come to the West.
While you're here . . .
We'll also give you the World.

(719) 395-8671

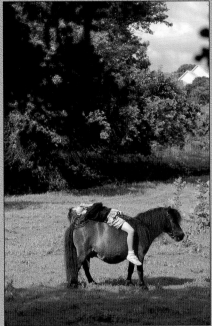
© Peggy Koyle

© Tomas del Amo

© Tim Haske

© Tim Haske

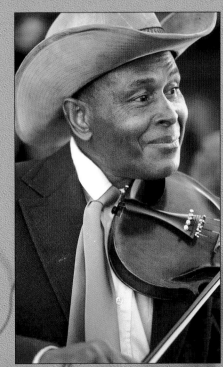
© Allen Russell

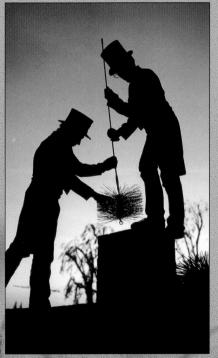
© Louis Raynor

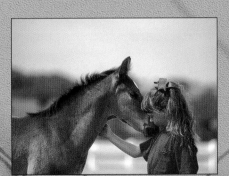
© Peggy Koyle

210 East Main – PO Box 1199 Buena Vista, Colorado 81211

(719) 395-8671 FAX (719) 395-8840

95

ProFiles West

When you want the West,
Come to the West.
While you're here . . .
We'll also give you the World.

(719) 395-8671

© Tim Brown

© Patti Barry Levy

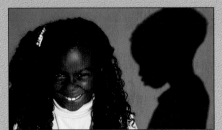
© Josh Mitchell

© Brian Bailey

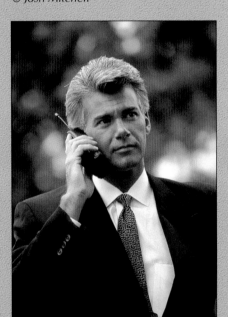
© Tomas del Amo

© Tomas del Amo

© Tomas del Amo

© N. R. Rowan

© Josh Mitchell

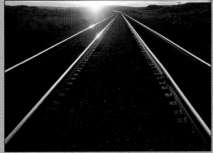

ProFiles West

When you want the West,
Come to the West.
While you're here . . .
We'll also give you the World.

(719) 395-8671

© Allen Russell

© R. L. Wolverton

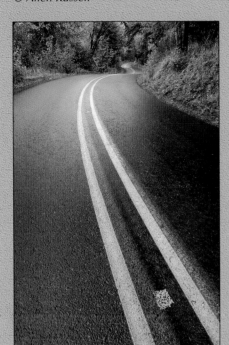

© Bob LeRoy

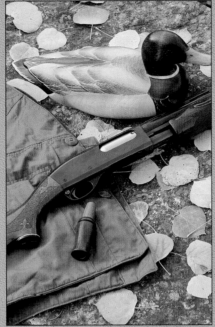

© Brian Bailey

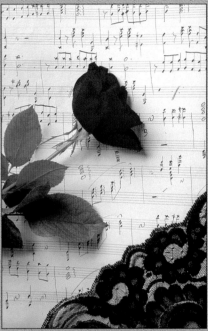

© Tomas del Amo

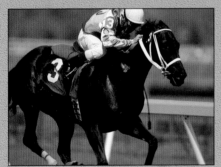

© Peggy Koyle

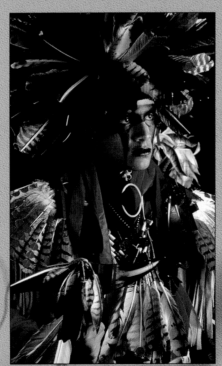

© Patti Barry Levy

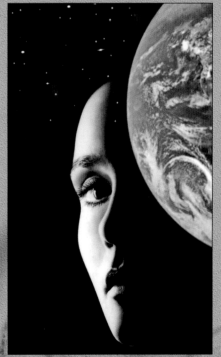

© Josh Mitchell

© Allen Russell

210 East Main – PO Box 1199 Buena Vista, Colorado 81211

(719) 395-8671 FAX (719) 395-8840

97

ProFiles West

When you want the West,
Come to the West.
While you're here . . .
We'll also give you the World.

(719) 395-8671

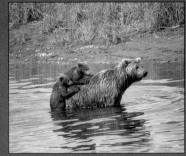
© E. Delaney

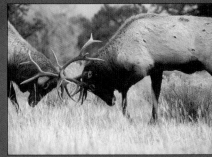
© Allen Russell

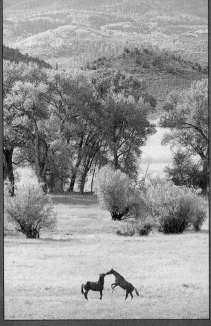
© Wiley/Wales

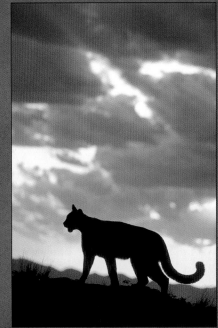
© Wiley/Wales

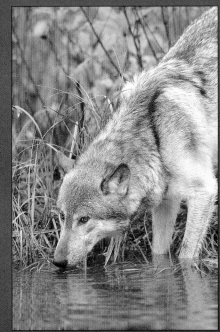
© Wiley/Wales

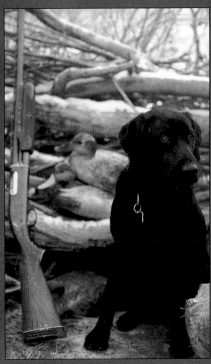
© Brian Bailey

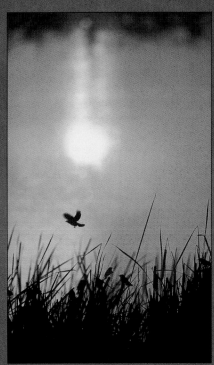
© Wiley/Wales

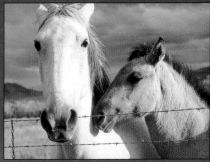
© Tim Haske

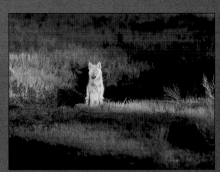
© Joe Rife

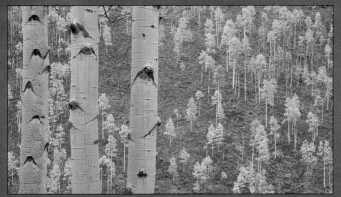
© Brian Bailey

ProFiles West

When you want the West,
Come to the West.
While you're here . . .
We'll also give you the World.

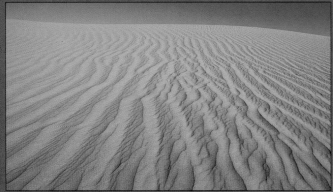
© Phil Lauro

© Allen Russell

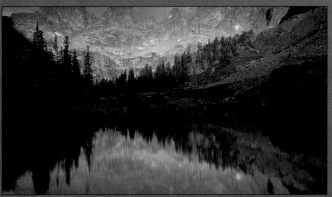
© Bob Lienemann

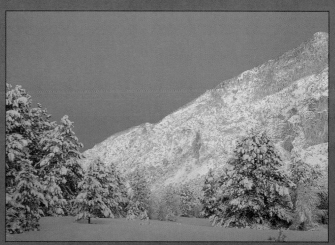
© Allen Russell

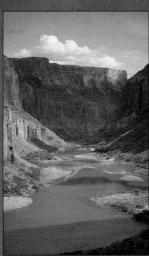
© Wiley/Wales

© Allen Russell

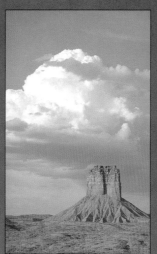
© Wiley/Wales

© Kevin Alexander

210 East Main – PO Box 1199 Buena Vista, Colorado 81211

(719) 395-8671 FAX (719) 395-8840

ProFiles West

When you want the West,
Come to the West.
While you're here . . .
We'll also give you the World.

(719) 395-8671

© Allen Russell

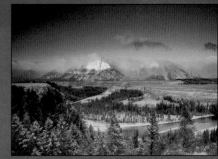

© Allen Russell

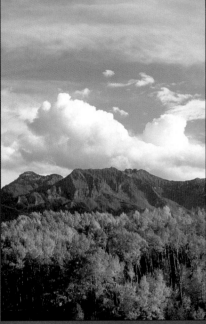

© Allen Russell

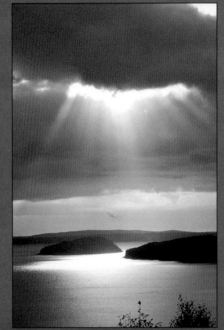

© E. Delaney

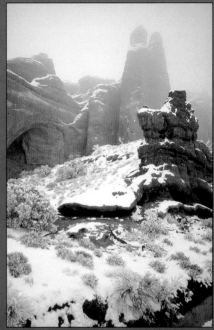

© Kevin Alexander

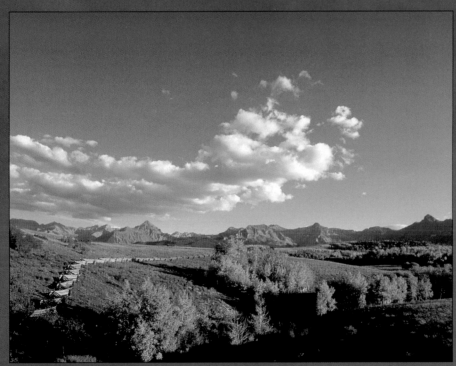

© Allen Russell

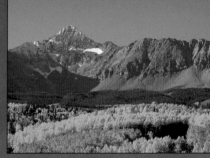

© Kevin Alexander

© Kevin Alexander

All images on the preceding pages, plus thousands more are available
digitally on ProFiles West's CD-ROM Catalog. Call for your copy.

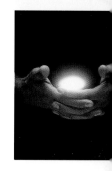

SCIENCE SOURCE

A Division of
PHOTO RESEARCHERS

60 EAST 56TH STREET
NEW YORK

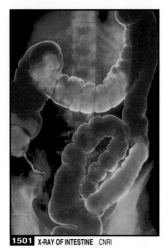

1501 X-RAY OF INTESTINE CNRI

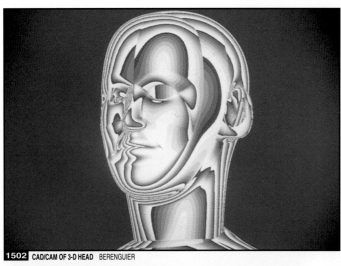

1502 CAD/CAM OF 3-D HEAD BERENGUIER

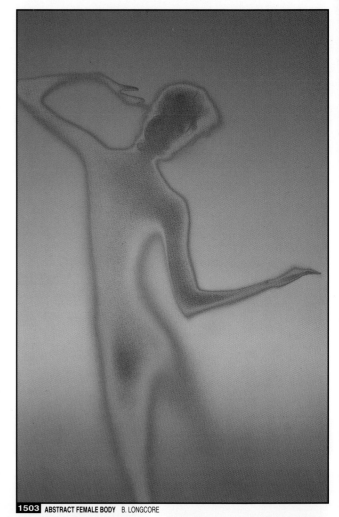

1503 ABSTRACT FEMALE BODY B. LONGCORE

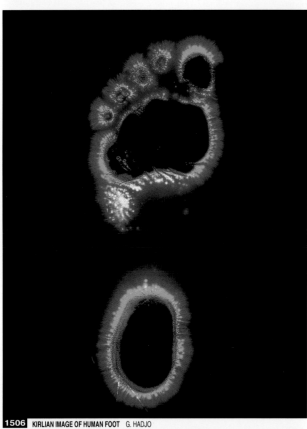

1506 KIRLIAN IMAGE OF HUMAN FOOT G. HADJO

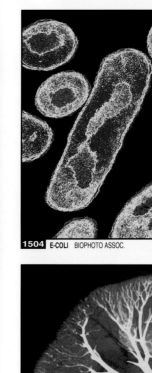

1504 E-COLI BIOPHOTO ASSOC.

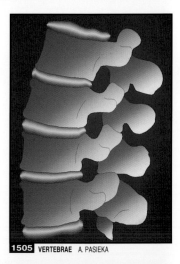

1505 VERTEBRAE A. PASIEKA

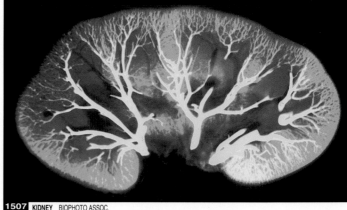

1507 KIDNEY BIOPHOTO ASSOC.

PHONE 212•758•3420 PHONE 800•833•9033 FAX 212•355•0731

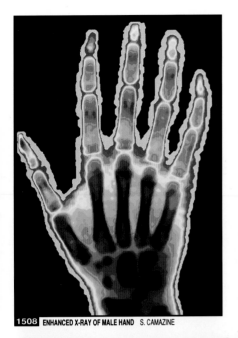
1508 ENHANCED X-RAY OF MALE HAND S. CAMAZINE

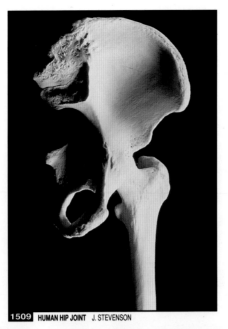
1509 HUMAN HIP JOINT J. STEVENSON

SCIENCE SOURCE
A Division of
PHOTO RESEARCHERS

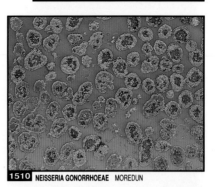
1510 NEISSERIA GONORRHOEAE MOREDUN

M
E
D
I
C
A
L

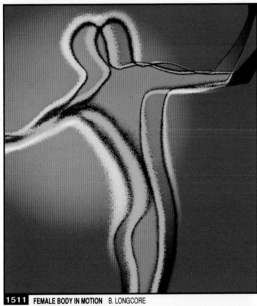
1511 FEMALE BODY IN MOTION B. LONGCORE

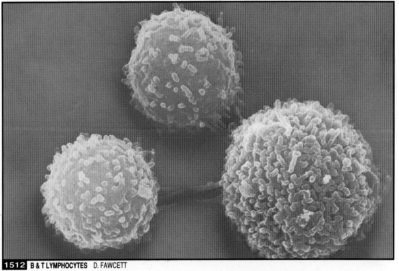
1512 B & T LYMPHOCYTES D. FAWCETT

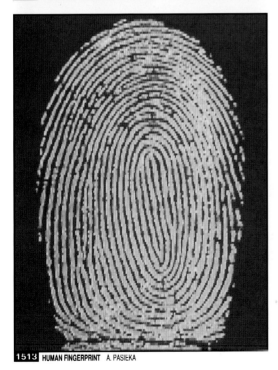
1513 HUMAN FINGERPRINT A. PASIEKA

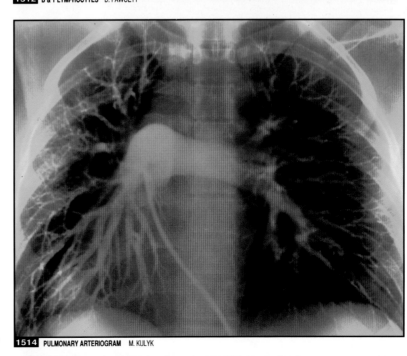
1514 PULMONARY ARTERIOGRAM M. KULYK

PHONE 212•758•3420 PHONE 800•833•9033 FAX 212•355•0731

SCIENCE SOURCE

A Division of
PHOTO RESEARCHERS

1515 WART VIRUS CNRI

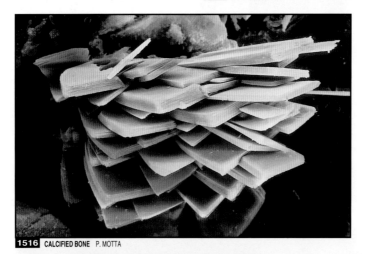

1516 CALCIFIED BONE P. MOTTA

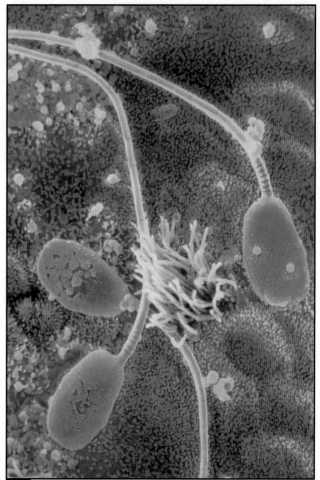

1517 SPERM ON UTERUS P. MOTTA

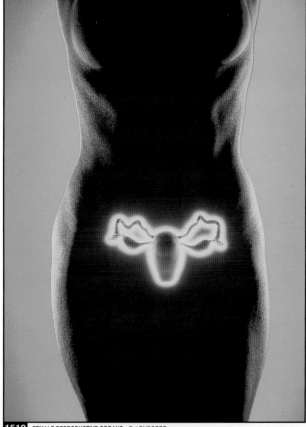

1519 FEMALE REPRODUCTIVE ORGANS B. LONGCORE

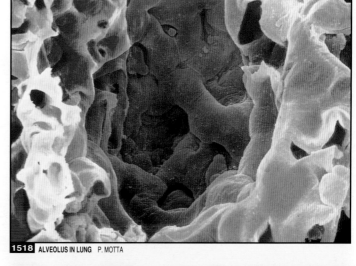

1518 ALVEOLUS IN LUNG P. MOTTA

1520 ADENOVIRUS (COMMON COLD) OMIKRON

PHONE **212•758•3420** PHONE **800•833•9033** FAX **212•355•0731**

104

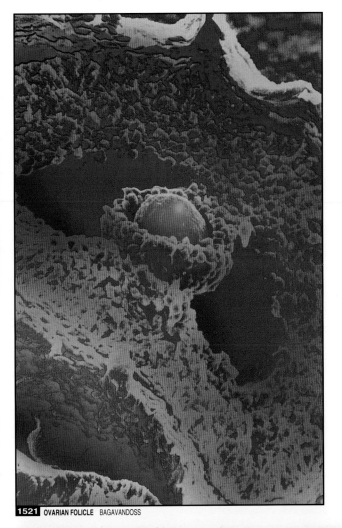

1521 OVARIAN FOLICLE BAGAVANDOSS

1522 NORMAL MRI S. CAMAZINE

SCIENCE SOURCE
A Division of
PHOTO RESEARCHERS

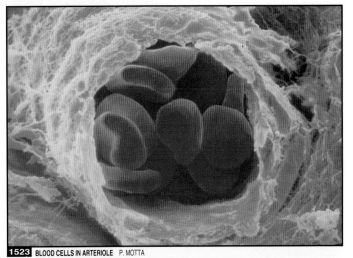

1523 BLOOD CELLS IN ARTERIOLE P. MOTTA

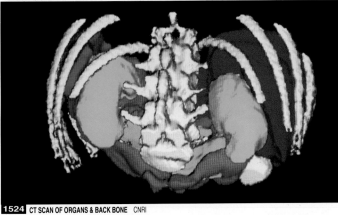

1524 CT SCAN OF ORGANS & BACK BONE CNRI

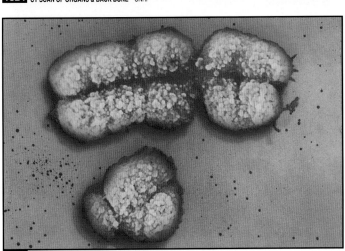

1525 X & Y HUMAN CHROMOSOMES BIOPHOTO ASSOC

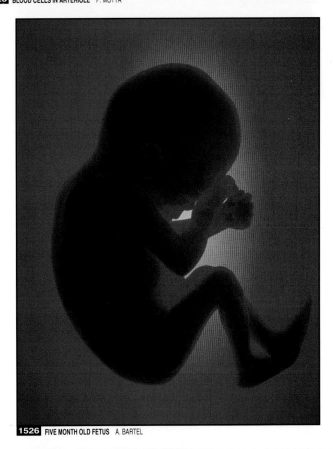

1526 FIVE MONTH OLD FETUS A. BARTEL

SCIENCE SOURCE

A Division of
PHOTO RESEARCHERS

1527 DNA OF E-COLI G. MURTI

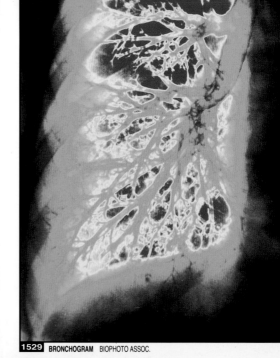

1529 BRONCHOGRAM BIOPHOTO ASSOC.

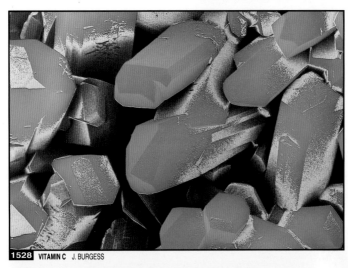

1528 VITAMIN C J. BURGESS

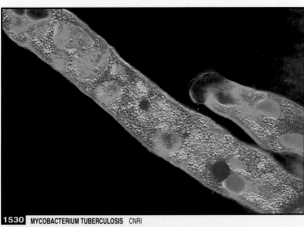

1530 MYCOBACTERIUM TUBERCULOSIS CNRI

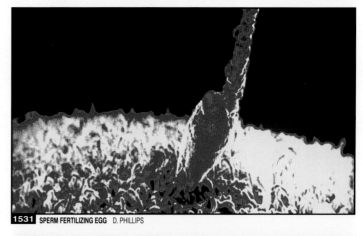

1531 SPERM FERTILIZING EGG D. PHILLIPS

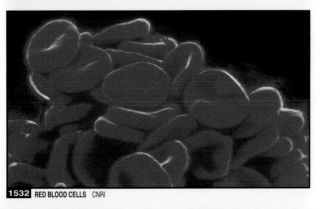

1532 RED BLOOD CELLS CNRI

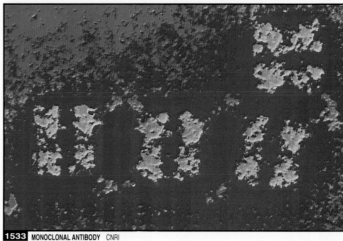

1533 MONOCLONAL ANTIBODY CNRI

PHONE 212•758•3420 PHONE 800•833•9033 FAX 212•355•0731

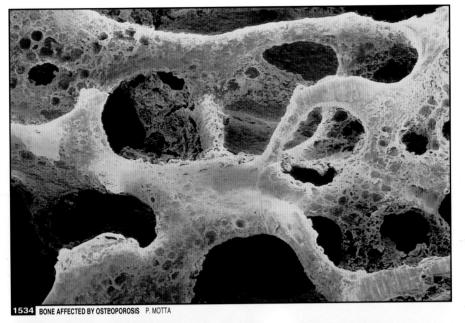
1534 BONE AFFECTED BY OSTEOPOROSIS P. MOTTA

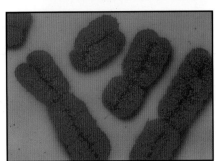
1535 HUMAN CHROMOSOMES BIOPHOTO ASSOC.

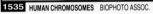

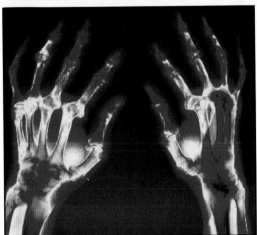
1536 RHEUMATOID ARTHRITIS S. CAMAZINE

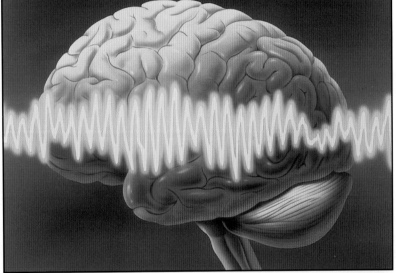
1537 ILLUSTRATION OF MIGRAINE J. BOVOSI

1538 X-RAY OF RICKETS BIOPHOTO ASSOC.

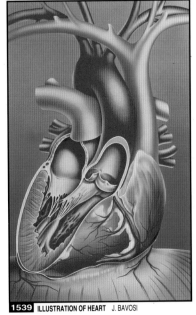
1539 ILLUSTRATION OF HEART J. BAVOSI

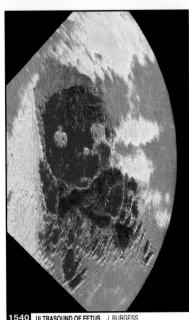
1540 ULTRASOUND OF FETUS J. BURGESS

MEDICAL

SCIENCE SOURCE

A Division of
PHOTO RESEARCHERS

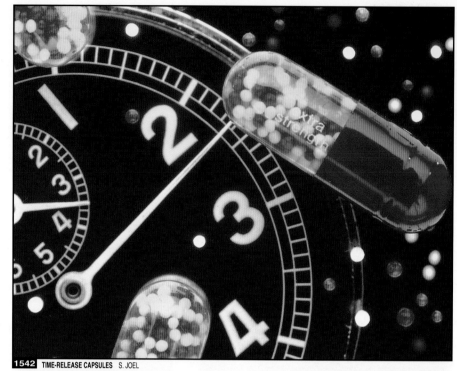

1542 TIME-RELEASE CAPSULES S. JOEL

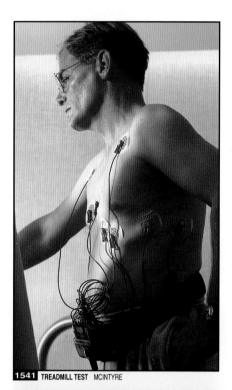

1541 TREADMILL TEST MCINTYRE

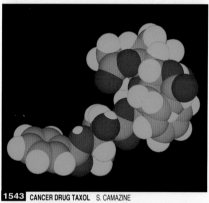

1543 CANCER DRUG TAXOL S. CAMAZINE

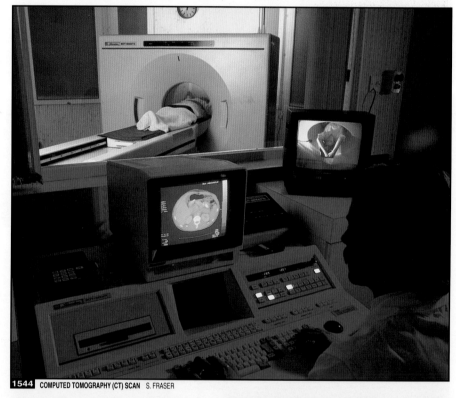

1544 COMPUTED TOMOGRAPHY (CT) SCAN S. FRASER

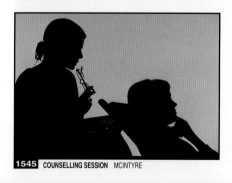

1545 COUNSELLING SESSION MCINTYRE

1546 INFANT IN IC GAILLARD

1547 DOCTOR STUDYING CHEST X-RAY BENELUX

PHONE **212•758•3420** PHONE **800•833•9033** FAX **212•355•0731**

108

1548 CHILD SICK IN BED O. BURRIEL

1549 CHECKUP B. SEITZ

1550 EYE LENS IMPLANTS C. RAYMOND

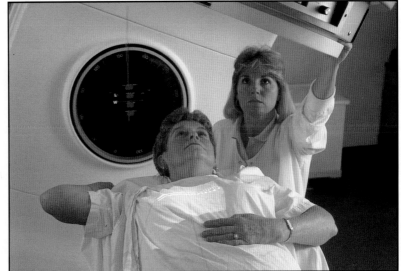
1551 LINEAR ACCELERATOR USED IN CANCER THERAPY J. NETTIS

1553 ELECTRO SHOCK THERAPY MCINTYRE

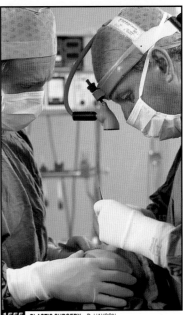
1555 PLASTIC SURGERY P. HAYSON

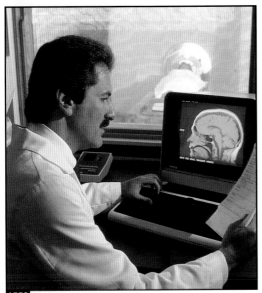
1552 DOCTOR VIEWS MRI SCAN H. MORGAN

1554 NEONATAL UNIT H. MORGAN

PHONE **212•758•3420** PHONE **800•833•9033** FAX **212•355•0731**

SCIENCE SOURCE
A Division of
PHOTO RESEARCHERS

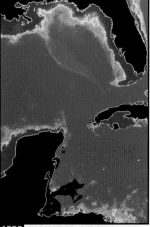

1556 GULF OF MEXICO G. FELDMAN

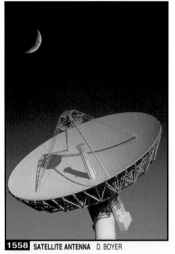

1558 SATELLITE ANTENNA D. BOYER

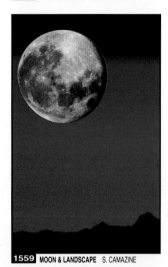

1559 MOON & LANDSCAPE S. CAMAZINE

1557 HURRICANE BOB, AUGUST 1991 NOAA

1560 FULL MOON OVER CITY C. BUTLER

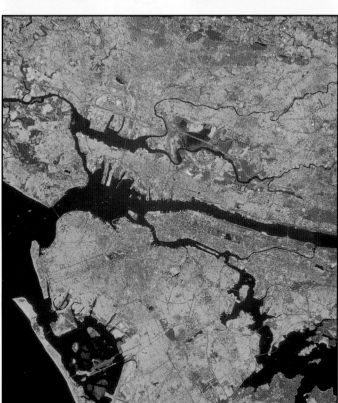

1561 SATELLITE IMAGE OF NEW YORK CNES/SPOT

1562 LANDSAT IMAGE OF NORTH AMERICA WORLDSAT

PHONE **212•758•3420** PHONE **800•833•9033** FAX **212•355•0731**

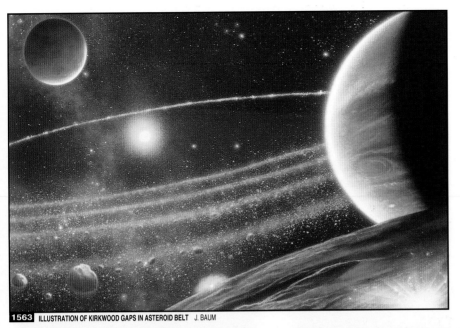

1563 ILLUSTRATION OF KIRKWOOD GAPS IN ASTEROID BELT J. BAUM

1564 SHUTTLE PHOTO OF CA NASA

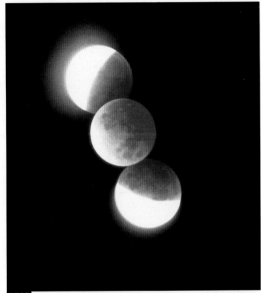

1565 TIME-LAPSE PHOTO OF LUNAR ECLIPSE P. PEKKA

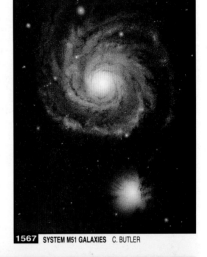

1566 FALLING STAR E. SCHREMPP

1567 SYSTEM M51 GALAXIES C. BUTLER

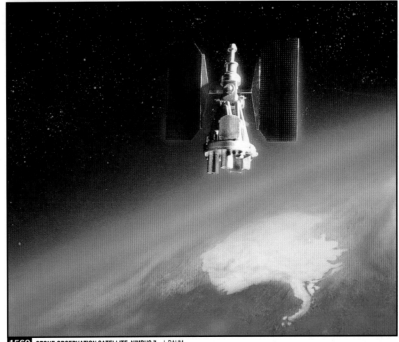

1569 OZONE OBSERVATION SATELLITE, NIMBUS-7 J. BAUM

1568 VENUS, MARS & JUPITER R. RACHMAN

EARTH & ASTRONOMY

SCIENCE SOURCE

A Division of
PHOTO RESEARCHERS

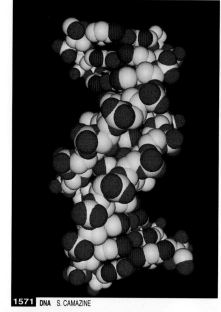
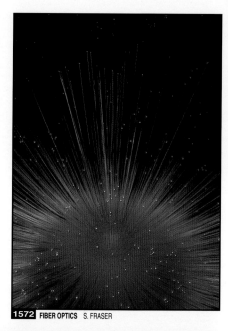
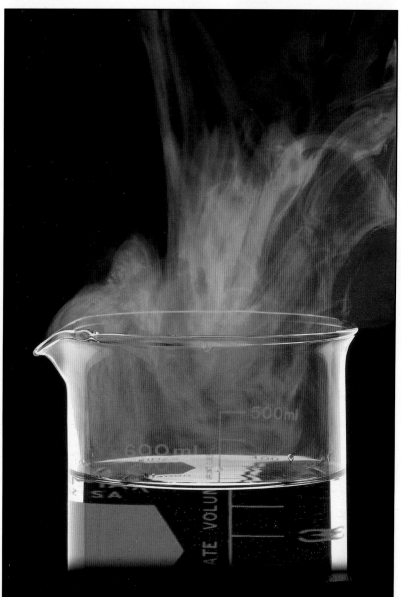
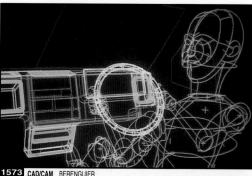
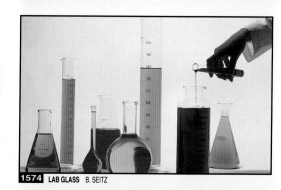
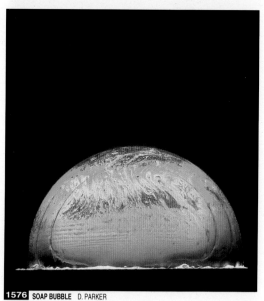
RESEARCH & TECHNOLOGY

PHONE **212•758•3420** PHONE **800•833•9033** FAX **212•355•0731**

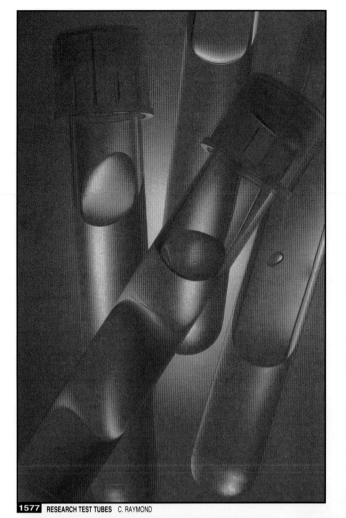

1577 RESEARCH TEST TUBES C. RAYMOND

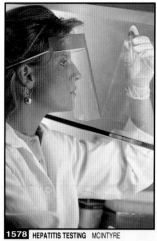

1578 HEPATITIS TESTING MCINTYRE

SCIENCE SOURCE

A Division of
PHOTO RESEARCHERS

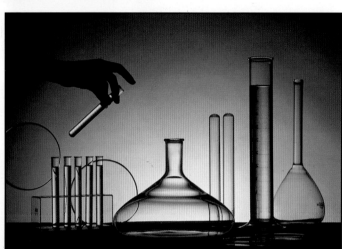

1579 GLASSWARE MCINTYRE

1581 WATER MOLECULES S. CAMAZINE

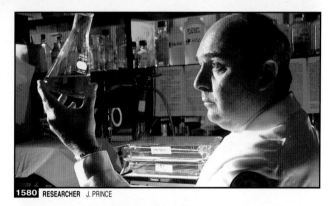

1580 RESEARCHER J. PRINCE

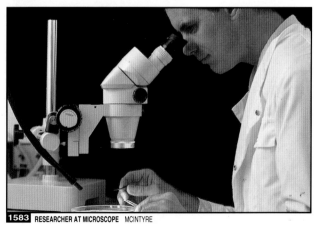

1583 RESEARCHER AT MICROSCOPE MCINTYRE

1582 PARTICLE TRACKS LAWRENCE LAB

PHONE **212•758•3420** PHONE **800•833•9033** FAX **212•355•0731**

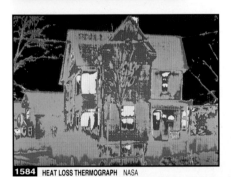

1584 HEAT LOSS THERMOGRAPH NASA

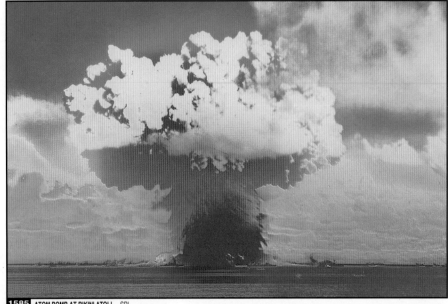

1585 ATOM BOMB AT BIKINI ATOLL SPL

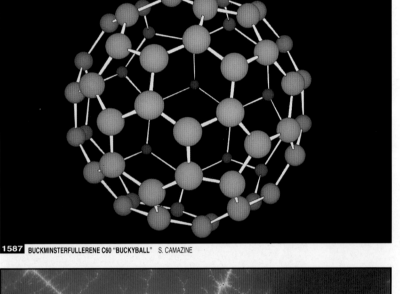

1587 BUCKMINSTERFULLERENE C60 "BUCKYBALL" S. CAMAZINE

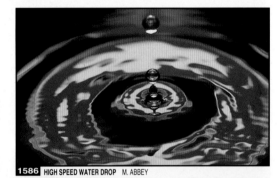

1586 HIGH SPEED WATER DROP M. ABBEY

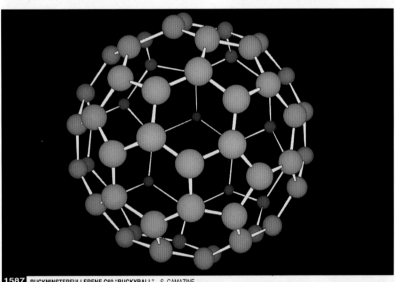

1588 HIGH SPEED TENNIS BALL G. SETTLES

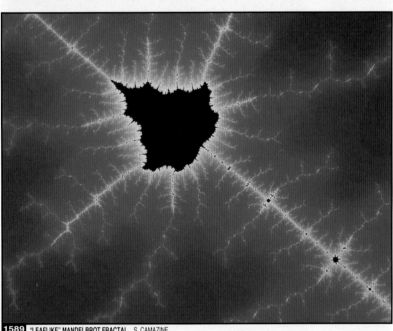

1589 "LEAFLIKE" MANDELBROT FRACTAL S. CAMAZINE

1590 FLY HEAD S. CAMAZINE/M. HEAD

NATURE SOURCE

A Division of
PHOTO RESEARCHERS

MAMMALS

1599 GIANT PANDA T. MCHUGH

1600 AFRICAN ELEPHANT TAKING DUST-BATH G. DIMIJIAN

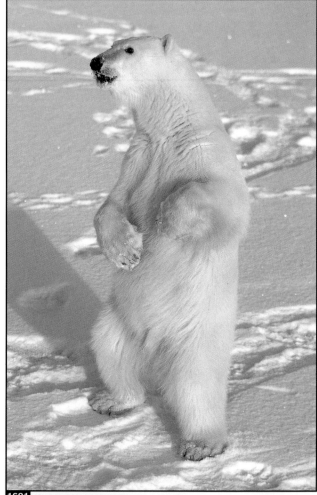

1601 POLAR BEAR STANDS FOR BETTER VIEW D. GURAVICH

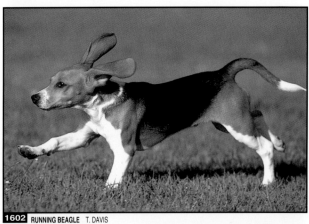

1602 RUNNING BEAGLE T. DAVIS

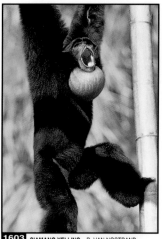

1603 SIAMANG YELLING R. VAN NOSTRAND

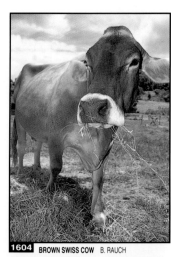

1604 BROWN SWISS COW B. RAUCH

1605 PERSIAN CAT G. FELIX

PHONE 212•758•3420 PHONE 800•833•9033 FAX 212•355•0731

1606 HIPPO THREATENING INTRUDER G. DIMIJIAN

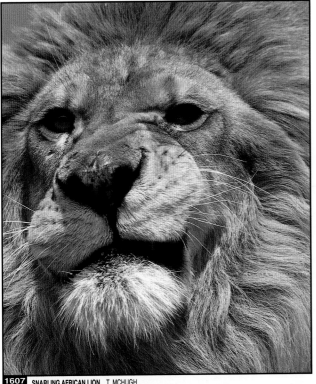

1607 SNARLING AFRICAN LION T. MCHUGH

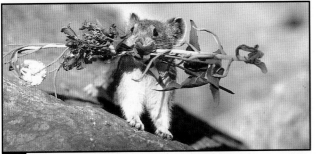

1609 PIKA COLLECTING FOOD SUPPLY T. & P. LEESON

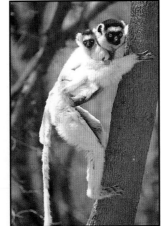

1608 VERREAUX'S LEMUR M. LOUP

1610 COMMON LONG-TONGUED BAT M. TUTTLE

1611 GOLDEN RETRIEVER R. LYNN

NATURE SOURCE

A Division of
PHOTO RESEARCHERS

1612 GIRAFFE L. MIGDALE

1613 ZEBRA WITH YOUNG S. KRASEMANN

1614 BORNEAN ORANGUTAN T. MCHUGH

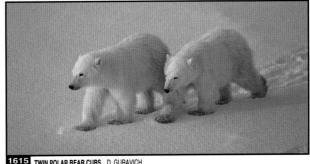

1615 TWIN POLAR BEAR CUBS D. GURAVICH

PHONE 212•758•3420 PHONE 800•833•9033 FAX 212•355•0731

NATURE SOURCE

A Division of
PHOTO RESEARCHERS

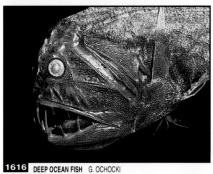

1616 DEEP OCEAN FISH G. OCHOCKI

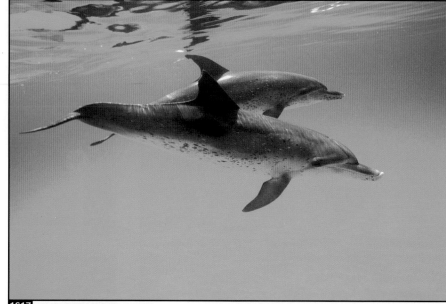

1617 ATLANTIC SPOTTED DOLPHINS F. GOHIER

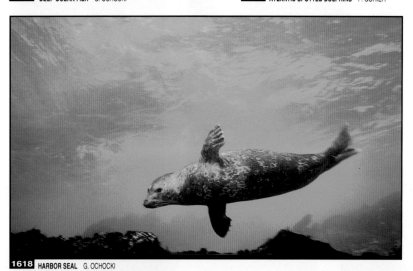

1618 HARBOR SEAL G. OCHOCKI

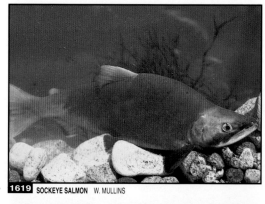

1619 SOCKEYE SALMON W. MULLINS

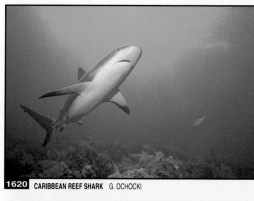

1620 CARIBBEAN REEF SHARK G. OCHOCKI

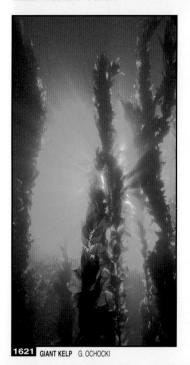

1621 GIANT KELP G. OCHOCKI

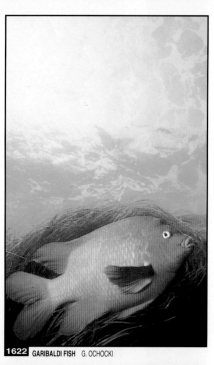

1622 GARIBALDI FISH G. OCHOCKI

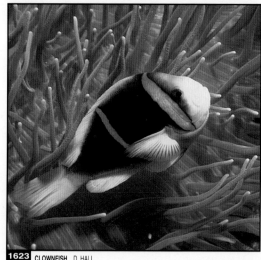

1623 CLOWNFISH D. HALL

PHONE 212•758•3420 PHONE 800•833•9033 FAX 212•355•0731

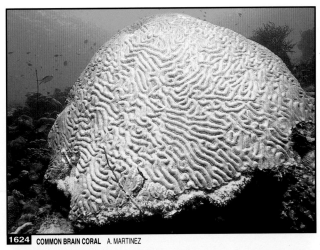

1624 COMMON BRAIN CORAL A. MARTINEZ

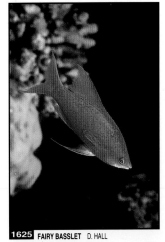

1625 FAIRY BASSLET D. HALL

MARINE

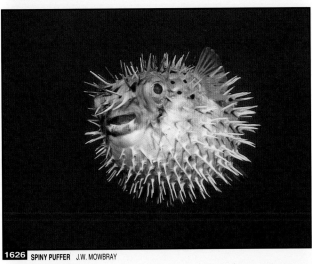

1626 SPINY PUFFER J.W. MOWBRAY

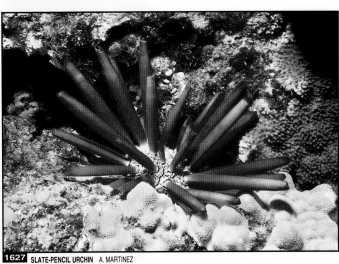

1627 SLATE-PENCIL URCHIN A. MARTINEZ

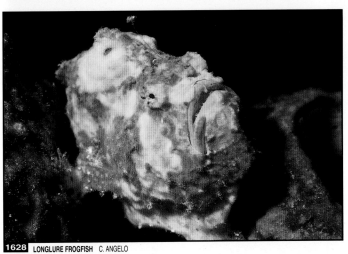

1628 LONGLURE FROGFISH C. ANGELO

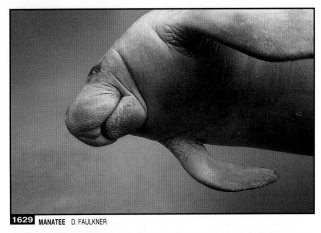

1629 MANATEE D. FAULKNER

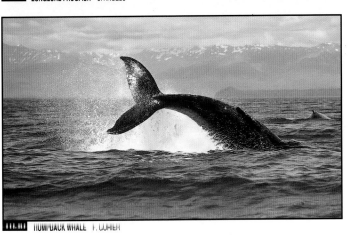

HUMPBACK WHALE F. GOHIER

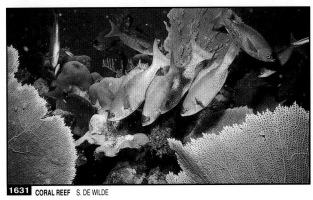

1631 CORAL REEF S. DE WILDE

NATURE SOURCE

A Division of
PHOTO RESEARCHERS

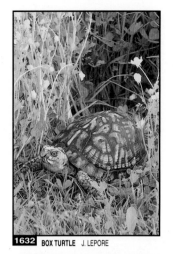

1632 BOX TURTLE J. LEPORE

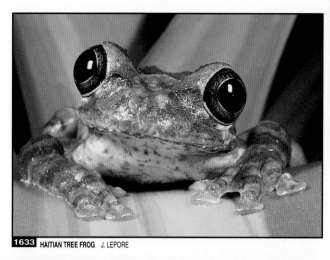

1633 HAITIAN TREE FROG J. LEPORE

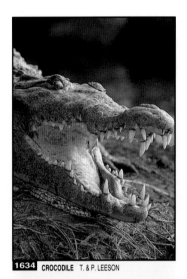

1634 CROCODILE T. & P. LEESON

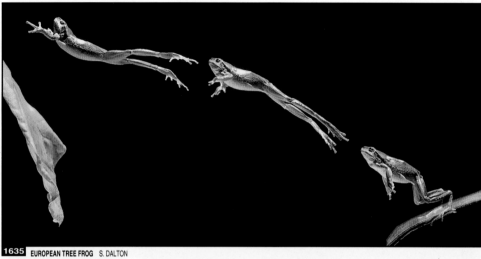

1635 EUROPEAN TREE FROG S. DALTON

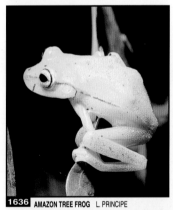

1636 AMAZON TREE FROG L. PRINCIPE

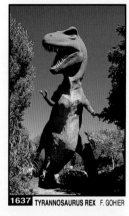

1637 TYRANNOSAURUS REX F. GOHIER

1638 MUD SALAMANDER P. DOTSON

1639 SIDEWINDER T. MCHUGH

1640 JESUS LIZARD WALKING ON WATER S. DALTON

PHONE **212·758·3420** PHONE **800·833·9033** FAX **212·355·0731**

1641 HYACINTH MACAWS K. FINK

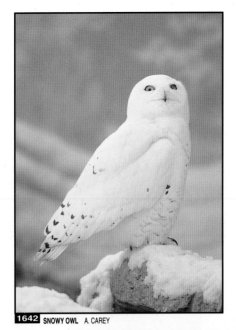

1642 SNOWY OWL A. CAREY

NATURE SOURCE

A Division of
PHOTO RESEARCHERS

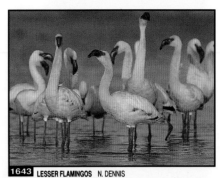

1643 LESSER FLAMINGOS N. DENNIS

B
I
R
D
S

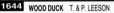

1644 WOOD DUCK T. & P. LEESON

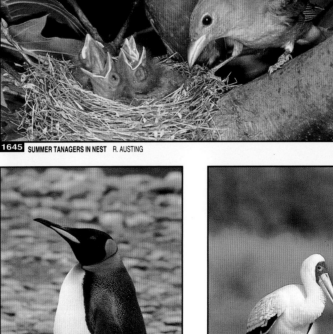

1645 SUMMER TANAGERS IN NEST R. AUSTING

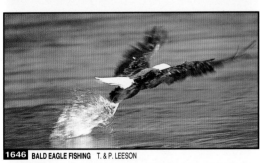

1646 BALD EAGLE FISHING T. & P. LEESON

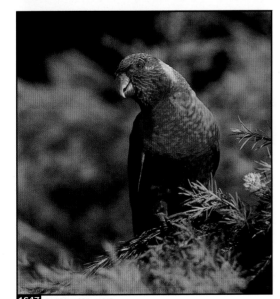

1647 RAINBOW LORY LABAT

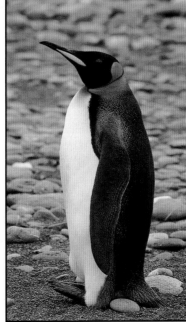

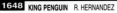

1648 KING PENGUIN R. HERNANDEZ

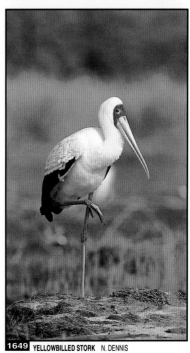

1649 YELLOWBILLED STORK N. DENNIS

PHONE 212•758•3420 PHONE 800•833•9033 FAX 212•355•0731

NATURE SOURCE

A Division of
PHOTO RESEARCHERS

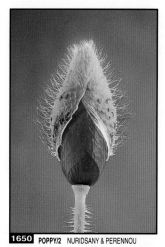

1650 **POPPY/2** NURIDSANY & PERENNOU

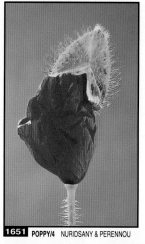

1651 **POPPY/4** NURIDSANY & PERENNOU

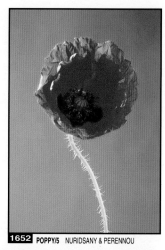

1652 **POPPY/5** NURIDSANY & PERENNOU

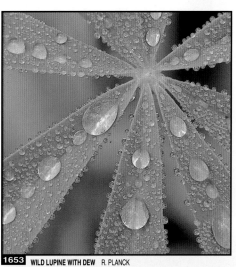

1653 **WILD LUPINE WITH DEW** R. PLANCK

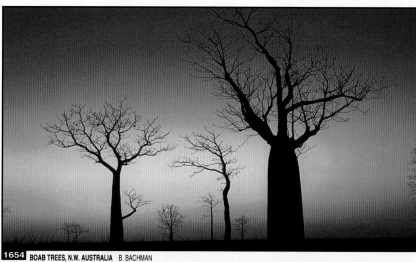

1654 **BOAB TREES, N.W. AUSTRALIA** B. BACHMAN

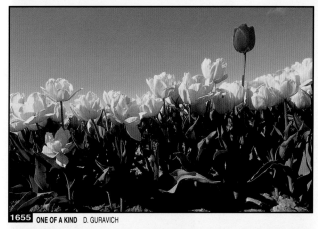

1655 **ONE OF A KIND** D. GURAVICH

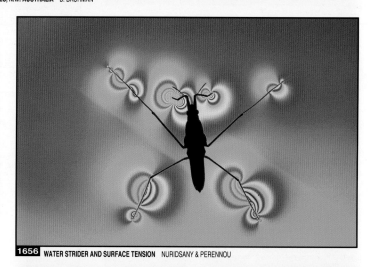

1656 **WATER STRIDER AND SURFACE TENSION** NURIDSANY & PERENNOU

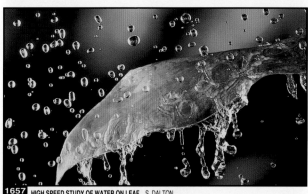

1657 **HIGH SPEED STUDY OF WATER ON LEAF** S. DALTON

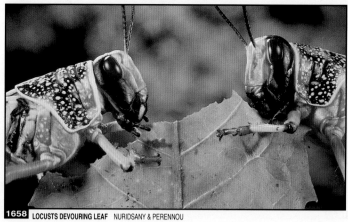

1658 **LOCUSTS DEVOURING LEAF** NURIDSANY & PERENNOU

PHONE **212•758•3420** PHONE **800•833•9033** FAX **212•355•0731**

122

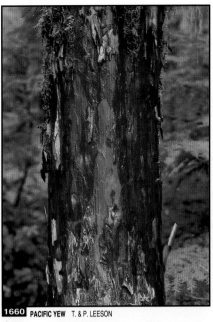

NATURE SOURCE
A Division of
PHOTO RESEARCHERS

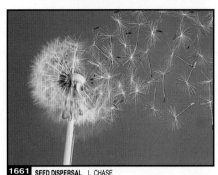

1659 OAK LEAF IN AUTUMN R. PLANCK

1660 PACIFIC YEW T. & P. LEESON

1661 SEED DISPERSAL L. CHASE

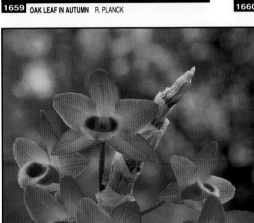

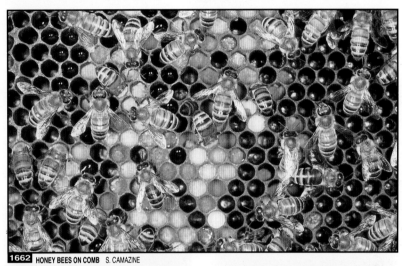

1662 HONEY BEES ON COMB S. CAMAZINE

1663 TROPICAL ORCHID H. EISENBEISS

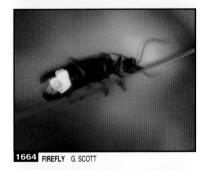

1664 FIREFLY G. SCOTT

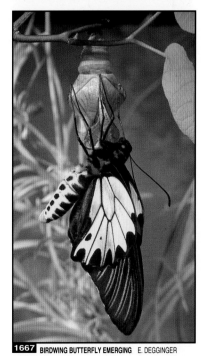

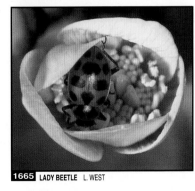

1665 LADY BEETLE L. WEST

1667 BIRDWING BUTTERFLY EMERGING E. DEGGINGER

1000 TROPICAL CLOUD FOREST G. DIMIJIAN

PHONE 212•758•3420 PHONE 800•833•9033 FAX 212•355•0731

PLANTS & INSECTS

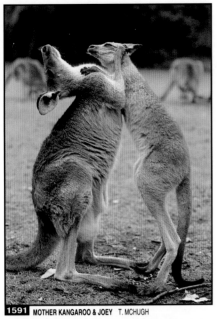
1591 MOTHER KANGAROO & JOEY T. MCHUGH

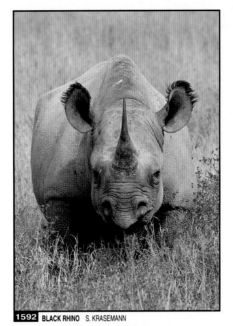
1592 BLACK RHINO S. KRASEMANN

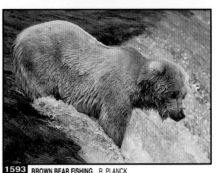
1593 BROWN BEAR FISHING R. PLANCK

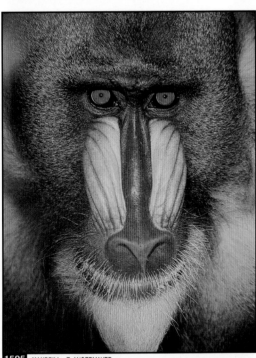
1595 MANDRILL T. ANGERMAYER

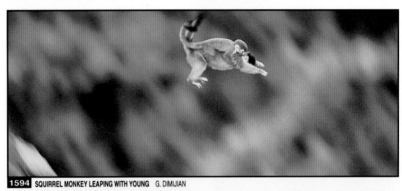
1594 SQUIRREL MONKEY LEAPING WITH YOUNG G. DIMIJIAN

1596 MOTTLED DOG B. BACHMAN

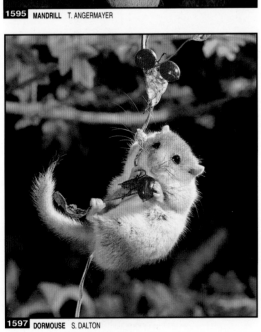
1597 DORMOUSE S. DALTON

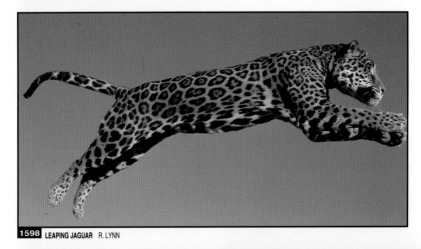
1598 LEAPING JAGUAR R. LYNN

PHONE 212•758•3420 PHONE 800•833•9033 FAX 212•355•0731

PHOTO RESEARCHERS

1669 MOTHER AND DAUGHTER REST DURING HIKE MCINTYRE

1668 FAMILY AT CHRISTMAS S. GRANT

1670 BIG BROTHER N. DURRELL MCKENNA

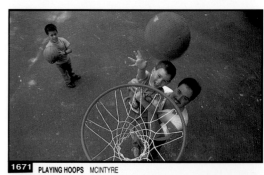
1671 PLAYING HOOPS MCINTYRE

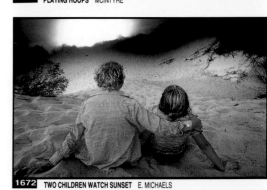
1672 TWO CHILDREN WATCH SUNSET E. MICHAELS

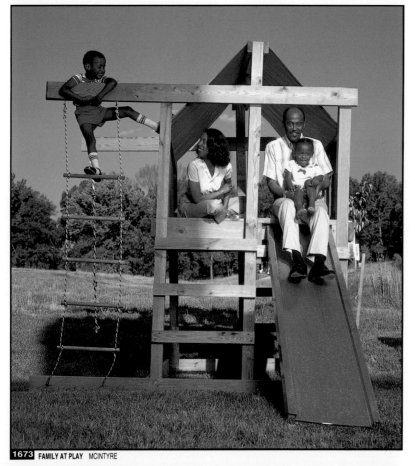
1673 FAMILY AT PLAY MCINTYRE

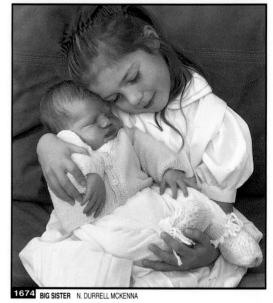
1674 BIG SISTER N. DURRELL MCKENNA

PHONE 212•758•3420 PHONE 800•833•9033 FAX 212•355•0731

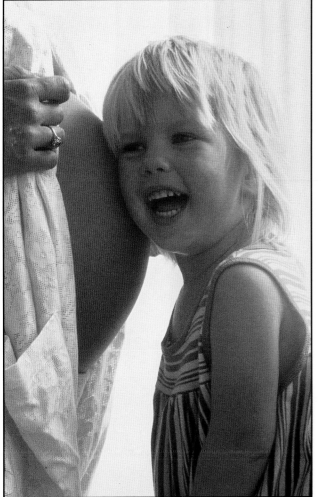

1675 CHILD LISTENS TO UNBORN SIBLING T. HENSTRA

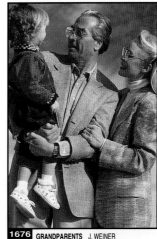

1676 GRANDPARENTS J. WEINER

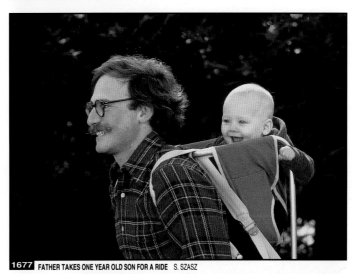

1677 FATHER TAKES ONE YEAR OLD SON FOR A RIDE S. SZASZ

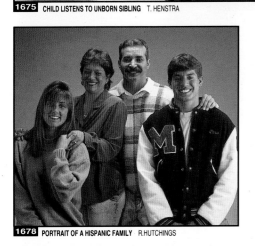

1678 PORTRAIT OF A HISPANIC FAMILY R.HUTCHINGS

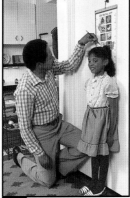

1679 DAD CHECKS HEIGHT L. MIGDALE

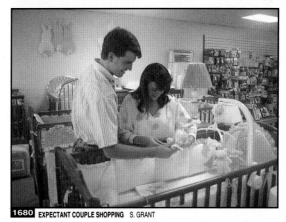

1680 EXPECTANT COUPLE SHOPPING S. GRANT

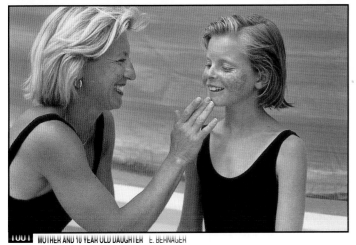

1681 MOTHER AND 10 YEAR OLD DAUGHTER E. BERNAGER

1682 FAMILY HIKE J.Y. RUSZNIEWSKI

PHONE 212•758•3420 PHONE 800•833•9033 FAX 212•355•0731

127

PHOTO RESEARCHERS

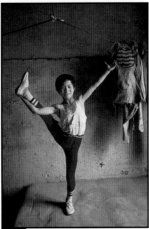

1683 YOUNG ASIAN A. LEVIN

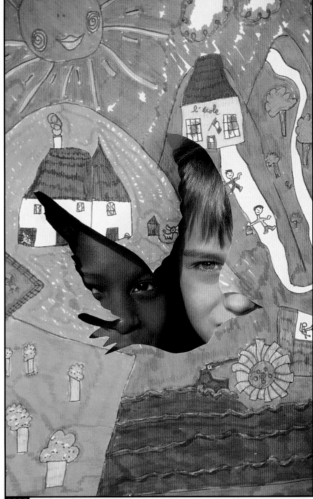

1685 TWO FRIENDS PEEK THROUGH BACKDROP GAILLARD

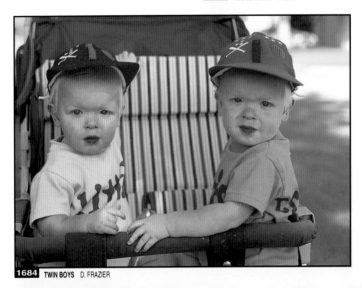

1684 TWIN BOYS D. FRAZIER

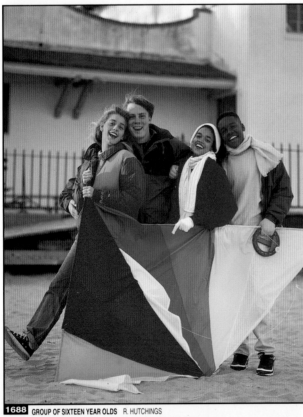

1688 GROUP OF SIXTEEN YEAR OLDS R. HUTCHINGS

1686 AUSTRALIAN BOY, AGE 13 B. BACHMAN

1687 TODDLER STAYS COOL J. GREENBERG

1689 TWO AND A HALF YEAR OLD BOY L. VOIGT

PHONE 212•758•3420 PHONE 800•833•9033 FAX 212•355•0731

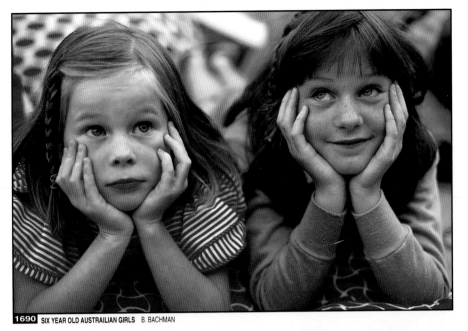

1690 SIX YEAR OLD AUSTRALIAN GIRLS B. BACHMAN

PHOTO
RESEARCHERS

1691 KIDS AND PUMPKINS R. HUTCHINGS

1694 NINE MONTH OLD GIRL S. SZASZ

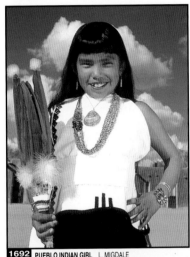

1692 PUEBLO INDIAN GIRL L. MIGDALE

1693 KIDS! R. HUTCHINGS

1695 KIDS AT EXPLORATORIUM T. DAVIS

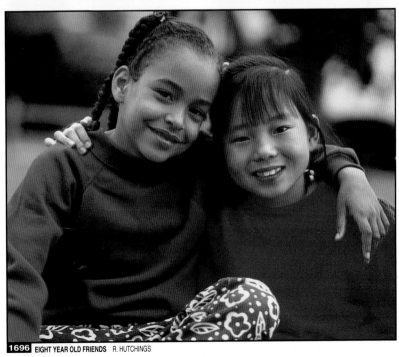

1696 EIGHT YEAR OLD FRIENDS R. HUTCHINGS

PHONE 212•758•3420 PHONE 800•833•9033 FAX 212•355•0731

PHOTO RESEARCHERS

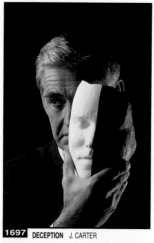

1697 DECEPTION J. CARTER

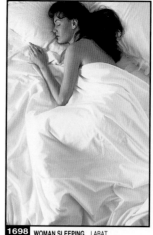

1698 WOMAN SLEEPING LABAT

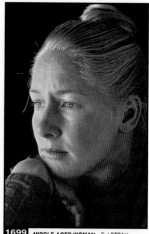

1699 MIDDLE-AGED WOMAN E. LETTAU

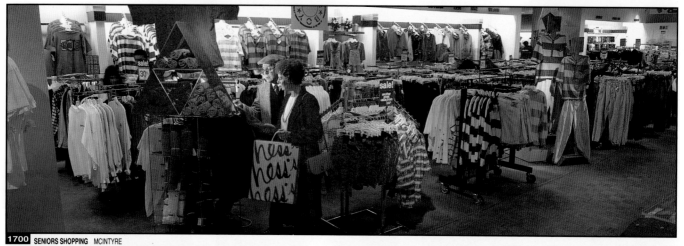

1700 SENIORS SHOPPING MCINTYRE

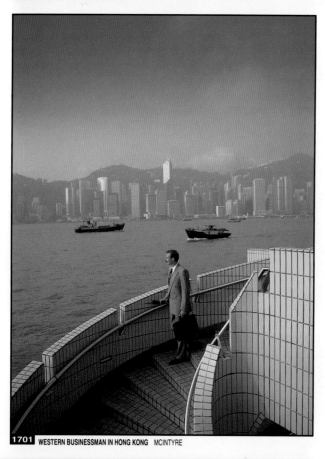

1701 WESTERN BUSINESSMAN IN HONG KONG MCINTYRE

1702 CROWD OF ADULTS MCINTYRE

PHONE 212•758•3420 PHONE 800•833•9033 FAX 212•355•0731

1703 MASTER OF THE UNIVERSE BUSINESSMAN O. BURRIEL

PHOTO RESEARCHERS

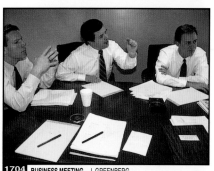

1704 BUSINESS MEETING J. GREENBERG

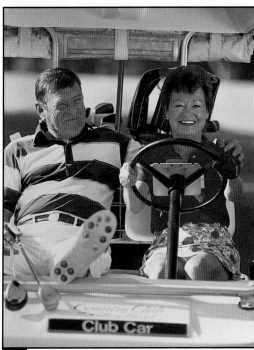

1706 RETIRED COUPLE GOLFING MCINTYRE

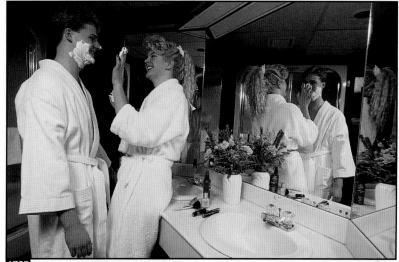

1705 YOUNG COUPLE CLOWNING B. SEITZ

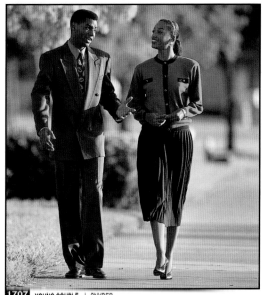

1707 YOUNG COUPLE L. SNYDER

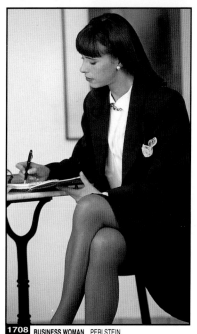

1708 BUSINESS WOMAN PERLSTEIN

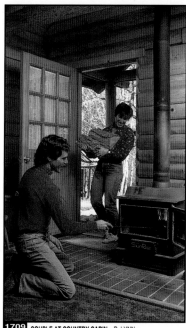

1709 COUPLE AT COUNTRY CABIN R. LYNN

PHONE 212•758•3420 PHONE 800•833•9033 FAX 212•355•0731

PHOTO RESEARCHERS

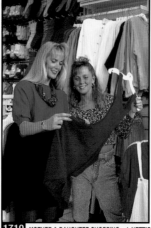

1710 MOTHER & DAUGHTER SHOPPING J. NETTIS

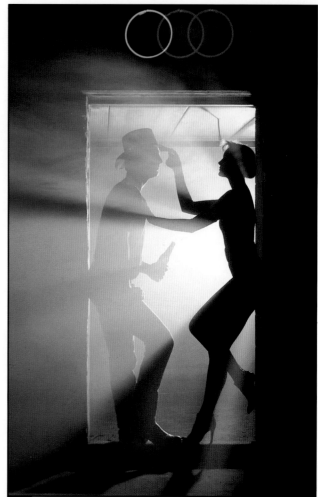

1712 WESTERN COUPLE J. WEINER

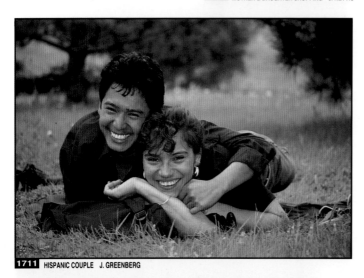

1711 HISPANIC COUPLE J. GREENBERG

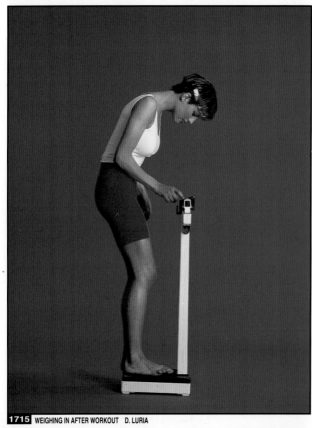

1715 WEIGHING IN AFTER WORKOUT D. LURIA

1713 SENIORS EXERCISING PERLSTEIN

1714 BUSINESS WOMAN R. LYNN

1716 TWO COUPLES ENJOYING REFRESHMENTS

PHONE 212•758•3420 PHONE 800•833•9033 FAX 212•355•0731

PHOTO RESEARCHERS

1717 RETIRED COUPLE VACATIONING N. THOMAS

1718 SENIORS EXERCISING MCINTYRE

1719 COUPLE ON THE BEACH D. FAULKNER

1722 JAPANESE SALES REP MCINTYRE

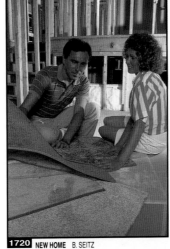

1720 NEW HOME B. SEITZ

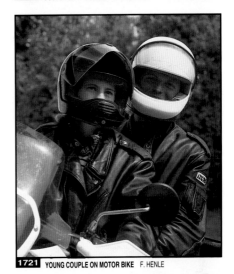

1721 YOUNG COUPLE ON MOTOR BIKE F. HENLE

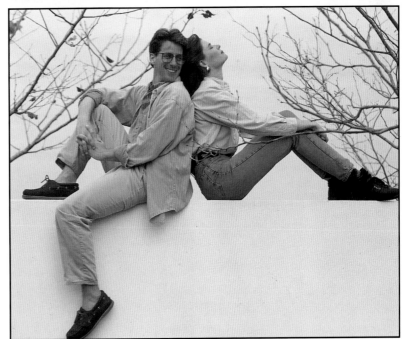

1724 YOUNG COUPLE L. SNYDER

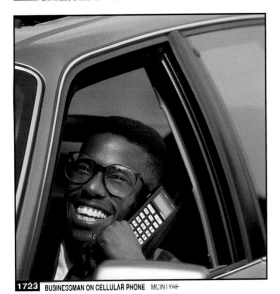

1723 BUSINESSMAN ON CELLULAR PHONE MCINTYRE

PHONE 212•758•3420 PHONE 800•833•9033 FAX 212•355•0731

PHOTO RESEARCHERS

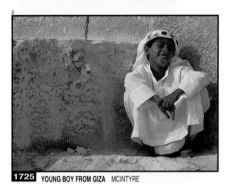

1725 YOUNG BOY FROM GIZA MCINTYRE

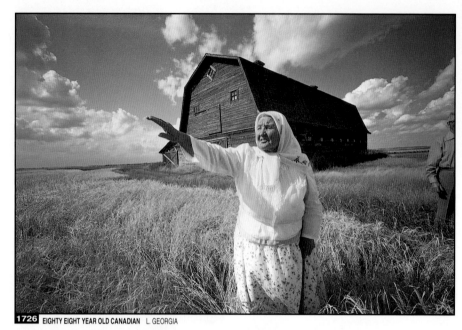

1726 EIGHTY EIGHT YEAR OLD CANADIAN L. GEORGIA

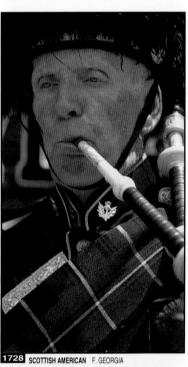

1728 SCOTTISH AMERICAN F. GEORGIA

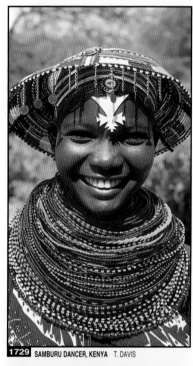

1729 SAMBURU DANCER, KENYA T. DAVIS

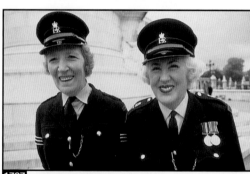

1727 ROYAL PARKS POLICEWOMEN S. MCCARTNEY

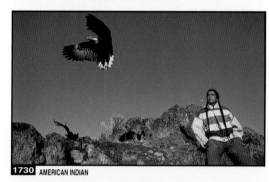

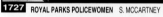

1730 AMERICAN INDIAN

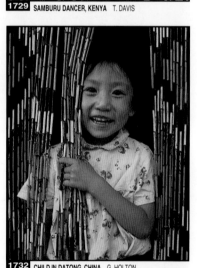

1731 CHOCO INDIAN, PANAMA D. GOODE

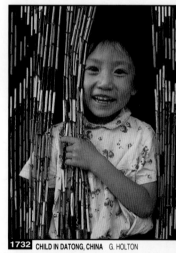

1732 CHILD IN DATONG, CHINA G. HOLTON

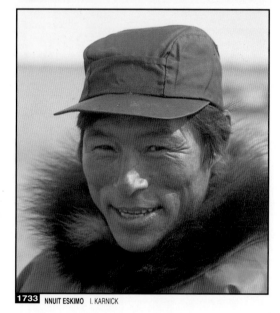

1733 NNUIT ESKIMO I. KARNICK

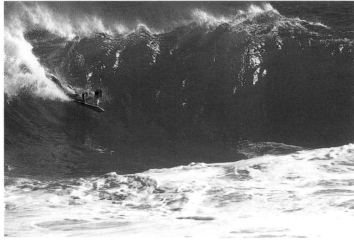

Steve Casimiro S7-101 California

Regis Lefebure S7-102 Bahamas

Kerrick James S7-103

Philip & Karen Smith S7-104

Joe Hancock S7-105 Mexico

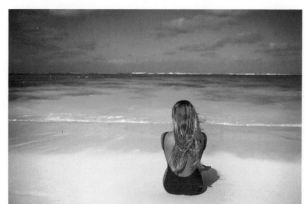

Mitch Diamond S7-106 Hawaii

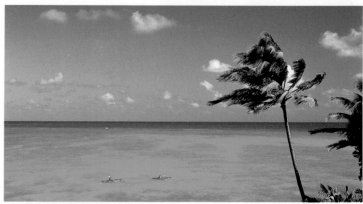

Mitch Diamond S7-107

Mitch Diamond S7-108

Philip & Karen Smith S7-109

Repro Dupe Assemblies by Reed Photo-Art

Steve Casimiro S7-201

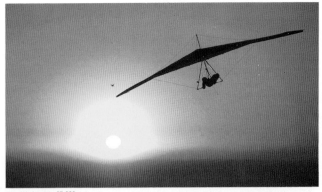

Kerrick James S7-202

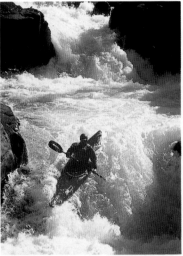

Mark Lisk S7-203

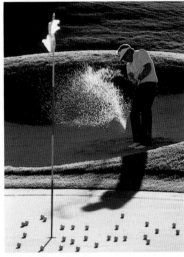

Kevin Saehlenou S7-204

Jack Affleck S7-205

Philip & Karen Smith S7-206

Philip & Karen Smith S7-207

Mitch Diamond S7-208

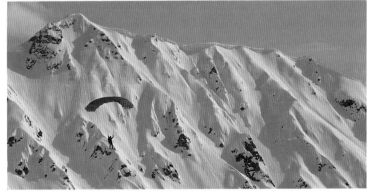

John Fowler S7-209

THE STOCK BROKER

(303) 698-1734 (800) 998-7411 Fax: (303) 698-1964

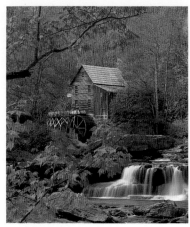

Larry Ulrich S7-301

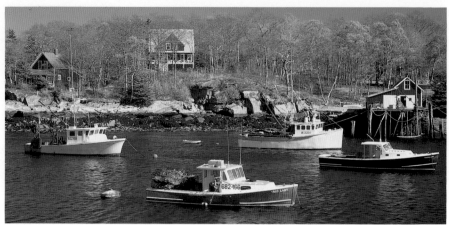

Larry Ulrich S7-302

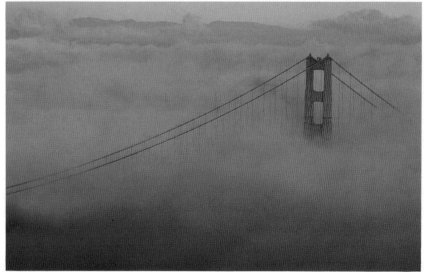

Kerrick James S7-303

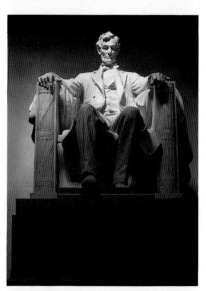

Jeff Cook S7-304

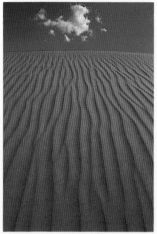

Joel Grimes S7-305

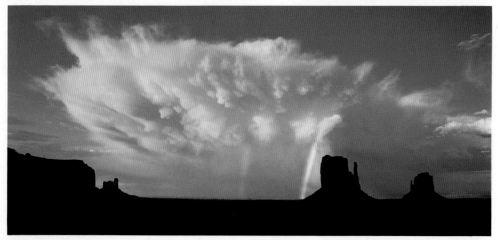

Kerrick James S7-306

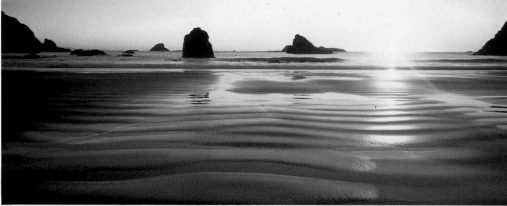

Larry Ulrich S7-307

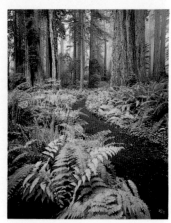

Larry Ulrich S7-308

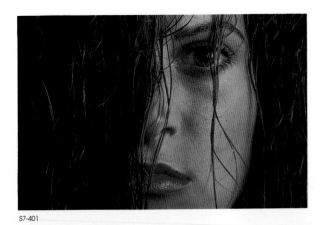

S7-401

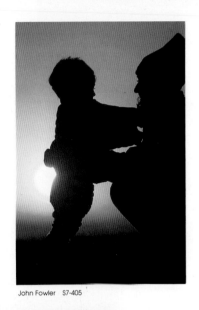

S7-402

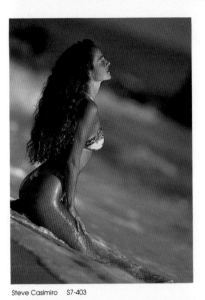

Steve Casimiro S7-403

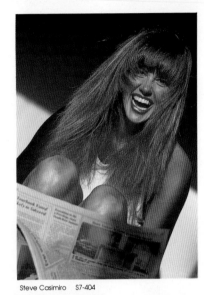

Steve Casimiro S7-404

John Fowler S7-405

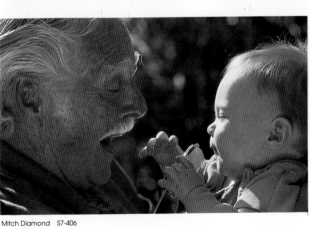

Mitch Diamond S7-406

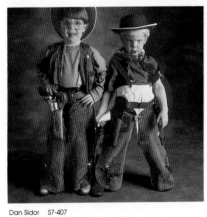

Dan Sidor S7-407

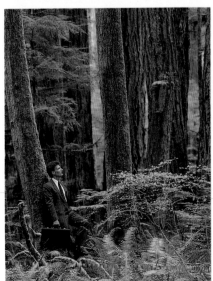

Philip & Karen Smith S7-408

Mitch Diamond S7-409

THE STOCK BROKER

(303) 698-1734 (800) 998-7411 Fax: (303) 698-1964

Repro Dupe Assemblies by Reed Photo-Art

John Fielder S7-501

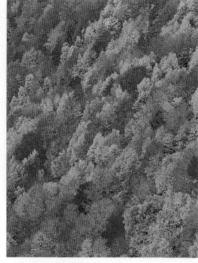

Michael Weeks S7-502

Michael Weeks S7-503

Steve Terrill S7-504

Charles Gurche S7-505

Steve Terrill S7-506

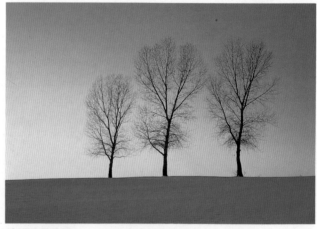

J.D. Marston S7-507

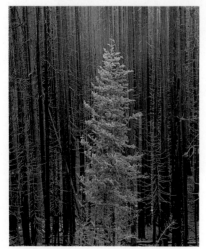

Steve Terrill S7-508

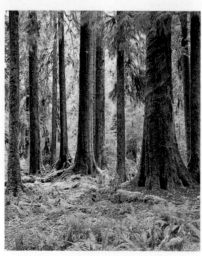

Charles Gurche S7-509

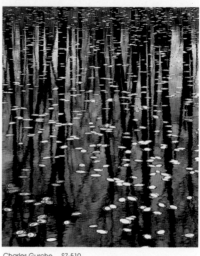

Charles Gurche S7-510

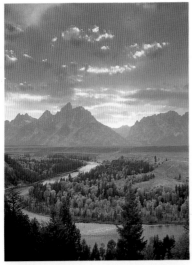

Perry Conway S7-601

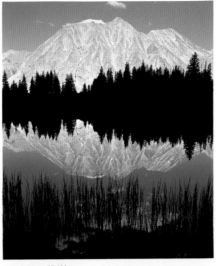

John Fielder S7-602

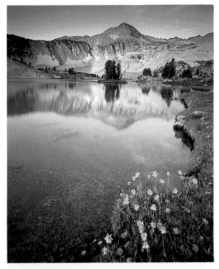

Mark Lisk S7-603

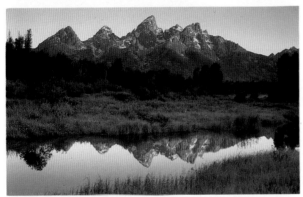

Dennis Flaherty S7-604

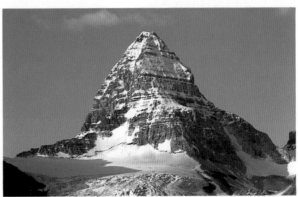

Philip & Karen Smith S7-605 Canada

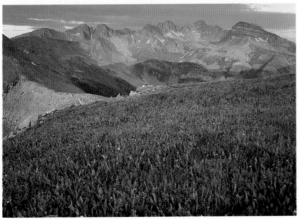

John Fielder S7-606

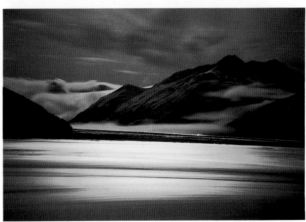

John Fowler S7-607

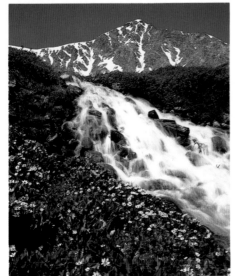

Mark Heifner S7-608

Michael Weeks S7-609

THE STOCK BROKER

(303) 698-1734 (800) 998-7411 Fax: (303) 698-1964

Repro Dupe Assemblies by Reed Photo-Art

Steve Terrill S7-701

S7-702

S7-703

Steve Terrill S7-704

John Fielder S7-705

John Fielder S7-706

Charles Gurche S7-707

Steve Terrill S7-708

Steve Terrill S7-709

Steve Terrill S7-710

Repro Dupe Assemblies by Reed Photo-Art

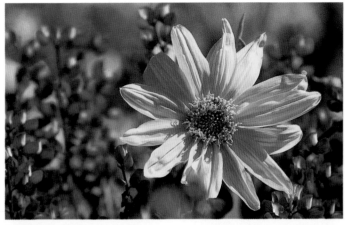

Linde Waidhofer S7-801

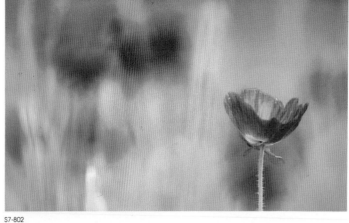

S7-802

John Fielder S7-803

John Fielder S7-804

Charles Gurche S7-805

John Fielder S7-806

Jan Oswald S7-807

Steve Terrill S7-808

Comnet S7-809

Jeff Cook S7-810

THE STOCK BROKER

(303) 698-1734 (800) 998-7411 Fax: (303) 698 1964

Repro Dupe Assemblies by Reed Photo-Art

Mark Heifner S7-901

Mark Lisk S7-902

Mitch Diamond S7-903

Jeff Cook S7-904

Karen Schulman S7-905

Karen Schulman S7-906

Jeff Cook S7-907

Regis Lefebure S7-908

Jeff Cook S7-909

Jeff Cook S7-910

Mark Heifner S7-911

Tim Benko S7-912

Repro Dupe Assemblies by Reed Photo-Art

Keith Brofsky S7-1001

Regis Lefebure S7-1002

Steve Casimiro S7-1003

Michael Weeks S7-1004

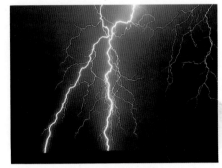

Jeff Uhrlaub S7-1005

Michael Weeks S7-1006

Michael Weeks S7-1007

Mark Heifner S7-1008

Steve Terrill S7-1009

THE STOCK BROKER
(303) 698-1734 (800) 998 7411 Fax: (303) 698-1964

Repro Dupe Assemblies by Reed Photo-Art

Nicholas DeSciose S7-1101

Nicholas DeSciose S7-1102

Nicholas DeSciose S7-1103

Nicholas DeSciose S7-1104

Nicholas DeSciose S7-1105

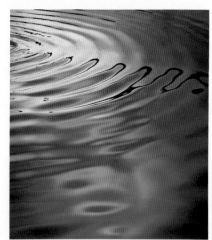

Nicholas DeSciose S7-1106

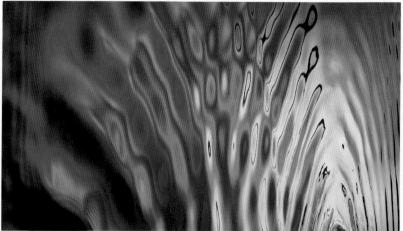

Nicholas DeSciose S7-1107

Nicholas DeSciose S7-1108

Nicholas DeSciose S7-1109

Nicholas DeSciose S7-1110

Nicholas DeSciose S7-1111

Repro Dupe Assemblies by Reed Photo-Art

Jeff Cook S7-1201

Jeff Cook S7-1202

Jeff Cook S7-1203

Jeff Cook S7-1204

Jeff Cook S7-1205

Jeff Cook S7-1206

Jeff Cook S7-1207

Jeff Cook S7-1208

Linde Waidhofer S7-1209

Jeff Cook S7-1210

Jeff Cook S7-1211

THE STOCK BROKER

(303) 698-1734 (800) 998-7411 Fax: (303) 698-1964

Repro Dupe Assemblies by Reed Photo-Art

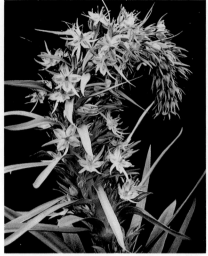

J.D. Marston S7-1301

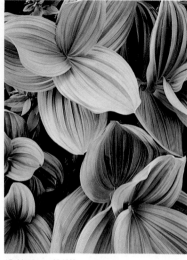

J.D. Marston S7-1302

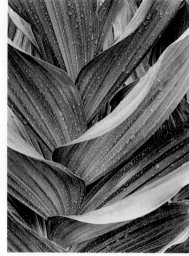

J.D. Marston S7-1303

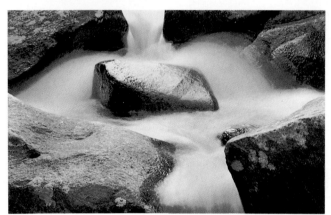

J.D. Marston S7-1304

J.D. Marston S7-1305

J.D. Marston S7-1306

J.D. Marston S7-1307

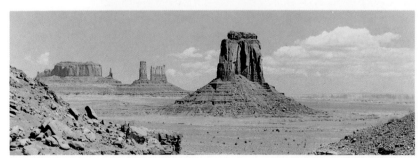

J.D. Marston S7-1308

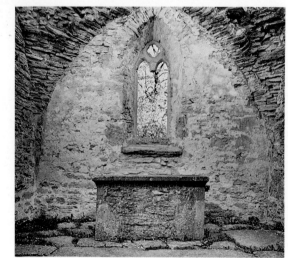

J.D. Marston S7-1309

THE STOCK BROKER

(303) 698-1734 (800) 998-7411 Fax: (303) 698-1964

NATURAL SELECTION
STOCK PHOTOGRAPHY, INC.

183 ST. PAUL STREET ROCHESTER NEW YORK 14604 716-232-1502 FAX: 716-232-6325

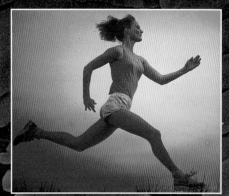
©Chris Luneski

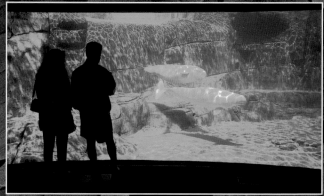
©Dave Fleetham

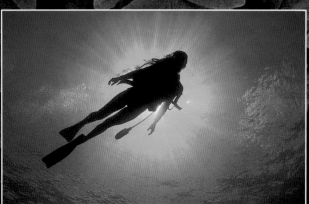
© Steve Simonsen

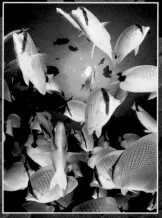
©Dave Fleetham

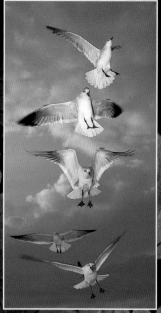
© Ralph Curtin

© Steve Alden

WHEN YOU
NEED NATURE IN ALL ITS
DIVERSITY MAKE THE
NATURAL SELECTION

NATURAL SELECTION
STOCK PHOTOGRAPHY, INC.

183 ST. PAUL STREET ROCHESTER NEW YORK 14604 716-232-1502 FAX: 716-232-6325

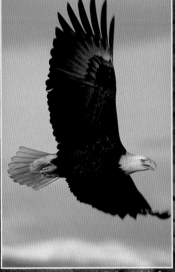
© Daniel J. Cox

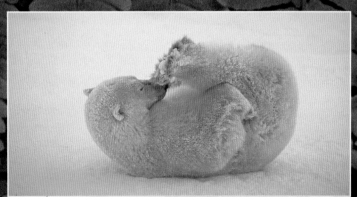
© Daniel J. Cox

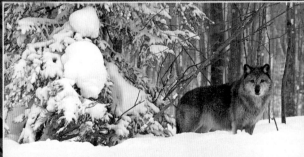
© Daniel J. Cox

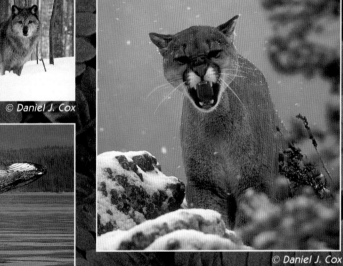
© Daniel J. Cox

© Daniel J. Cox

WHEN YOU
NEED NATURE IN ALL ITS
DIVERSITY MAKE THE
NATURAL SELECTION

NATURAL SELECTION
STOCK PHOTOGRAPHY, INC.

183 ST. PAUL STREET ROCHESTER NEW YORK 14604 716-232-1502 FAX: 716-232-6325

© Steve Kaufman

©Ron Sauter

© Pat Bates

© Dave Spier

© Larsh Bristol

© Jeff March

*W*HEN YOU
NEED NATURE IN ALL ITS
DIVERSITY MAKE THE
NATURAL SELECTION

NATURAL SELECTION

STOCK PHOTOGRAPHY, INC.

183 ST. PAUL STREET ROCHESTER NEW YORK 14604 716-232-1502 FAX: 716-232-6325

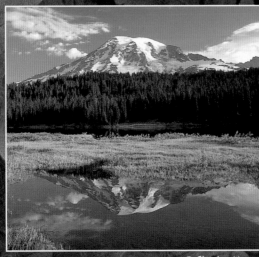

© Charles Mauzy

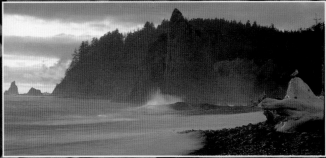

© Charles Mauzy

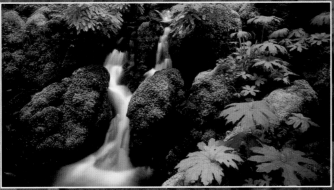

© Charles Mauzy

© Charles Mauzy

© Charles Mauzy

© Charles Mauzy

WHEN YOU
NEED NATURE IN ALL ITS
DIVERSITY MAKE THE
NATURAL SELECTION

NATURAL SELECTION
STOCK PHOTOGRAPHY, INC.

183 ST. PAUL STREET ROCHESTER NEW YORK 14604 716-232-1502 FAX: 716-232-6325

© Dave Fleetham

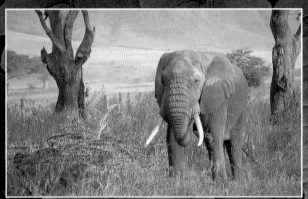
©Len Clifford

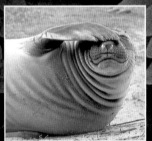
© Frank Balthis

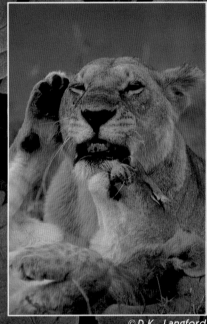
© D.K. Langford

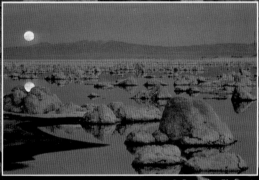
© Dennis Flaherty

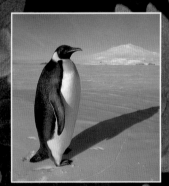
© Rich Kirchner

© David Cavagnaro

*WHEN YOU
NEED NATURE IN ALL ITS
DIVERSITY MAKE THE
NATURAL SELECTION*

NATURAL SELECTION

STOCK PHOTOGRAPHY, INC.

183 ST. PAUL STREET ROCHESTER NEW YORK 14604 716-232-1502 FAX: 716-232-6325

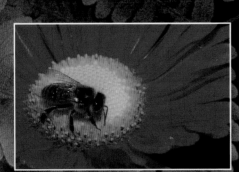

©Jeff March

©Frank Balthis

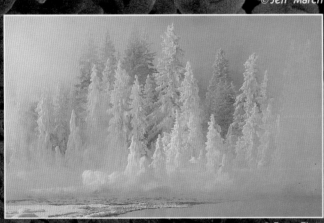

© Tom Tietz

©Robert de Jonge

© Ian Adams

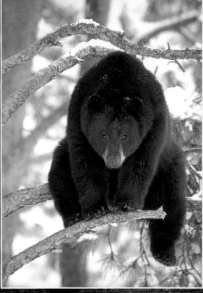

© Judd Cooney

© Anthony Mercieca

WHEN YOU
NEED NATURE IN ALL ITS
DIVERSITY MAKE THE
NATURAL SELECTION

NATURAL SELECTION

STOCK PHOTOGRAPHY, INC.

183 ST. PAUL STREET ROCHESTER NEW YORK 14604 716-232-1502 FAX: 716-232-6325

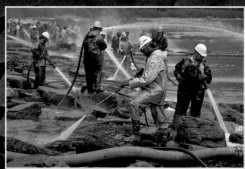

© Ken Graham

© Ken Graham

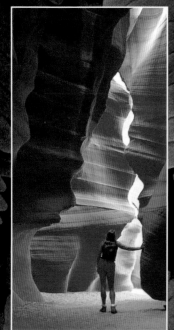

©Glenn Randall

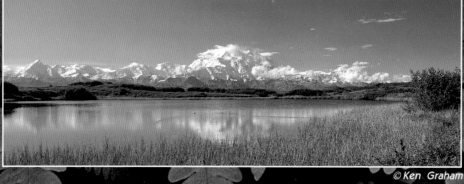

© Ken Graham

© Glenn Randall

©Glenn Randall

WHEN YOU
NEED NATURE IN ALL ITS
DIVERSITY MAKE THE
NATURAL SELECTION

NATURAL SELECTION
STOCK PHOTOGRAPHY, INC.

183 ST. PAUL STREET ROCHESTER NEW YORK 14604 716-232-1502 FAX: 716-232-6325

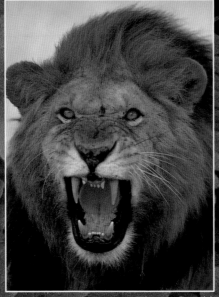

© Joe McDonald

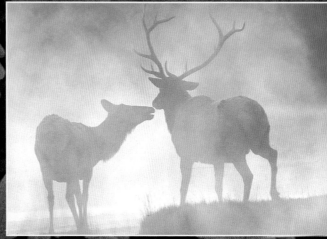

© Joe McDonald

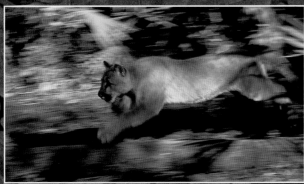

© Joe McDonald

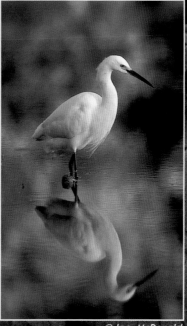

© Joe McDonald

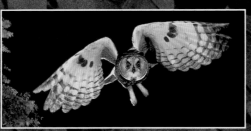

© Joe McDonald

© Joe McDonald

WHEN YOU
NEED NATURE IN ALL ITS
DIVERSITY MAKE THE
NATURAL SELECTION

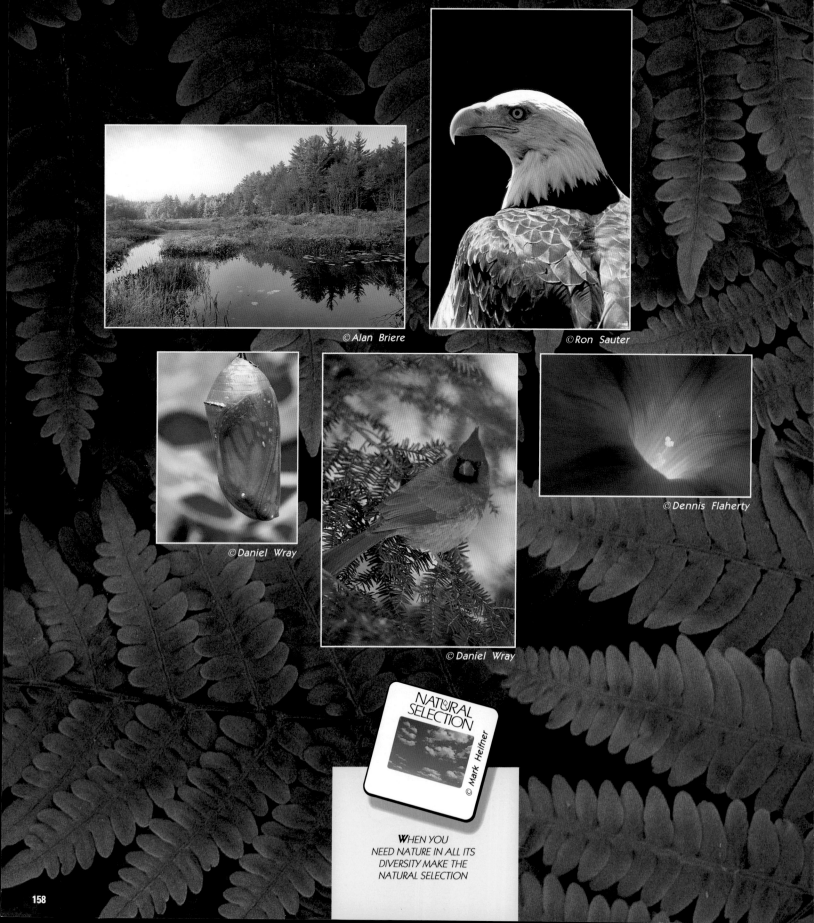

©Alan Briere

©Ron Sauter

©Daniel Wray

©Daniel Wray

©Dennis Flaherty

NATURAL SELECTION

©Mark Heifner

*W*HEN YOU
NEED NATURE IN ALL ITS
DIVERSITY MAKE THE
NATURAL SELECTION

INTERNATIONAL
LIAISON

N279

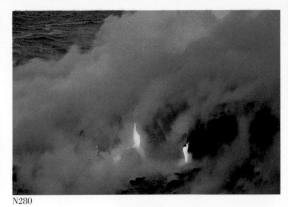

N280

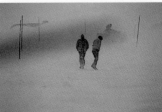

N281

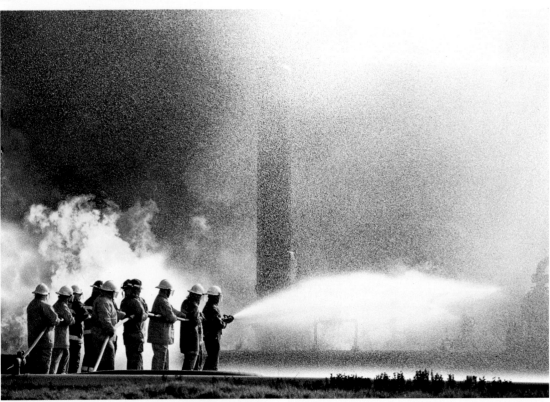

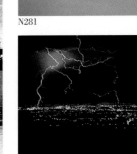

N282

I326

I327

N283

I328

N284

N285

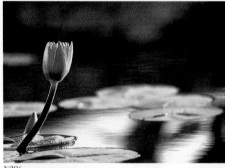

N286

N287

N288

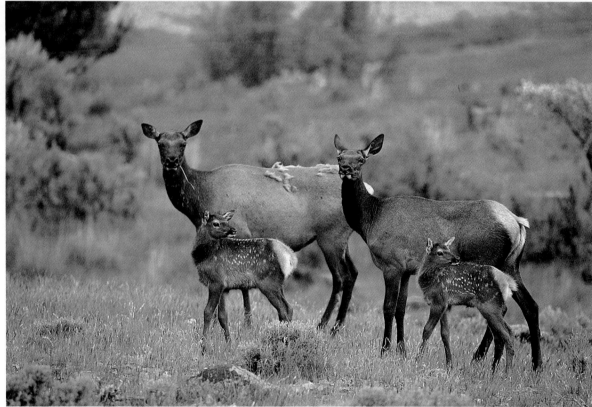

N289

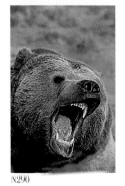

N290

N291

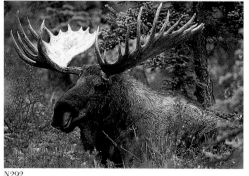

N292

INTERNATIONAL
LIAISON

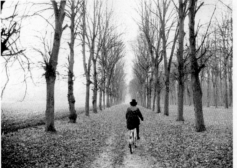

P204

P205

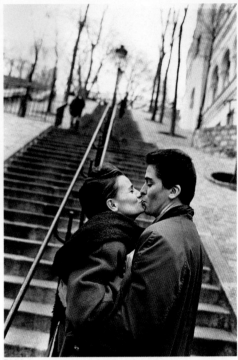

P206

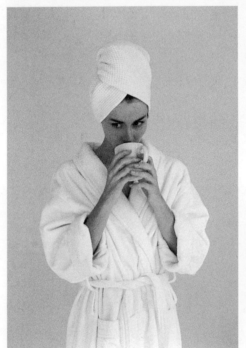

P207

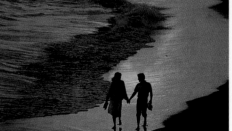

P209

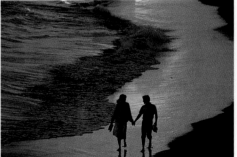

P208

P210

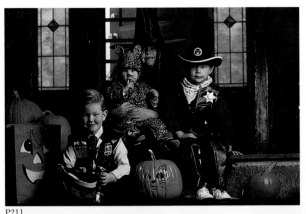

P211

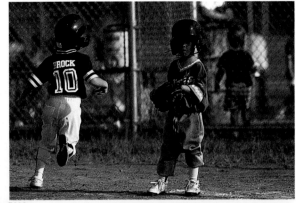

P212

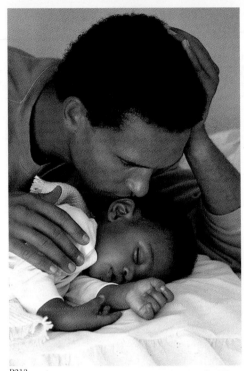

P213

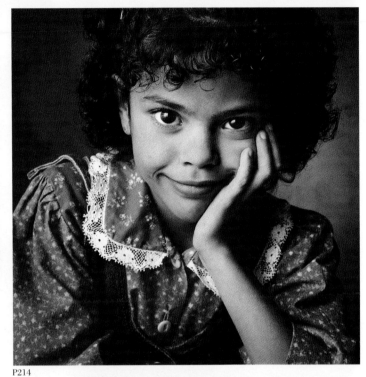

P214

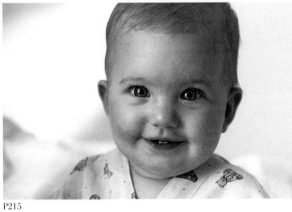

P215

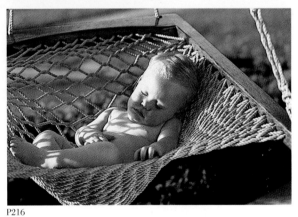

P216

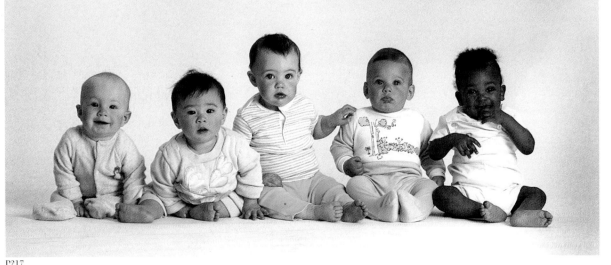

P217

INTERNATIONAL LIAISON

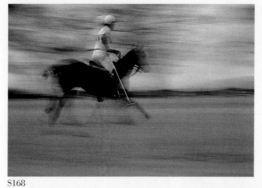

S168

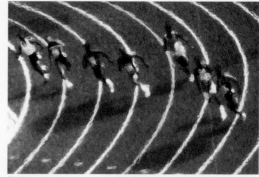

S169

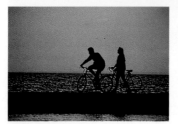

S170

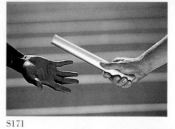

S171

S172

S173

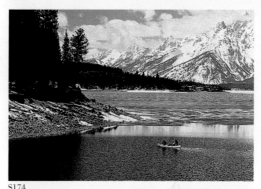

S174

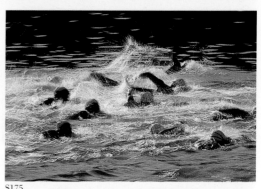

S175

S176

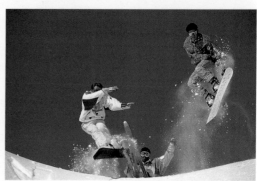

S177

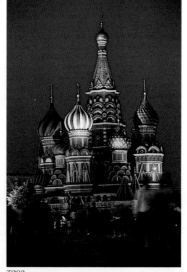

T202

T203

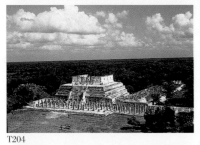

T204

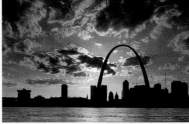

T205

T206

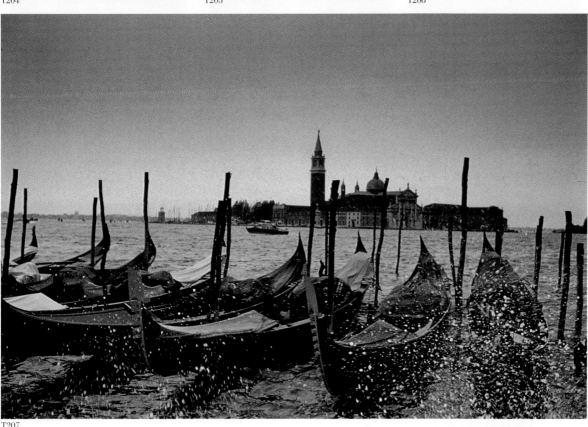

T207

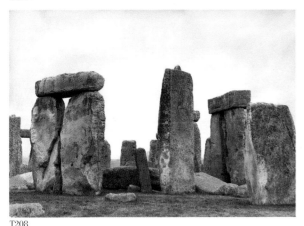

T208

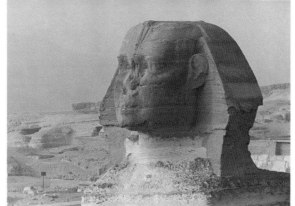

T209

I329

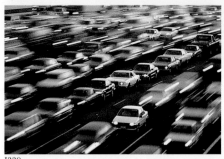
I330

I331

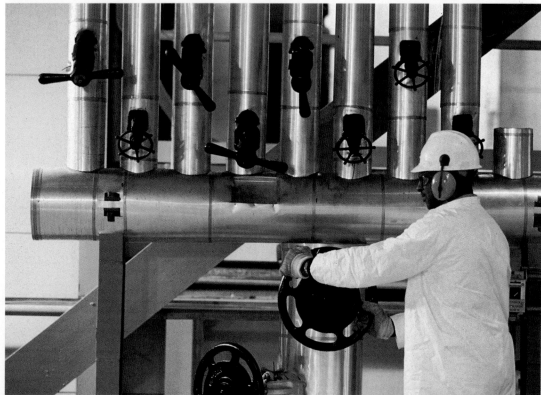
I332

I333

I334

I335

F136

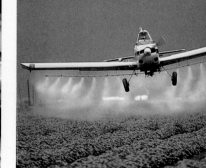
I336

I337

I325

I338

I339

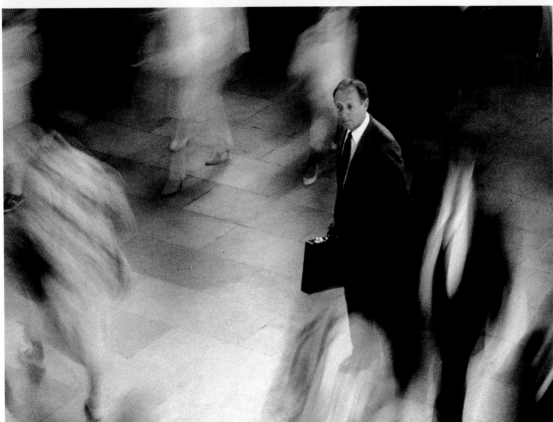

I340

I341

I342

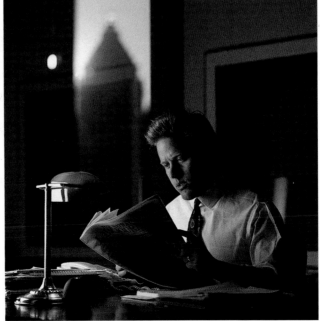

I343

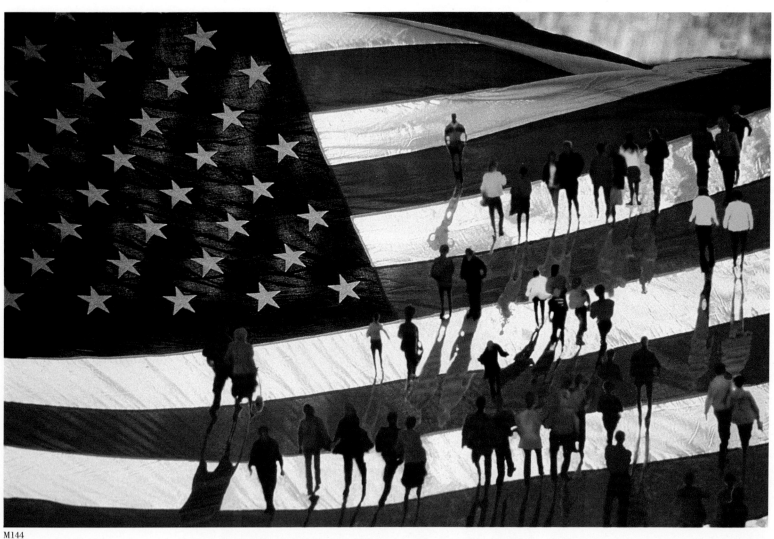

preceeding page: Fred J. Maroon

Tal McBride

Eric Poggenpohl

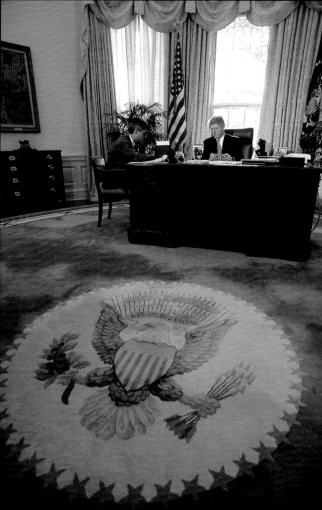

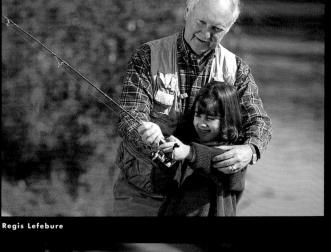
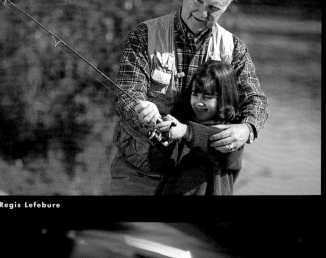

Regis Lefebure

Wally McNamee

Alan Goldstein

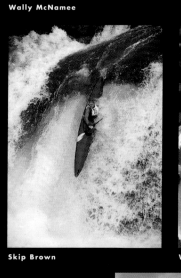
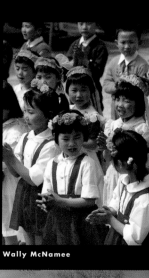

Skip Brown

Wally McNamee

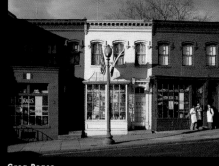

Greg Pease

FOLIO INC
THE IMAGE AGENCY

TEL 202-965-2410 • 800-662-1992
FAX 202-625-1577 • 800-247-1577

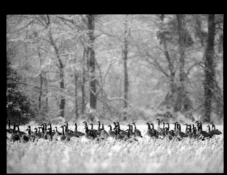

David Harp

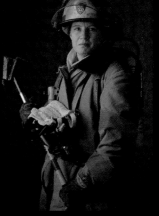

Matthew Borkoski

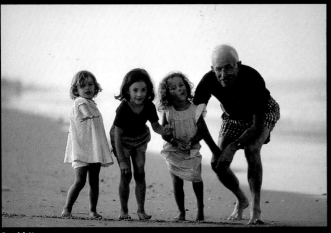

David Harp

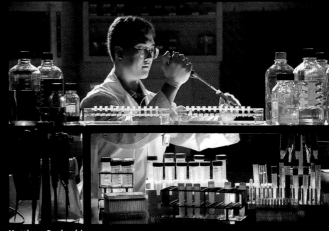

Matthew Borkoski

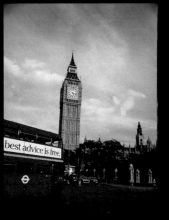

Dennis Johnson

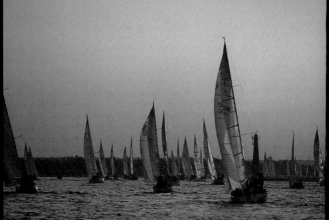

Skip Brown

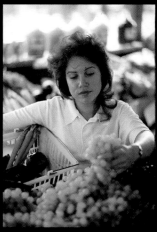

Ed Castle

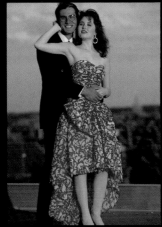

Stephen R. Brown

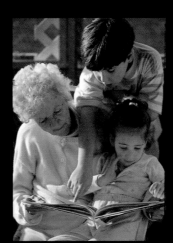

Robert Rathe

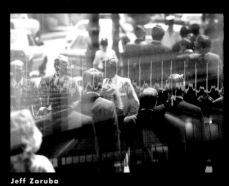

Jeff Zaruba

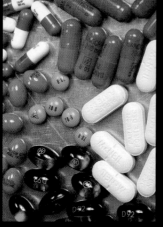

Ron Jautz

Don Hamerman

Bob Burgess

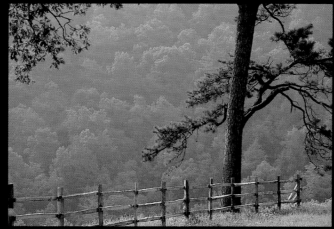

Everett C. Johnson

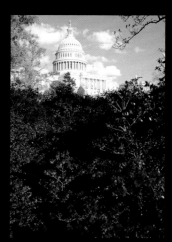

Lelia Hendren

Regis Lefebure

Stephen R. Brown

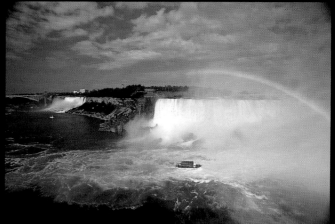

Linda Bartlett

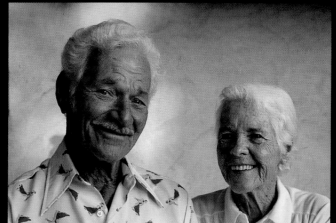

Gregg A. Rummel

Michael Ventura

FOLIO INC
THE IMAGE AGENCY
TEL 202-965-2410 • 800-662-1992

Jon Riley

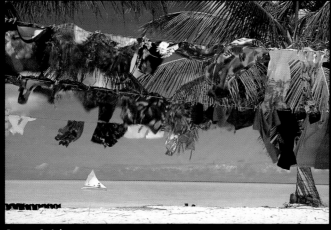

Everett C. Johnson

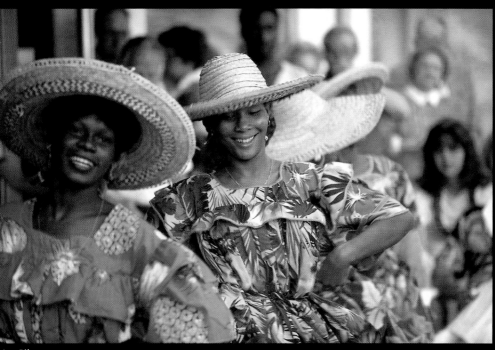

Jon Riley

Jon Riley

Jeff Zaruba

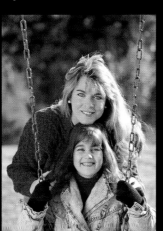

Regis Lefebure

Jon Riley

FOLIO INC
THE IMAGE AGENCY

TEL 202-965-2410 • 800-662-1992

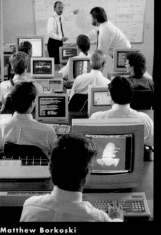

Matthew Borkoski

Terry Ashe

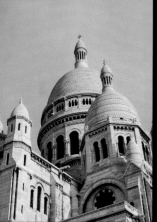

Fred Stork

Alan Goldstein

Ed Castle

Alan Goldstein

Matthew Borkoski

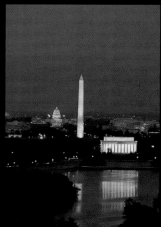

Stephen R. Brown

Michael Patrick

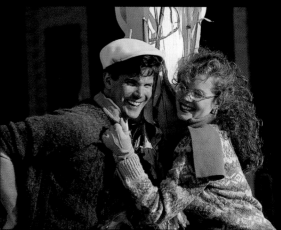

Stephen R. Brown

FOLIO INC
THE IMAGE AGENCY

TEL 202-965-2410 • 800-662-1992
FAX 202-625-1577 • 800-247-1577

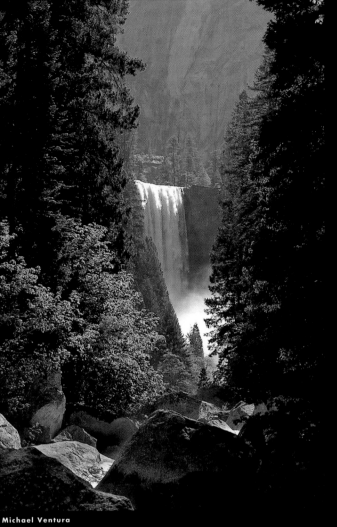

Michael Ventura

Skip Brown

Eric Poggenpohl

Terry Ashe

Dennis Johnson

Stephen R. Brown

Don Carstens

FOLIO INC
THE IMAGE AGENCY
TEL 202-965-2410 • 800-662-1992

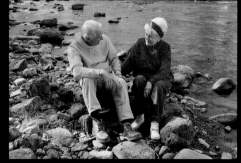

Everett Johnson

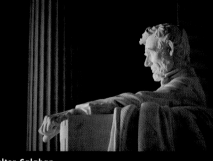

Walter Calahan

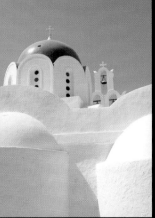

Richard Quataert

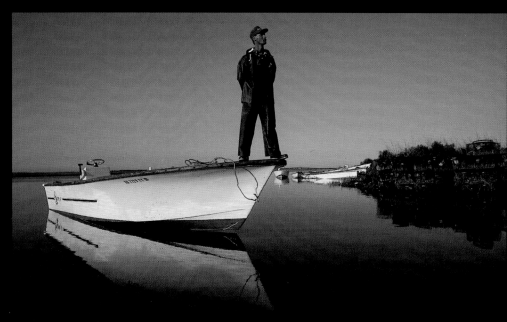

David Harp

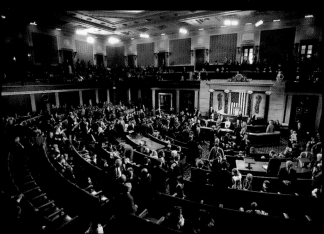

Terry Ashe

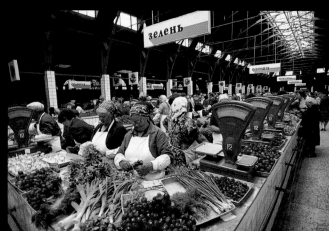

Richard Quataert

Regis Lefebure

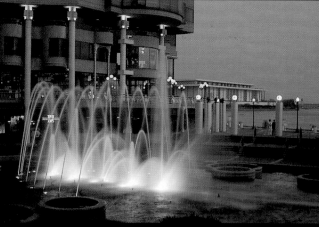

Lloyd Wolf

FOLIO INC
THE IMAGE AGENCY

TEL 202 965 2410 • 800 662 1992
FAX 202 625 1577 • 800-247 1577

Don Carstens

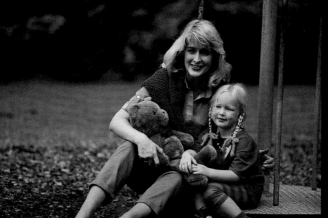

Fredde Lieberman

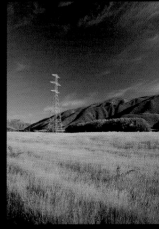

Dennis johnson

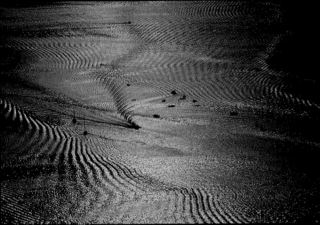

Stephen R. Brown

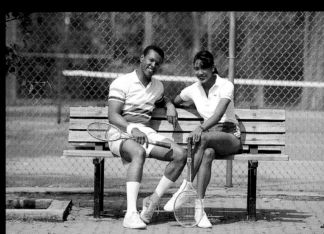

Fredde Lieberman

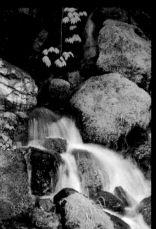

Ron Jautz

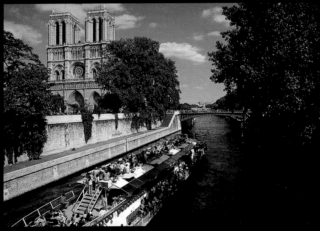

Linda Bartlett

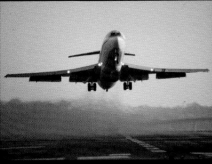

Walter Calahan

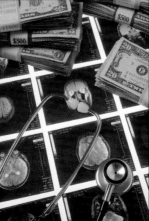

Matthew Borkoski

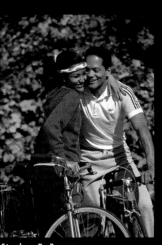
Stephen R. Brown

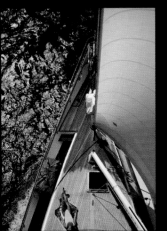
Eric Poggenpohl

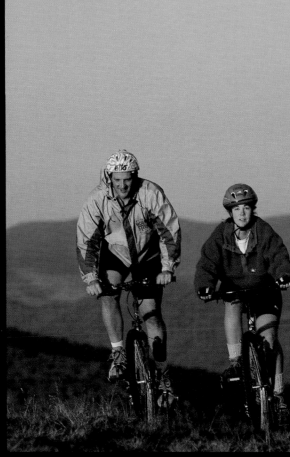
Skip Brown

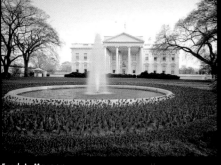
Fred J. Maroon

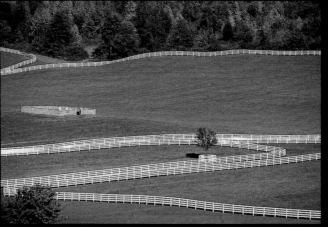
Greg Pease

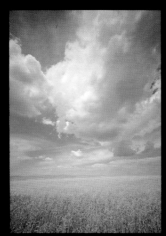
Fred J. Maroon

FOLIO INC
THE IMAGE AGENCY
TEL 202·965·2410 · 800·662·1992
FAX 202·625·1577 · 800·247·1577

Alan Goldstein

Greg A. Rummel

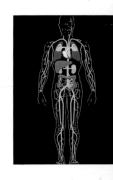

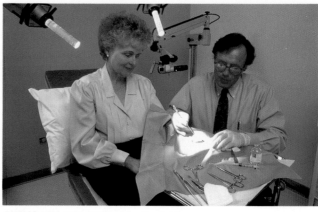
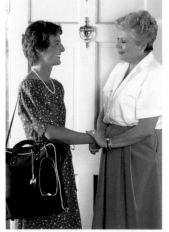

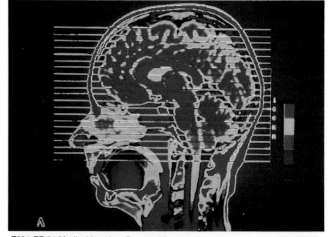

Z129-Q-12 Biomedical Research, *E. coli* Colonies

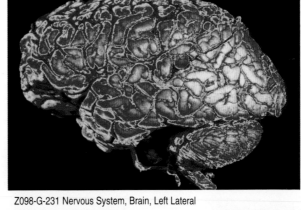

Z098-G-231 Nervous System, Brain, Left Lateral

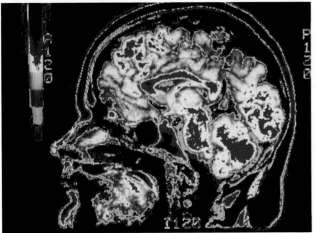

Z002-FF-715 Medical Imaging, Male, Magnetic Resonance

Z102-M-2038, Surgical Techniques,
Laser Laparoscopic Cholecystectomy

Z500-QQQ-8289 Virology, Hepatitis B Virus

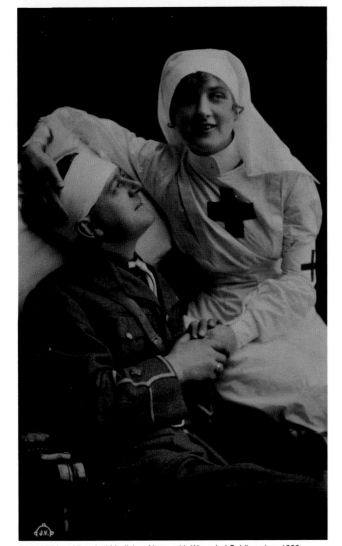

Z500-SS-11530 Laboratories, Lab Workers

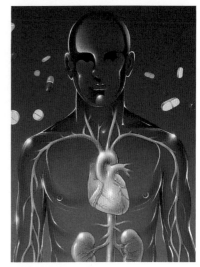

Z202-J-1 Circulatory System

Z157-XXX-84 Historical Medicine, Nurse with Wounded Soldier, circa 1900

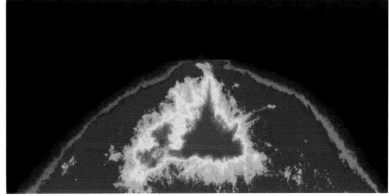

Z175-NNN-241 Health Issues, Mammogram, Scirrhus Cancer

Custom Medical Stock Photo, Inc. *Medical & Scientific Photography & Illustration* 800.373.2677

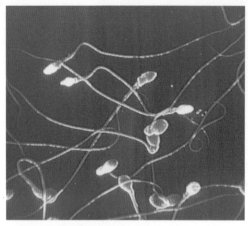

Z156-N-197 Human Sperm, SEM

Z500-NN-12474 Pregnancy, Working Woman

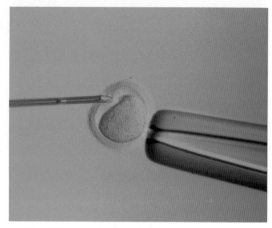

Z131-N-25 Microscopy, In-Vitro Fertilization

Z500-FF-2289 Fetal Ultrasound, 4-Month Fetus, Male

Z102-NN-2988 Neonatal Care, Fetal Ultrasound

Z002-NN-3980 Infants, 20 Seconds After Birth

Custom Medical Stock Photo, Inc. *Medical & Scientific Photography & Illustration* **800.373.2677**

Z194-T-35 Pediatrics

Z192-Q-69 Microbiology, *Hemophilis influenzae with Staphylococcus aureus*

Z500-Q-7180 Virology, *Influenza A* Virus, x 600,000 TEM

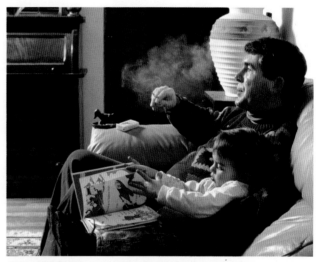
Z001-I-9558 Environmental Issues, Passive Smoking

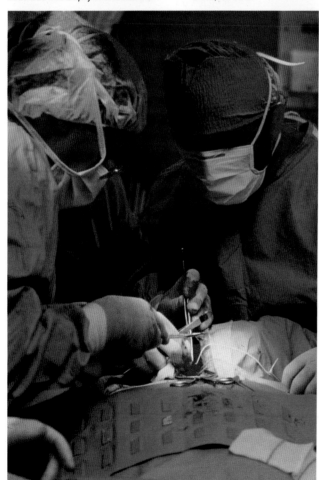
Z500-U-2011 Surgery

Z194-SSS-93 Medical Equipment

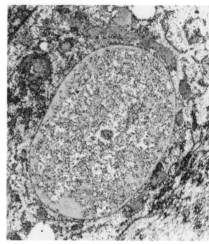
Z156-BB-155 Normal Tissue, Mammalian Cell, Nucleus, Mitochondria, TEM

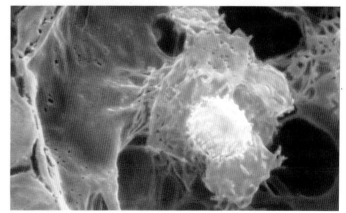
Z061-LL-5 Blood Components, Lymphocyte & Macrophage, SEM

Z500-SS-13755 Physicians

Z194-SS-102 Surgeon

Z500-U-1996 Laser Surgery

Z500-EEE-11648 Senior Rehabilitation

Z194-RRR-43 Occupational Therapy

Z175-G-232 Magnetic Resonance, MRI, Brain at Pituitary

Z500-F-11297 Men's Health Issues

Custom Medical Stock Photo, Inc. *Medical & Scientific Photography & Illustration* **800.373.2677**

Z201-FF-4 Diagnostic Imaging, Magnetic Resonance Imaging, MRI, Female

CMSP

CUSTOM MEDICAL STOCK PHOTO, INC.

3819 North Southport Avenue
Chicago IL 60613 USA
312.248.3200
(FAX 312.248.7427)
800.373.2677

Z191-SS-182 Hospital Scenes, Nurses

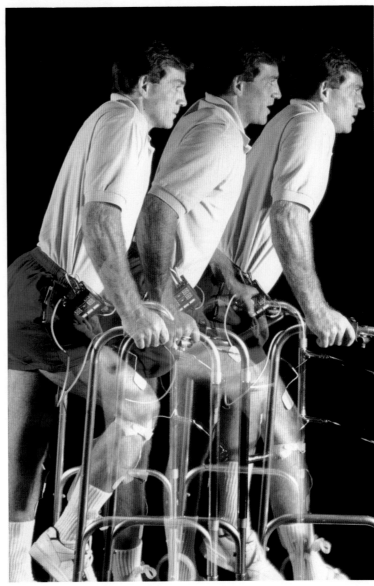

Z208-EEE-1 Therapy and Recovery

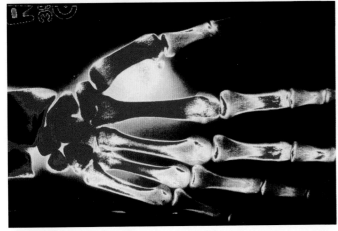

Z001-F-10331 Radiograph, Digitized, Normal Hand

Z500-SS-3229 Radiologists

Are you ready for the real thing? Not just a bunch of staged smiles and pseudo-science. But real, interesting images taken from highly unique perspectives—of the people, places and things within the world of health and medicine.

Z061-LL-332 Immunology, HIV, AIDS Virus, x200,000 SEM

Z113-Q-393 Electron Microscopy, Yeast, *Candida albicans*

Z165-ZZZZ-164 Science & Industry

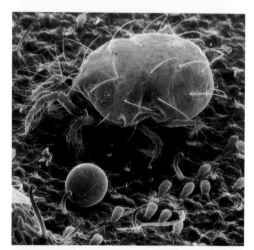

Z203-A-15 Biology, Mite With Egg, *Tetranychus urticae* x120 SEM

Z194-D-3 Genetic Research

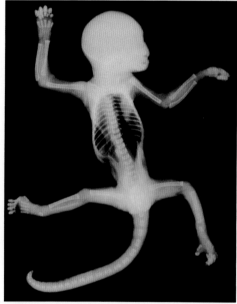

Z039-A-148 Biology, Wooley Monkey

Z186-MM-17 Molecular Model, Vitamin C

Z500-QQQ-4188 Immunology Research, HIV Research

Custom Medical Stock Photo, Inc. *Medical & Scientific Photography & Illustration* **800.373.2677**

Z102-SSS-3184 Medical Office, Waiting Room

CMSP

CUSTOM MEDICAL STOCK PHOTO, INC.

3819 North Southport Avenue
Chicago IL 60613 USA
312.248.3200
(FAX 312.248.7427)
800.373.2677

Z500-WW-6272 Mature Adults, Physician and Senior

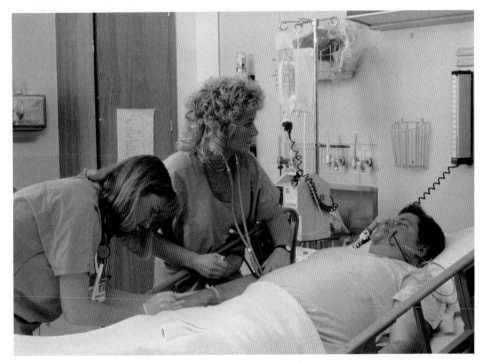

Z500-SS-3598 Hospital Support Staff, Intensive Care Unit

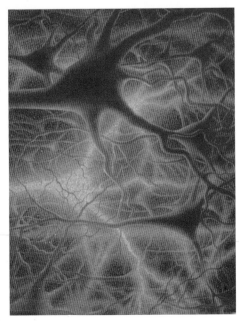

z082-G-64 Medical Illustrations, Neurons of Human Brain

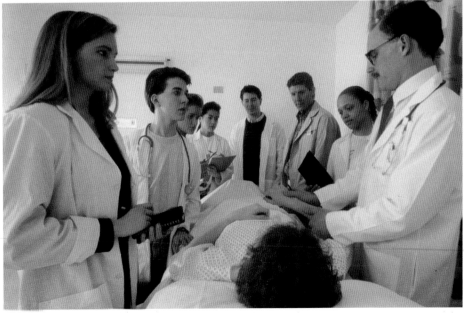

Z500-SS-8383 Medical Education, Students on Rounds

CMSP

CUSTOM MEDICAL STOCK PHOTO, INC.

3819 North Southport Avenue
Chicago IL 60613 USA
312.248.3200
(FAX 312.248.7427)
800.373.2677

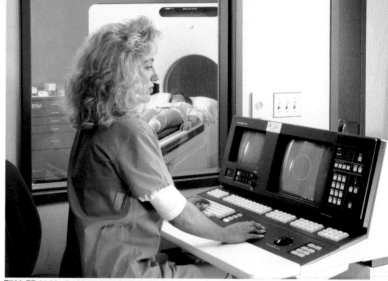
Z700-FF-80 Medical Imaging, CAT Scan, Computer Aided Tomography

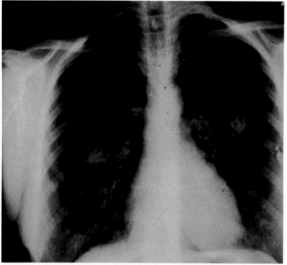
Z133-I-395 Oncology, Lung Cancer, Female

Z500-J-66261 Cardiology, Normal Arterial Section

Z500-J-7218 Pathology, Atherosclerosis, Artery

Z500-SS-2105 Healthcare Workers, Patient's Viewpoint

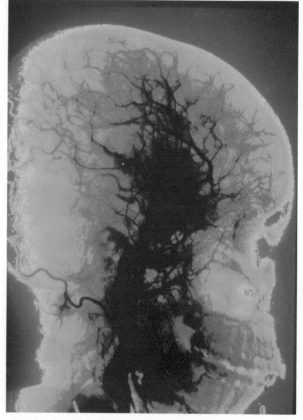
Z001-J-9526 Circulatory System, Angiogram, Enhanced Vessels

KJ-12713-R L. Powers

KJ-12697-R J. Harp

KA-7977-R J. Patton

KJ-10639-R K. Benser/ZEFA

KS-29377-R D. Degnan

KJ-12501-R D. Degnan

KJ-12684-R R. Walker

KJ-12737-R L. Powers

KB-29075-R R. Walker

KS-32156-R LaFoto

KW-12422-R Winter/Bavaria

KJ-12571-R LaFoto

Free catalogs upon request

KJ-12726-R L. Powers

KB-28503-R L. Powers

KJ-12669-R L. Powers

KJ-12567-R LaFoto

KJ-12611-R L. Powers

KJ-12527-R LaFoto

KJ-11358-R J. Whitmer

KJ-12753-R L. Powers

KJ-12852-R D. Petku

KB-29076-R R. Walker

KH-10925-R B. Taylor

KJ-12699-R H. Willson

Free catalogs upon request

191

KJ-12850-R S. Lissau

KJ-12829-R M. Elenz-Tranter

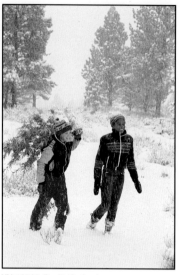

KX-10788-R R. C. Paulson

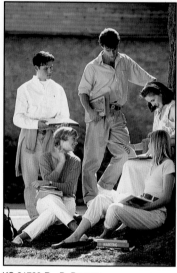

KS-31723-R D. Degnan

KW-12293-R R. Walker

KC-11488-R R. Walker

KS-33021-R L. Powers

KS-27653-R J. Nettis

KB-29082-R J. Harp

KJ-12851-R ZEFA-U.K.

KB-29188-R B. Paulson

KB-29001-R D. Degnan

Free catalogs upon request

KS-32518-R G. Hunter

KP-5248-R Picturebank

KJ-12751-R L. Powers

KS-24453-R D. Degnan

KM-9128-R B. Taylor

KS-32547-R J. Nettis

KP-5679-R S. Feld

KS-33443-R LaFoto

KS-33377-R D. Degnan

KH-11150-R T. del Amo

KS-32084-R J. Nettis

KS-27486-R Picturebank

Free catalogs upon request

KH-10915-R H. Willson

KD-5760-R LaFoto

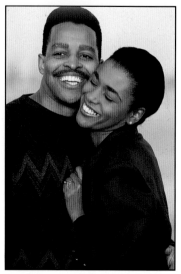

KS-32842-R L. Powers

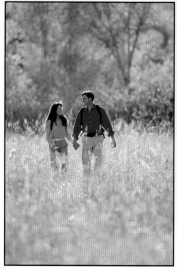

KH-11000-R R. Walker

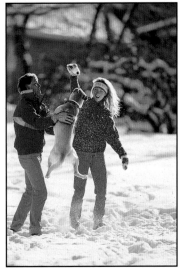

KW-12289-R R. Walker

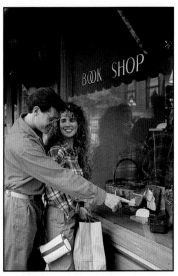

KS-32269-R H. Willson

KS-33298-R S. Barth

KB-28964-R H. Willson

KS-32489-R Blackfan

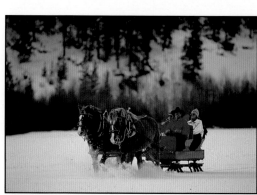

KW-12283-R R. Walker

KS-31810-R D. Degnan

KS-33306-R S. Barth

Free catalogs upon request

KR-81180-R M. T. O'Keefe

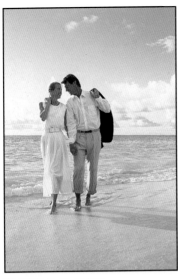

KS-31927-R T. del Amo

KS-32708-R Picturebank

KD-5805-R M. Berman

KL-17501-R T. del Amo

KR-90147-R M. Berman

KM-9835-R R. Walker

KS-31833-R CVT

KR-92495-R G. Hunter

KS-33381-R T. del Amo

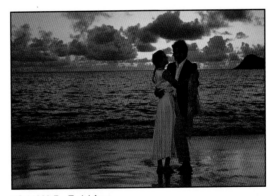

KS-31929-R T. del Amo

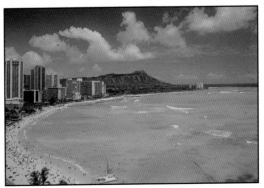

KR-87734-R T. del Amo

Free catalogs upon request

KS-32998-R Top Shot/Bavaria

KO-3448-R J. Nettis

KO-3447-R J. Nettis

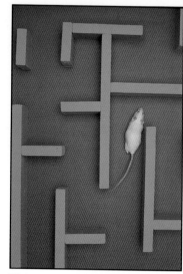
KS-31995-R S. Feld

KS-31452-R L. Powers

KS-32973-R L. Powers

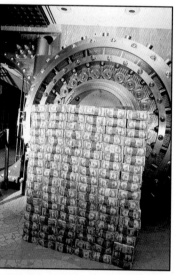
KO-2935-R T. del Amo

KO-3513-R B. Paulson

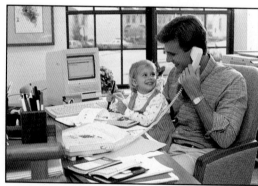
KH-10850-R J. Nettis

KS-32941-R Summer/Bavaria

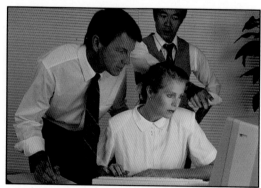
KO-3364-R T. del Amo

KB-20312-R J. Myers

Free catalogs upon request

KO-3149-R Karageorge

KS-31188-R T. del Amo

KO-3388-R T. del Amo

KO-3357-R T. del Amo

KO-3292-R R. Kord

KO-3437-R H. Willson

KO-3476-R C. Brewer

KO-2502-R T. Thompson

KS-33189-R B. Paulson

KS-32723-R Picturebank

KS-32144-R R. Krubner

KO-3460-R Picturebank

Free catalogs upon request

KB-28207-R W. Metzen

KS-32138-R P. Degginger

KL-17066-R Karageorge

KS-31670-R M. Barrett

KI-9391-R P. W. Smith

KS-31300-R B. Peterson

KS-32142-R P. Degginger

KS-28901-R B. Peterson

KF-29502-R L. Smith

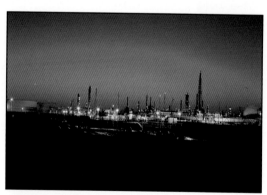

KI-9894-R R. Kord

KS-32911-R H. Willson

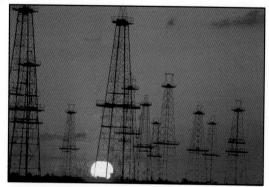

KI-6509-R M. Roessler

Free catalogs upon request

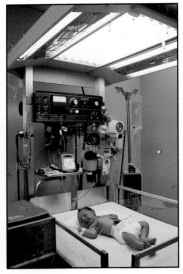

KM-9073-R J. Nettis

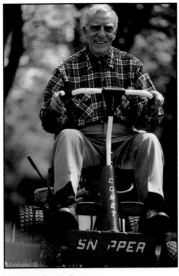

KG-9991-R D. Degnan

KL-18866-R B. Paulson

KS-32137-R P. Degginger

KM-10527-R B. Paulson

KS-30555-R L. O'Shaughnessy

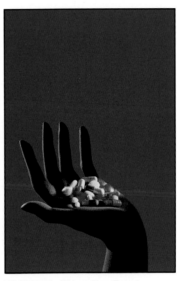

KS-32897-R Picture Crew/Bavaria

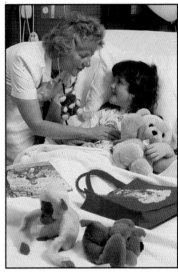

KM-9428-R J. Nettis

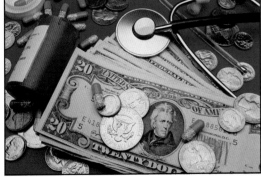

KM-10364-R C. Brewer

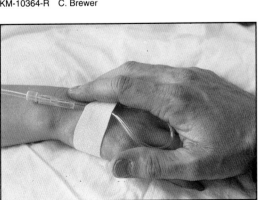

KM-10561-R S. Feld

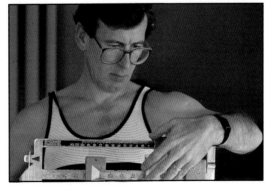

KB-29184-R B. Paulson

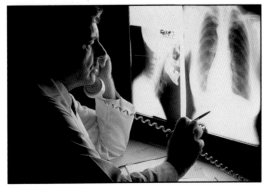

KM-9233-R H. Abernathy

Free catalogs upon request

KA-7328-R Kalt/ZEFA

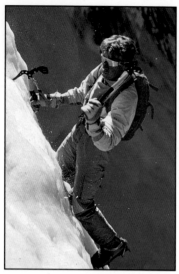
KC-11776-R P. Royer

KB-27705-R R. Walker

KW-11558-R R. Walker

KW-12360-R L. Powers

KS-33155-R B. Paulson

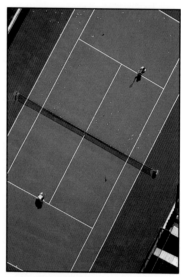
KT-6317-R B. Paulson

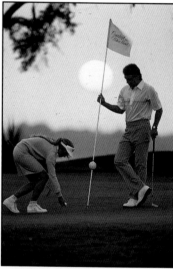
KG-10542-R LaFoto

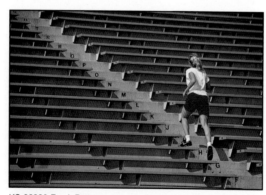
KS-32380-R J. Patton

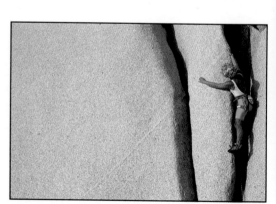
KC-12118-R P. Royer

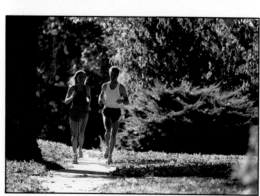
KS-32529-R R. Walker

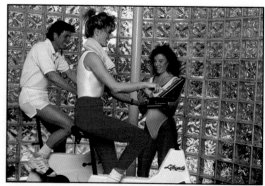
KS-33378-R LaFoto

Free catalogs upon request

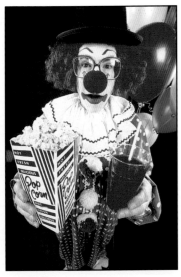
KC-12012-R H. Willson

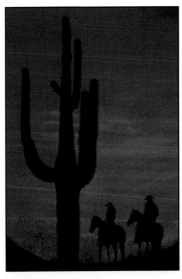
KH-7987-R M. Roessler

KC-12170-R R. Visser

KP-5856-R L. O'Shaughnessy

KW-12622-R M. Elenz-Tranter

KM-10317-R S. Feld

KS-33294-R G. L. French

KI-9800-R C. Brewer

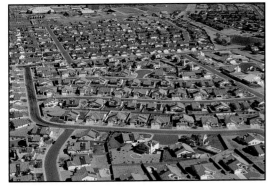
KA-7880-R G. Hunter

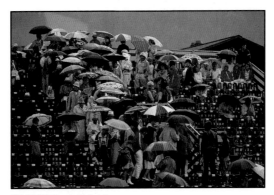
KS-31502-R A. Hubrich

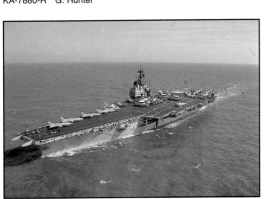
KM-10560-R L. Smith

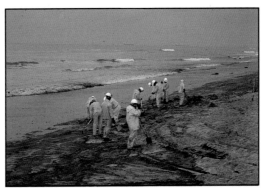
KS-33379-R M. Roessler

Free catalogs upon request

KS-33380-R D. Degnan

KV-815-R D. Carriere

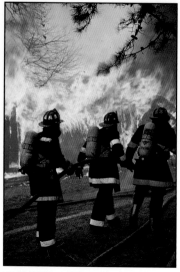
KF-28388-R L. O'Shaughnessy

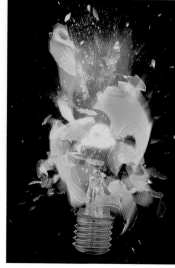
KS-28745-R ZEFA-U.K.

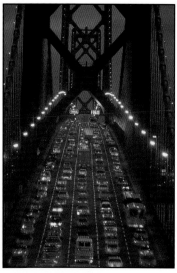
KB-29196-R B. Paulson

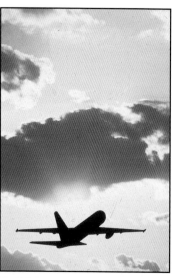
KA-8146-R R. Kord

KS-32146-R L. Smith

KH-10966-R C. Brewer

KF-24921-R G. Hunter

KF-29294-R H. Abernathy

KM-10271-R S. Feld

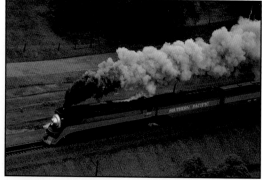
KR-92384-R P. Wallick

Free catalogs upon request

KG-11468-R D. Corson

KG-11319-R G. Hampfler

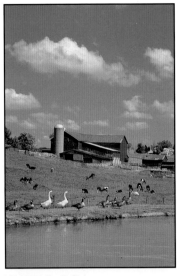

KF-28980-R F. Sieb

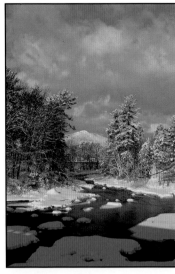

KW-12623-R F. Sieb

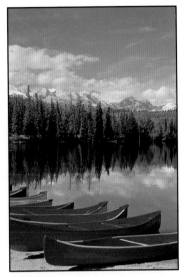

KR-87666-R F. Sieb

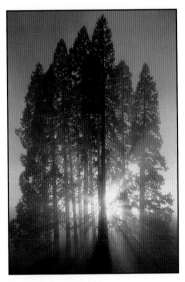

KL-18221-R ZEFA-U.K.

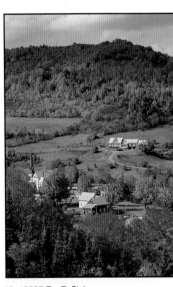

KL-18907-R F. Sieb

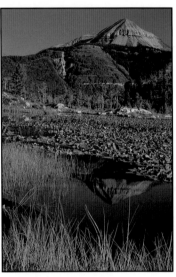

KR-89686-R H. Abernathy

KW-12265-R J. Amos

KP-5251-R R. Kord

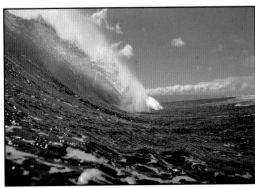

KM-6622-R S. Lissau

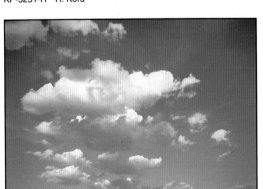

KC-10941-R R. Kord

Free catalogs upon request

203

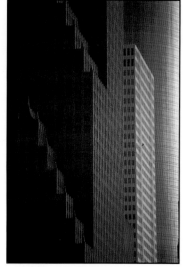

KB-29164-R R. Kord

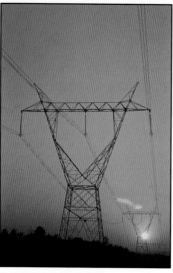

KI-9046-R H. Abernathy

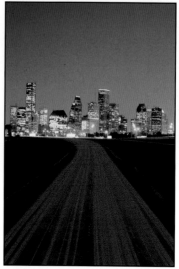

KR-93274-R R. Kord

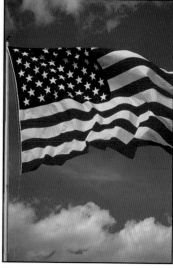

KH-9640-R F. Sieb

KF-29337-R D. Petku

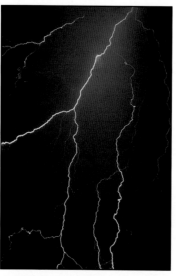

KL-15931-R R. Krubner

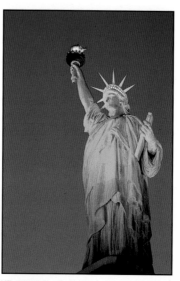

KR-78762-R C. Ursillo

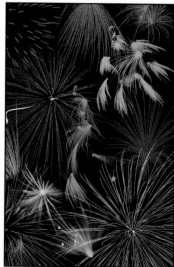

KF-20564-R R. Krubner

KB-28983-R D. Petku

KF-29574-R F. Sieb

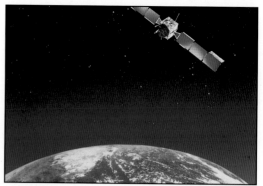

KR-87571-R F. Sieb

KA-8054-R ZEFA-U.K.

Free catalogs upon request

KR-93959-R A. Jackamets Seattle

KR-95019-R R. Kord Los Angeles

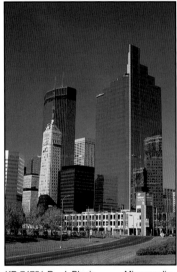

KR-85843-R J. Blank New York

KR-95040-R J. Blank Indianapolis

KR-76531-R J. Blank St. Louis

KR-91903-R R. Krubner Chicago

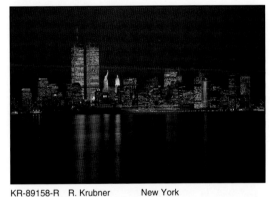

KR-89158-R R. Krubner New York

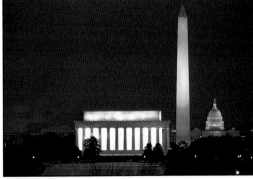

KR-74751-R J. Blank Minneapolis

KR-76366-R A. Tovy Dallas

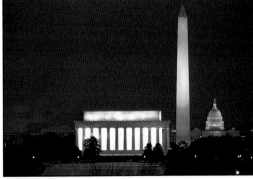

KR-82122-R J. Patton Washington

KR-81898-R J. Patton Pittsburgh

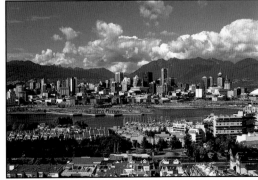

KR-90849-R G. Hunter Vancouver

KB-28192-R T. Ulrich

KB-27687-R L. Rue, Jr.

KZ-4220-R Jansen

KD-5859-R B. von Hoffmann

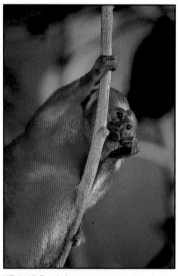

KZ-4117-R J. Amos

KD-5986-R K. Reno

KZ-3925-R Wisniewski/ZEFA

KZ-3395-R ZEFA

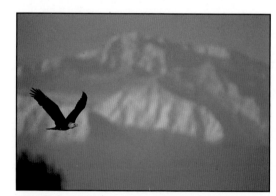

KB-29321-R T. Ulrich

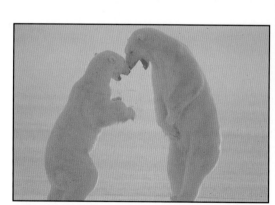

KZ-4019-R T. Ulrich

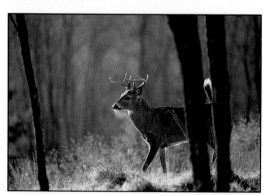

KZ-4408-R J. Patton

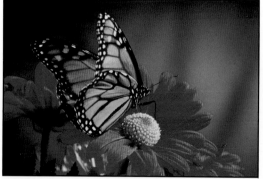

KI-9621-R B. Taylor

Free catalogs upon request

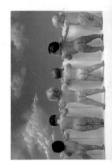

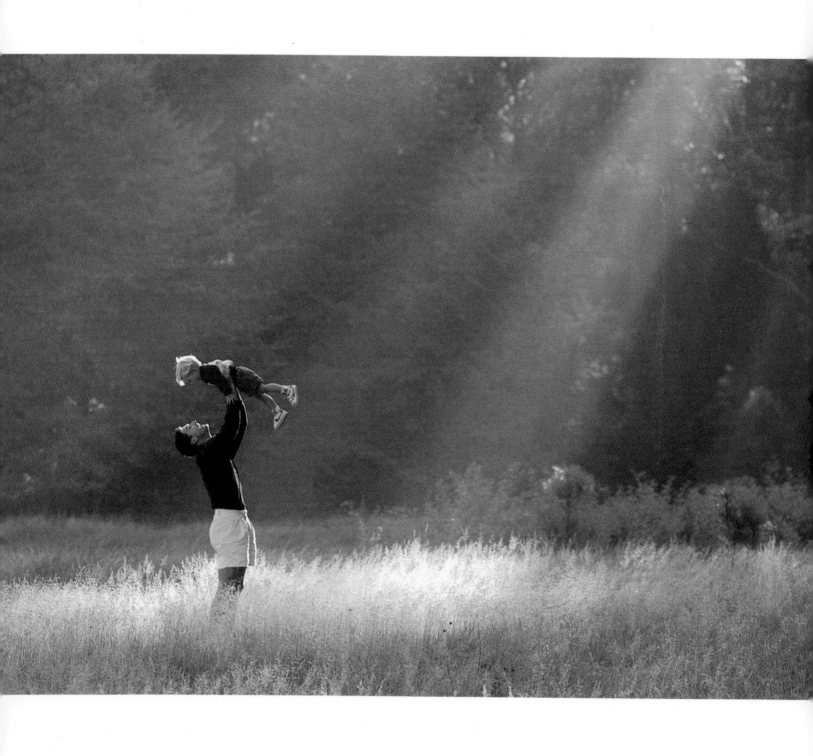

ZEPHYRPICTURES

800-537-3794

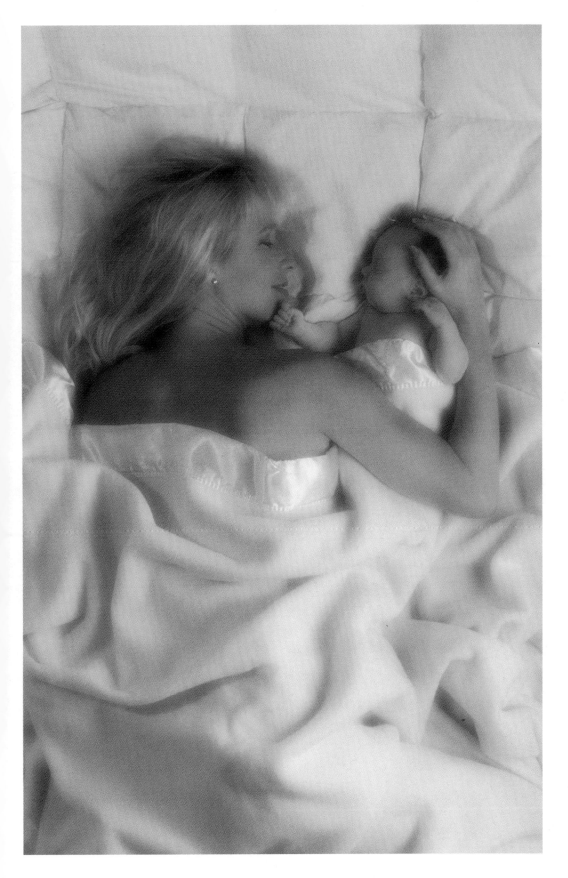

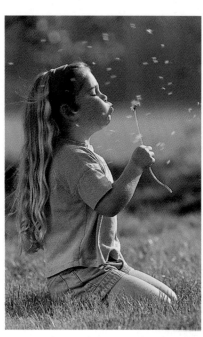

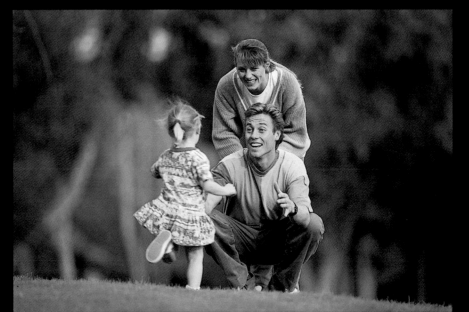

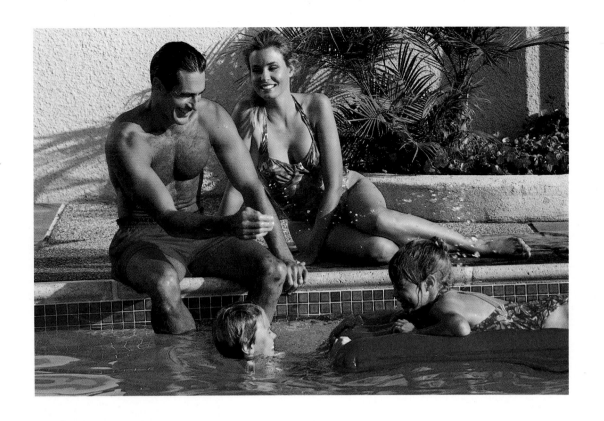

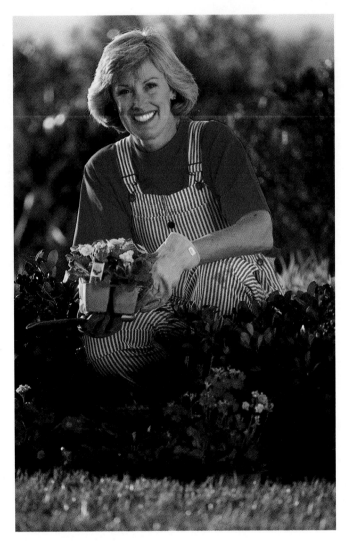

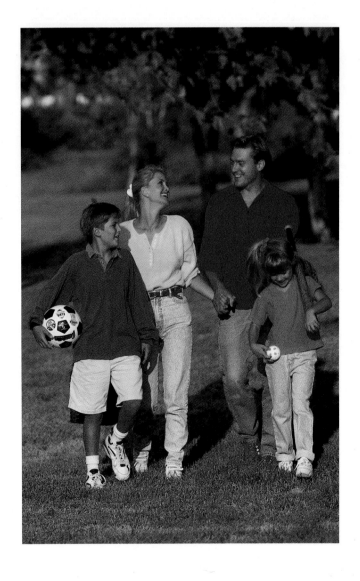

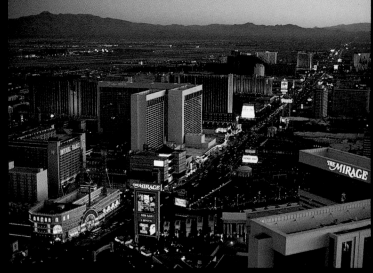

LAS VEGAS

HOUSTON

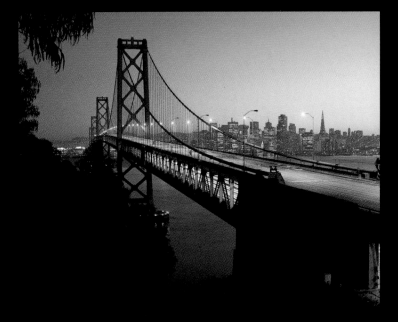

SAN FRANCISCO

WASHINGTON D. C.

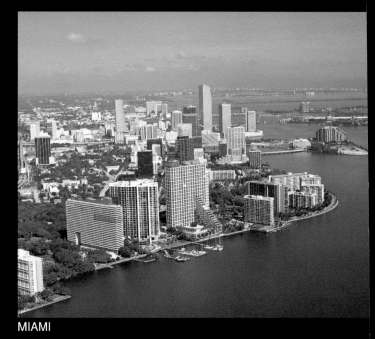

MIAMI

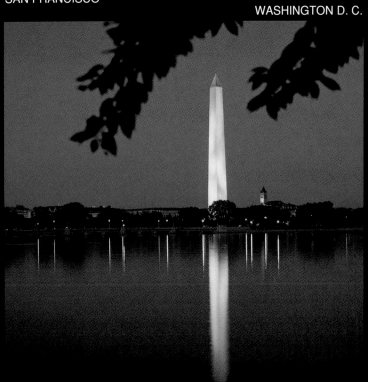

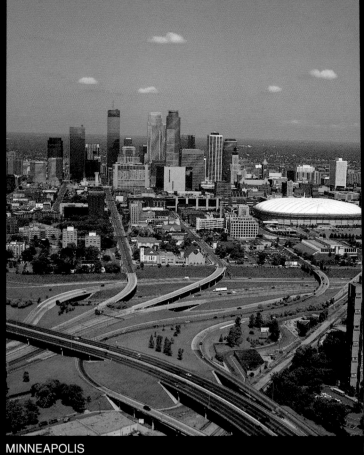

MINNEAPOLIS

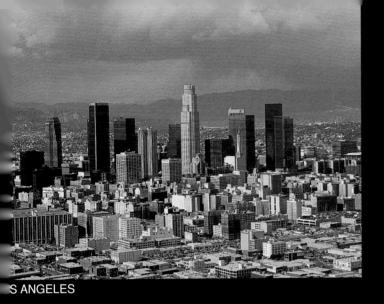

S ANGELES

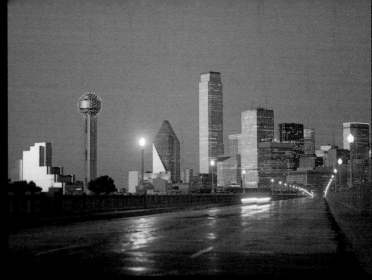

DALLAS

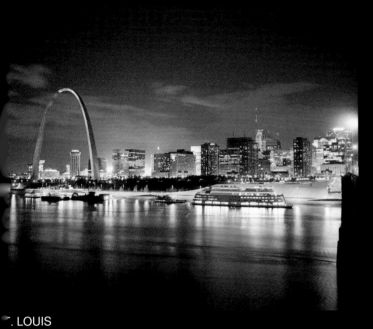

. LOUIS

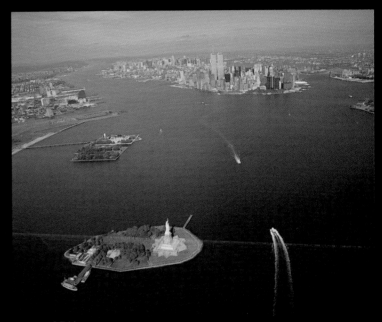

NEW YORK

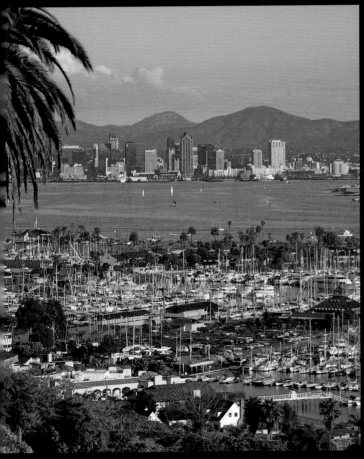

SAN DIEGO

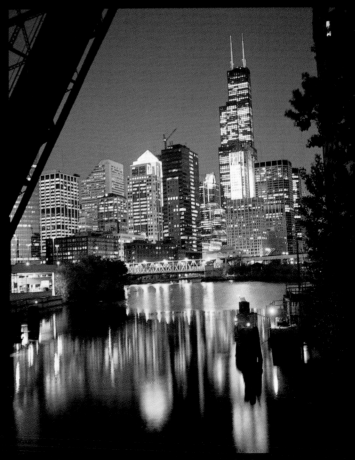

CHICAGO

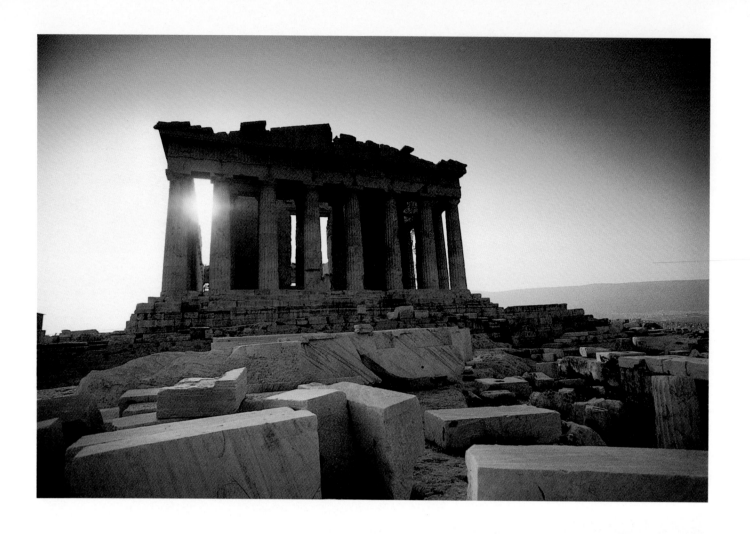

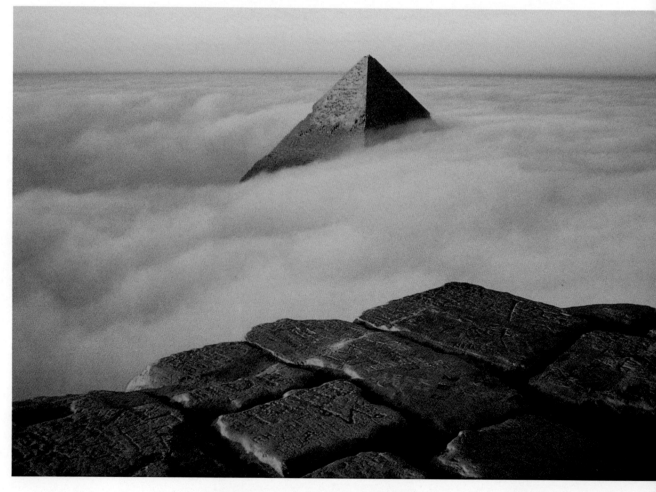

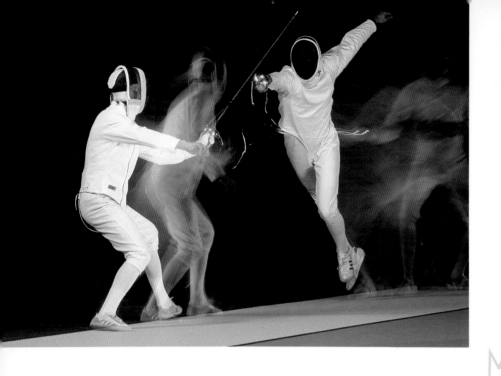

ACTION

ENERGY

IS NEITHER CREATED

NOR DESTROYED,

IT SIMPLY

CHANGES FORM.

DUOMO

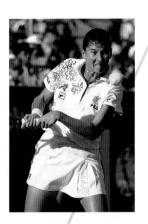

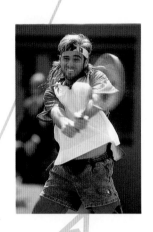

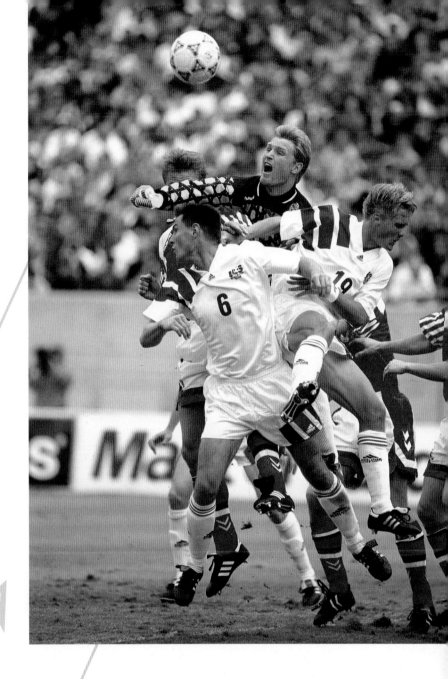

R E A C T I O N

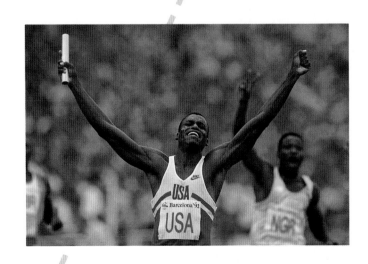

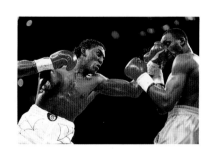

DUOMO PHOTOGRAPHY INC.
133 WEST 19TH STREET, NEW YORK, NY 10011
212.243.1150 FAX: 212.633.1279

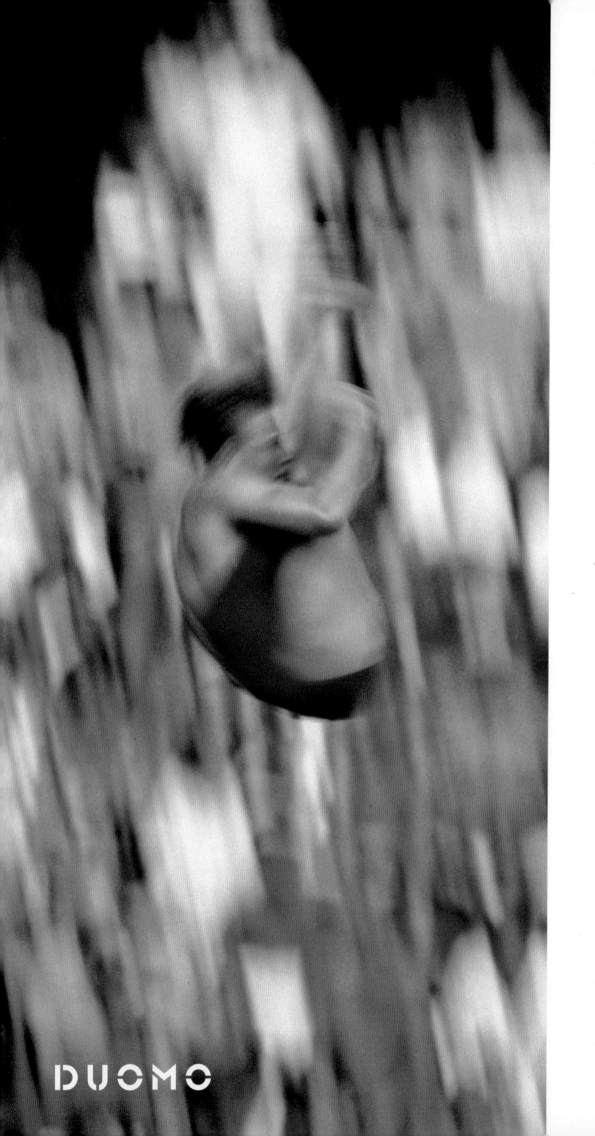

$$F = m \left(a + g \right)$$

athlete

DUOMO

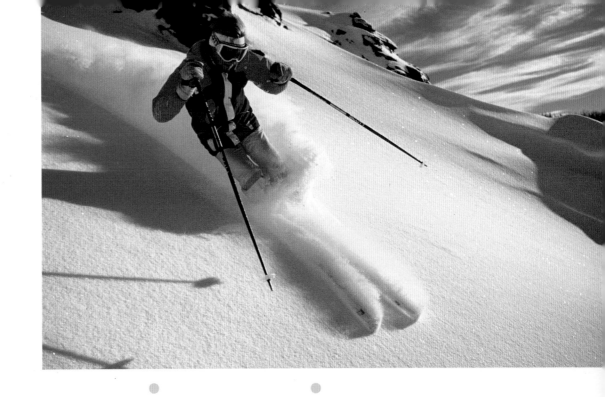

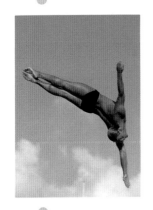

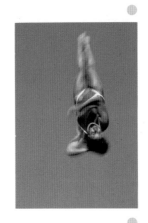

G R A V I T Y

What rises

must fall

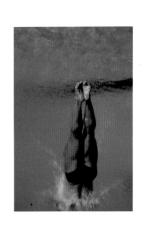

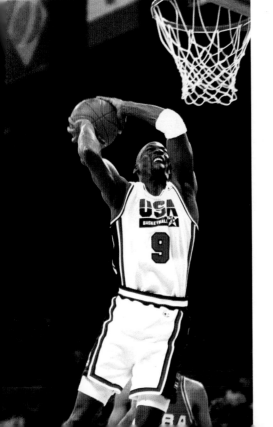

DUOMO PHOTOGRAPHY INC.
133 WEST 19TH STREET, NEW YORK, NY 10011
212.243.1150 FAX: 212.633.1279

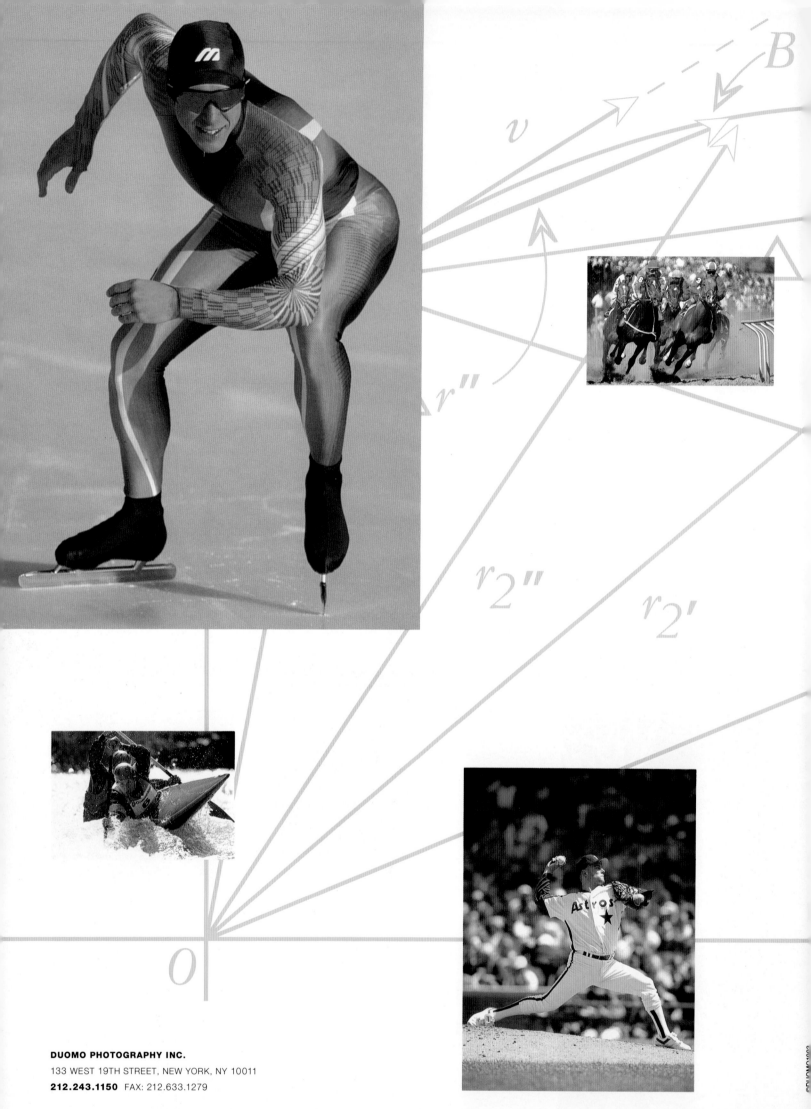

v

B

r"

r₂"

r₂'

O

DUOMO PHOTOGRAPHY INC.

133 WEST 19TH STREET, NEW YORK, NY 10011

212.243.1150 FAX: 212.633.1279

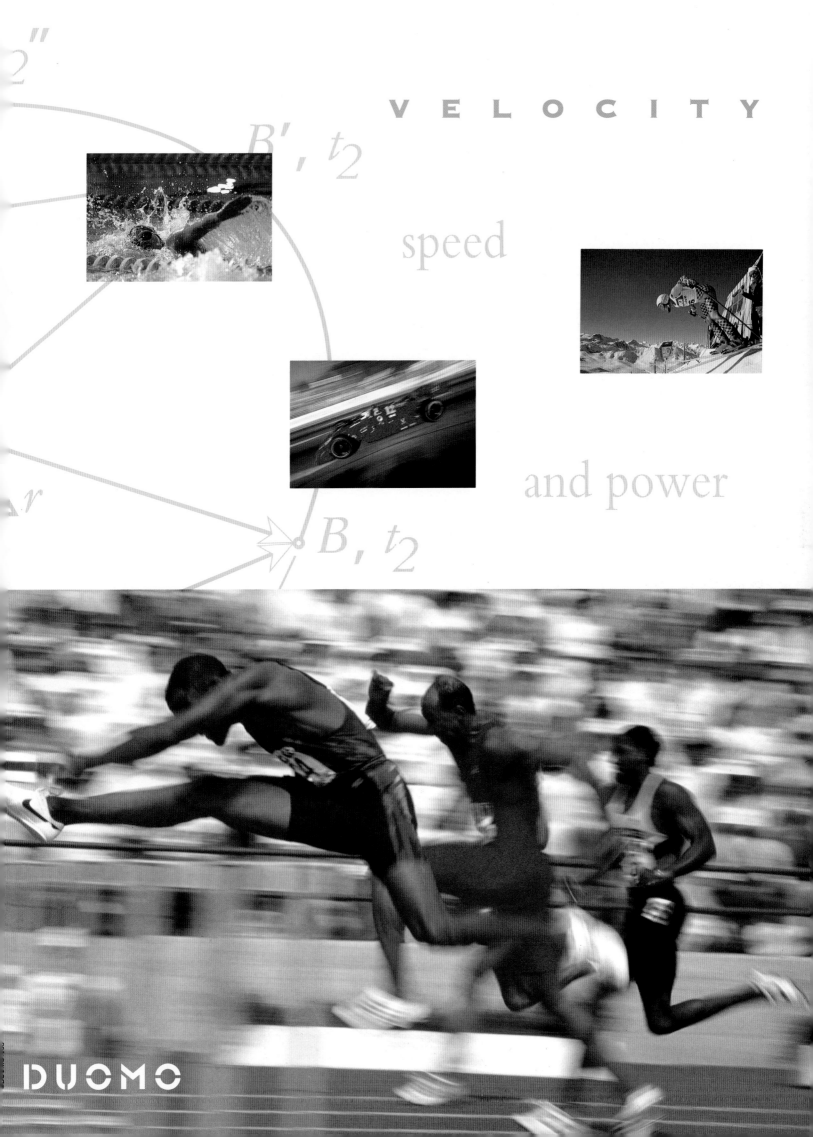

VELOCITY

speed

and power

DUOMO

The

path

of a

TRAJECTORY moving

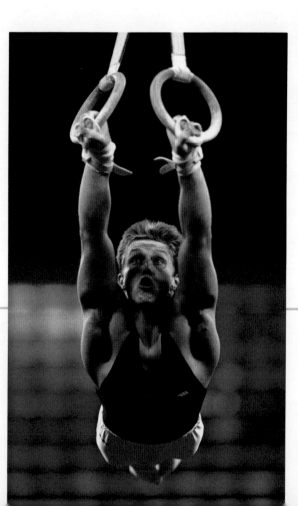

DUOMO PHOTOGRAPHY INC.
133 WEST 19TH STREET, NEW YORK, NY 10011
212.243.1150 FAX: 212.633.1279

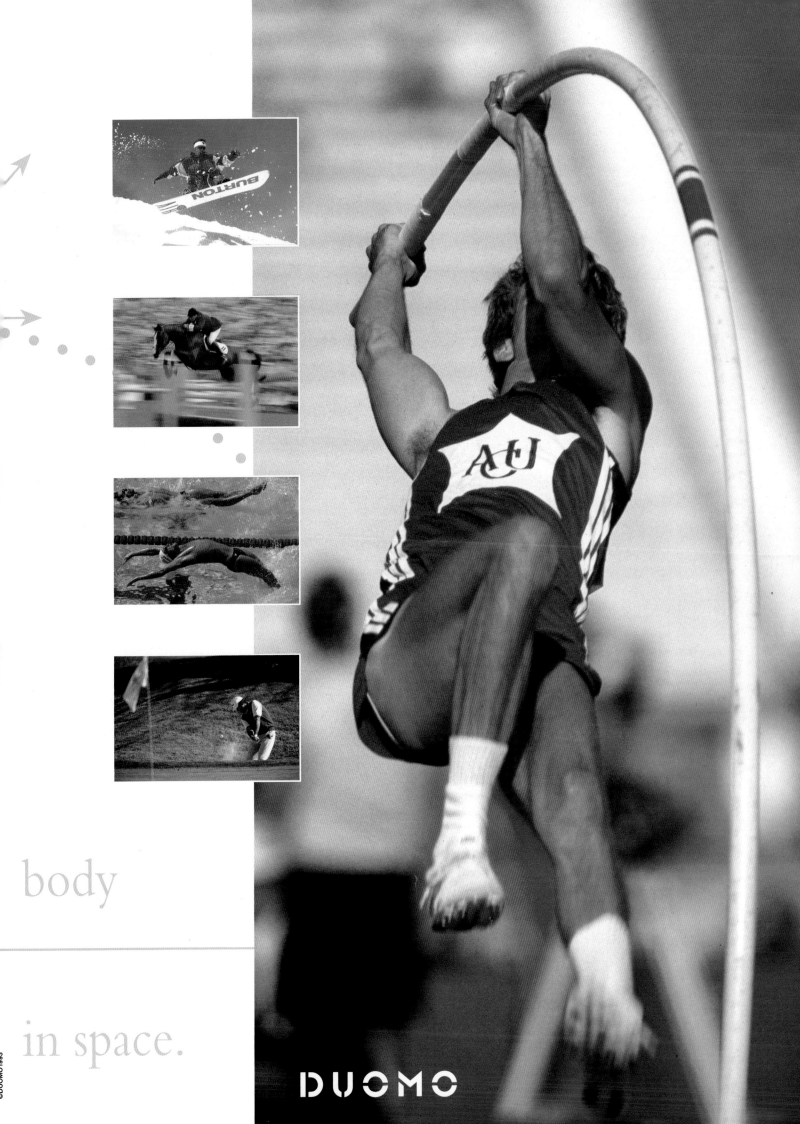

body

in space.

DUOMO

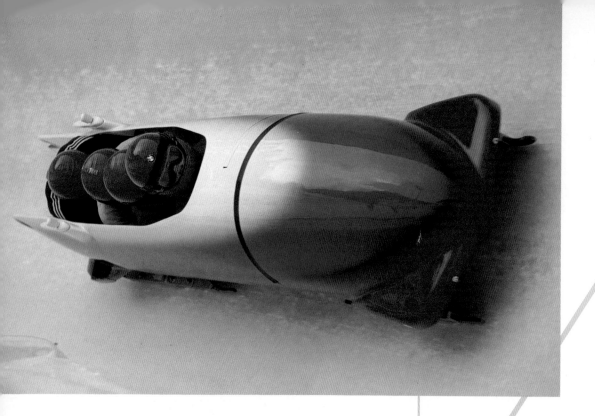

C E N T R I P E T A L

acceleration

spinning

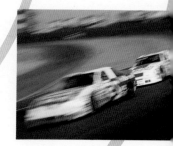

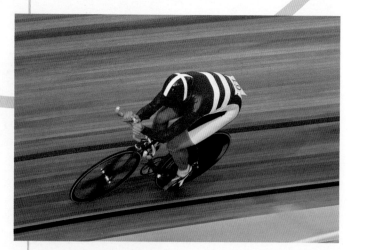

DUOMO PHOTOGRAPHY INC.
133 WEST 19TH STREET, NEW YORK, NY 10011
212.243.1150 FAX: 212.633.1279

THE FUTURE STARTS HERE ➡

*West*light®

LEADER IN INTERACTIVE IMAGE TECHNOLOGY

Changing Industry Standards & Perceptions

The "digital revolution" is here with the premiere of Westlight's Digital Search Technology, the exciting new way to look at stock. This seamlessly integrated image library and database is available under special license exclusively to Westlight clients on Kodak's first Photo CD Catalog. Just pop the disc into your computer CD-ROM drive and you have thousands of dazzling digital images on your monitor and at your fingertips. With Westlight's exclusive digital files, you'll accomplish in minutes what previously took days, at a fraction of the cost, without sacrificing quality. For further convenience, Westlight's companion Kodak Photo CD Player version allows you to review thousands of the world's finest images with your clients on an ordinary TV. Take a look at the quality of the images on the following pages, all digitally separated from Westlight's specially produced Photo CD's. We think you'll agree, Westlight's Digital Search Technology is the total image solution for the "digital revolution"!

Westlight®

DIGITAL IMAGE SOLUTIONS

▶ **WESTLIGHT'S New Kodak Photo CD Catalog**

The most powerful, user-friendly computer driven image search system available. Thousands of photographs, computer graphics and illustrations at the click of a mouse! Photo research has never been easier. Specify Macintosh or Microsoft Windows 3.1 (PC) version when ordering. Westlight's "Power Editing Secrets" booklet included free with disc.

▶ **WESTLIGHT'S Kodak Photo CD Catalog (Player Version)**

Over 4,000 categorized digital images on one convenient disc. Designed specifically for TV viewing; it's fun to use and the ideal format for group presentation.

▶ **POWER CONCEPTS**

Our exclusive 2,500-word cross-referenced database gives you unlimited creative control. Traditional subject search is available, but "power users" will prefer the creative freedom Power Concepts can offer.

▶ **Easy-To-Use Specialty Files**

Abstracts, Backgrounds, Business, Computer Graphics, High Tech, Illustrations, Maps & Flags, People, Scenics, Textures, Pacific Rim, Get Real people, Silhouette Solutions, etc.

▶ **Stock Workbook Disc 2**

Available from Stock Workbook, this CD-ROM disc features over 1,000 of the finest Westlight images.

▶ **Digital File Reproduction**

All images in the Westlight section of Stock Workbook 7 are reproduced directly from Kodak Photo CD format. Thousands of high-resolution, reproduction-quality files and transparencies are available by special license. Please call for further details.

Toll free: 800 • 872 • 7872 FAX: 310 • 820 • 2687

Westlight®

Every Image Quest is an adventure

Westlight's *exclusive* **Digital Image Search Technology** is designed specifically for finding images that are perfectly designed for precise graphic needs. It incorporates thousands of different keywords to make up a new, sophisticated graphic and aesthetic classification system that takes the user well beyond the limits of traditional cross-referencing. It's the most powerful image search system of its kind! Unlimited search options include hundreds of unique search paths. This proprietary search system is designed to stimulate ideas and provide the user with endless creative possibilities for finding problem-solving images...**fast!**

IMAGE SEARCH FLOW-CHART

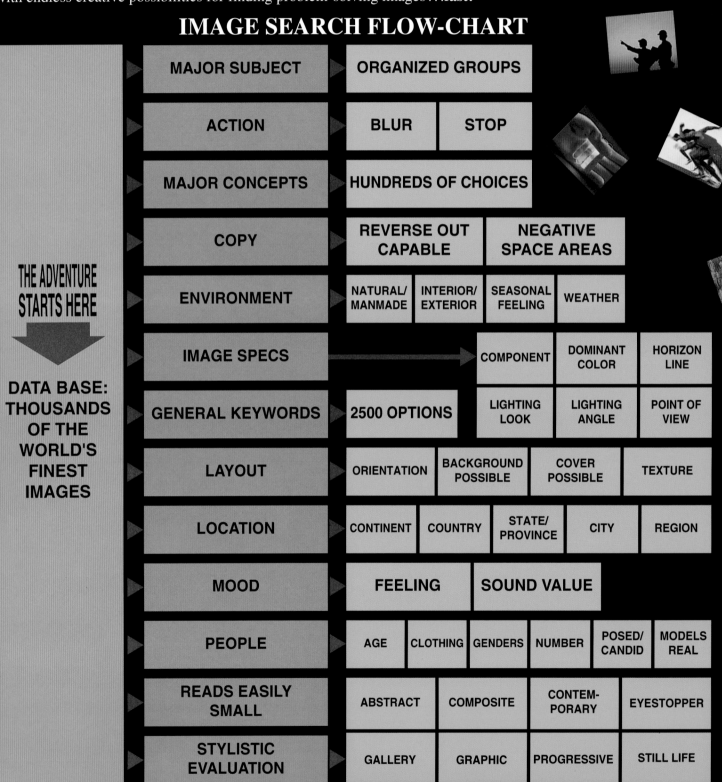

THE ADVENTURE STARTS HERE

DATA BASE: THOUSANDS OF THE WORLD'S FINEST IMAGES

MAJOR SUBJECT	ORGANIZED GROUPS
ACTION	BLUR / STOP
MAJOR CONCEPTS	HUNDREDS OF CHOICES
COPY	REVERSE OUT CAPABLE / NEGATIVE SPACE AREAS
ENVIRONMENT	NATURAL/MANMADE / INTERIOR/EXTERIOR / SEASONAL FEELING / WEATHER
IMAGE SPECS	COMPONENT / DOMINANT COLOR / HORIZON LINE
GENERAL KEYWORDS	2500 OPTIONS — LIGHTING LOOK / LIGHTING ANGLE / POINT OF VIEW
LAYOUT	ORIENTATION / BACKGROUND POSSIBLE / COVER POSSIBLE / TEXTURE
LOCATION	CONTINENT / COUNTRY / STATE/PROVINCE / CITY / REGION
MOOD	FEELING / SOUND VALUE
PEOPLE	AGE / CLOTHING / GENDERS / NUMBER / POSED/CANDID / MODELS REAL
READS EASILY SMALL	ABSTRACT / COMPOSITE / CONTEM-PORARY / EYESTOPPER
STYLISTIC EVALUATION	GALLERY / GRAPHIC / PROGRESSIVE / STILL LIFE

Complete detailed flow-chart available.

1·800·872·7872

©1993 Westlight

FAX:1·310·820·2687

Westlight®

Cross Searching
Classic Concepts

Americana ▶
Beauty
Caring ▶
Celebrations
Communication ▶
Competition
Concentration
Cooperation
Craftsmanship
Education
Energy
Entertainment
Excellence
Freedom
Fun
Futuristic
Global
Good Life
Happiness
Hard Work
Health
Imagination
Kindness
Leadership
Love
Opportunity
Peace
Power
Pride
Romance
Security
Service
Speed
Strength
Success ▶
Teamwork
Time
Wealth
Winning

Americana

Flags

Horizon
Middle

Color
Orange

Caring

Medical

Family

Couples

Communication

High Tech

Executives

Female

Success

Business

Sports

ADDITIONAL
SAMPLES ➔

Examples of cross-referenced searches

1•800•872•7872 ©1993 Westlight FAX:1•310•820•2687

233

Westlight®

Cross Searching Examples

Dominant Colors
Red
Yellow
Blue
Orange
Green
Violet
Magenta
White
Black
Brown
Gray
Multi-colored
Neutral-colored

People

Age
Babies
Children
Teens
Adults
Seniors

Clothing
Formal
Semi-formal
Business
Casual
Uniform
Costume

Genders
Male
Female
Both

Number
None
One
Two
Group
Crowd

Color

Blue & Business

Magenta & Silhouettes

Orange & Industry

Clothing

Casual & Friendly

Uniform & Red

Formal

People/Gender

Women & Red Outdoors & One

Male/Children & Casual

Both/Business & High Angle

Examples of cross-referenced searches

1•800•872•7872 ©1993 Westlight FAX:1•310•820•2687

Westlight®
Producing images for the future℠

As the leader in Digital Imagery Westlight represents some of the world's finest image files including:

Backgrounds and Textures for Advertising

Introduced by Westlight and now a universal concept. Backgrounds and Textures continues to be a Westlight specialty. The most versatile imagery available for advertising is about to become the most popular for media use, and our collection is unsurpassed.

PACIFIC RIM™

Pacific Rim

The comprehensive stock collection for contemporary images reflecting the changing lifestyles and growing industries in the Pacific Rim area.

Silhouette Solutions

The ultimate collection of graphically striking images designed to convey meaning through elegant simplicity.

Get Real

Real people in realistic situations are the hallmark of our GET REAL! collection, first featured in Stock Workbook 5. When you want more natural, photojournalistic type photography... GET REAL!

Digital Image Reproduction ▶

We're proud to announce that all Westlight images displayed in Stock Workbook 7 have been separated from Kodak Photo CD files ranging from the 4.5 MB to 18 MB sizes.

In digital imagery, quality control makes the difference. At Westlight, prior to scanning all images are meticulously cleaned, color-balanced and finally scanned *in-house* for the highest quality results possible.

1•800•872•7872 ©1993 Westlight **FAX:1•310•820•2687**

235

*West*light ®

50931WL ©Bud Freund 51408WL ©Bud Freund

50500WL ©Gary Bartholomew 50957WL ©Adamsmith Productions

1•800•872•7872 FAX: 1•310•820•2687

Westlight®

31450WL ©C. Moore

51529WL ©Randy Faris

31463WL ©C. Moore

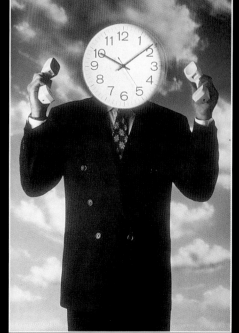

50510WL ©Scott Morgan

West*light*®

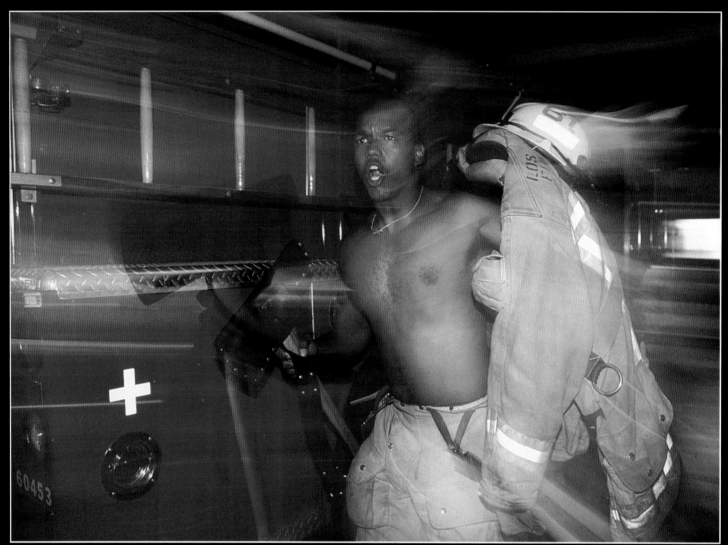

53692WL ©Steve Smith

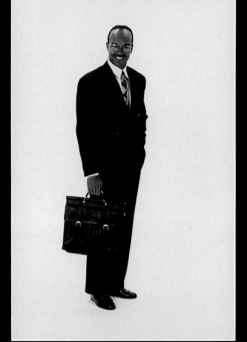

53738WL ©Adamsmith Productions

53746WL ©Adamsmith Productions

53739WL ©Adamsmith Productions

1•800•872•7872 FAX: 1•310•820•2687

Westlight®

31363WL ©W. Cody

31362WL ©W. Cody

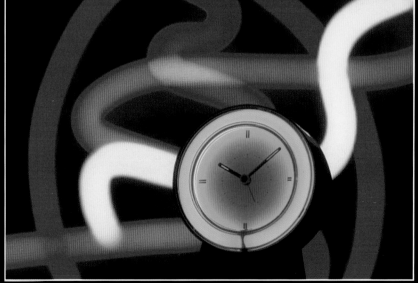

31296WL ©W. Cody

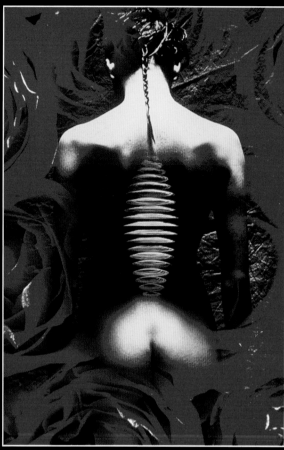

52238WL ©Scott Morgan

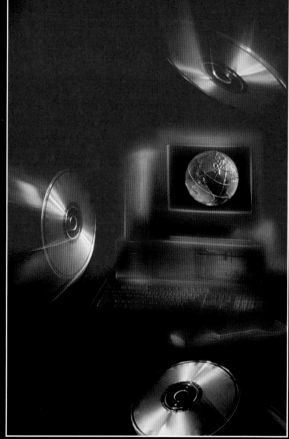

31328WL ©W. Cody

Westlight®

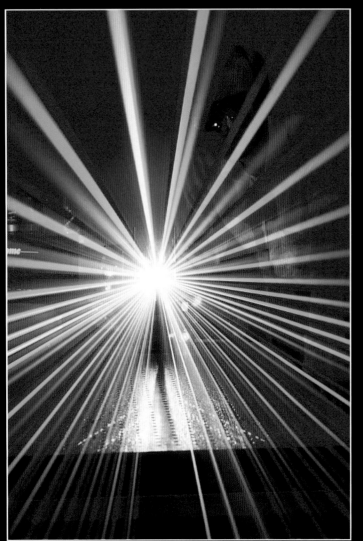

53681WL ©Lawrence Manning

53659WL ©Lawrence Manning

53819WL ©Jim Zuckerman

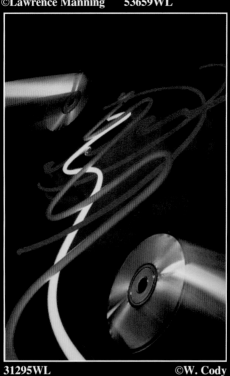

31295WL ©W. Cody

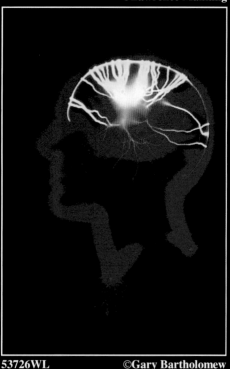

53726WL ©Gary Bartholomew

1•800•872•7872 FAX: 1•310•820•2687

Westlight®

50721WL ©Digital Art

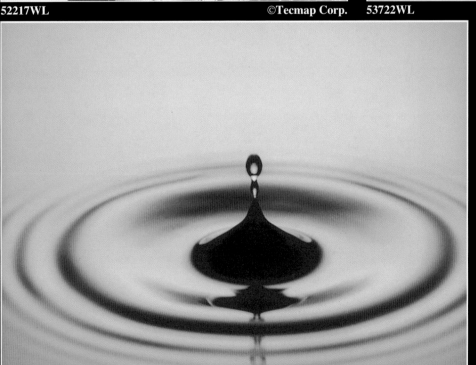

52217WL ©Tecmap Corp.

53722WL ©Charles M. Murray

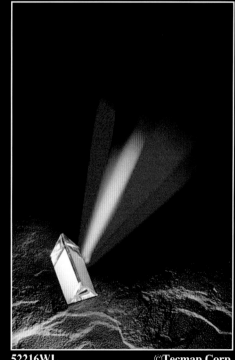

9642WL ©Tecmap Corp.

52216WL ©Tecmap Corp.

Westlight®

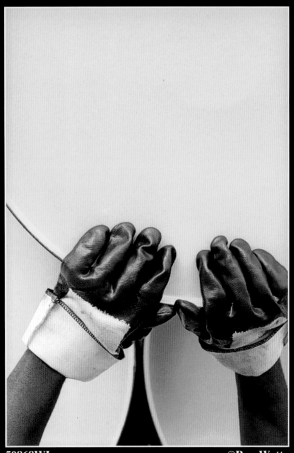

50868WL ©Ron Watts

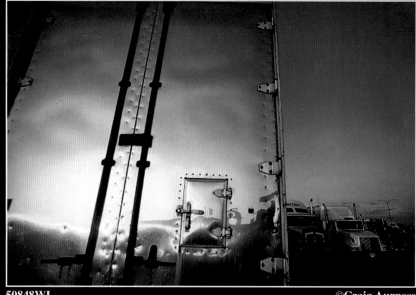

50848WL ©Craig Aurness

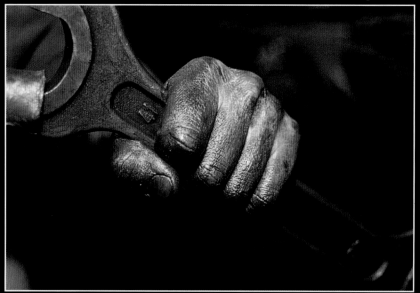

50851WL ©Randy Faris

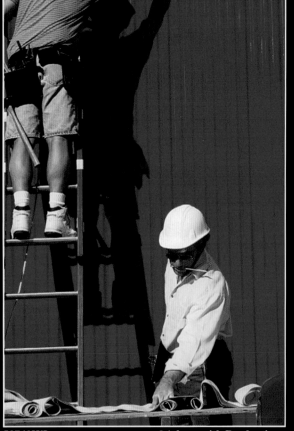

53740WL ©Adamsmith Productions

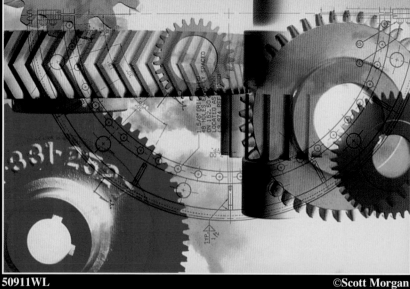

50911WL ©Scott Morgan

*West*light®

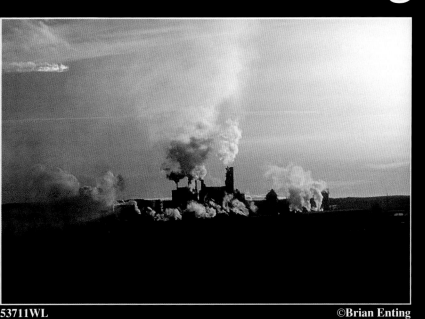

53711WL ©Brian Enting

53693WL ©Charles O'Rear

50912WL ©Jed Share

50847WL ©Annie Griffiths-Belt

53676WL ©Jay & Becky Dickman

Westlight®

53811WL ©Adamsmith Productions

52237WL ©Walter Hodges

51669WL ©Ron Watts

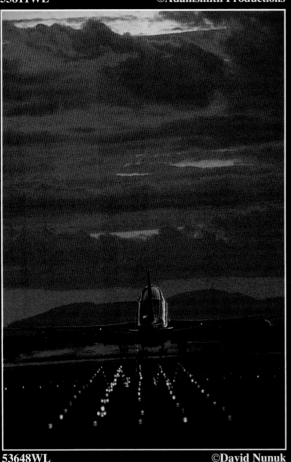

53648WL ©David Nunuk

52257WL ©Richard Fukuhara

52869WL ©Robert Landau

*West*light®

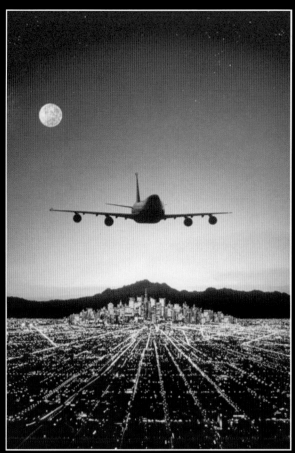

50819WL ©Bill Ross

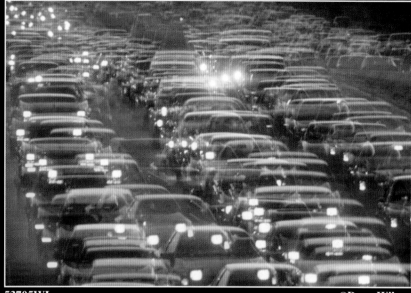

53705WL ©Doug Wilson

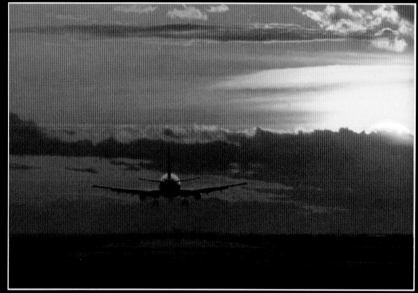

53682 ©David Nunuk

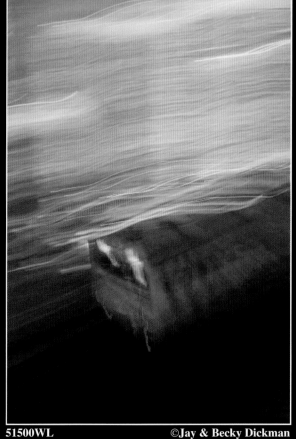

51500WL ©Jay & Becky Dickman

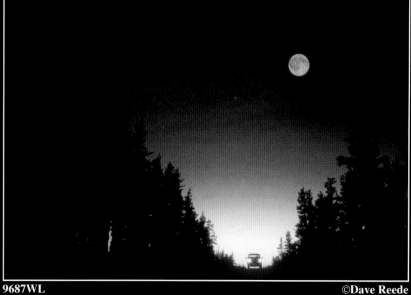

9687WL ©Dave Reede

1•800•872•7872 FAX: 1•310•820•2687

Westlight®

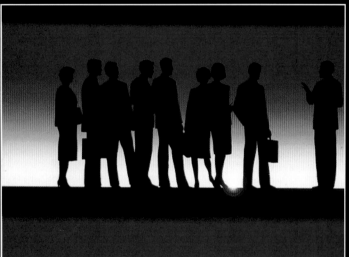

50738WL ©Digital Art

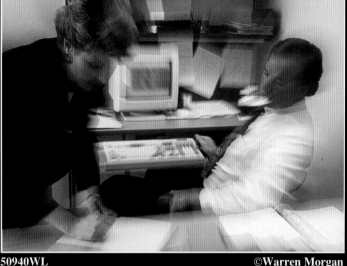

50940WL ©Warren Morgan

31403WL ©C. Moore

53587WL ©Walter Hodges

51528WL ©Randy Faris

53588WL ©Walter Hodges

53690WL ©Dennis Degnan

Westlight®

31583WL ©C. Moore

6808WL ©Walter Hodges

53765WL ©Walter Hodges

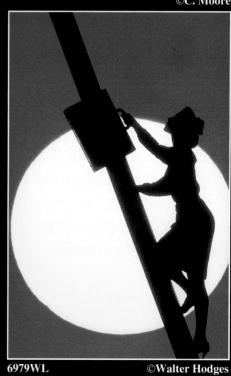

6979WL ©Walter Hodges

Westlight®

31526WL ©C. Moore

53697WL ©Charles M. Murray

51356WL ©Charles O'Rear

51331WL ©Tecmap Corp.

53768WL ©Walter Hodges

53710WL ©Warren Morgan

Westlight®

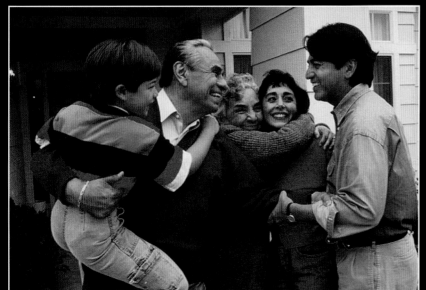

53592WL ©Walter Hodges

51602WL ©Ron Watts

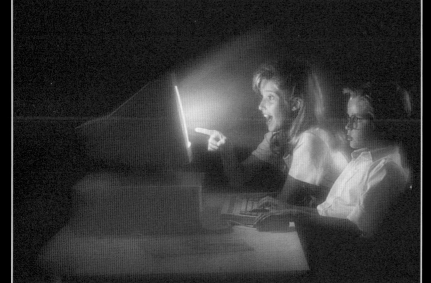

31441WL ©C. Moore

51606WL ©Ron Watts

53807WL ©J. Cochrane

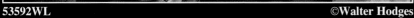

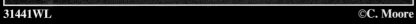

Westlight®

53656WL ©Warren Morgan

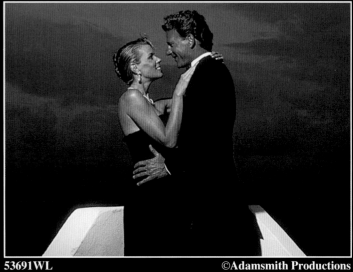

53691WL ©Adamsmith Productions

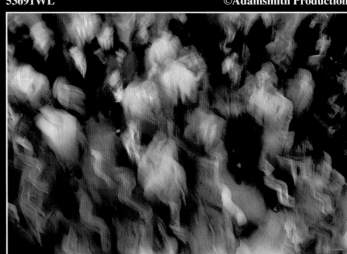

51407WL ©Walter Hodges

31416WL ©C. Moore

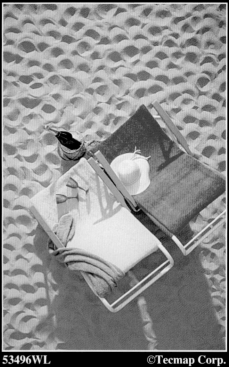

53496WL ©Tecmap Corp.

*West*light ®

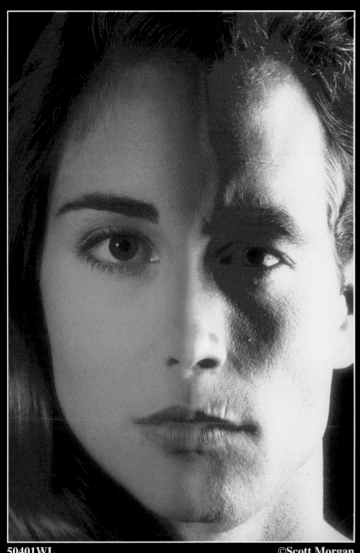

50401WL ©Scott Morgan

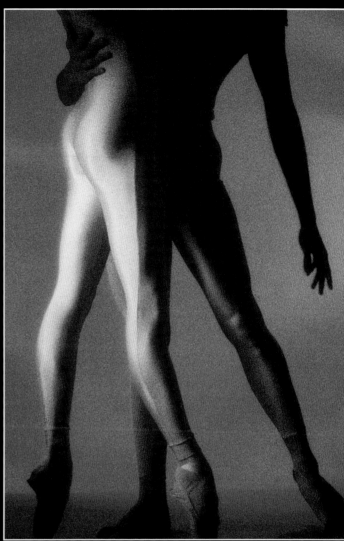

53699WL ©Adamsmith Productions

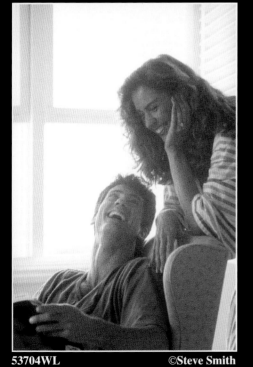

53704WL ©Steve Smith

31605WL ©W. Cody

1 • 800 • 872 • 7872 FAX: 1 • 310 • 820 • 2687

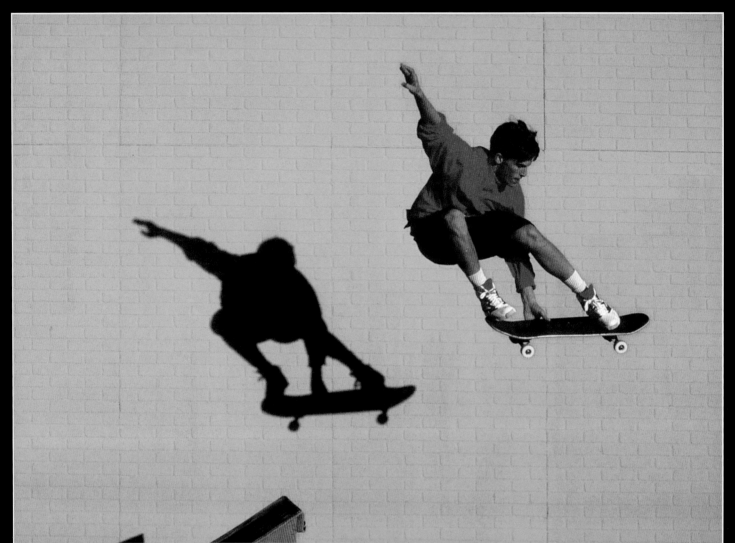

54037WL ©Steve Chenn

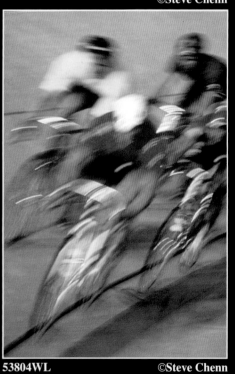

53815WL ©Steve Chenn 53804WL ©Steve Chenn

Westlight®

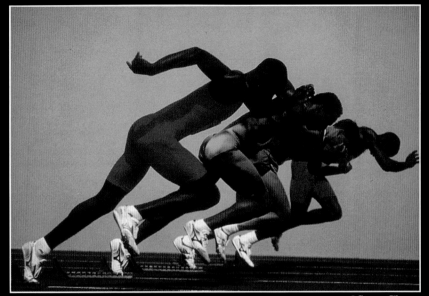

53801WL ©Steve Chenn

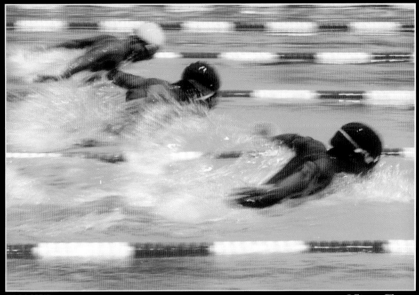

53803WL ©Steve Chenn

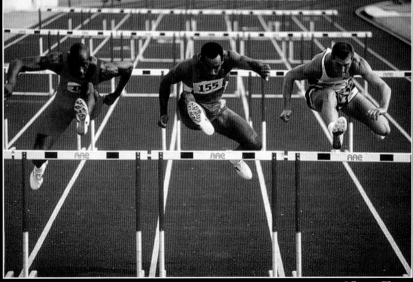

53802WL ©Steve Chenn

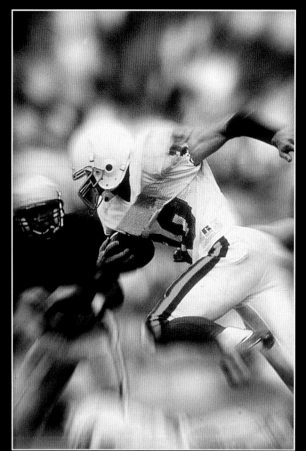

53701WL ©Warren Morgan

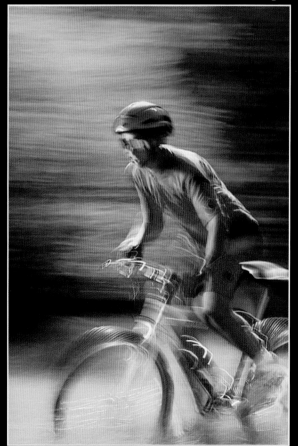

31589WL ©C. Moore

1•800•872•7872 FAX: 1•310•820•2687

Westlight®

51484WL ©Tecmap Corp.

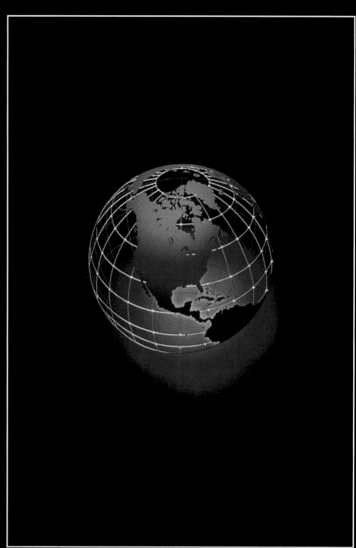

53812WL ©Ferdinand Mels

51399WL ©Tecmap Corp.

31346WL ©W. Cody

53795WL ©Ferdinand Mels

West_lig..._

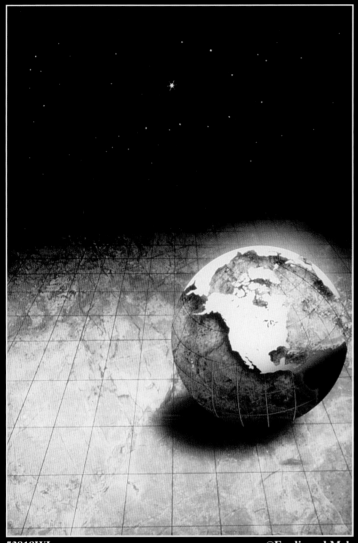

53818WL ©Ferdinand Mels

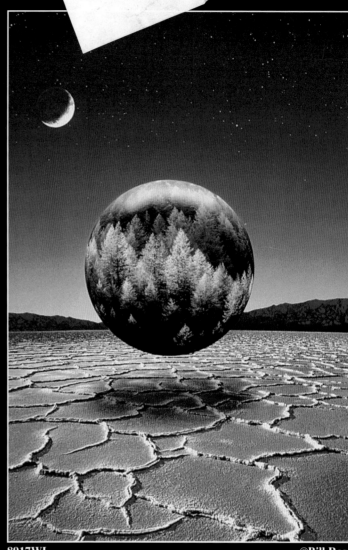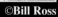

8917WL ©Bill Ross

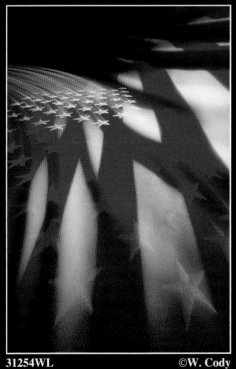

31254WL ©W. Cody

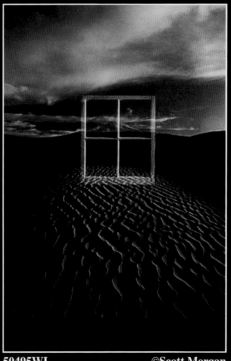

50495WL ©Scott Morgan

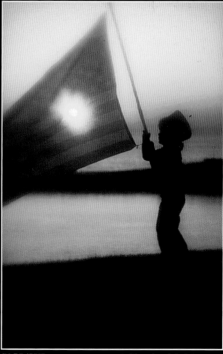

50554WL ©Charles M. Murray

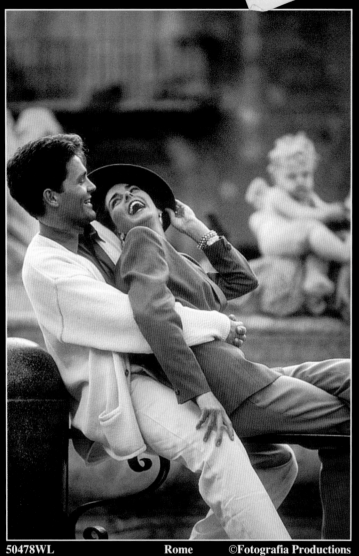

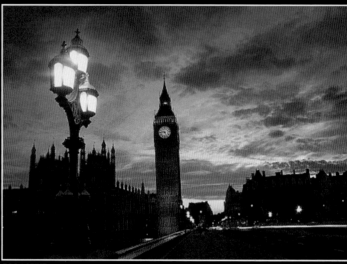

53813WL London ©Jim Richardson

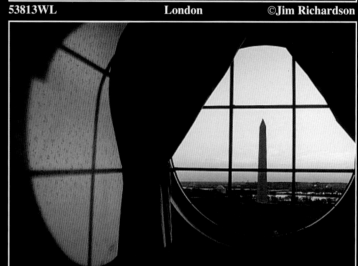

50478WL Rome ©Fotografia Productions 51423WL Washington, DC ©Kenneth Garrett

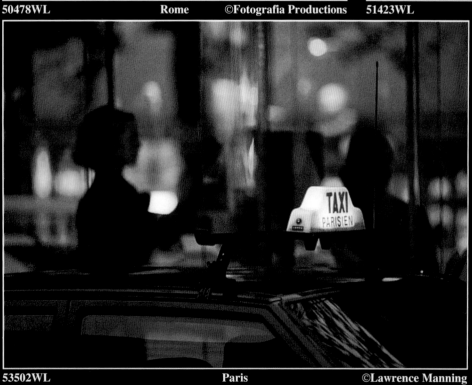

53502WL Paris ©Lawrence Manning 51497WL ©Jay & Becky Dickman

Westlight®

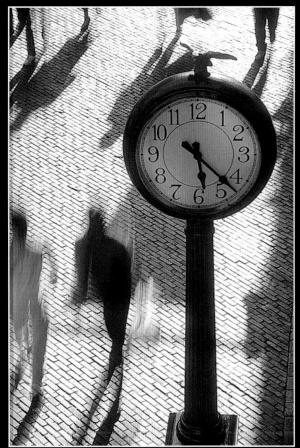

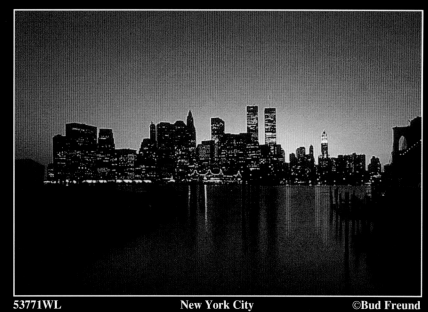

53771WL New York City ©Bud Freund

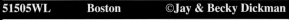

51505WL Boston ©Jay & Becky Dickman

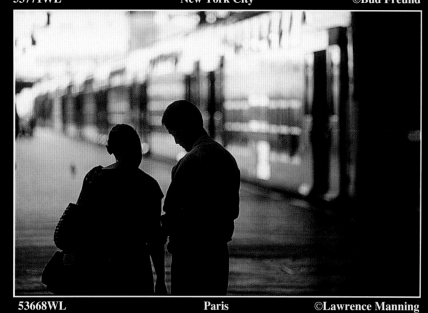

53668WL Paris ©Lawrence Manning

54036WL Rio de Janeiro ©Jim Zuckerman

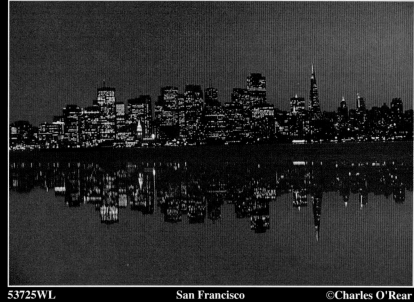

53725WL San Francisco ©Charles O'Rear

Westlight®

9659WL Cook Islands ©Bill Ross

53651WL ©Lois Frank

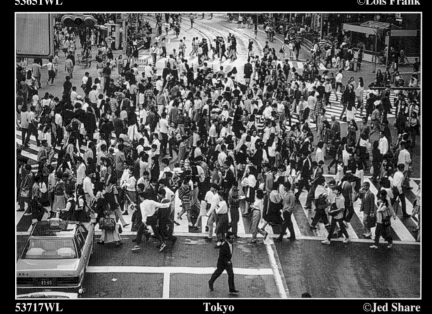

53717WL Tokyo ©Jed Share

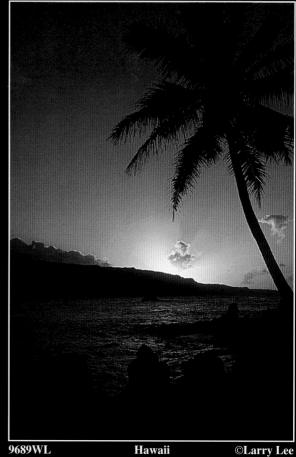

9689WL Hawaii ©Larry Lee

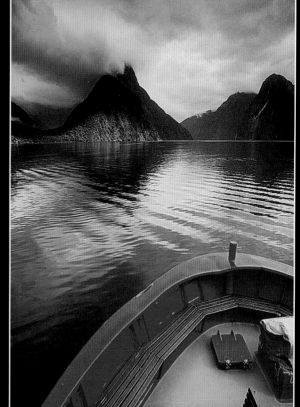

51027WL New Zealand ©R. Ian Lloyd

1•800•872•7872 FAX: 1•310•820•2687

Westlight®

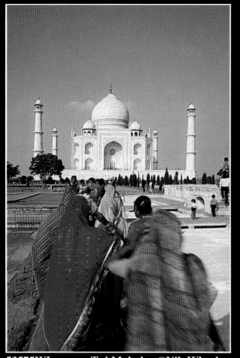

53575WL Taj Mahal ©Nik Wheeler

53652WL Kyoto ©Jay & Becky Dickman

53749WL ©Adamsmith Productions

53786WL ©Jed Share

53728WL ©Jed Share

53789WL ©Ralph Clevenger

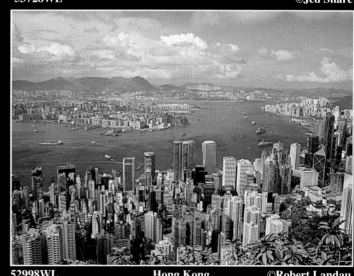

52998WL Hong Kong ©Robert Landau

*West*light®

50903WL Fire ©Ken Rogers

53647WL ©Adamsmith Productions

71157WL Gold Leaf ©W. Cody

31310WL ©W. Cody

31300WL ©W. Cody

30324WL ©W. Cody

Westlight®

53724WL ©Lawrence Manning

9083WL ©Ron Watts

8713WL ©Ralph Clevenger

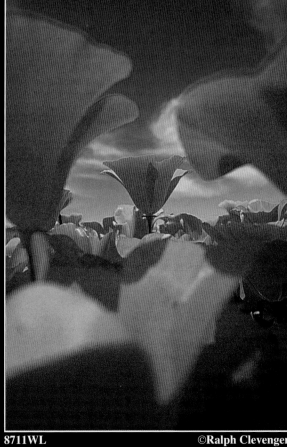

8711WL ©Ralph Clevenger

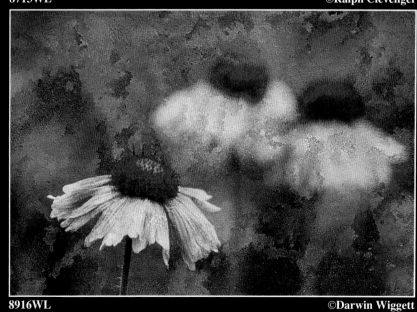

8916WL ©Darwin Wiggett

1·800·872·7872 FAX: 1·310·820·2687

*West*light®

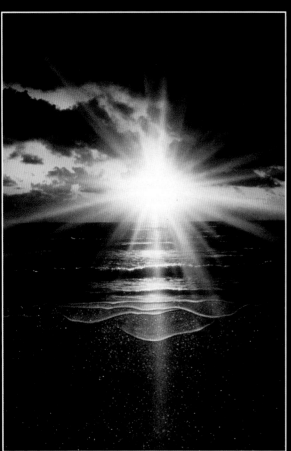

9640WL　　　　　　　　　　©William Warren

9646WL　　　　　　　　　　　　©Bill Ross

9641WL　　　　　　　　　　©William Warren

9679WL　　　　　　　　©Jim Zuckerman

52264WL　　　　　　　　　　©Jim Richardson

*West*light®

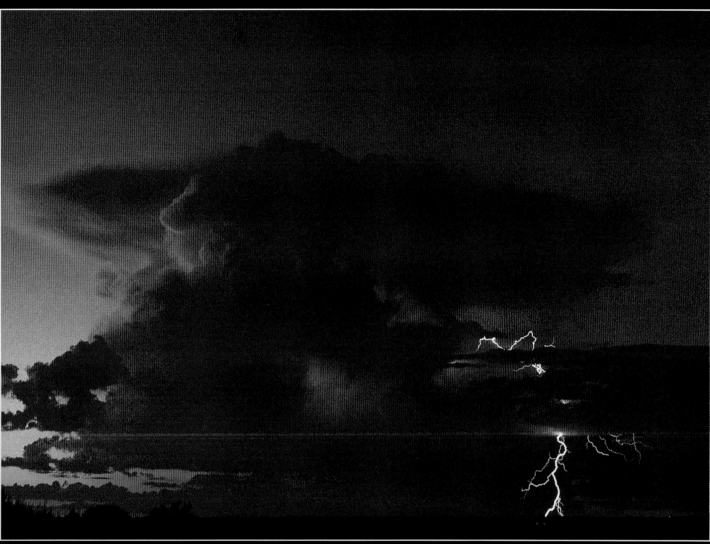

8699WL ©Charles O'Rear

9690WL ©Larry Lee 9700WL ©Robert Landau 9669WL ©Chase Swift

*West*light®

9125WL ©Ron Watts

9675WL ©Jim Zuckerman

51495WL ©Charles O'Rear

52892WL ©Robert Landau 8872WL ©Ralph Clevenger 8991WL ©Ron Watts

*West*light®

9456WL ©Robert Landau

7153WL ©Mark Stephenson

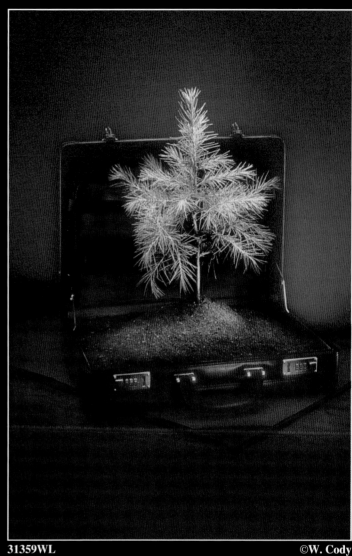

31359WL ©W. Cody

8198WL ©W. Cody

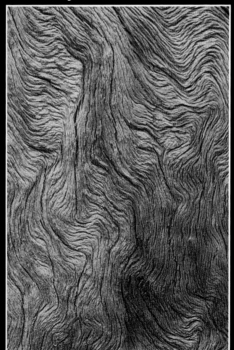

8333WL ©W. Cody

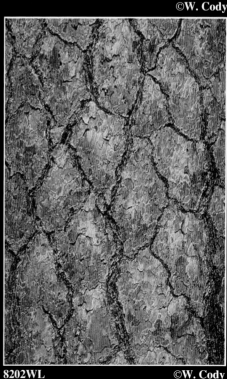

8202WL ©W. Cody

Westlight®

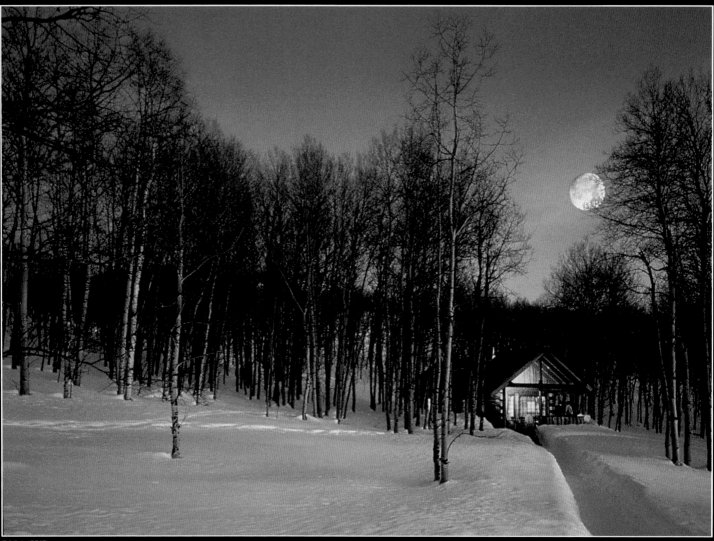

53816WL

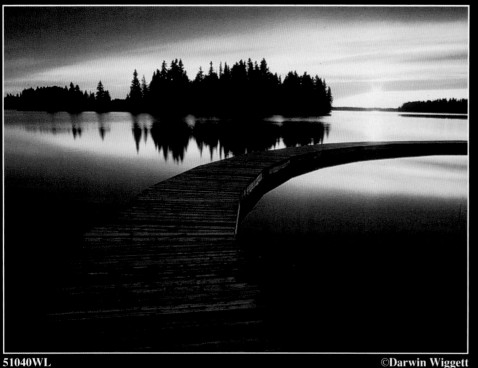

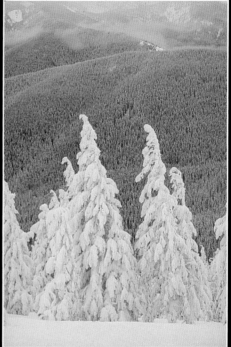

51040WL 9650WL

*West*light ®

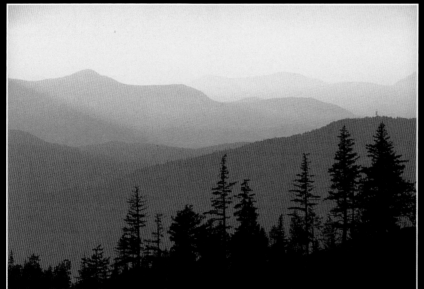

8999WL ©Ron Watts

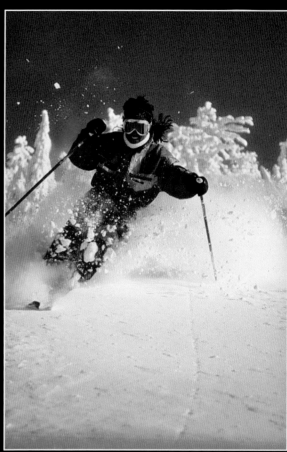

54035WL ©Warren Morgan

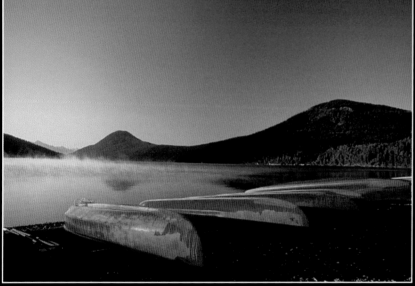

53817WL ©Steve Short

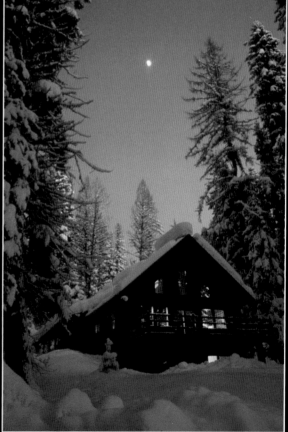

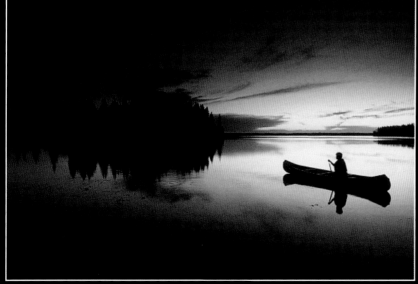

53798WL ©Darwin Wiggett

53707WL ©Patrick W. Stoll

F-Stock
INC.

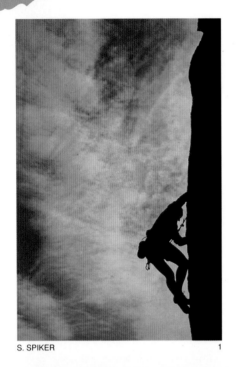

S. SPIKER 1

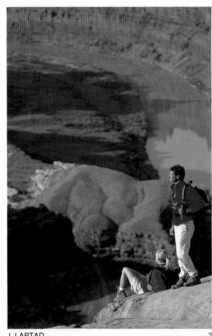

J. LAPTAD 2

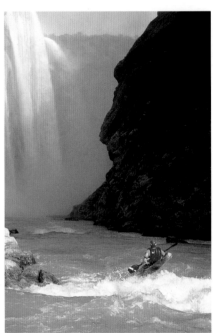

G. AMARAL 3

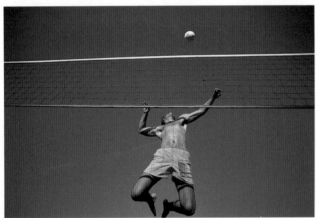

J. LAPTAD 4

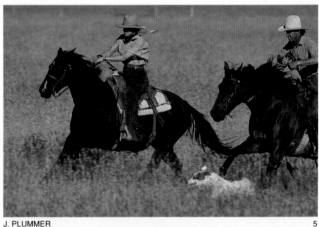

J. PLUMMER 5

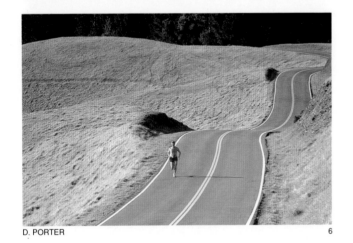

D. PORTER 6

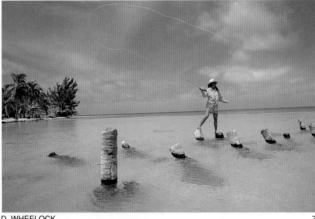

D. WHEELOCK 7

celebrate ■ fresh ■ power ■ freedom

323 LEWIS ST. #P
P.O. BOX 3956
KETCHUM, ID 83340
PHONE (208) 726-1378
FAX (208) 726-8456

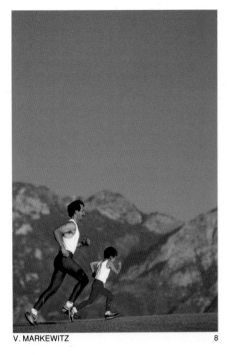

V. MARKEWITZ 8

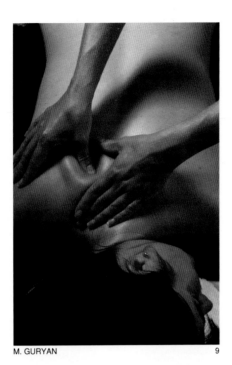

M. GURYAN 9

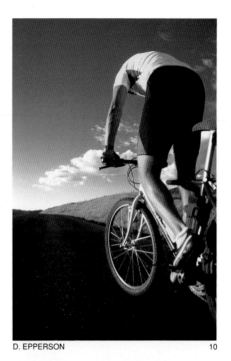

D. EPPERSON 10

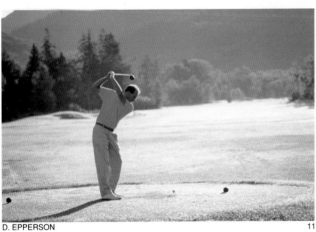

D. EPPERSON 11

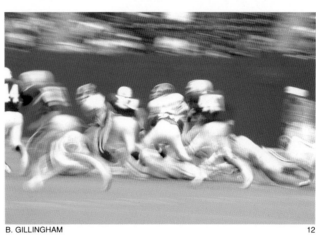

B. GILLINGHAM 12

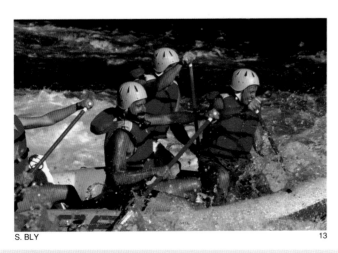

S. BLY 13

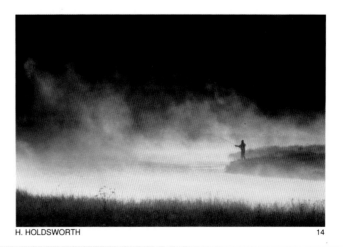

H. HOLDSWORTH 14

escape ■ teamwork ■ buy ■ satisfaction

F-Stock
INC.

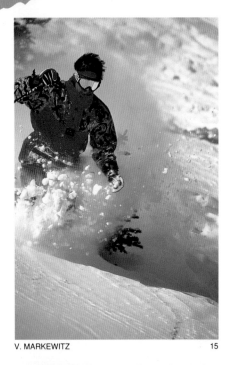

V. MARKEWITZ 15

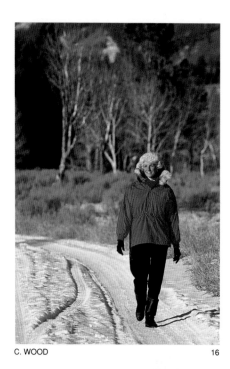

C. WOOD 16

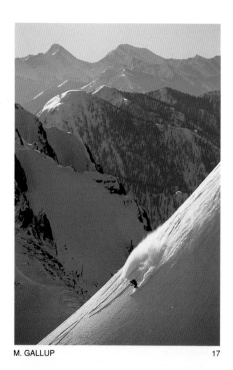

M. GALLUP 17

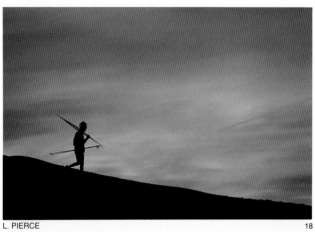

L. PIERCE 18

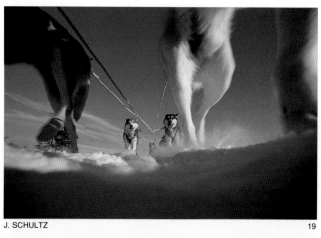

J. SCHULTZ 19

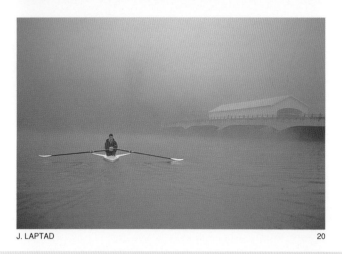

J. LAPTAD 20

C. WOOD 21

rare ■ glamour ■ risk ■ reward

323 LEWIS ST. #P
P.O. BOX 3956
KETCHUM, ID 83340
PHONE (208) 726-1378
FAX (208) 726-8456

SUNSTAR 22

B. DRAKE 23

SUNSTAR 24

SUNSTAR 25

SUNSTAR 26

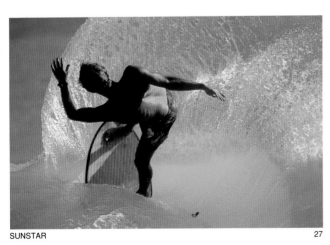

SUNSTAR 27

D. PORTER 28

peace of mind ■ healthy ■ today

F-Stock
INC.

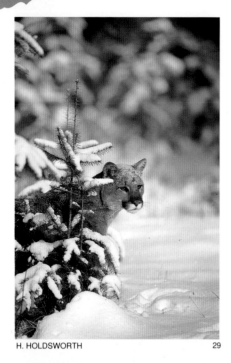

H. HOLDSWORTH 29

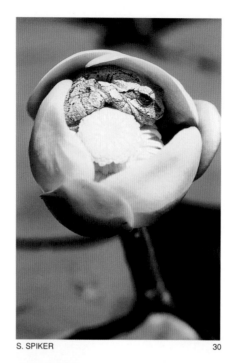

S. SPIKER 30

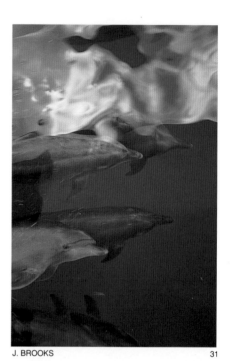

J. BROOKS 31

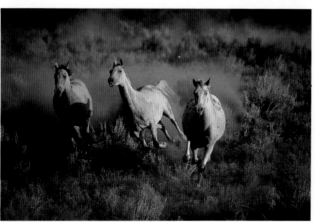

B. GILLINGHAM 32

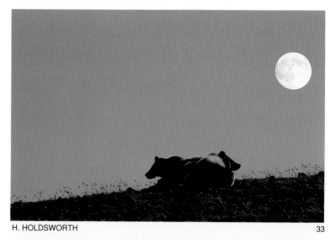

H. HOLDSWORTH 33

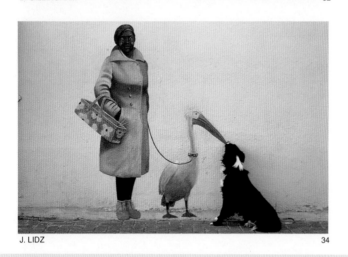

J. LIDZ 34

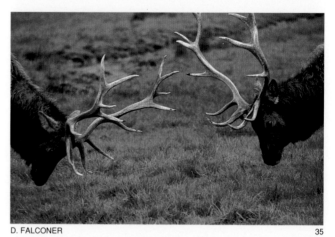

D. FALCONER 35

senses ▪ eternal ▪ vision ▪ carefree

323 LEWIS ST. #P
P.O. BOX 3956
KETCHUM, ID 83340
PHONE (208) 726-1378
FAX (208) 726-8456

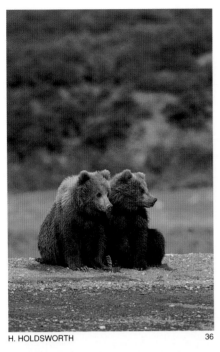

H. HOLDSWORTH 36

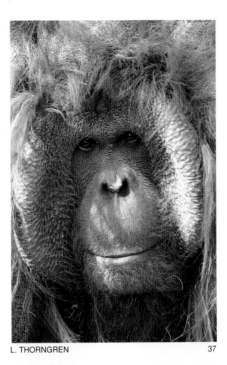

L. THORNGREN 37

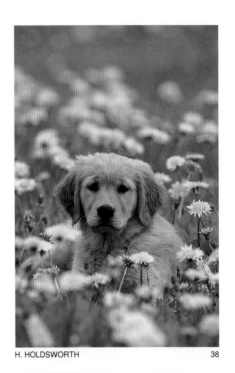

H. HOLDSWORTH 38

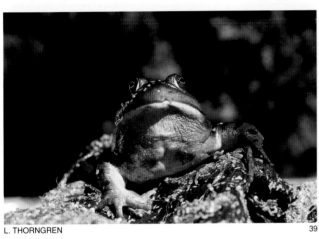

L. THORNGREN 39

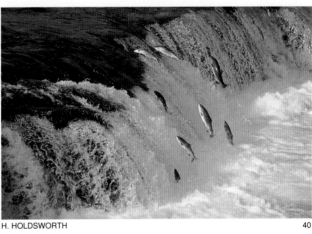

H. HOLDSWORTH 40

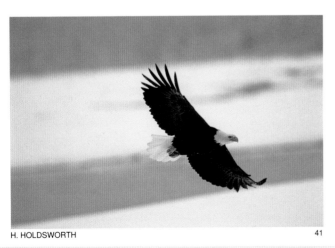

H. HOLDSWORTH 41

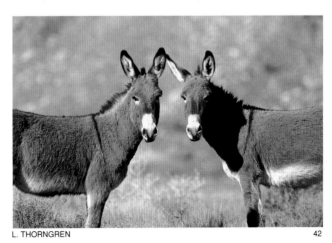

L. THORNGREN 42

danger ■ unity ■ pure ■ buy

F-Stock
INC.

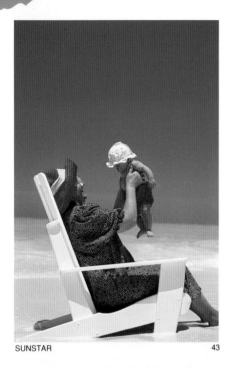

SUNSTAR 43

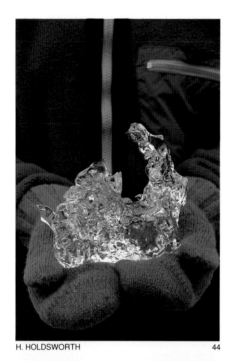

H. HOLDSWORTH 44

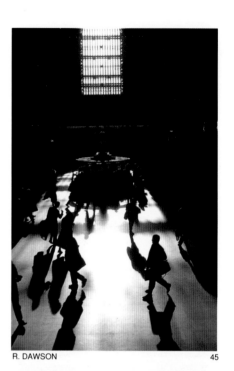

R. DAWSON 45

G. ALLISON 46

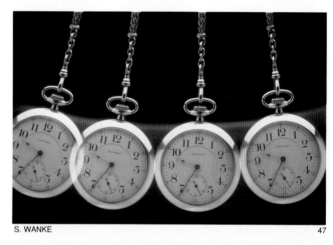

S. WANKE 47

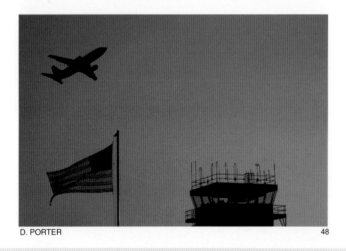

D. PORTER 48

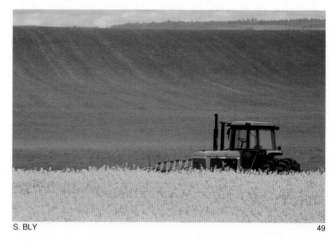

S. BLY 49

safe ■ imagination ■ togetherness ■ call

323 LEWIS ST. #P
P.O. BOX 3956
KETCHUM, ID 83340
PHONE (208) 726-1378
FAX (208) 726-8456

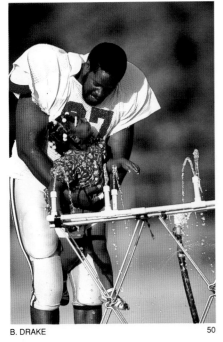

B. DRAKE 50

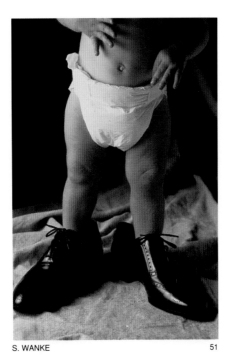

S. WANKE 51

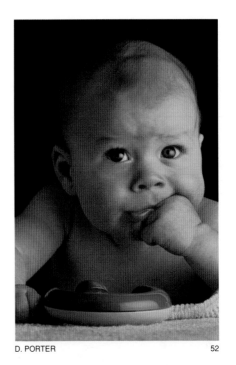

D. PORTER 52

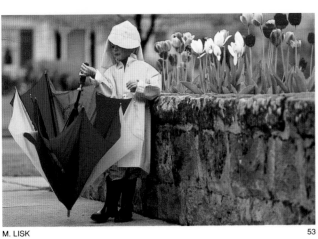

M. LISK 53

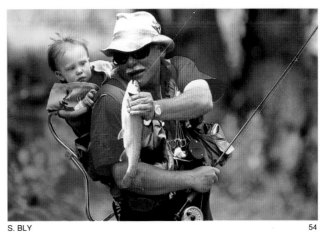

S. BLY 54

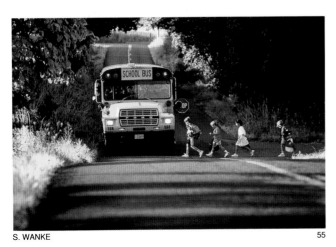

S. WANKE 55

J. LIDZ 56

tenderness ■ forever ■ trust ■ communication

275

F-Stock
INC.

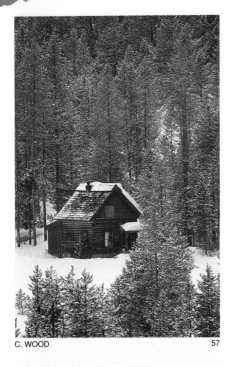

C. WOOD 57

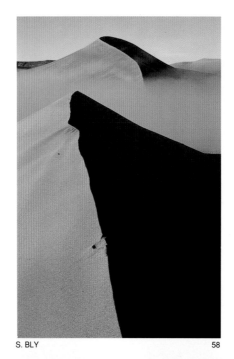

S. BLY 58

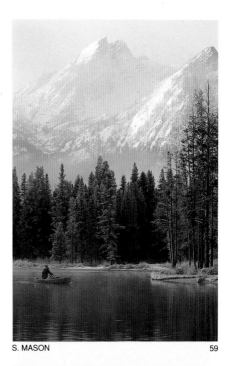

S. MASON 59

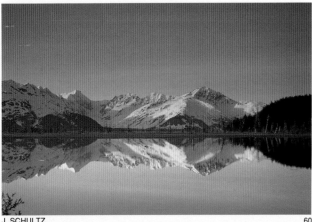

J. SCHULTZ 60

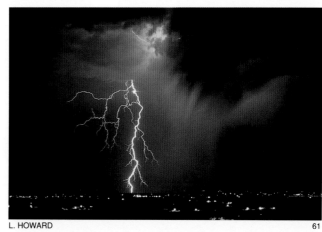

L. HOWARD 61

B. THARP 62

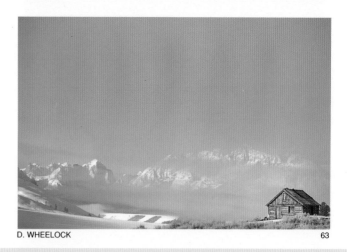

D. WHEELOCK 63

environment ■ **global** ■ **everlasting** ■ **peace**

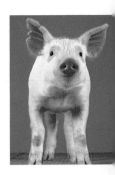

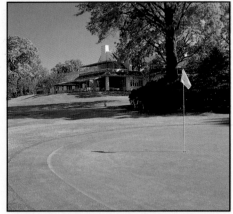

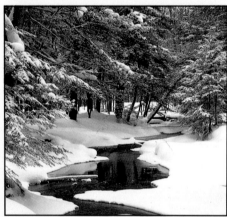
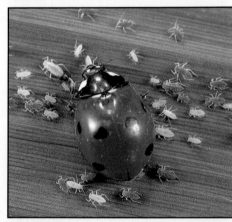

CO6-A6-20

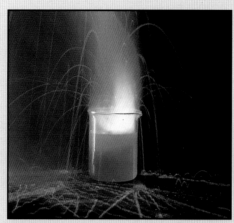

CZGA5-67

CJ5G-1022

CO6-A11-15

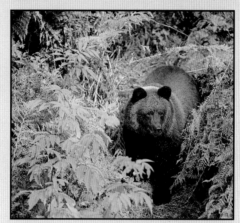

3Q-BEB-41

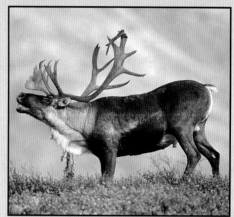

3Q-CAB-19

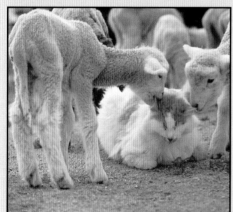

CG2-394

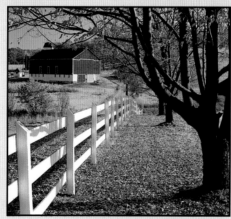

CT4D-48

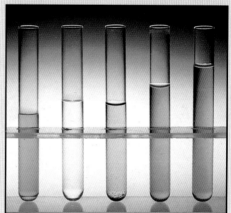

CR3-543B

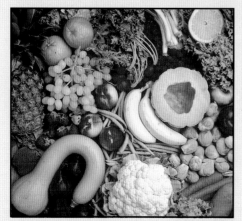

CT6A-216

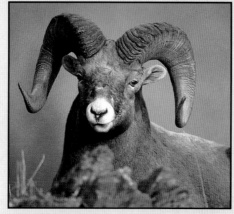

3Q-SHM-56

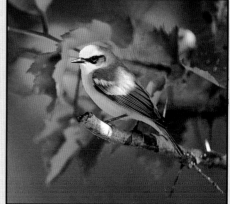

3P-WAB-42

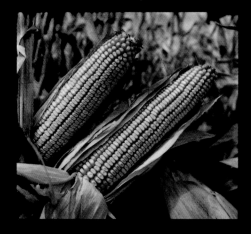

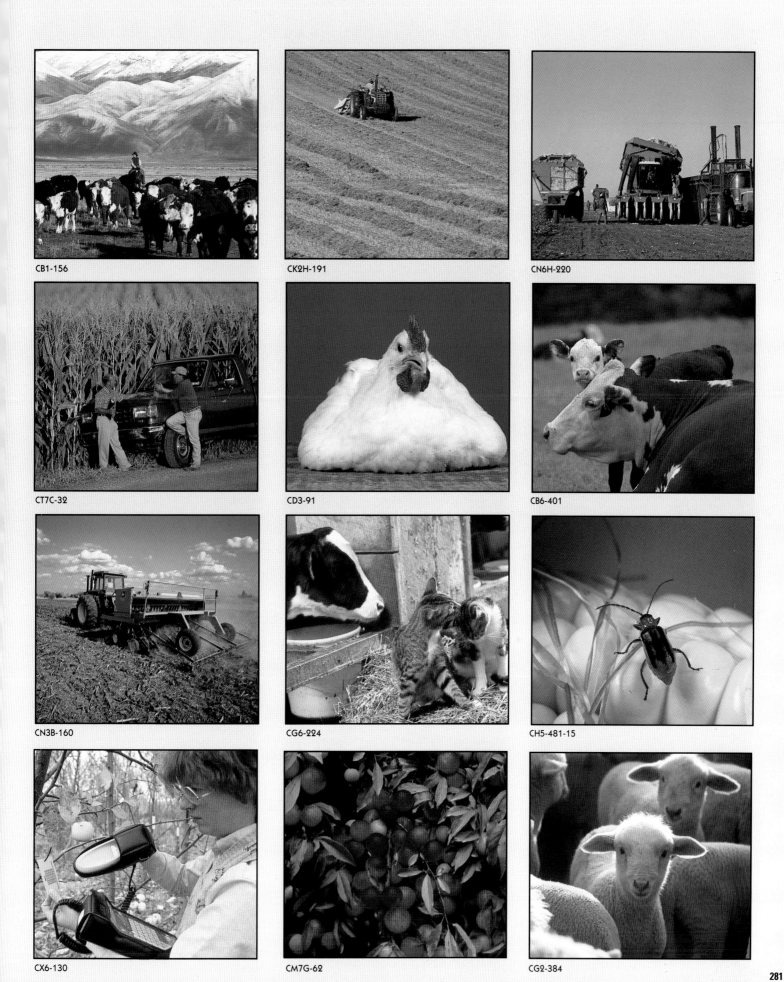

CB1-156

CK2H-191

CN6H-220

CT7C-32

CD3-91

CB6-401

CN3B-160

CG6-224

CH5-481-15

CX6-130

CM7G-62

CG2-384

CN13G-121

CJ3G-450

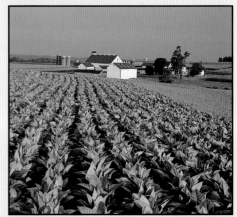

CN10G-138

CF4-184

CS4E-324

CY6-78

CL22Q-10

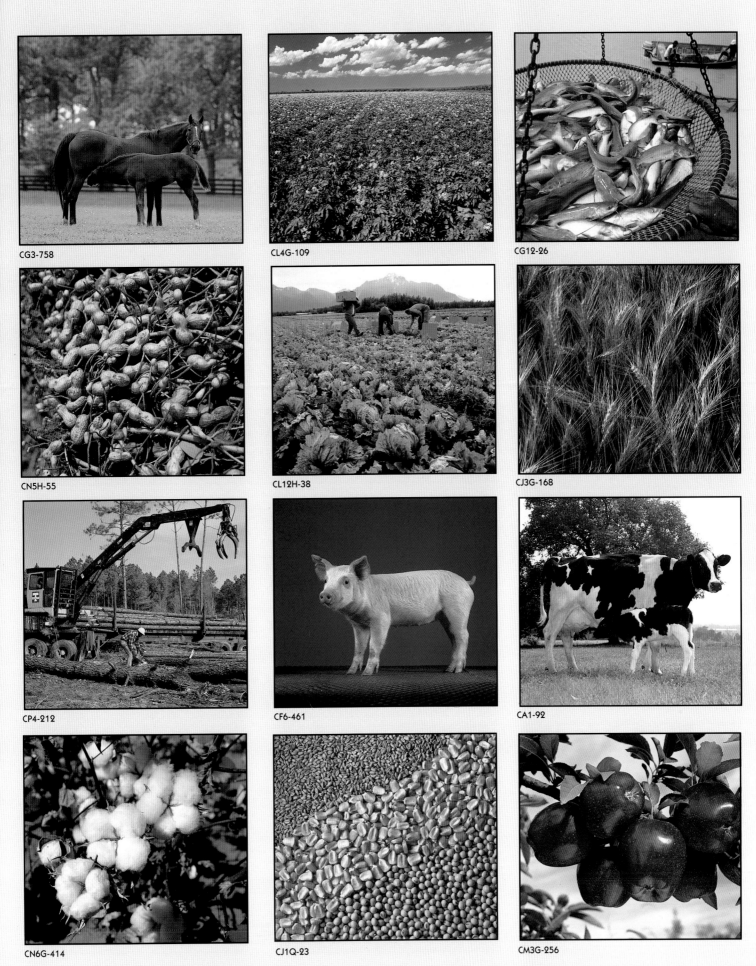

CG3-758

CL4G-109

CG12-26

CN5H-55

CL12H-38

CJ3G-168

CP4-212

CF6-461

CA1-92

CN6G-414

CJ1Q-23

CM3G-256

3QRAA-30

CZGB1A-112

CZML-52

CR3-749

CO10A-46

CR2-47

CR4-48

CO4-DRR-17

CZGA4-378

CZGA5-72

3J-LEA-12

CR3-820

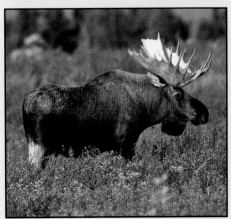

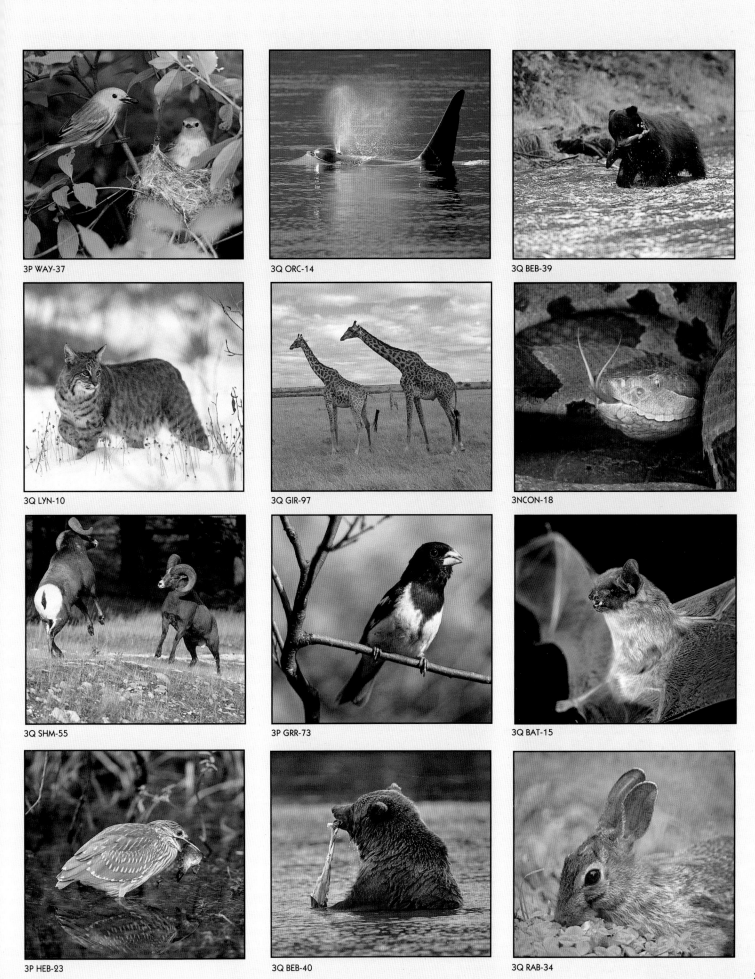

3P WAY-37

3Q ORC-14

3Q BEB-39

3Q LYN-10

3Q GIR-97

3NCON-18

3Q SHM-55

3P GRR-73

3Q BAT-15

3P HEB-23

3Q BEB-40

3Q RAB-34

CO6D1-28

CV12-106

CO7-308

CO8-309

CO7-81

CO4-AGA-14

CO18-SAO-13

CO6X-10

CO8-297

CO6A3-39

CO4-CAJ-13

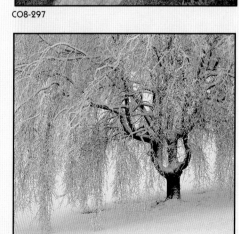
CV8-1145

"Interesting things.
Interesting places.
Interesting pictures."

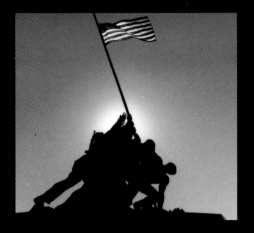

SPECIALTIES ARE OUR SPECIALTY. BUT
YOU DON'T TRAVEL ABOUT THE WORLD
AS OFTEN, OR FOR AS LONG AS WE
HAVE WITHOUT COLLECTING A HUGE FILE
OF BEAUTIFUL LANDSCAPES AND
INTERESTING GENERAL SUBJECT
PHOTOS. THE CALL IS FREE. THE
RESEARCH IS KNOWLEDGEABLE AND FREE.
YOU MAY BE PLEASANTLY SURPRISED IF
YOU CALL US FIRST FOR YOUR
GENERAL SUBJECT NEEDS.

•NO RESEARCH FEES
•KNOWLEDGEABLE RESEARCH
•FAST, FRIENDLY SERVICE
•ACCURATE CAPTIONS AND
SALES HISTORIES

GREAT IMAGES BY

GRANT HEILMAN PHOTOGRAPHY INC.

800 622-2046
OR 717 626-0296
FAX 717 626-0971

506 WEST LINCOLN AVE, PO BOX 317 • LITITZ, PA 17543

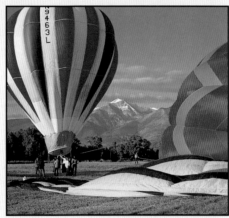

CZAD-172

CZLA-123

CG6-235

CZWA-187

CZFB-150

CZCC-330

CZBA-753

CZSB1-122

S h a r p s h o o t e r s ™

P r e m i u m S t o c k P h o t o g r a p h y

U S A a n d C a n a d a **1 - 8 0 0 - 6 6 6 - 1 2 6 6**

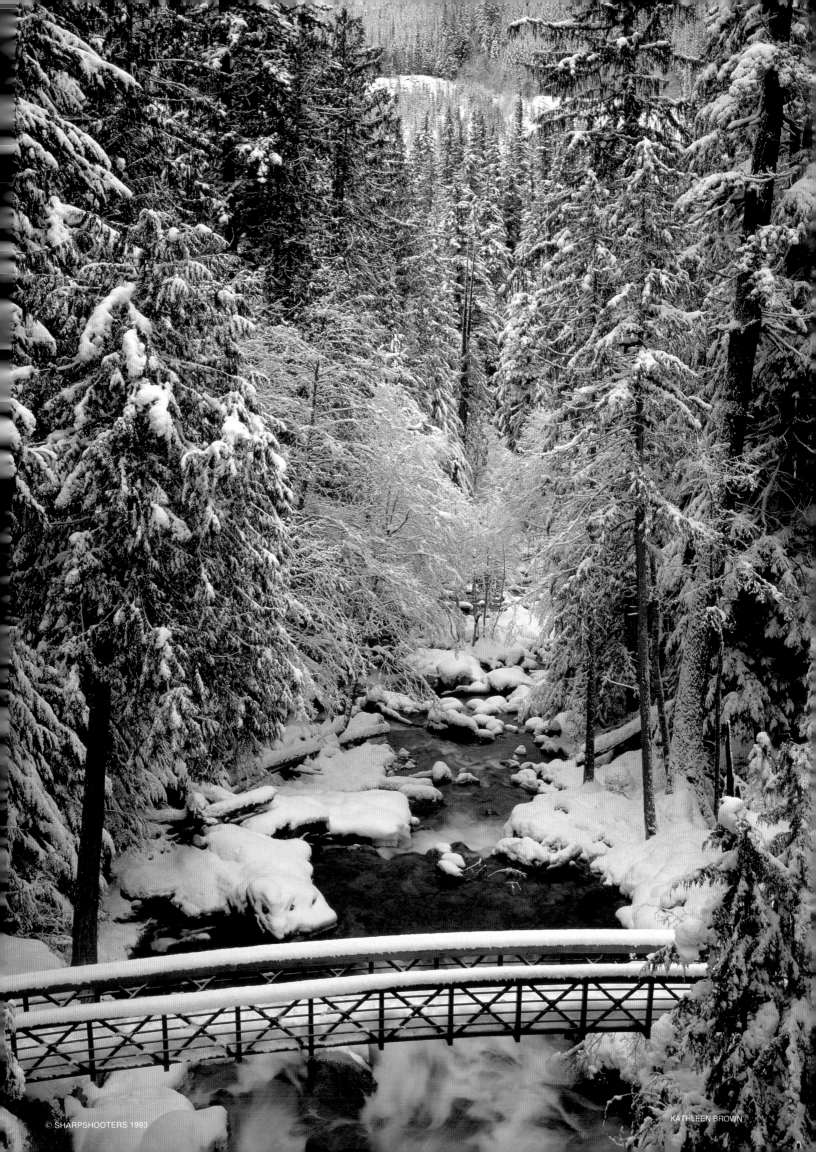

KATHLEEN BROWN

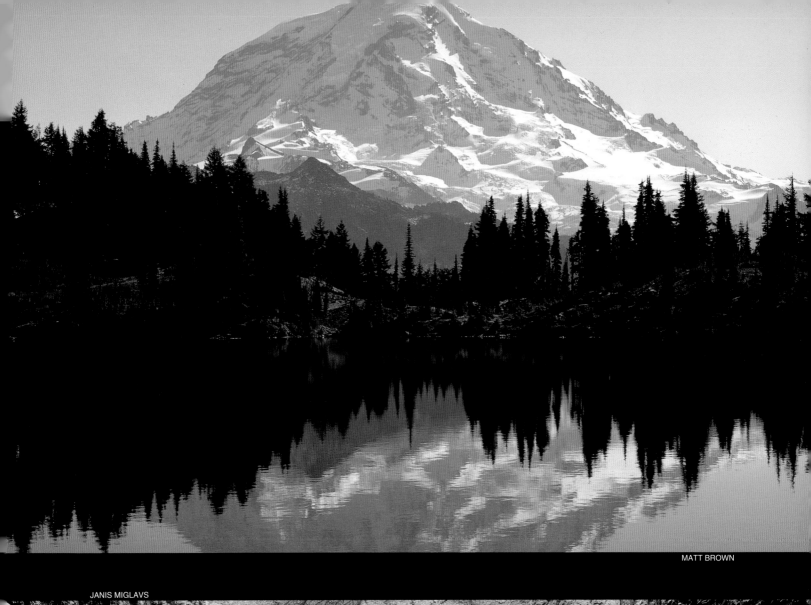

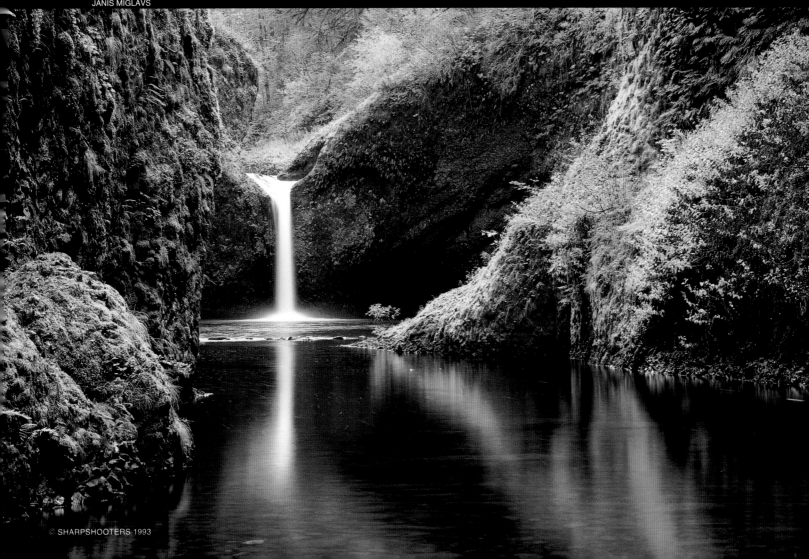

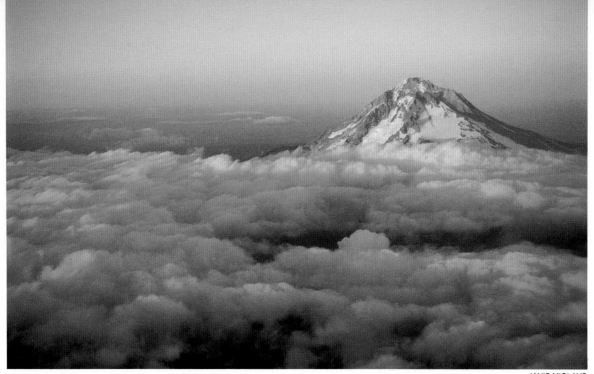

JANIS MIGLAVS

Sharpshooters ™

Premium Stock Photography

USA and Canada **1 - 800 - 666 - 1266**

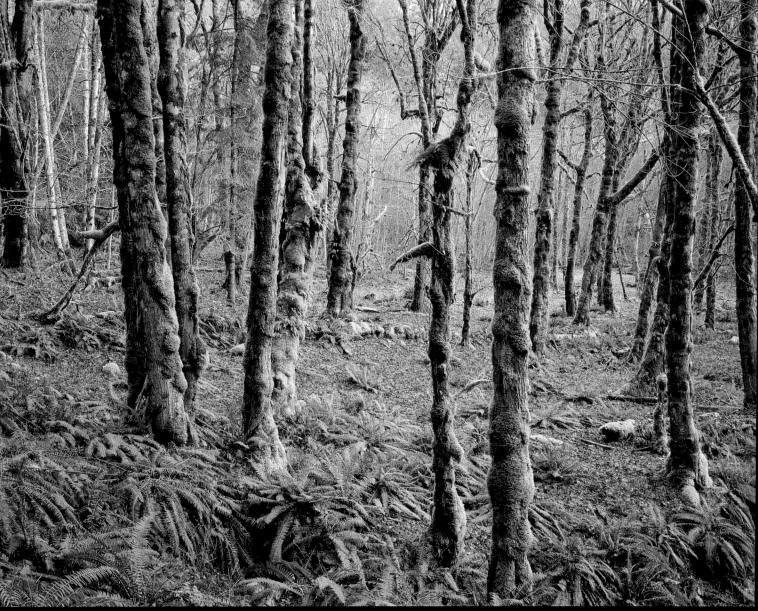

KATHLEEN BROWN

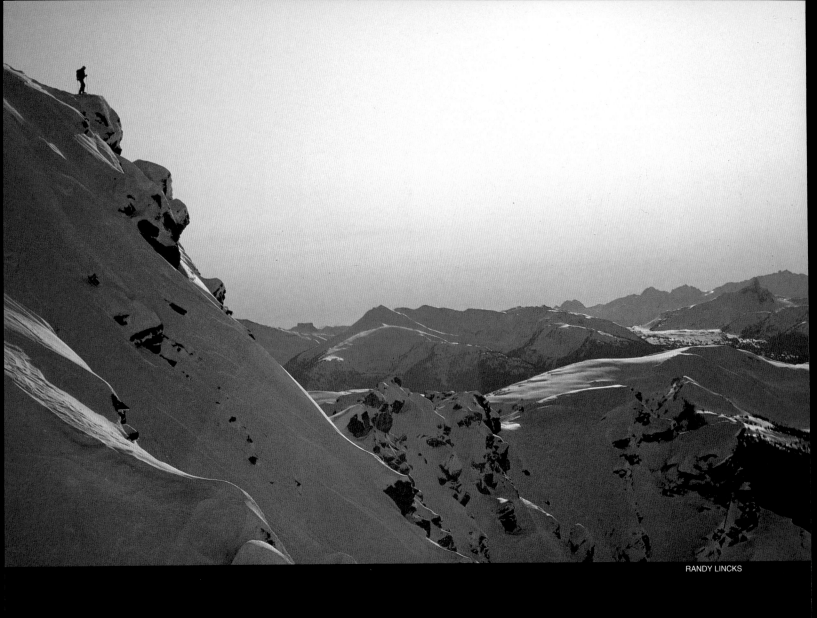

RANDY LINCKS

S h a r p s h o o t e r s ™

Premium Stock Photography

USA and Canada 1 - 8 0 0 - 6 6 6 - 1 2 6 6

BILL FRAKES

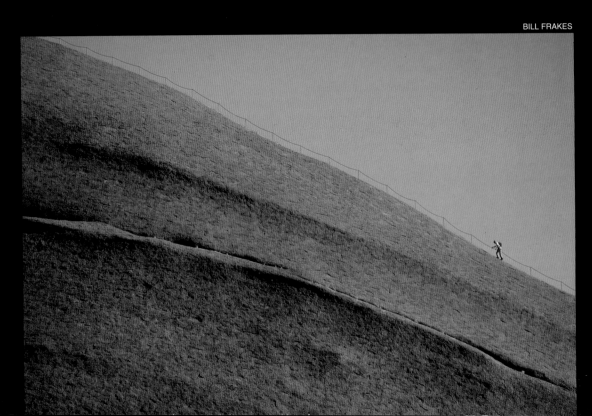

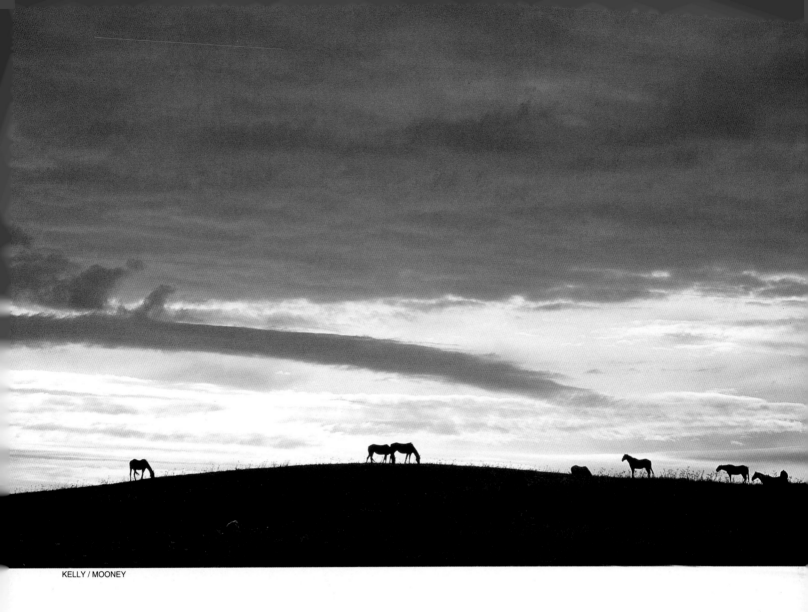

KELLY / MOONEY

S h a r p s h o o t e r s ™

P r e m i u m S t o c k P h o t o g r a p h y

U S A a n d C a n a d a **1 - 8 0 0 - 6 6 6 - 1 2 6 6**

HUGH BEEBOWER

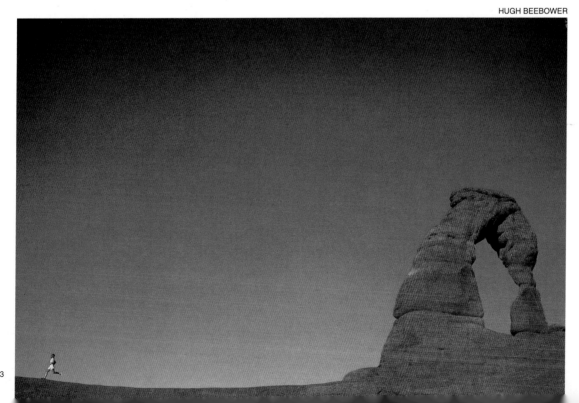

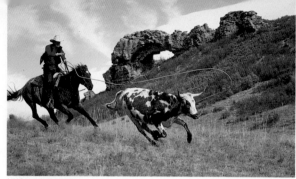

HUGH BEEBOWER

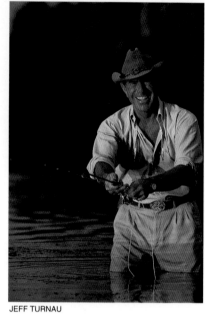

JEFF TURNAU

S h a r p s h o o t e r s ™

Premium Stock Photography

USA and Canada **1 - 8 0 0 - 6 6 6 - 1 2 6 6**

VALENTINE ATKINSON

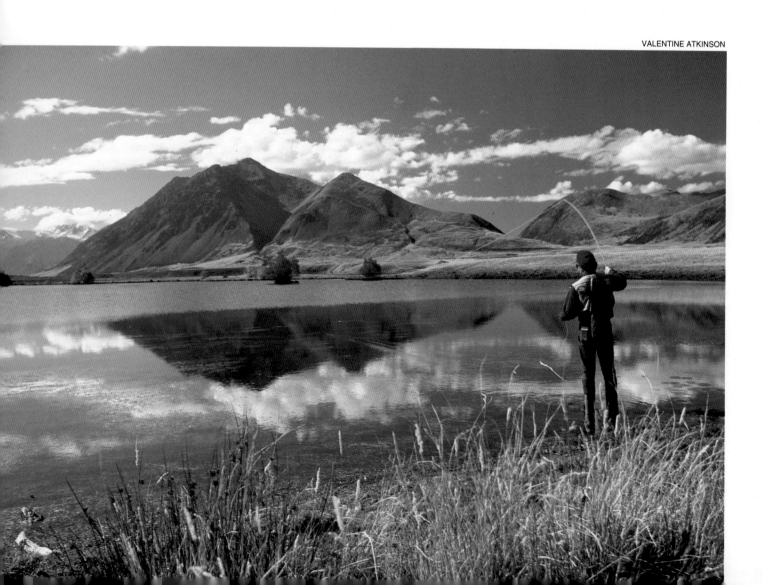

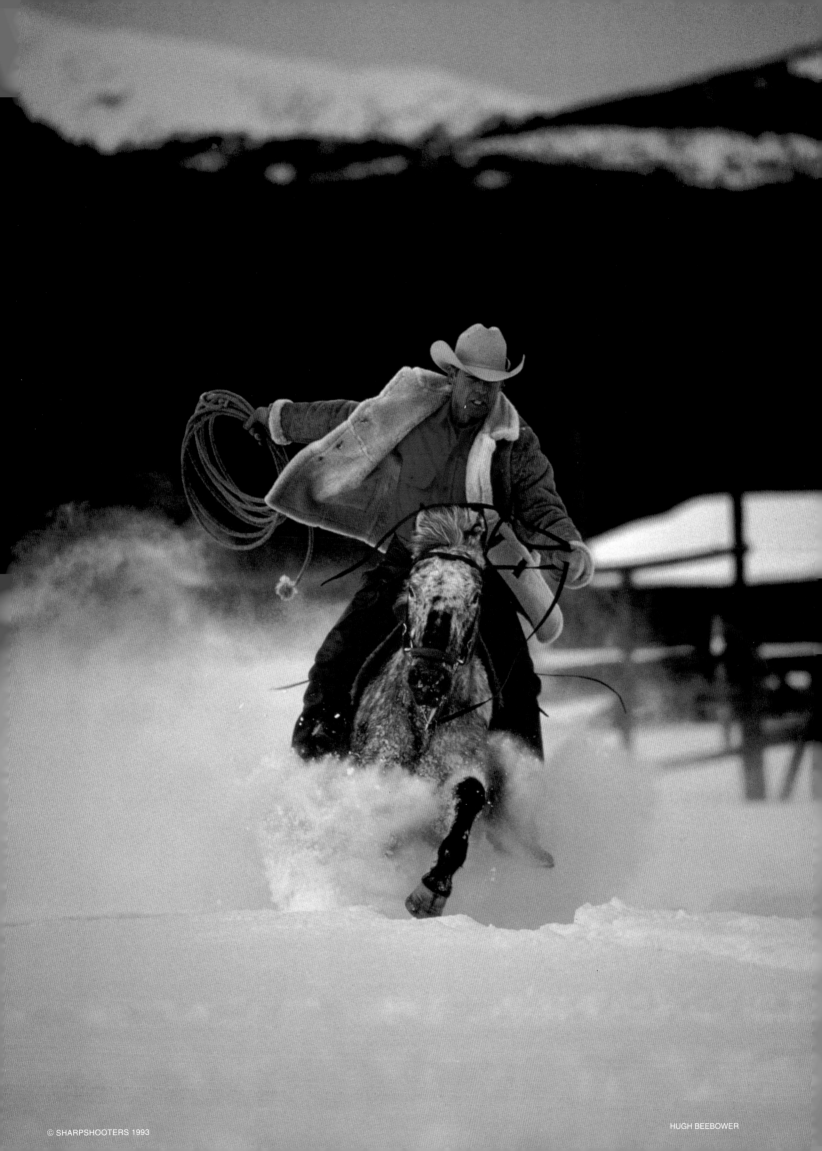

HUGH BEEBOWER

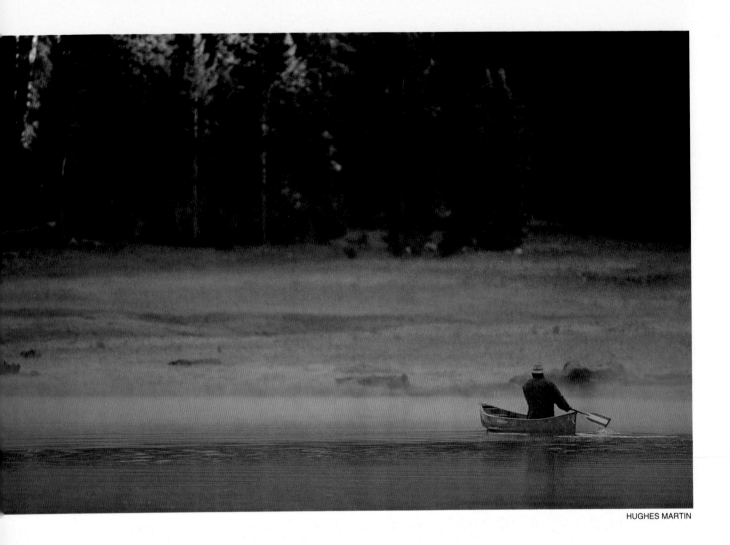
HUGHES MARTIN

S h a r p s h o o t e r s ™

P r e m i u m S t o c k P h o t o g r a p h y

U S A a n d C a n a d a **1 - 8 0 0 - 6 6 6 - 1 2 6 6**

GARY KUFNER

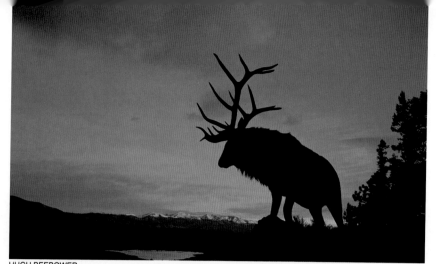

HUGH BEEBOWER

Sharpshooters ™

Premium Stock Photography

USA and Canada **1 - 8 0 0 - 6 6 6 - 1 2 6 6**

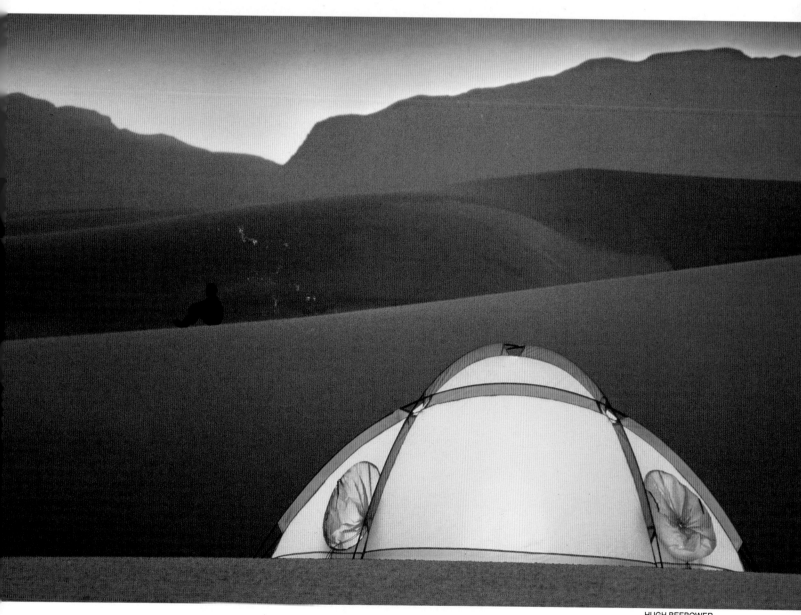

HUGH BEEBOWER

303

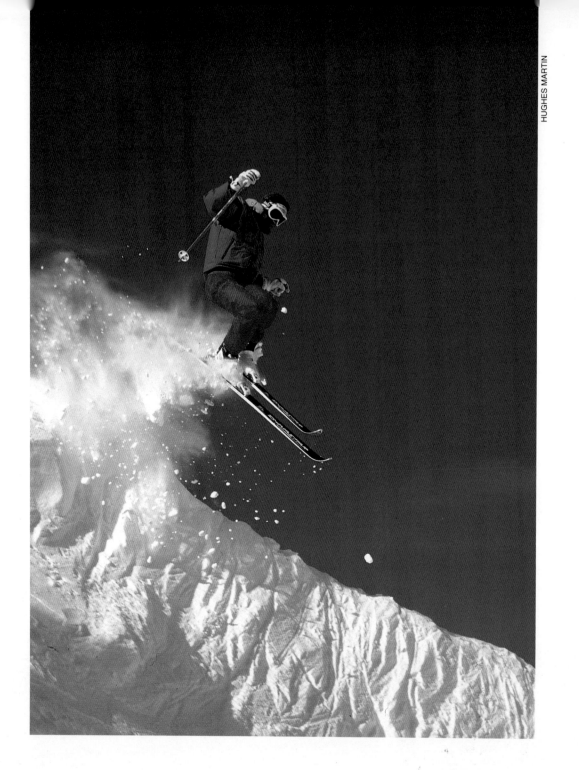

HUGHES MARTIN

Sharpshooters ™

Premium Stock Photography

USA and Canada **1 - 800 - 666 - 1266**

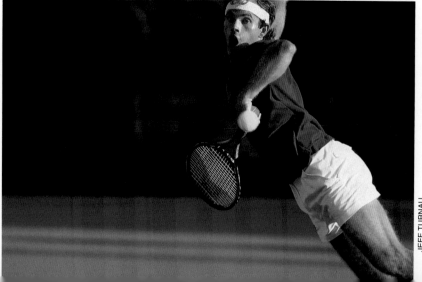

JEFF TURNAU

TIM PANNELL

S h a r p s h o o t e r s ™

Premium Stock Photography

USA and Canada 1 - 8 0 0 - 6 6 6 - 1 2 6 6

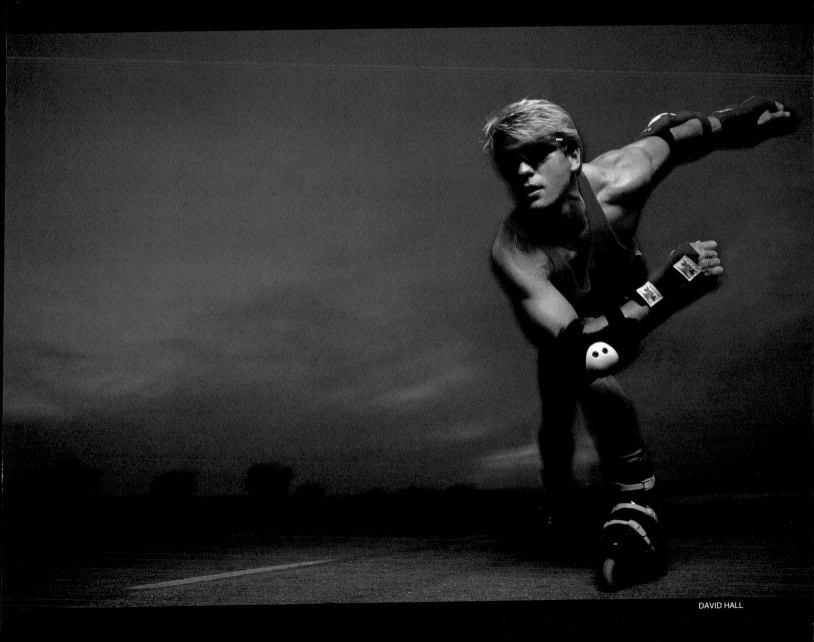

DAVID HALL

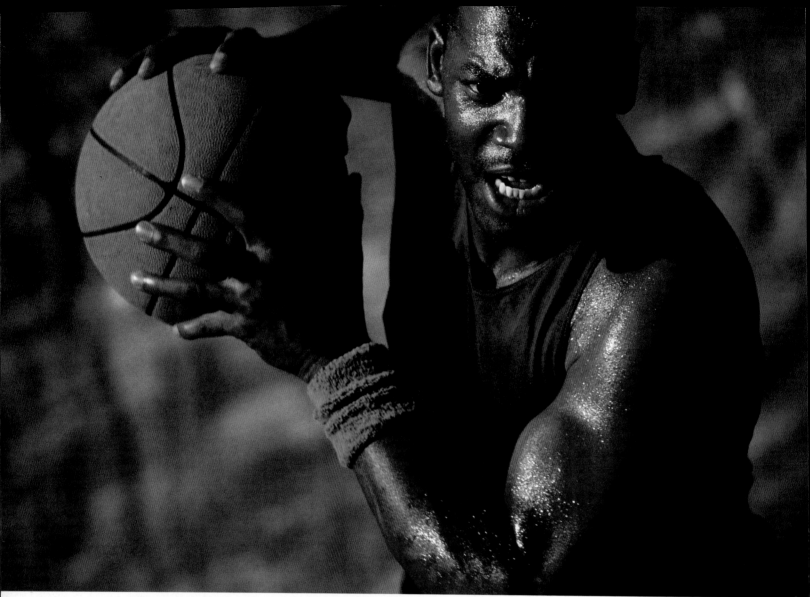

S h a r p s h o o t e r s ™

P r e m i u m S t o c k P h o t o g r a p h y

U S A a n d C a n a d a **1 - 8 0 0 - 6 6 6 - 1 2 6 6**

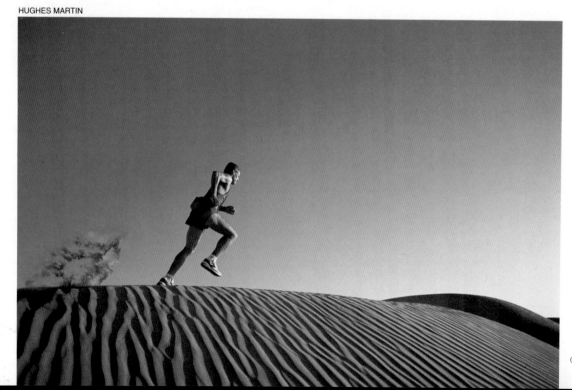

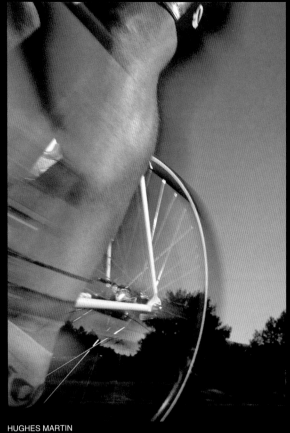

HUGHES MARTIN

S h a r p s h o o t e r s ™

Premium Stock Photography

USA and Canada 1 - 8 0 0 - 6 6 6 - 1 2 6 6

TIM PANNELL

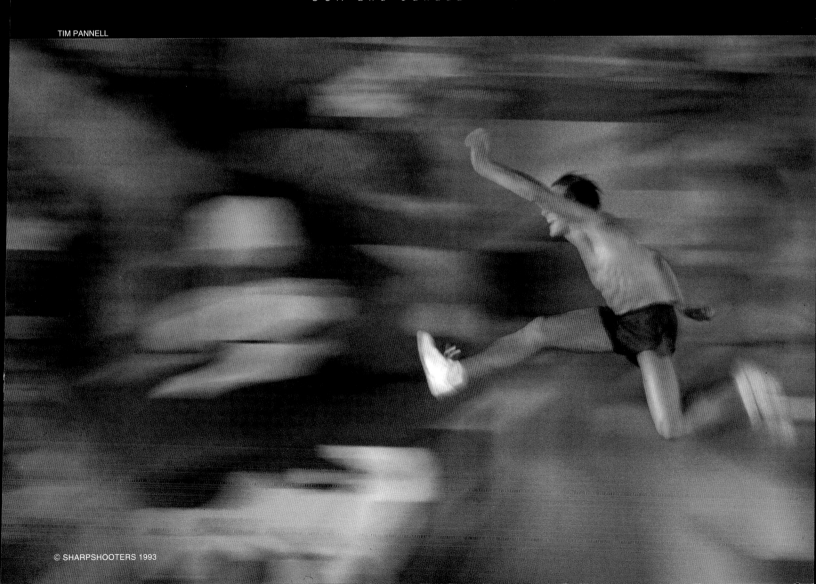

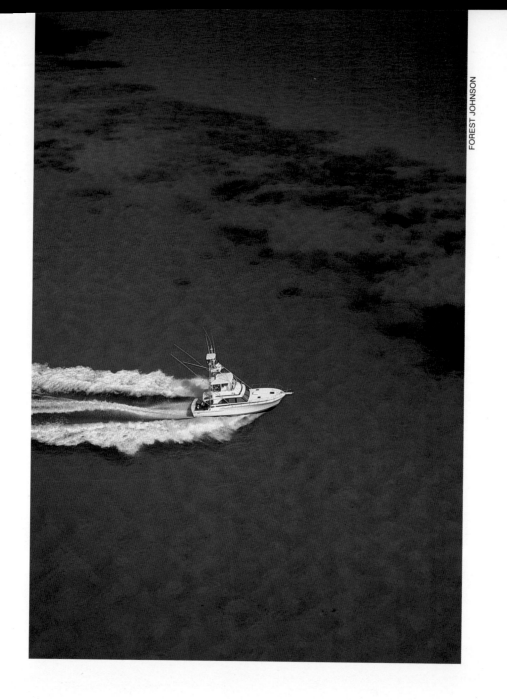

FOREST JOHNSON

S h a r p s h o o t e r s ™

P r e m i u m S t o c k P h o t o g r a p h y

U S A a n d C a n a d a **1 - 8 0 0 - 6 6 6 - 1 2 6 6**

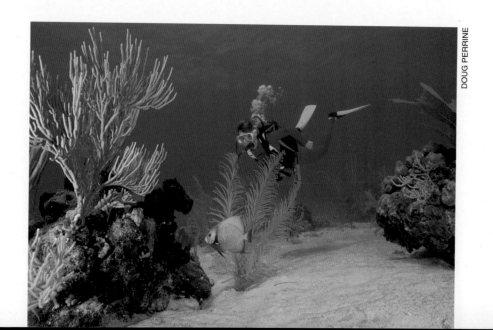

DOUG PERRINE

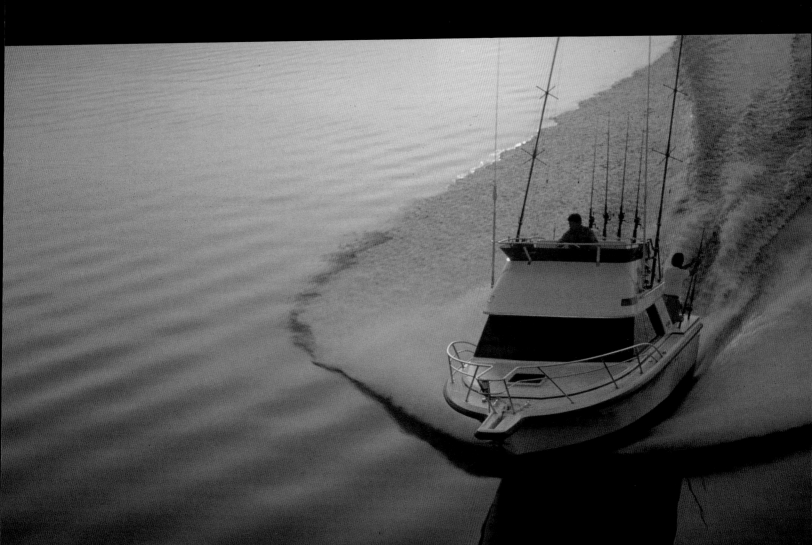

Sharpshooters™

Premium Stock Photography

USA and Canada 1 - 8 0 0 - 6 6 6 - 1 2 6 6

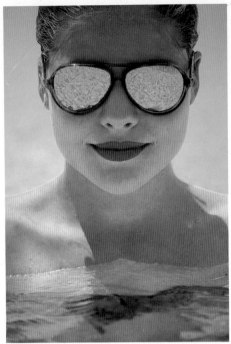

BOB GELBERG

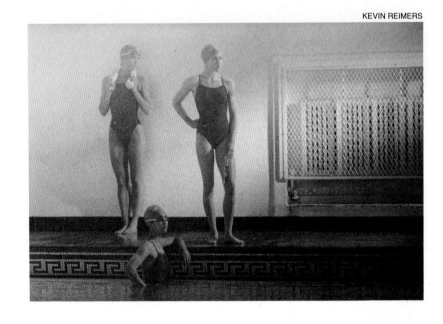

Sharpshooters ™

Premium Stock Photography

USA and Canada **1 - 800 - 666 - 1266**

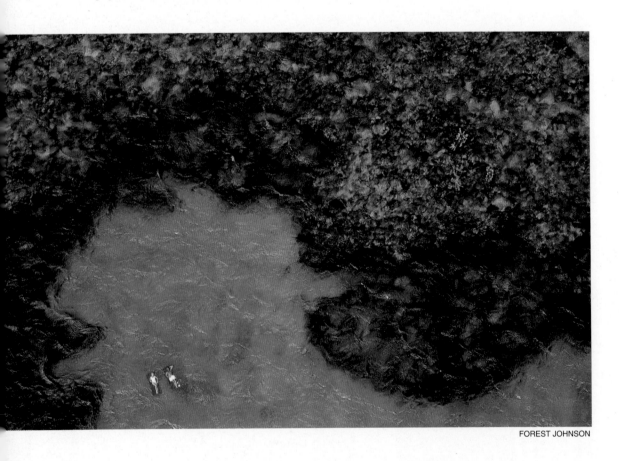

FOREST JOHNSON

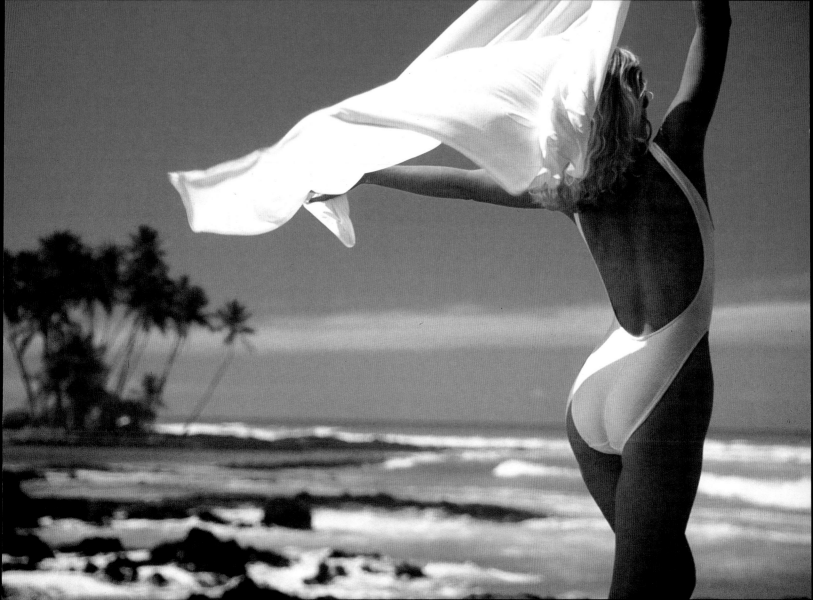

RANDY MILLER

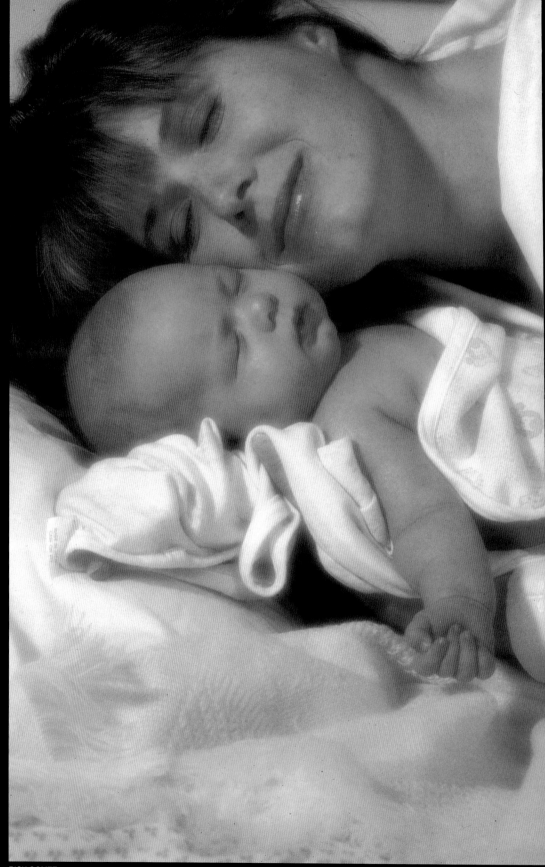

RICK GOMEZ

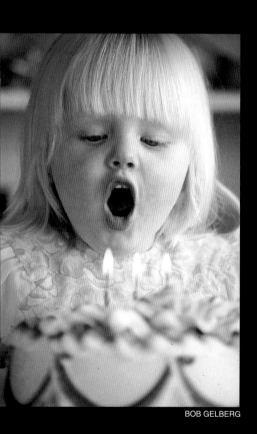

BOB GELBERG

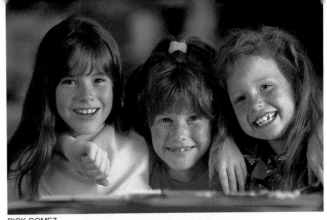

RICK GOMEZ

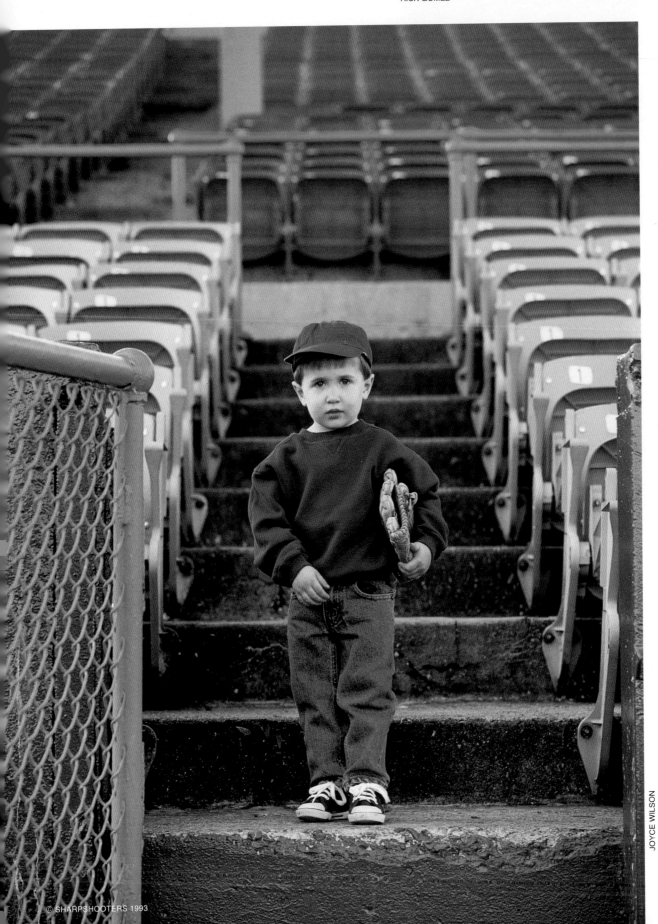

JOYCE WILSON

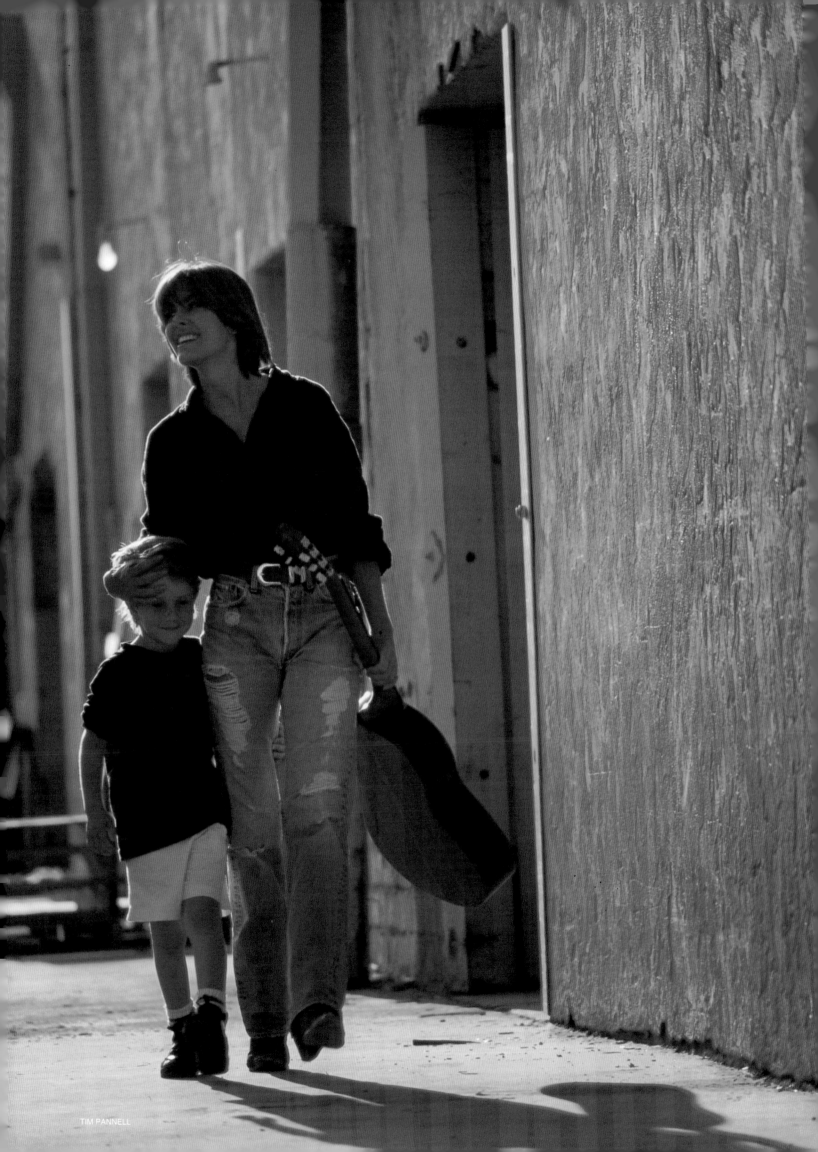

JERRY TOBIAS

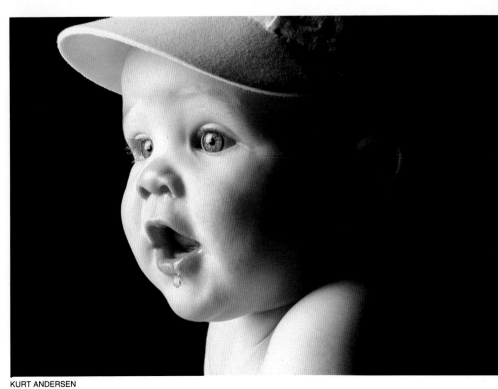
KURT ANDERSEN

Sharpshooters ™
Premium Stock Photography

USA and Canada **1 - 8 0 0 - 6 6 6 - 1 2 6 6**

JOYCE WILSON

KEN SCHIFF

Sharpshooters ™
Premium Stock Photography

USA and Canada **1 - 8 0 0 - 6 6 6 - 1 2 6 6**

KEVIN REIMERS

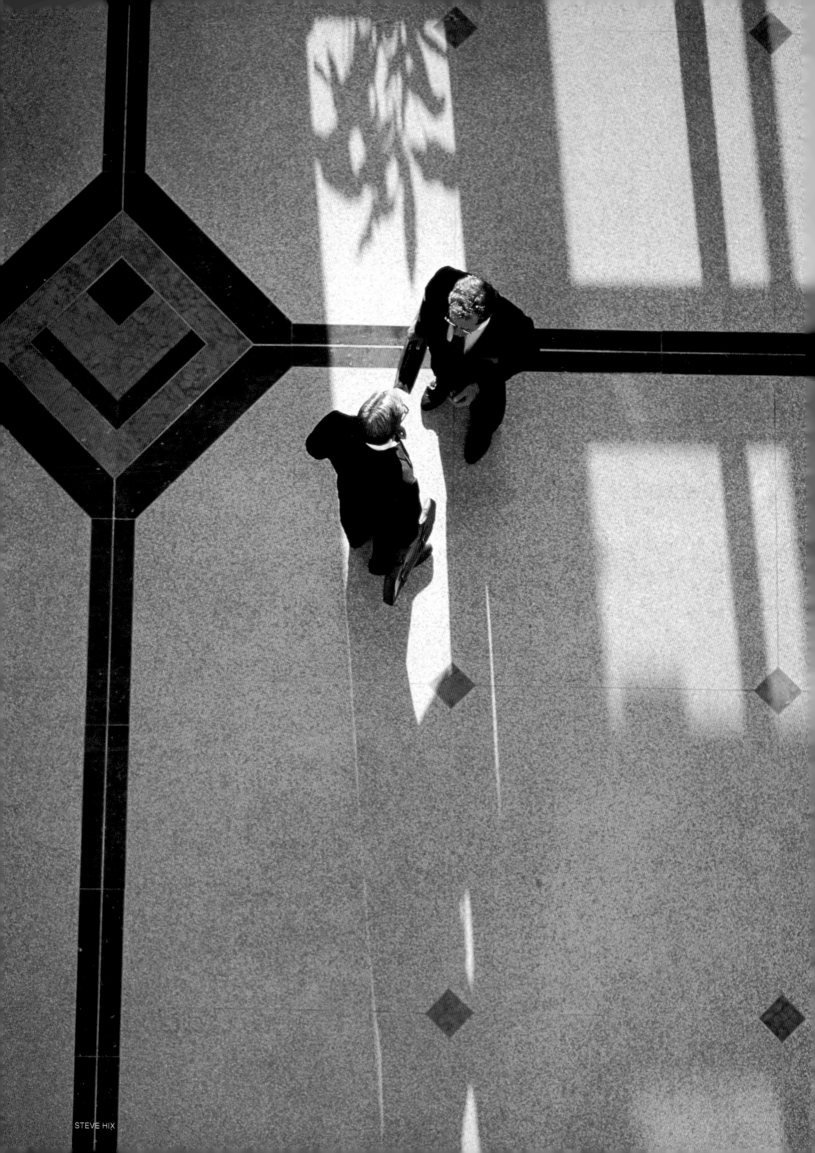

STEVE HIX

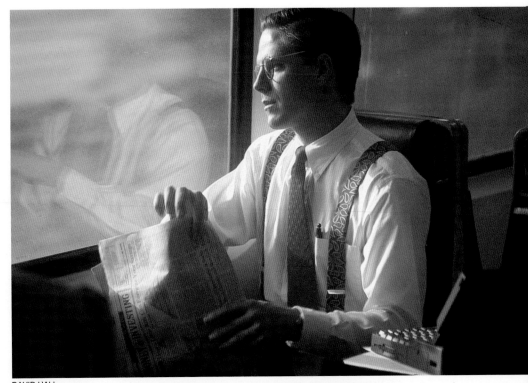

DAVID HALL

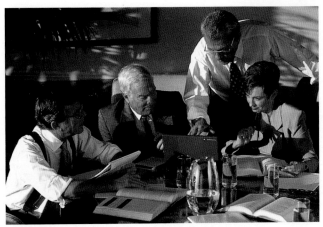

KEN SCHIFF

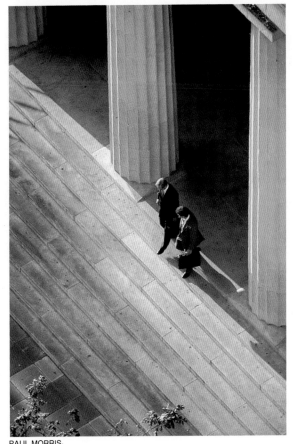

PAUL MORRIS

Sharpshooters ™

Premium Stock Photography

USA and Canada 1-800-666-1266

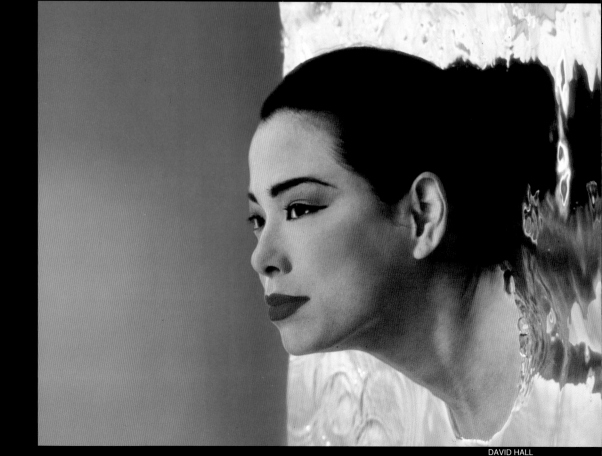

ZEFA Leipzig
Telefon (37 41) 29 58 94

ZEFA Wein
Telefon (43 1) 32 74 50

ZEFA Amsterdam
Telefon (31 20) 66 138 66

ZEFA London
Telephone (44 1) 262 0101

ZEFA Paris
Telephone (33 1) 42 74 55 47

ZEFA Lyon
Telephone (33 7) 78 92 87 66

ZEFA Milan
Telefono (39 2) 48 00 45 25

ZEFA Zürich
Telefon (41 1) 3 63 06 07

SJÖBERG PRESS SERVICE
Stockholm
Telefon (46 8) 999 263

AUSCHROMES
Melbourne
Phone (61 3) 646 6977

DAVID HALL

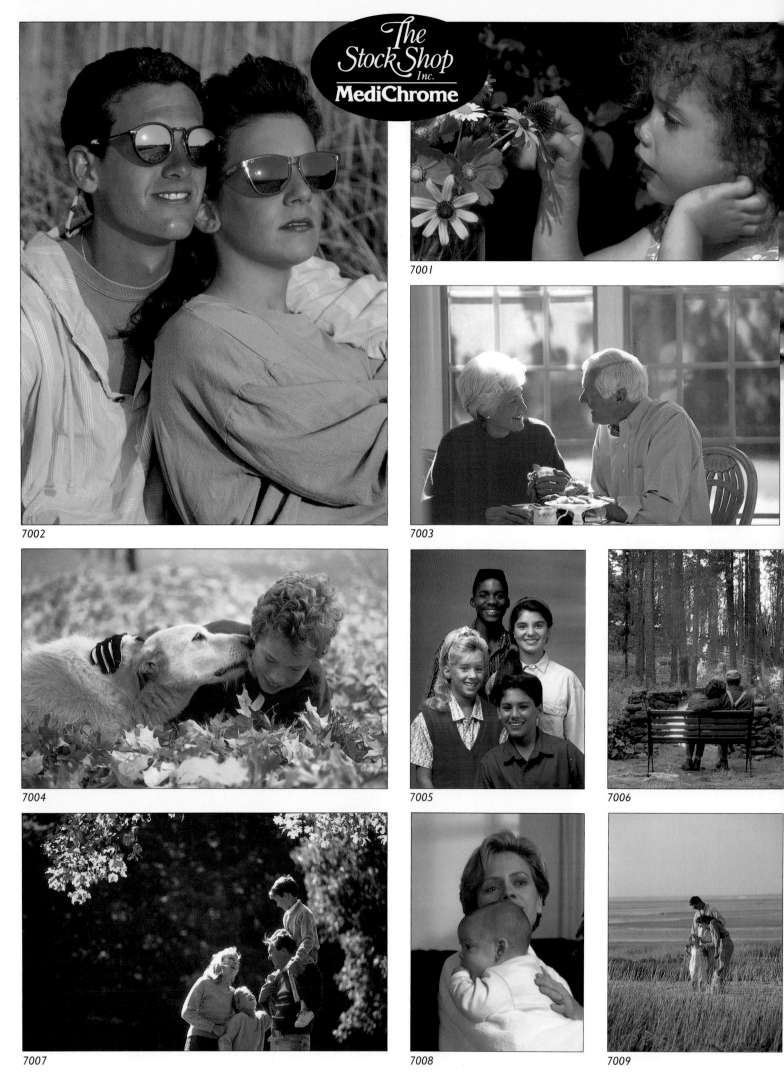

The Stock Shop Inc.
MediChrome

7001

7002

7003

7004

7005

7006

7007

7008

7009

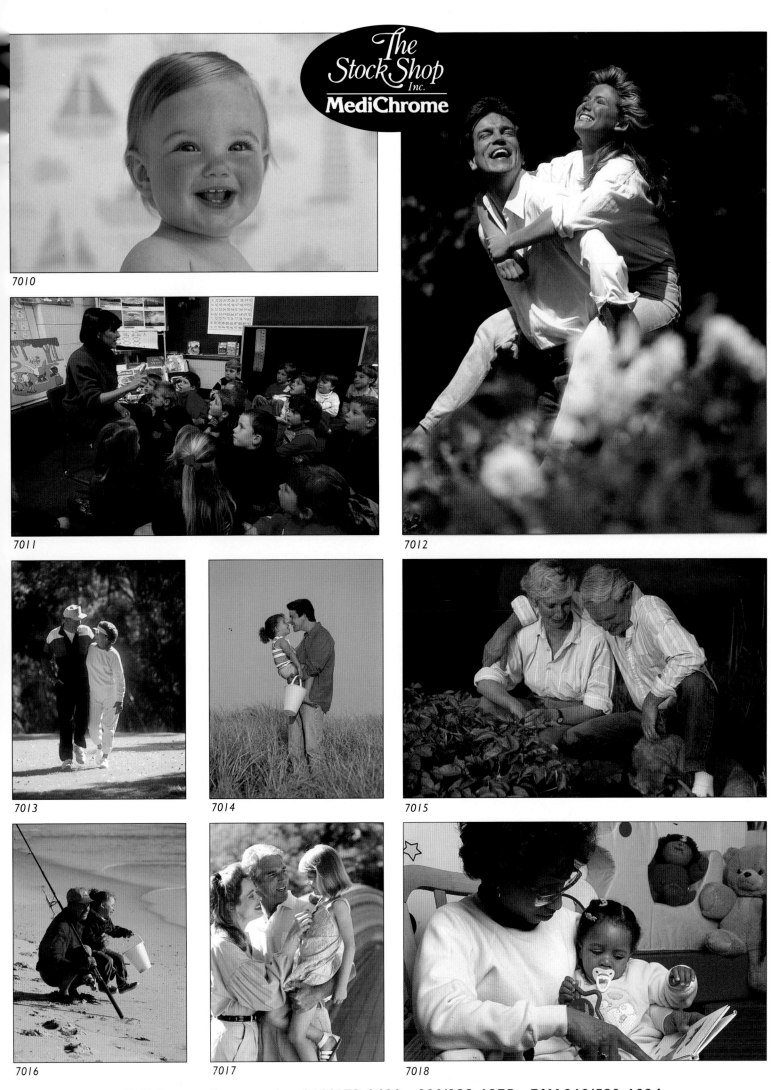

7010

7011

7012

7013

7014

7015

7016

7017

7018

7019

7020

7021

7022

7023

7024

7025

7026

7027

7028

7029

7031

7030

7032

7033

7034

7035

7036

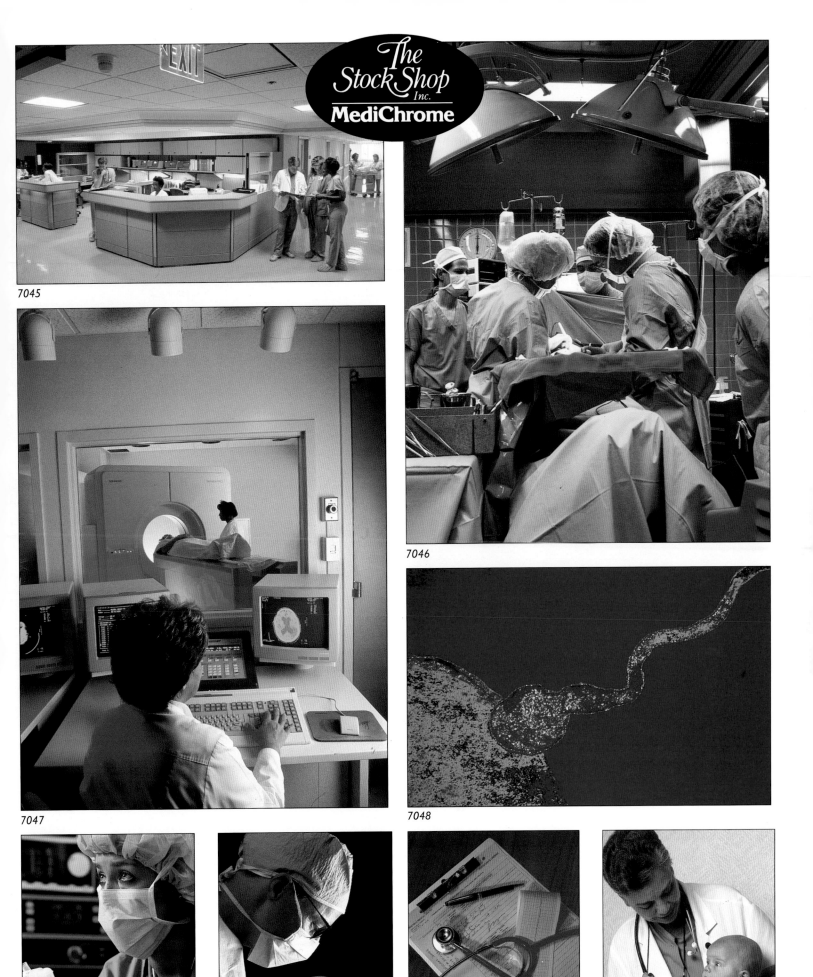

7045

7046

7047

7048

7049

7050

7051

7052

Call for our free catalog 212/679-8480 • 800/233-1975 • FAX 212/532-1934

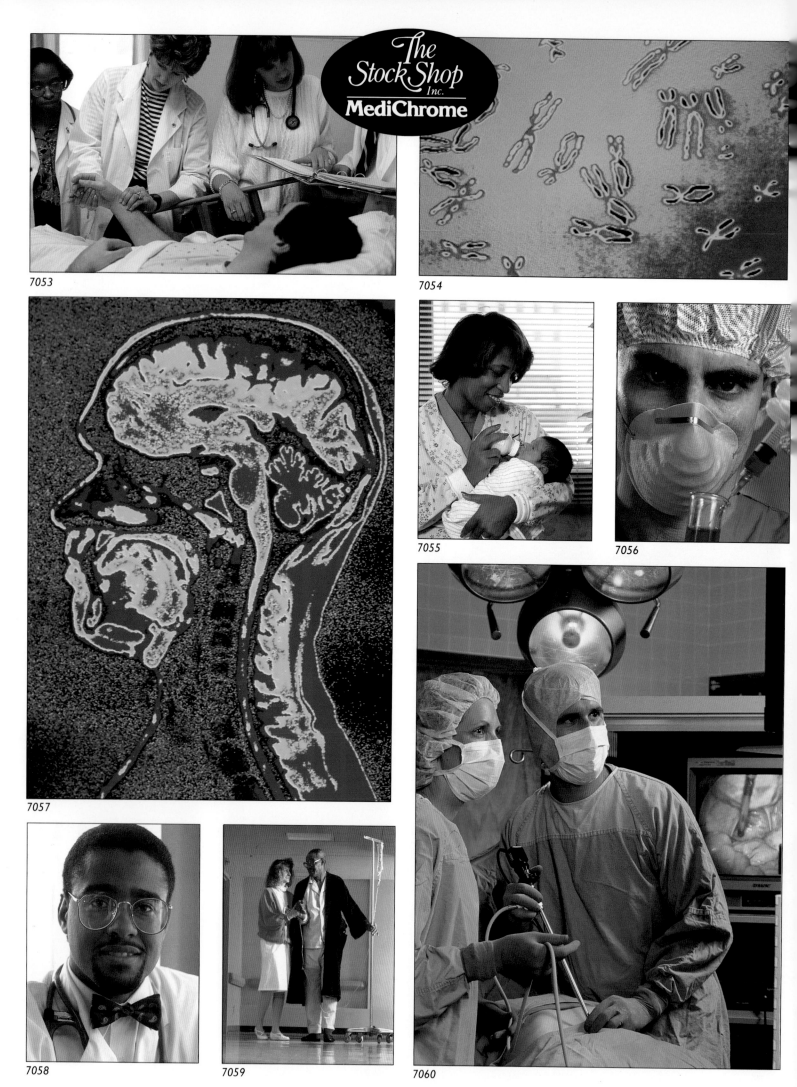

7053

7054

7055

7056

7057

7058

7059

7060

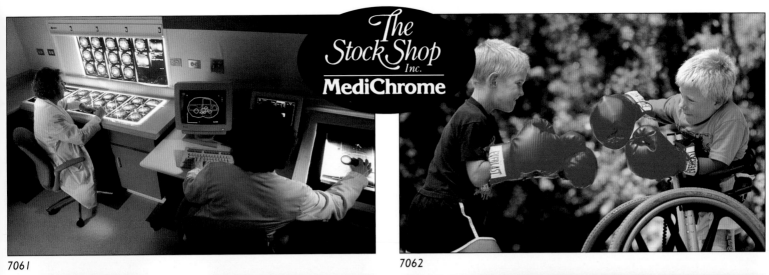

7061

7062

7063

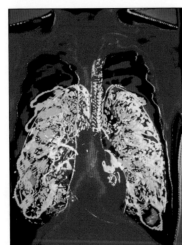

7064

7066

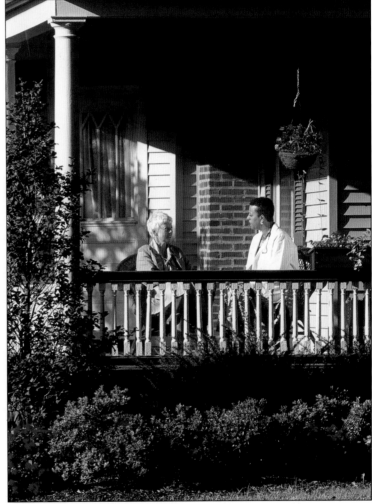

7065

7067

7068

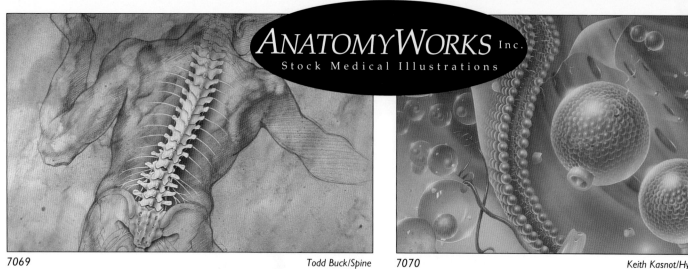

AnatomyWorks Inc.
Stock Medical Illustrations

7069 *Todd Buck/Spine*

7070 *Keith Kasnot/Hypercholesterolemia*

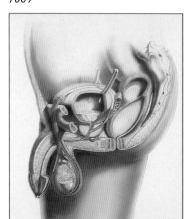

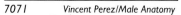

7071 *Vincent Perez/Male Anatomy*

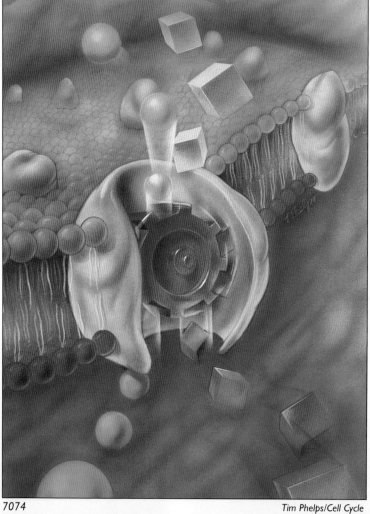
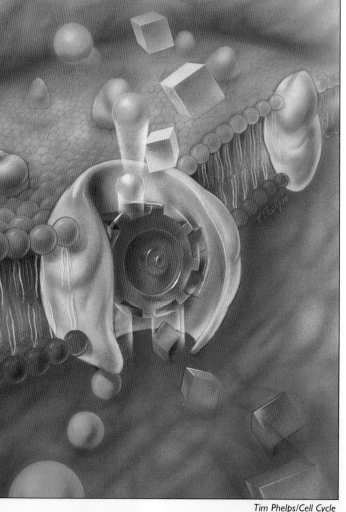

7072 *Lauren Shavell/Pregnancy*

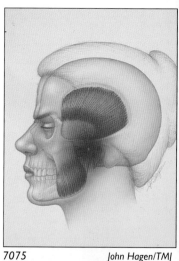

7073 *Todd Buck/Streptococcus Infections*

7074 *Tim Phelps/Cell Cycle*

7075 *John Hagen/TMJ*

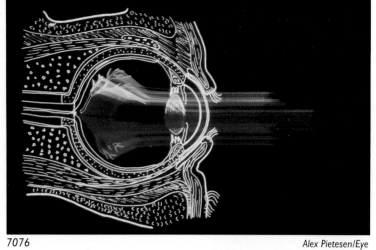

7076 *Alex Pietesen/Eye*

7077 *John Hagen/Basel Cell Carcinoma*

212/679-8480 • 800/233-1975 • FAX 212/532-1934

Steve Alden

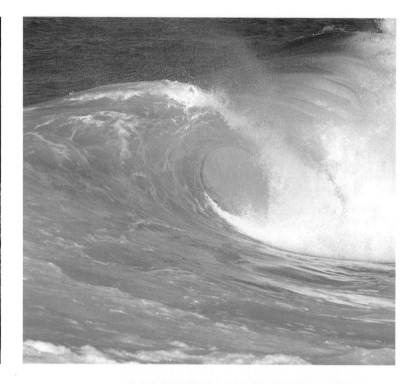

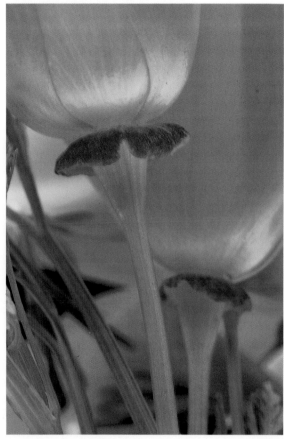

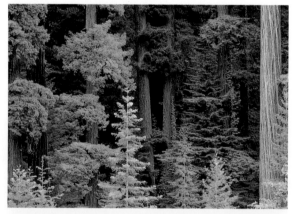

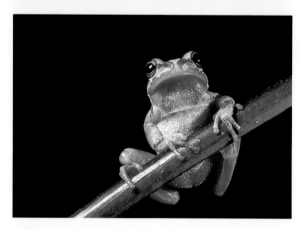

WEST STOCK

TEL: 1-800-821-9600
FAX: 1-206-728-7638

Brian Drake

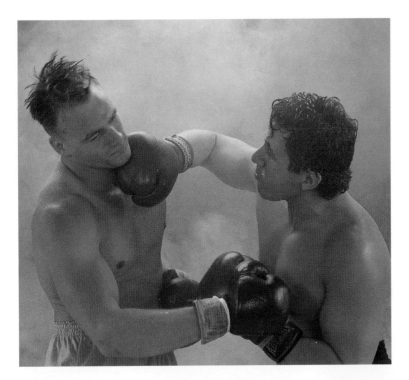

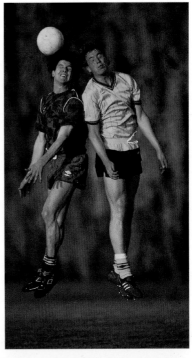

WEST STOCK

TEL: 1-800-821-9600
FAX: 1-206-728-7638

Jeff Gnass

AMSTERDAM

BARCELONA

BRISBANE

BRUSSELS

GENEVA

HONG KONG

LONDON

MEXICO CITY

MILAN

MUNICH

PARIS

SEATTLE

SEOUL

STOCKHOLM

TOKYO

TORONTO

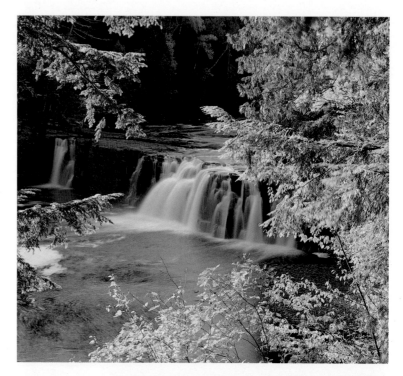

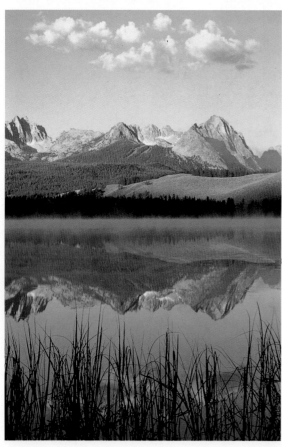

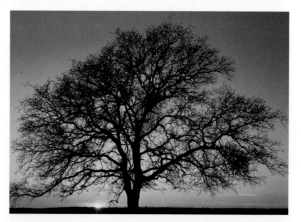

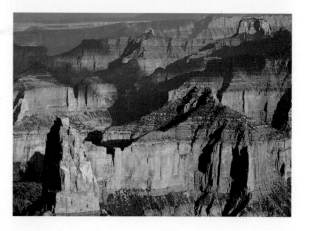

TEL: 1-800-821-9600
FAX: 1-206-728-7638

John Laptad

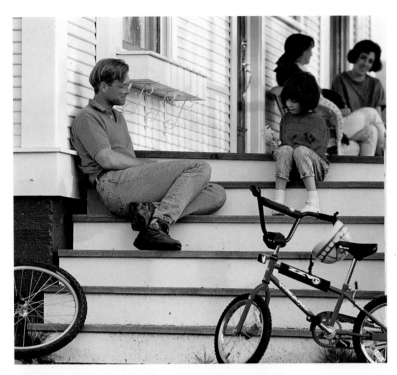

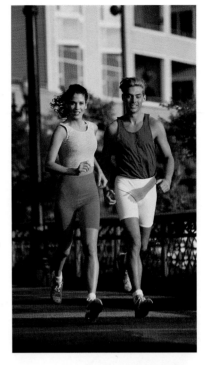

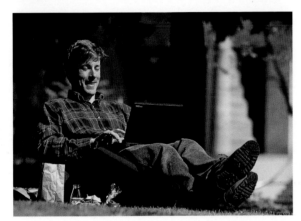

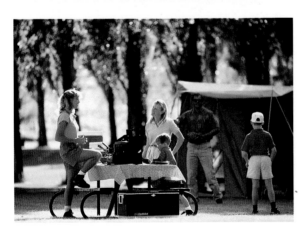

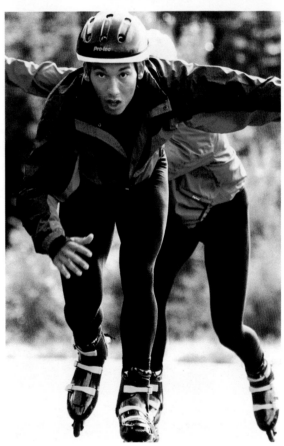

WEST STOCK

TEL: 1-800-821-9600
FAX: 1-206-728-7638

Rick Morley

AMSTERDAM

BARCELONA

BRISBANE

BRUSSELS

GENEVA

HONG KONG

LONDON

MEXICO CITY

MILAN

MUNICH

PARIS

SEATTLE

SEOUL

STOCKHOLM

TOKYO

TORONTO

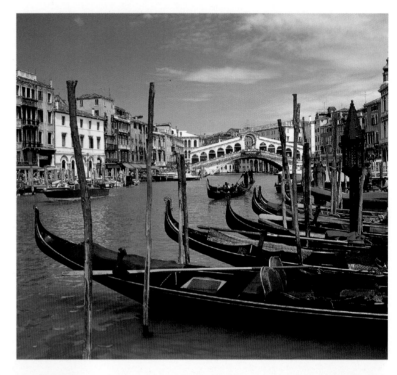

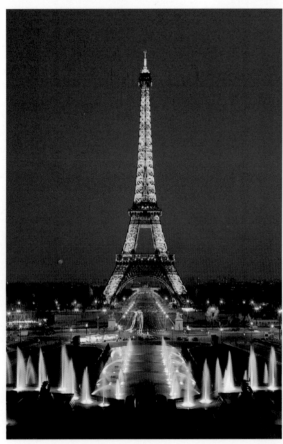

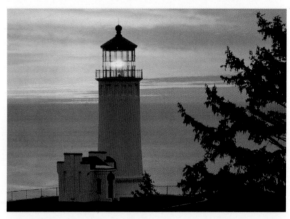

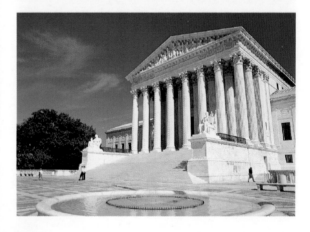

TEL: 1-800-821-9600
FAX: 1-206-728-7638

WEST STOCK

Mark Newman

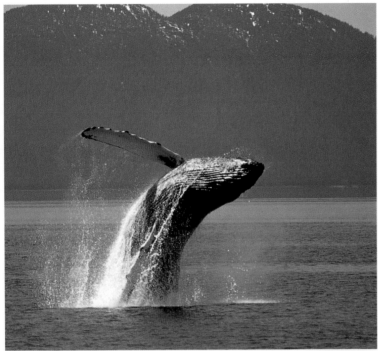

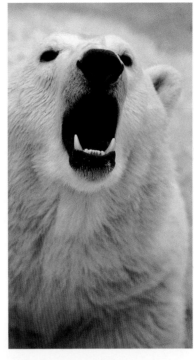

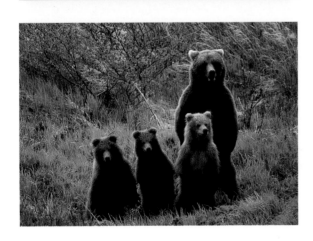

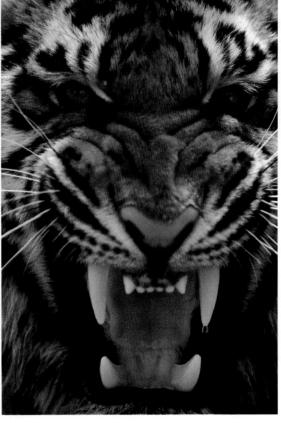

AMSTERDAM

BARCELONA

BRISBANE

BRUSSELS

GENEVA

HONG KONG

LONDON

MEXICO CITY

MILAN

MUNICH

PARIS

SEATTLE

SEOUL

STOCKHOLM

TOKYO

TORONTO

WEST STOCK

TEL: 1-800-821-9600
FAX: 1-206-728-7638

Kent Knudson

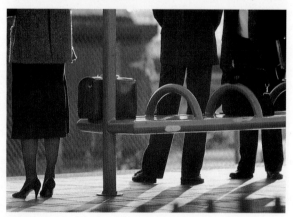

WEST STOCK

TEL: 1-800-821-9600
FAX: 1-206-728-7638

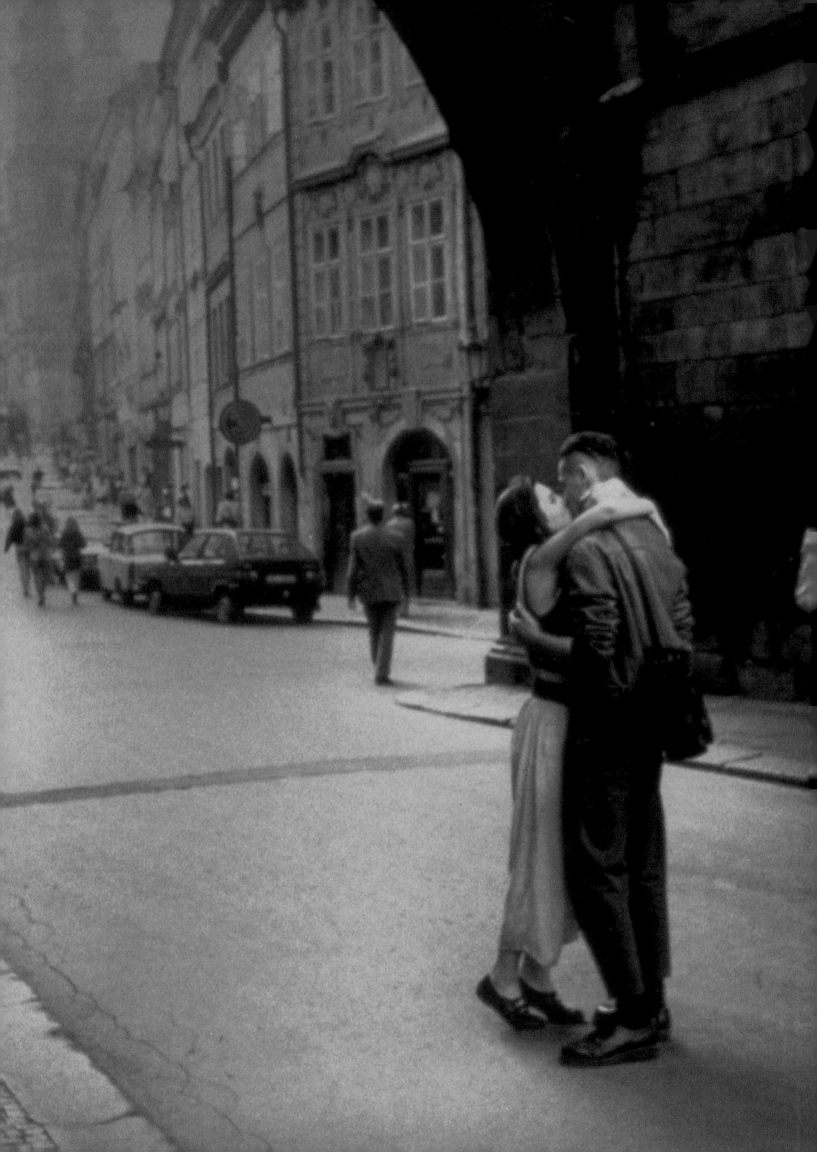

OPEN YOUR MIND™

THE **IMAGE** BANK®

Global Visionaries.™

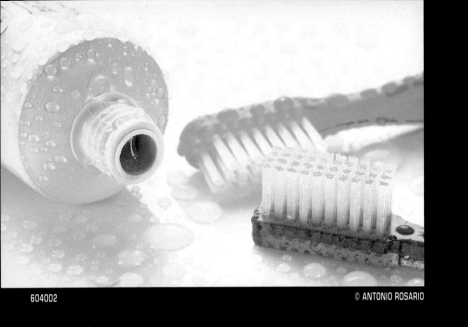

604002

© ANTONIO ROSARIO

O

P

N E

Y

O

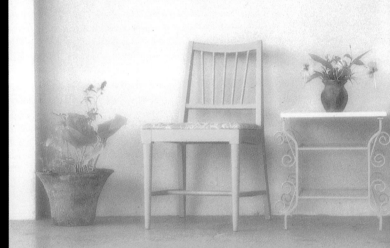

604003

© ANDRE GALLA

U R

604004

© MAGNUS RIETZ

M

I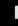

604005

© ERIC MEOLA

THE **IMAGE** BANK®

Global Visionaries.™

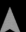

OPEN

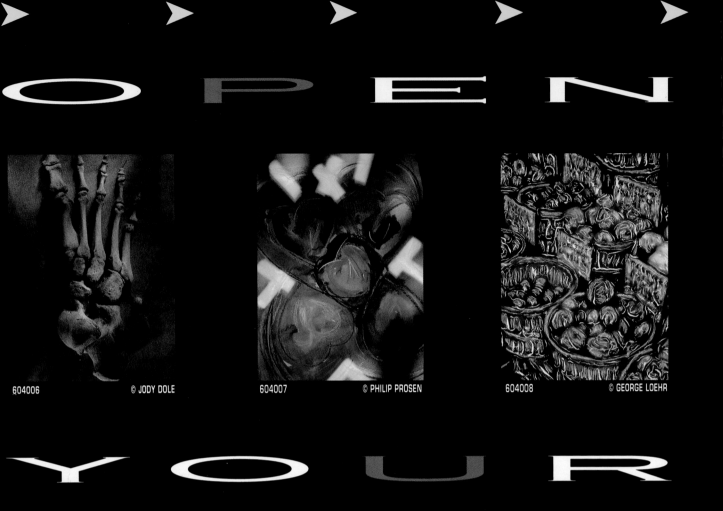

604006 © JODY DOLE 604007 © PHILIP PROSEN 604008 © GEORGE LOEHR

YOUR

© SERGIO DUART

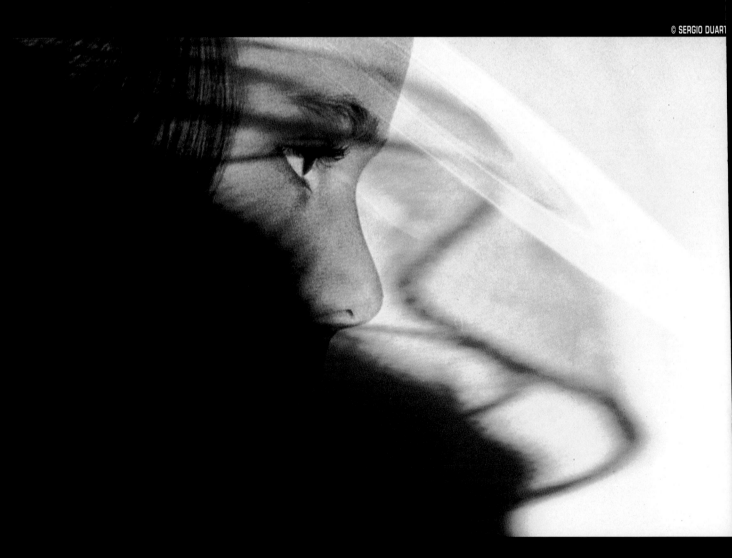

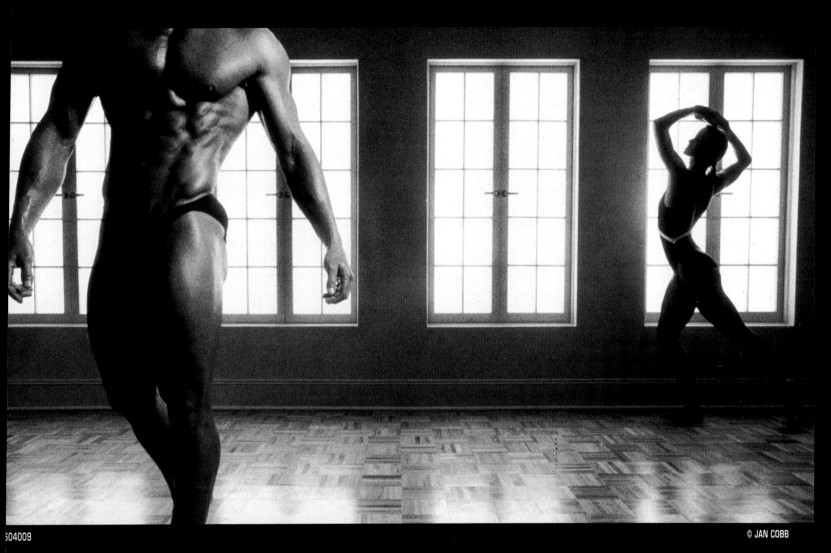

604009 © JAN COBB

MIND™

604011 © PAT LACROIX

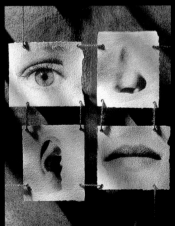

604012 © WHITE/PACKERT

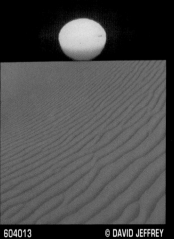

604013 © DAVID JEFFREY

THE IMAGE BANK®

Global Visionaries.™

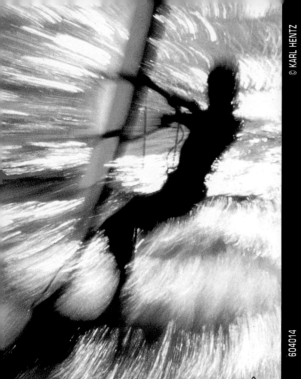

O P

604014

604015

Y

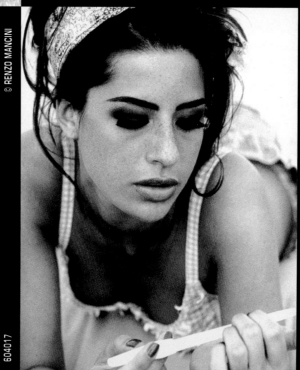

U R

604017

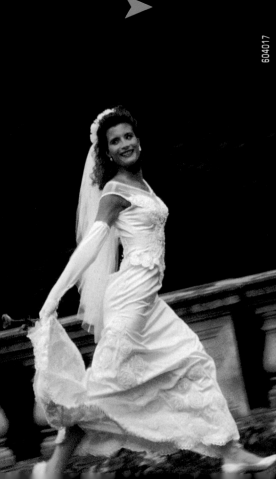

M

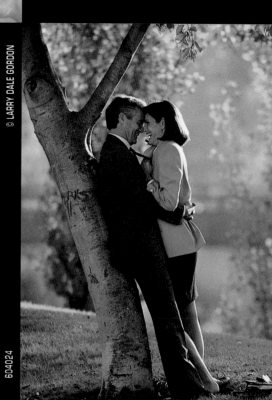

604020

604024

604016

604018

604019

THE **IMAGE** BANK®

Global Visionaries.™

604022

604023 © PER-ERIK BERGLUND

20 million existing images.
450 gifted photographers.
100,000 illustrations.
350 inventive artists.
64 worldwide offices.

Atlanta 404•233•9920/Fax 404•231•9389 Boston 617•267•8866/Fax 617•267•4682
Chicago 312•329•1817/Fax 312•329•1029 Dallas 214•528•3888/Fax 214•528•3878
Detroit 313•524•1850/Fax 313•524•3243 Houston 713•668•0066/Fax 713•664•4441
Los Angeles 213•930•0797/Fax 213•930•1089 Minneapolis 612•332•8935/Fax 612•344•171
Naples, Florida 813•262•1227/Fax 813•262•6272 New York 212•529•6700/Fax 212•529•702
San Francisco 415•788•2208/Fax 415•392•6637 Seattle 206•343•9319/Fax 206•343•9317
Montreal 514•849•8840/Fax 514•849•8055 Toronto 416•322•8840/Fax 416•322•8855

Corporate Headquarters: Williams Square, Suite 700
5221 N.O'Connor Boulevard, Irving, Texas 75039
214•432•3900/Fax 214•432•3960

THE **IMAGE** BANK®

Global Visionaries.™

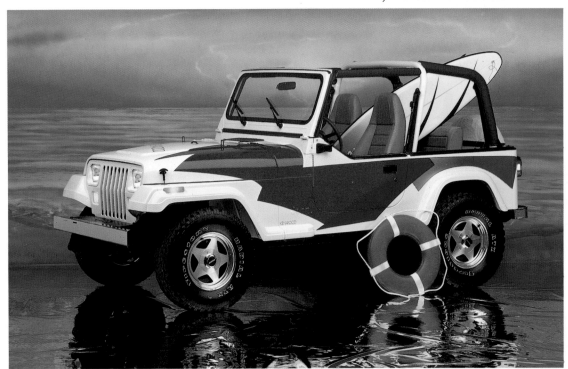

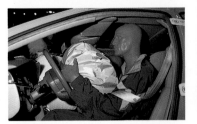
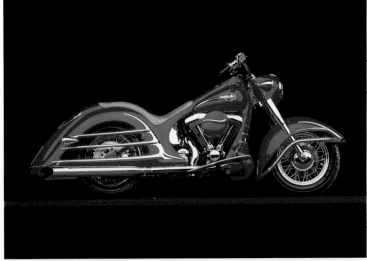

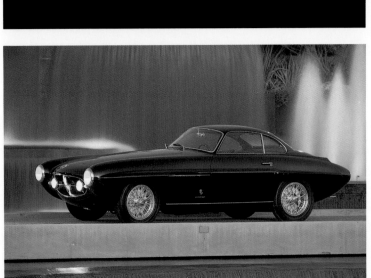

RON KIMBALL STOCK

ADVERTISING AUTOMOBILES

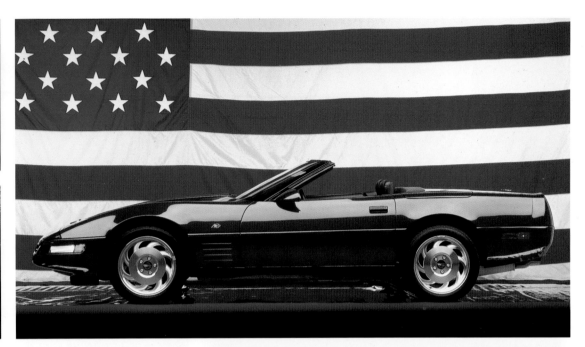

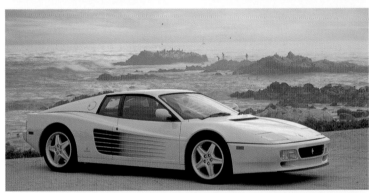

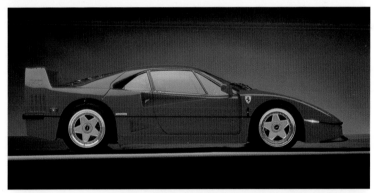

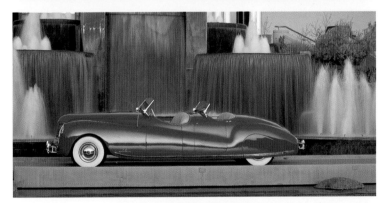

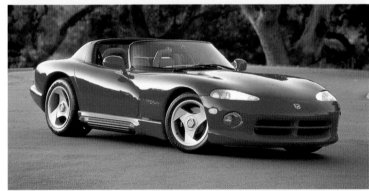

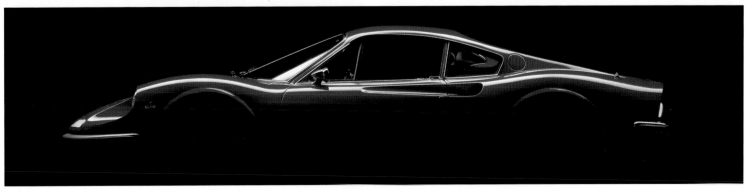

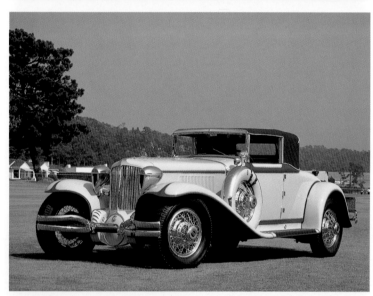
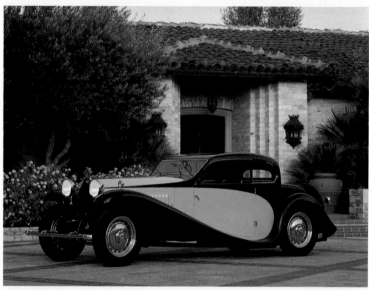
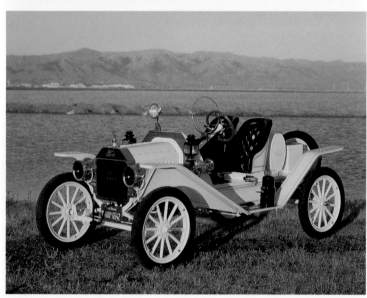
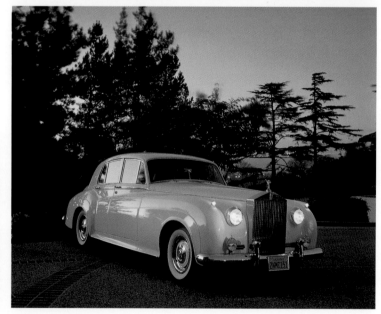

Ron Kimball Photography • 1960 Colony Street, Mountain View, California 94043 • 415/969-0682

RON KIMBALL STOCK

ADVERTISING AUTOMOBILES

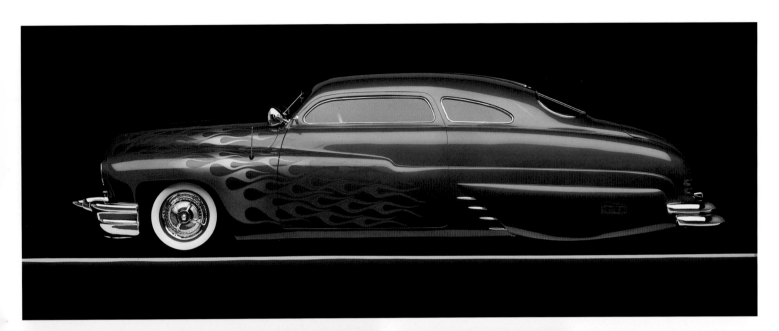

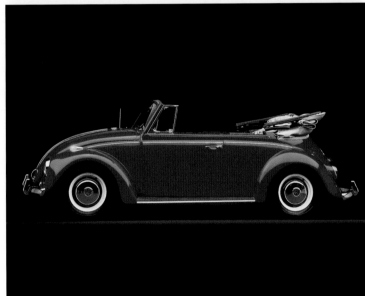

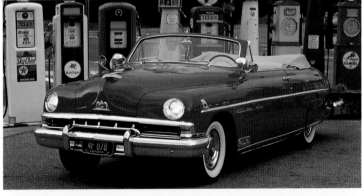

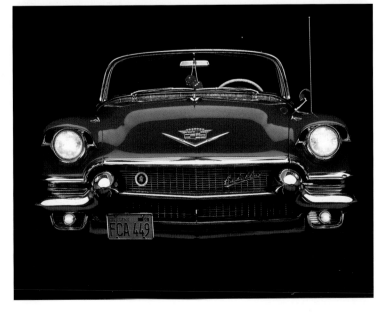

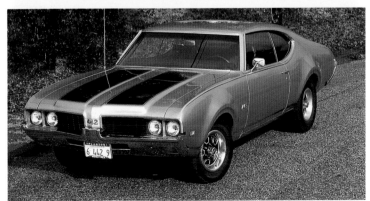

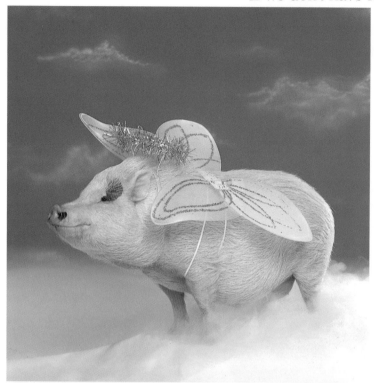
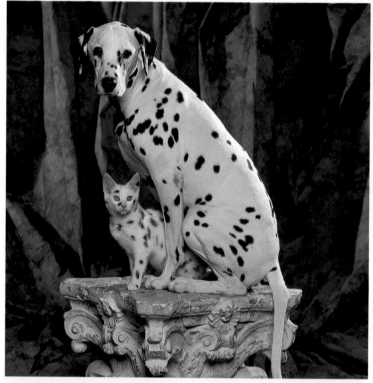

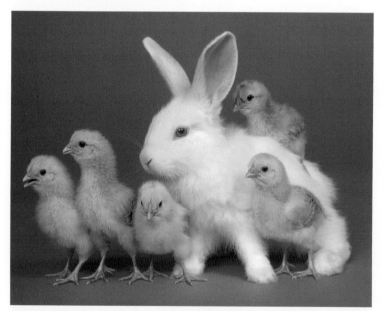
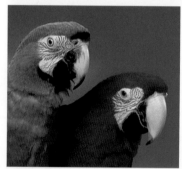
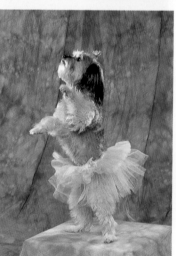

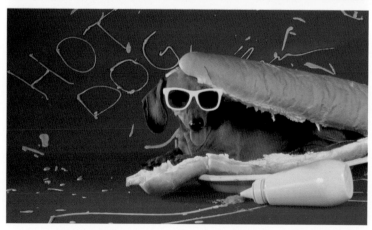

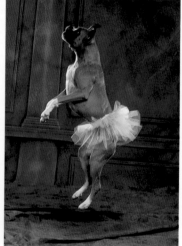

Ron Kimball Photography • 1960 Colony Street, Mountain View, California 94043 • 415/969-0682

RON KIMBALL STOCK

ADVERTISING ANIMALS

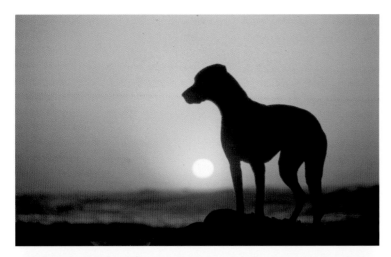

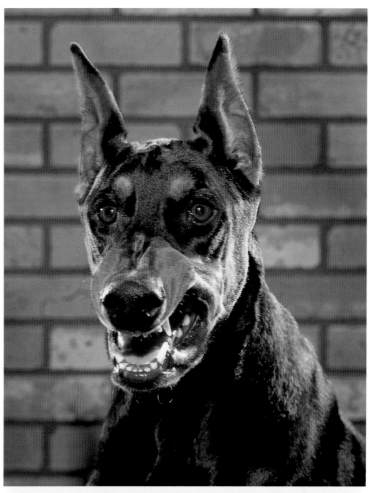

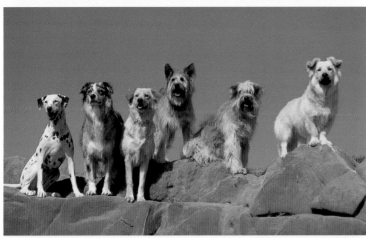

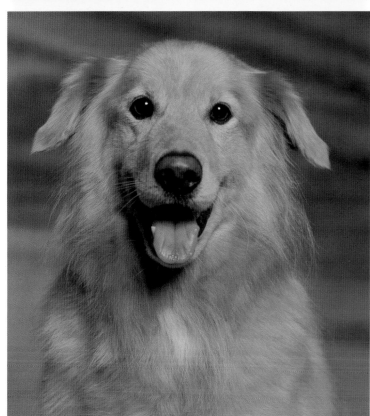

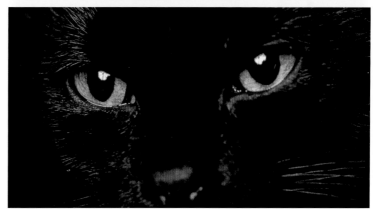

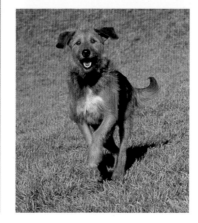

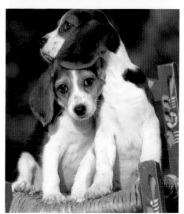

ADVERTISING ANIMALS
If we don't have it, we can shoot it!

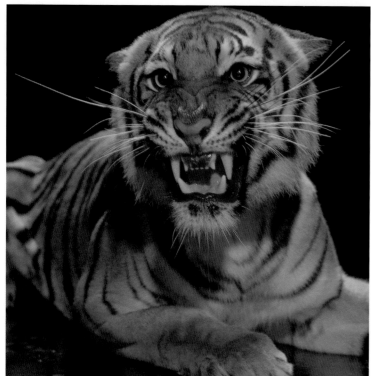
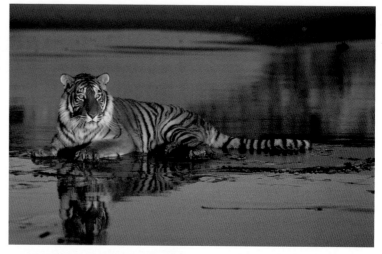

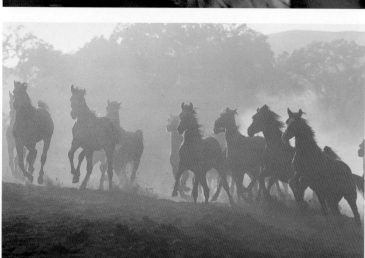

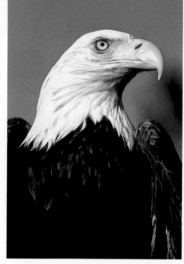

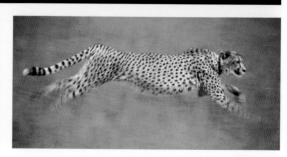

Ron Kimball Photography • 1960 Colony Street, Mountain View, California 94043 • 415/969-0682

RON KIMBALL STOCK

ADVERTISING ANIMALS

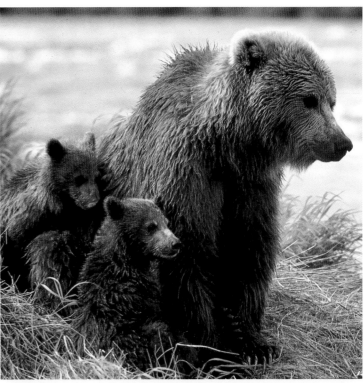

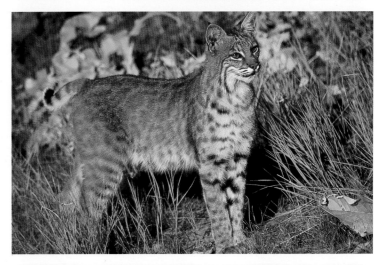

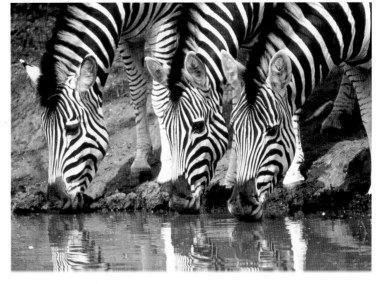

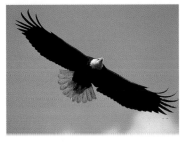

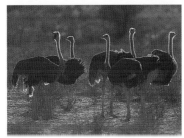

© 1993 CHARLIE AND RITA SUMMERS

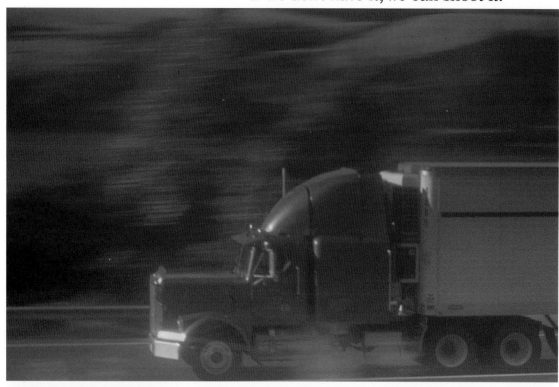

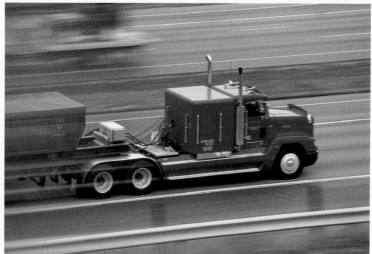

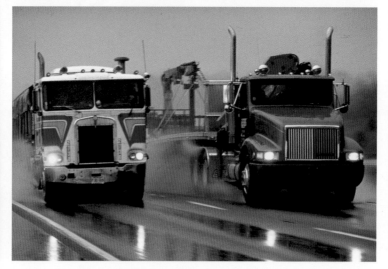

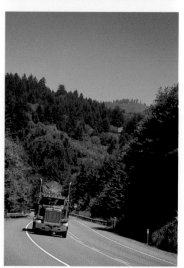

© 1993 BETTE S. GARBER

© Marion Stirrup / Girl Outdoors with Computer

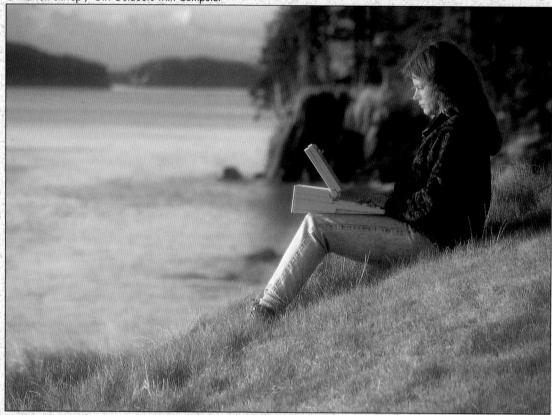

© John Warden / Caribou and Mountains

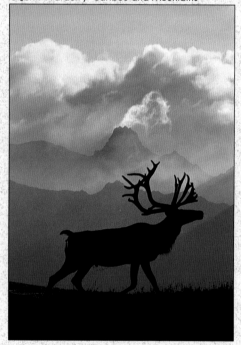

© Arend-Pinkerton / Campers and Lake

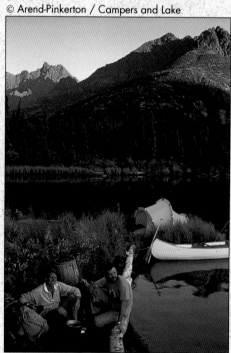

© Johnny Johnson / Timber Wolf

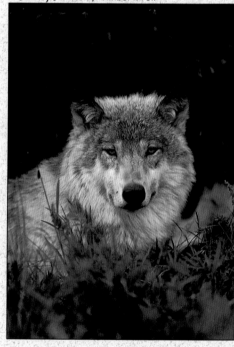

© John Warden / Caribou & Northern Lights

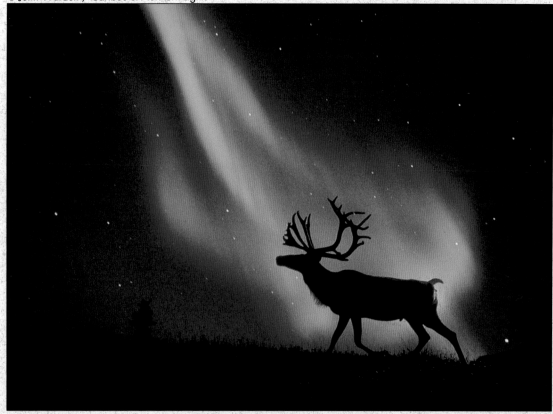

© Jeff Schultz / Canoeist at Sunrise

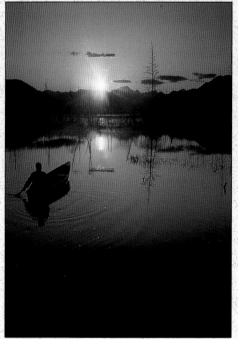

© Randy Brandon / Christmas Tree in Forest

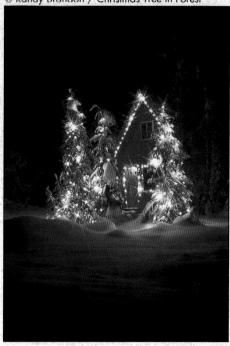

© Chris Arend / Highway and Mountains

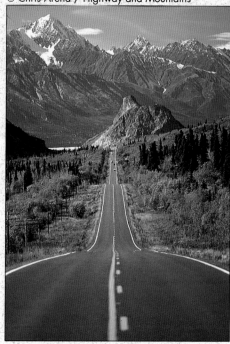

© Mark Kelley / Salmon Migration

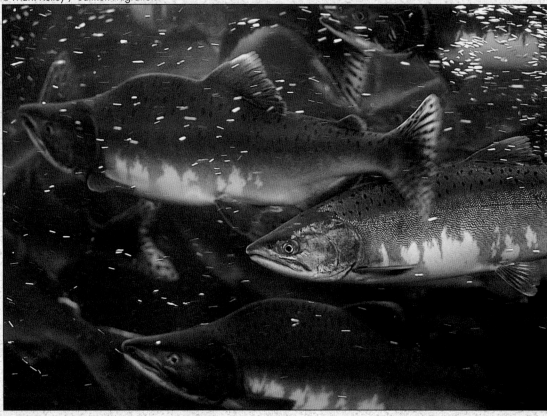

© Jeff Schultz / Crevasse Climber

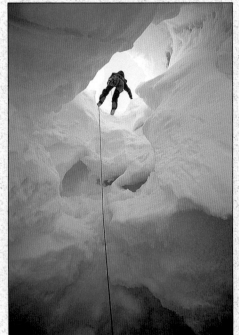

© Johnny Johnson / Penguin

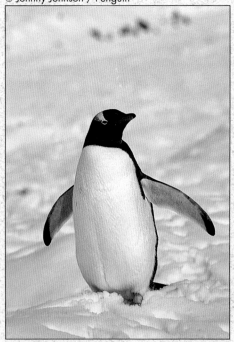

© Jeff Schultz / Dog Mushing

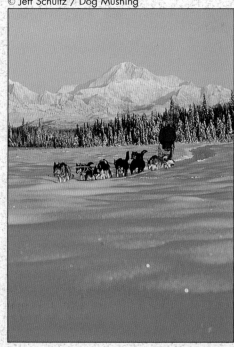

AlaskaStock
I M A G E S

1-800-487-4285 • 907-276-1343
800 West 21st Avenue, Anchorage, Alaska 99503 FAX:(907)258-7848

© Johnny Johnson / King Penguins

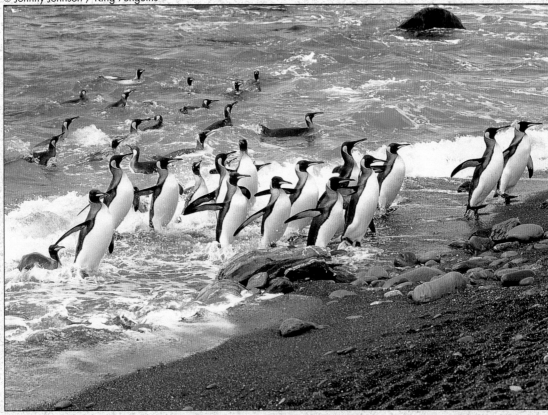

© Mark Kelley / Kayaker in Mountain Lake

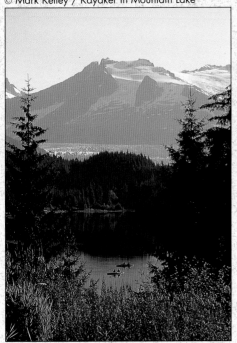

© Steven L. Nelson / Horse-Drawn Sleigh Ride

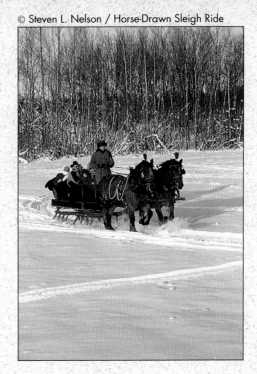

© Clark Mishler / Couple in Rowboat

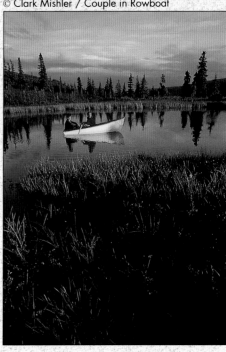

AlaskaStock
IMAGES

1-800-487-4285 • 907-276-1343
800 West 21st Avenue, Anchorage, Alaska 99503 FAX:(907)258-7848

© John Hyde / Bald Eagle in Flight

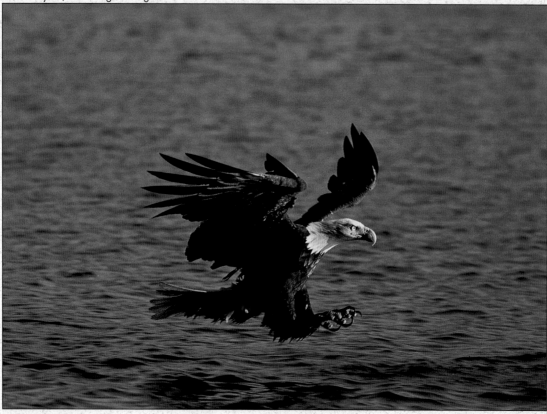

© Randy Brandon / Iceberg & Mountain

© Tom Soucek / Sunset over Ocean

© Johnny Johnson / Spring Buds

AlaskaStock
I M A G E S

1-800-487-4285 • 907-276-1343
800 West 21st Avenue, Anchorage, Alaska 99503 FAX:(907)258-7848

© Tom Evans / Ice Climber

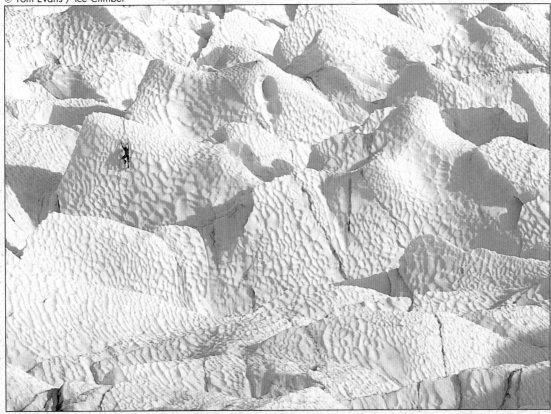

© Michael DeYoung / Vehicles in Snowstorm

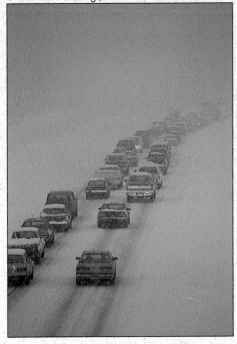

© Clark Mishler / Pleasure Boater

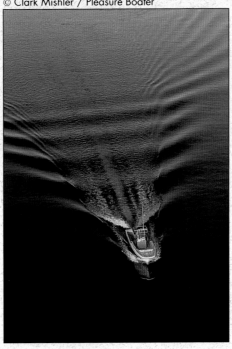

© Cliff Riedinger / Snowstorm Snowblower

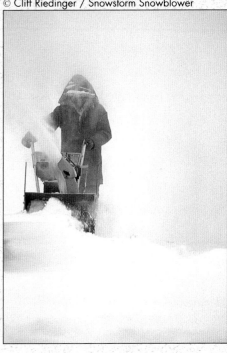

AlaskaStock
IMAGES

1-800-487-4285 • 907-276-1343
800 West 21st Avenue, Anchorage, Alaska 99503 FAX:(907)258-7848

Printed in Japan

© Mark Kelley / Girl with Salmon

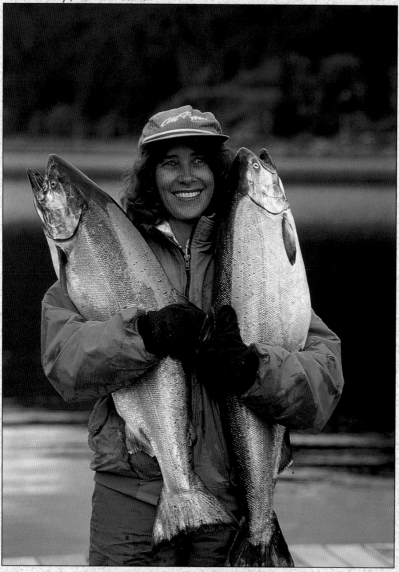

© Clark Mishler / Man & Snowbound Cars

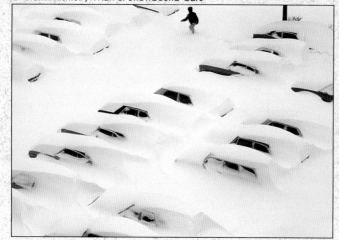

© John Warden / Bald Eagle Over Forest

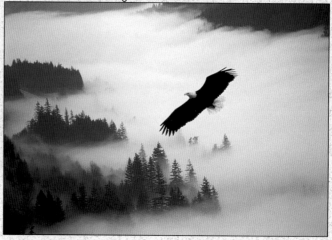

© Jeff Schultz / Igloo

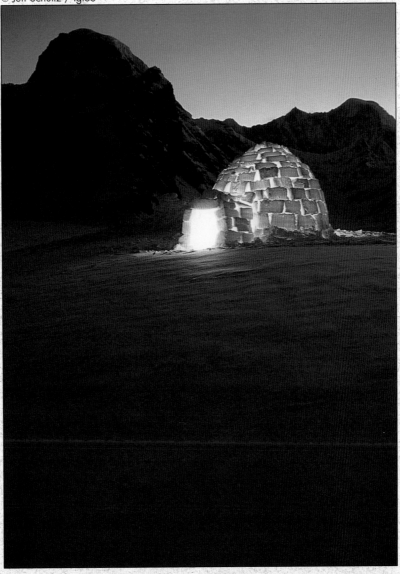

© Richard Johnson / Killer Whale Breaching

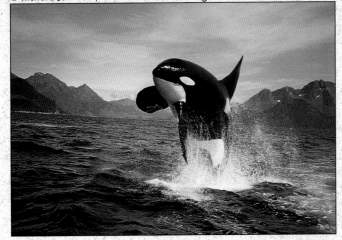

© Chris Arend / Eskimo Hunter on Ice

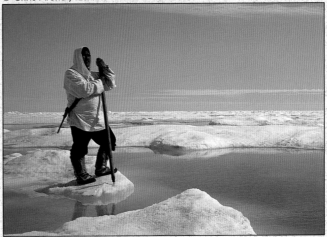

AlaskaStock
IMAGES

1-800-487-4285 • 907-276-1343

800 West 21st Avenue, Anchorage, Alaska 99503 FAX:(907)258-7848

© Mark Kelley / Man Viewing Mountains

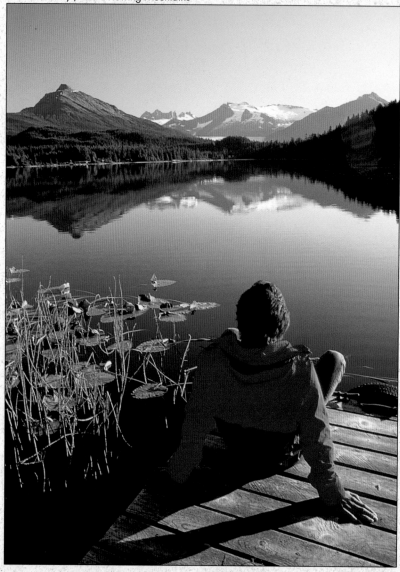

© Chris Arend / Water Reflection

© John Warden / Grizzly Bear Growling

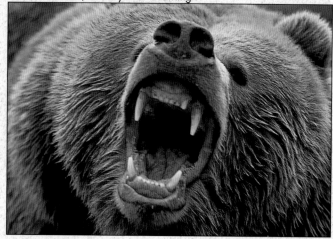

AlaskaStock
I M A G E S

1-800-487-4285 • 907-276-1343
800 West 21st Avenue, Anchorage, Alaska 99503 FAX:(907)258-7848

370

Peter Arnold, Inc.

THE INTERNATIONAL PHOTO AGENCY

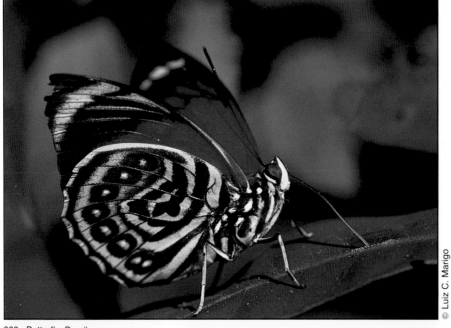

© Luiz C. Marigo

660 Butterfly, Brazil

© Günter Ziesler

662 Fern, Olympic National Park

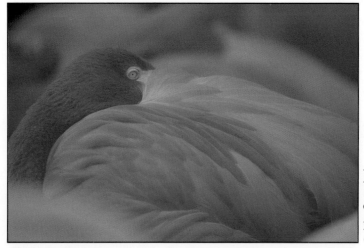

© John Cancalosi

663 Greater Flamingo

© Kevin Schafer

664 Tulip

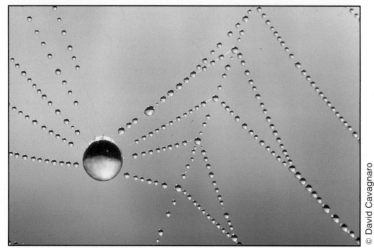

© David Cavagnaro

665 Dew on Garden Spider Web

© Stephen J. Krasemann

661 Swift River, White Mountains, New Hampshire

1181 BROADWAY, NEW YORK, NY 10001 212/481-1190 FAX: 212/481-3409 800/289-7468

Peter Arnold, Inc.
THE INTERNATIONAL PHOTO AGENCY

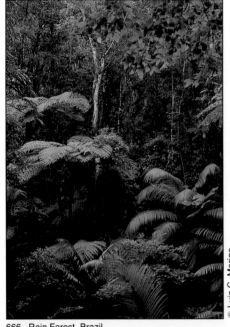

© Luiz C. Marigo

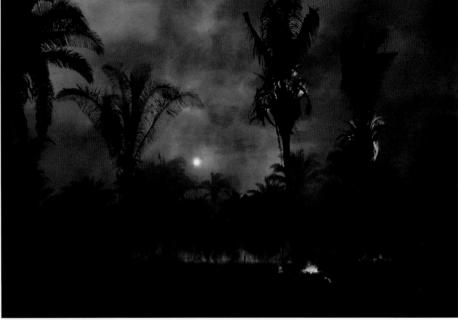

© Peter May

666 Rain Forest, Brazil

667 Burning Palms, Brazil

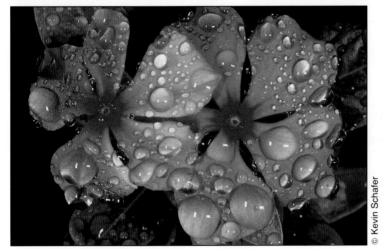

© Kevin Schafer

© Kevin Schafer/Martha Hill

668 Rosy Periwinkle, Medicinal Plant

669 La Paz Waterfall, Costa Rica

© Jacques Jangoux

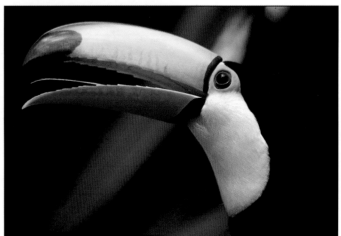

© Kevin Schafer/Martha Hill

670 Tree Fern, Rain Forest, Columbia

671 Toco Toucan, Amazon River, Brazil

1181 BROADWAY, NEW YORK, NY 10001 **212/481-1190** **FAX: 212/481-3409** **800/289-7468**

Peter Arnold, Inc.
THE INTERNATIONAL PHOTO AGENCY

UNDERWATER

© Jeff Rotman

672 Scorpionfish, Red Sea

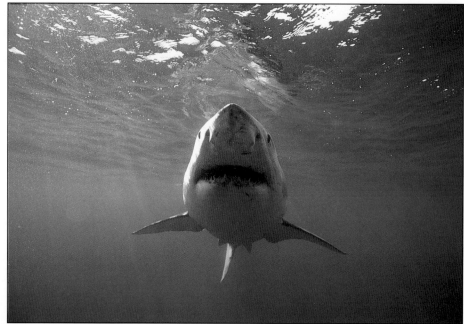
© Kelvin Aitken

673 Great White Shark, Australia

© Norbert Wu

674 Diver, Grand Cayman

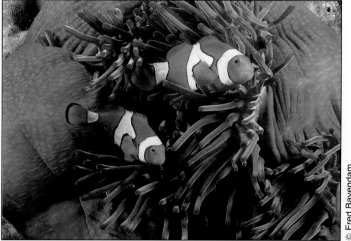
© Fred Bavendam

675 Clown Anemonefish, Papua New Guinea

© Kelvin Aitken

676 Divers on Coral Reef, Australia

© Norbert Wu

677 Sea Bottom, Baja California, Mexico

© Norbert Wu

678 Viperfish Chasing Hatchetfish

1181 BROADWAY, NEW YORK, NY 10001 **212/481-1190** **FAX: 212/481-3409** **800/289-7468**

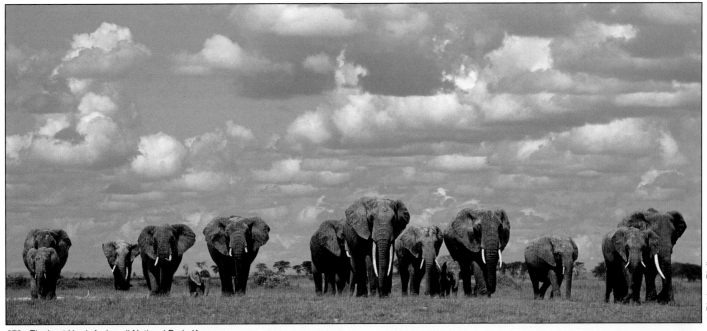

679 Elephant Herd, Amboseli National Park, Kenya

© Dianne Blell

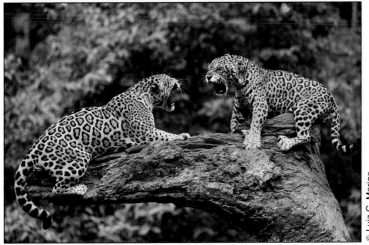

680 Fighting Jaguars, Brazil

© Luiz C. Marigo

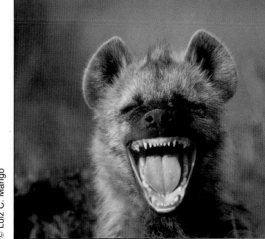

681 Hyena

© Yann Arthus-Bertrand

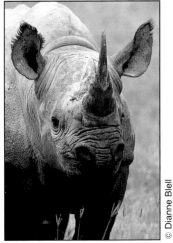

682 Black Rhinoceros

© Dianne Blell

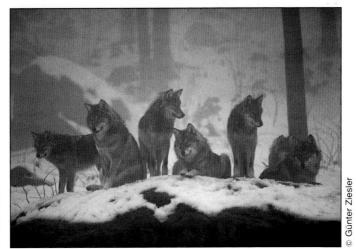

683 Wolves, Bavarian Forest National Park, Germany

© Günter Ziesler

684 Japanese Snow Monkeys

© Steve Kaufman

Peter Arnold, Inc.

THE INTERNATIONAL PHOTO AGENCY

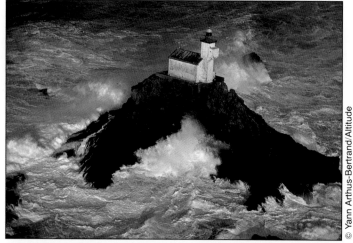

© Yann Arthus-Bertrand/Altitude

685 Lighthouse, Brittany, France

© Jim Wark

686 Monument Valley, Utah

© Jeri Gleiter

687 Combining Wheat, Kansas

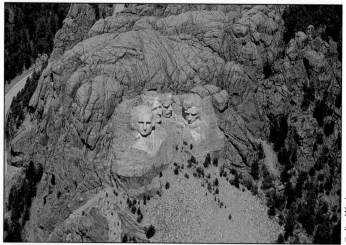

© Jim Wark

688 Mount Rushmore, South Dakota

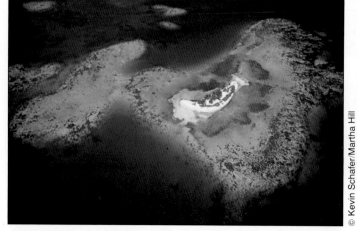

© Kevin Schafer/Martha Hill

689 Tropical Island, Caribbean

© Alex S. MacLean

690 Scituate Reservoir in Fall, Rhode Island

1181 BROADWAY, NEW YORK, NY 10001 212/481-1190 **FAX: 212/481-3409** 800/289-7468

Peter Arnold, Inc.

THE INTERNATIONAL PHOTO AGENCY

691 Smog, Santiago de Chile, Chile

© Richard Weiss

© Horst Schafer

692 Junkyard

© Ray Pfortner

693 Paper Mill/Air Pollution, New York

© Ray Pfortner

694 Sanitary Landfill, New Jersey

© Luiz C. Marigo

695 Deforestation, Brazil

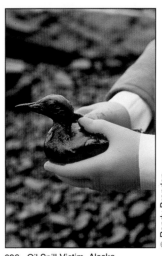

© Randy Brandon

696 Oil Spill Victim, Alaska

1181 BROADWAY, NEW YORK, NY 10001 **212/481-1190** **FAX: 212/481-3409** **800/289-7468**

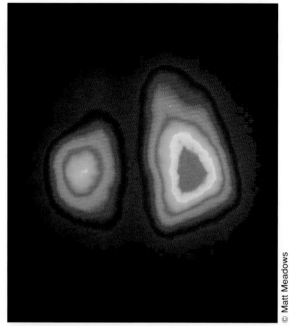

© Matt Meadows

697 Nuclear Medicine/Perfusion Lung Scan

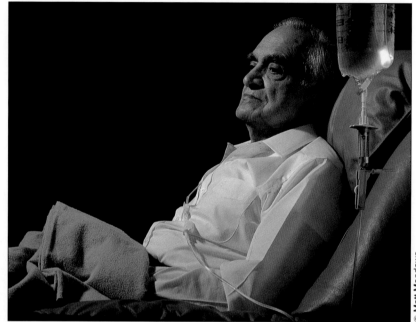

© Matt Meadows

698 Cancer Chemotherapy

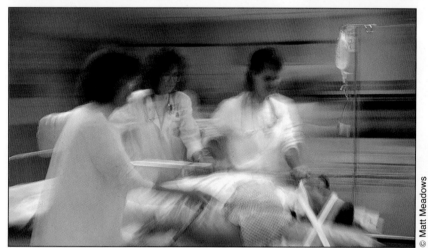

© Matt Meadows

699 En Route to Emergency Room

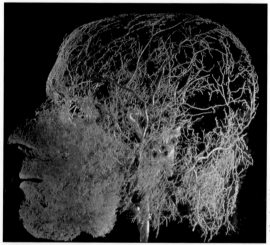

© Manfred Kage

700 Circulatory System In Head

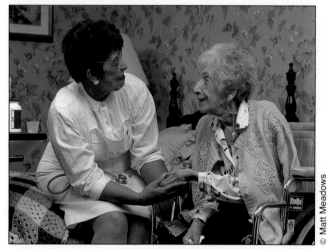

© Matt Meadows

701 Nurse with 101 Year-Old Patient, Nursing Home

© Matt Meadows

702 Hematology Technician Testing Blood Sample

Peter Arnold, Inc.
THE INTERNATIONAL PHOTO AGENCY

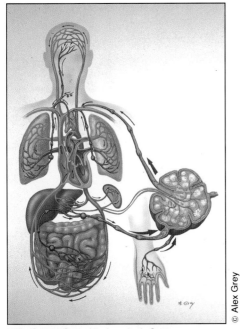

703 Organs Served by Lymphatic System

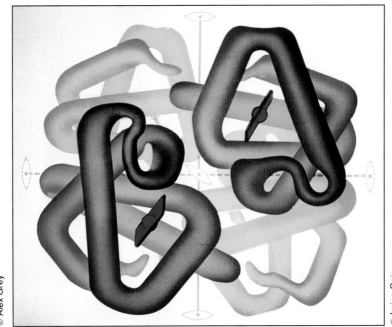

704 Folded Protein Structure of Hemoglobin

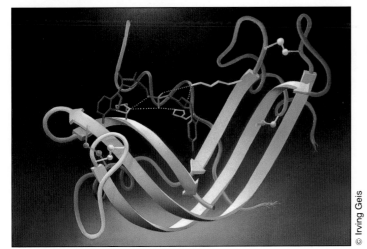

705 Enzyme, Ribonuclease-S Showing Folding Pattern

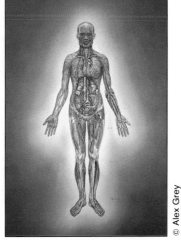

706 Complete Lymphatic System

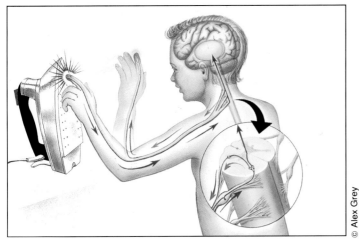

707 Pain Perception and Reaction-Nervous System

708 Neural Impulse Pathway

1181 BROADWAY, NEW YORK, NY 10001 212/481-1190 FAX: 212/481-3409 800/289-7468

Peter Arnold, Inc.

THE INTERNATIONAL PHOTO AGENCY

709 Influenza Virus in Tissue (250,000x)

710 Virtual Reality in Space Flight Simulator

711 Segment of DNA Double Helix

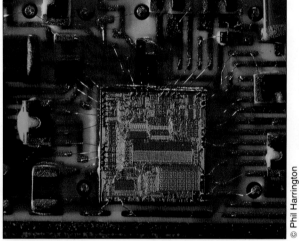

712 Computer Chip

713 4-Megabyte Wafer

714 Ultraviolet Fluorescence

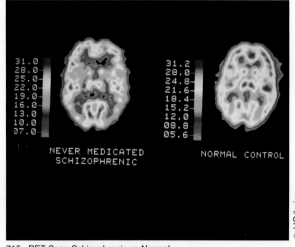

NEVER MEDICATED
SCHIZOPHRENIC

NORMAL CONTROL

715 PET Scan-Schizophrenic vs Normal

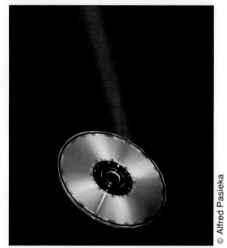

716 Compact Disc with Laser Beam

1181 BROADWAY, NEW YORK, NY 10001 **212/481-1190** **FAX: 212/481-3409** **800/289-7468**

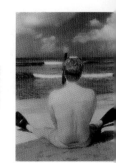

telephone
206.622.6262

facsimile
206.622.6662

toll free
1.800.248.8116

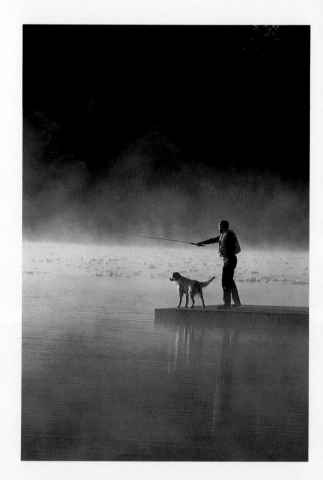

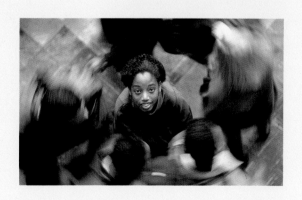

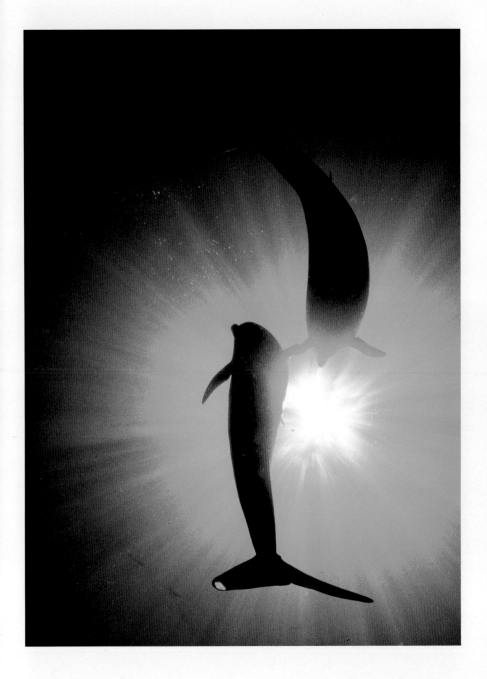

telephone
206.622.6262

facsimile
206.622.6662

toll free
1.800.248.8116

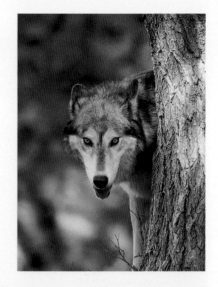

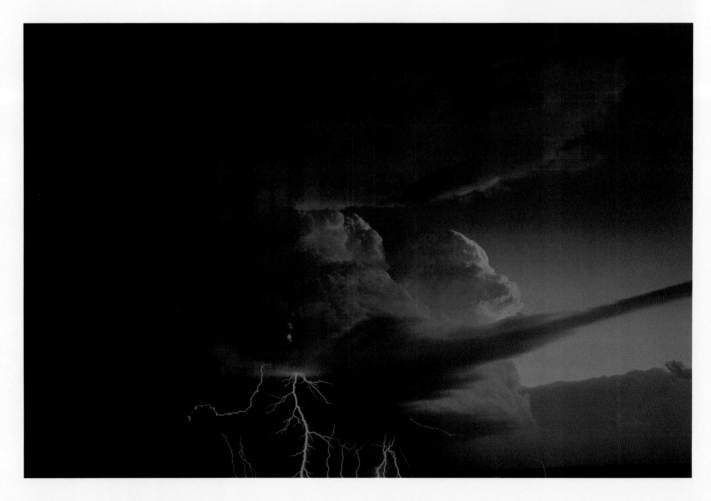

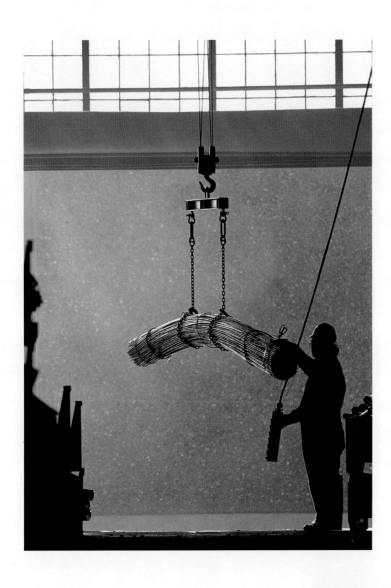

Some people think

our new catalog,

"Words & Pictures,"

is actually an art book.

Call, write, fax, send a runner.

It's big, it's gorgeous,

and it's free.

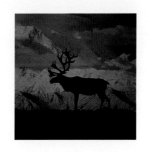

telephone
206.622.6262

facsimile
206.622.6662

toll free
1.800.248.8116

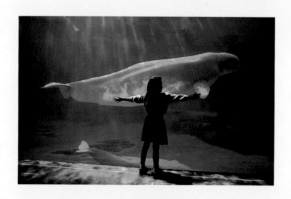

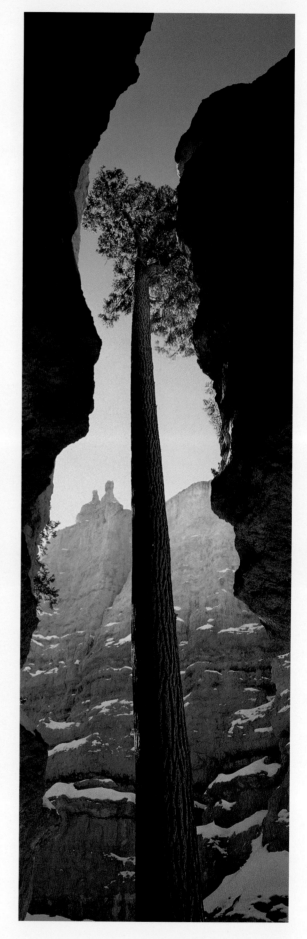

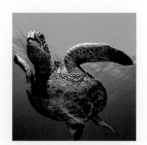

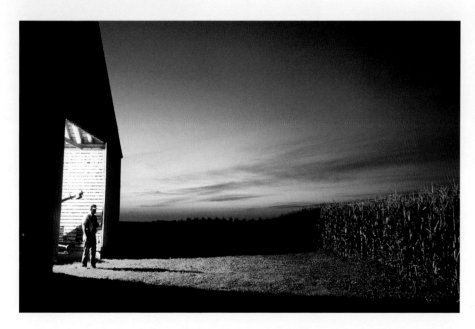

telephone
206.622.6262

facsimile
206.622.6662

toll free
1.800.248.8116

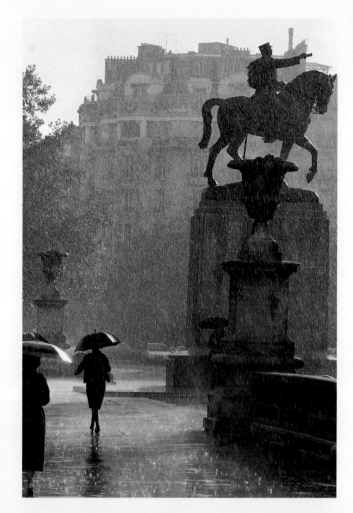

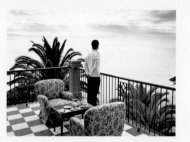

This business is drowning in

look-alike images. Don't you

deserve more than generic mush?

When you're ready for stock that

doesn't look like stock, call AllStock.

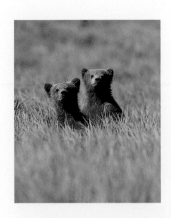

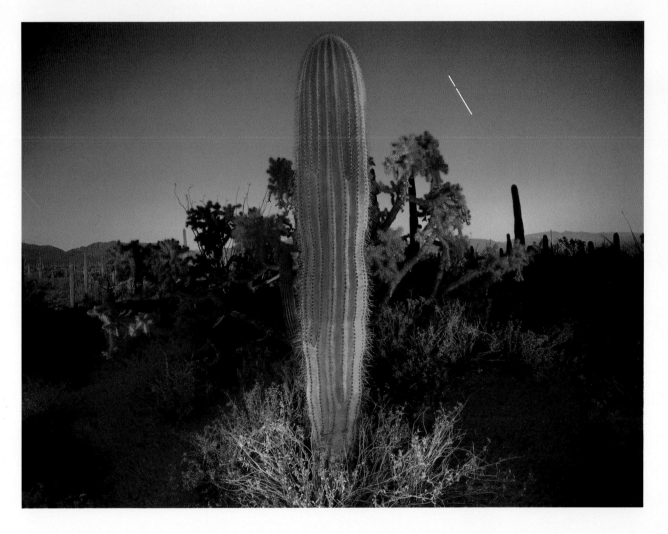

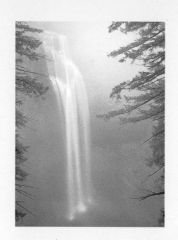

ALLSTOCK

BEYOND STOCK PHOTOGRAPHY

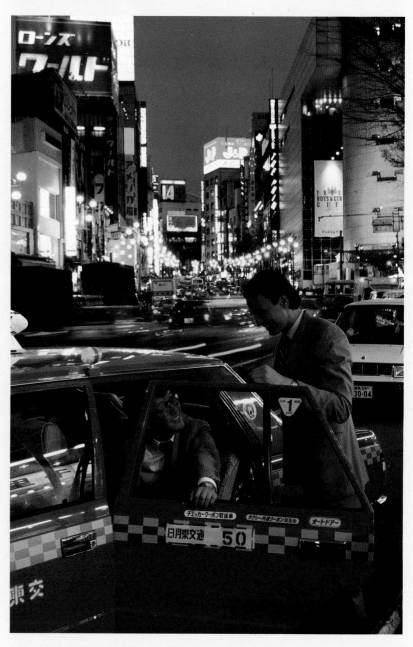

telephone

206.622.6262

facsimile

206.622.6662

toll free

1.800.248.8116

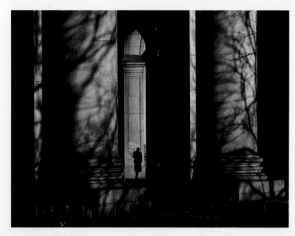

{ *no research fee* }

Tad Tucker

Larry Pierce

Adina Tovy Amsel

Larry Pierce

Larry Pierce

[**PHOTOGRAPHIC RESOURCES**]

toll free 1 800 933 5838

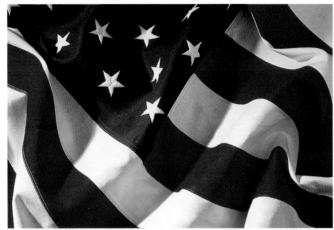

Bruce Mathews

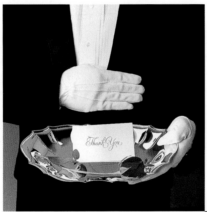

Terry Farmer

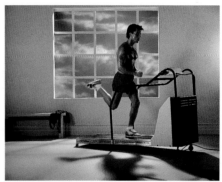

John Anderson

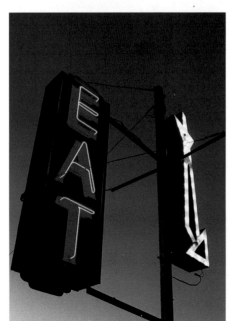

Tom Ebenhoh

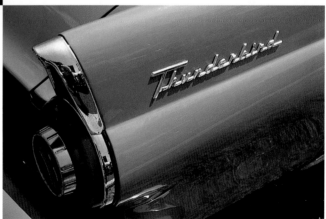

Tom Ebenhoh

{ *no research fee* }

Sam Sargent

toll free 1 800 933 5838

Natalie Pelafos

Chet Hanchett

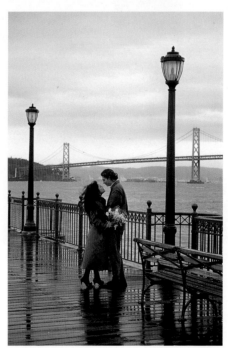

Curtis Martin

Sam Sargent

[P H O T O G R A P H I C R E S O U R C E S]

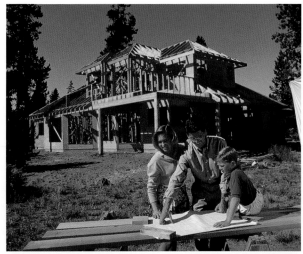

Michael Houska

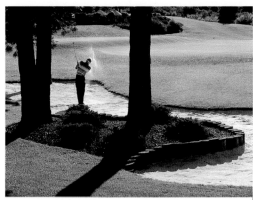

Michael Houska

Dan Rockafellow

Tom Tracy

Terry Farmer

toll free 1 800 933 5838

{ n o r e s e a r c h f e e }

Chet Hanchett

Chet Hanchett

Kim Frazier

Tom Tracy

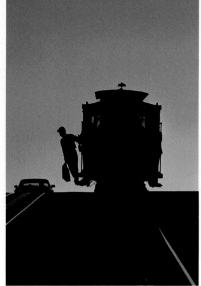

Sam Sargent

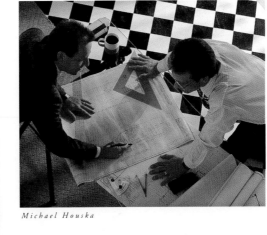

Michael Houska

Tom Tracy

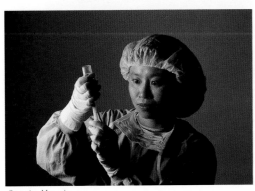

Curtis Martin

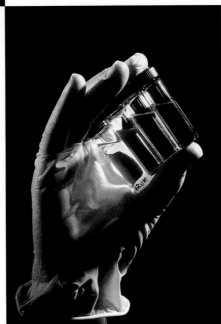

Jim Argo

Dan Rockafellow

[P H O T O G R A P H I C R E S O U R C E S]

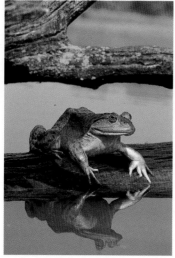

Frank Oberle

Frank Oberle

Frank Oberle

Garry M^cMichael

Terry Farmer

[PHOTOGRAPHIC RESOURCES]

Jim Argo

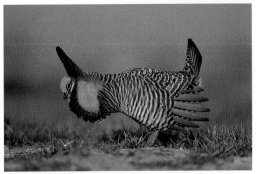

Frank Oberle

Frank Oberle

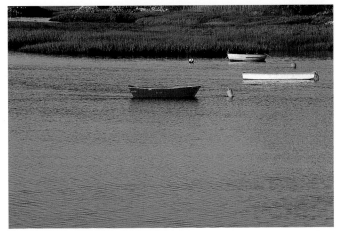

Tad Tucker

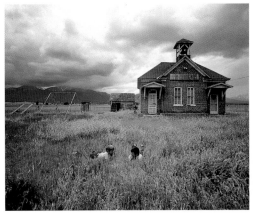

Frank Oberle

toll free 1 800 933 5838

{ *no research fee* }

no research fee

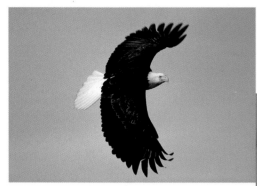

Frank Oberle (series)

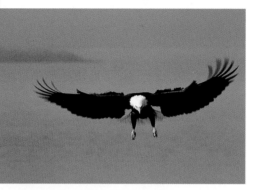

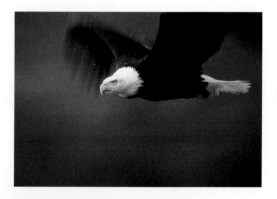

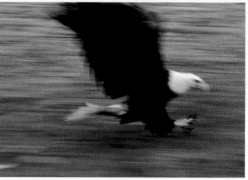

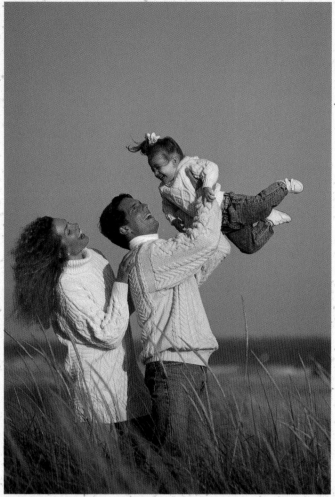

WB-P284 © Michael Keller

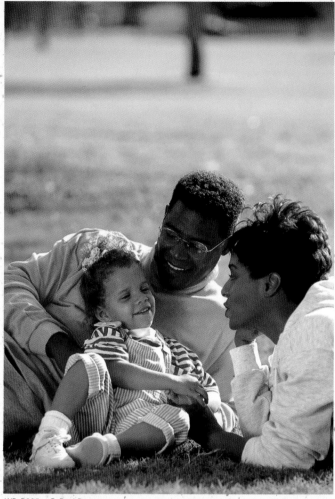

WB-P285 © Paul Barton

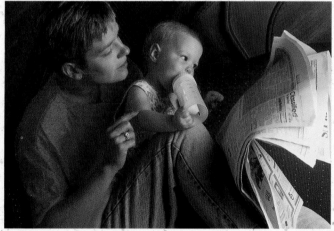

WB-P286 © Mug Shots

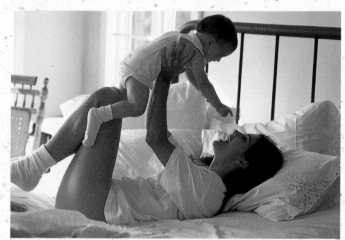

WB-P287 © Ariel Skelley

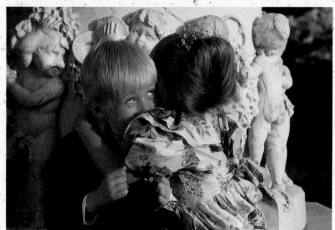

WB-P288 © Phil Kramer

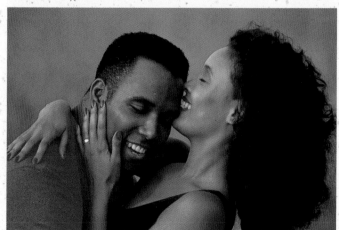

WB-P289 © Roy Morsch

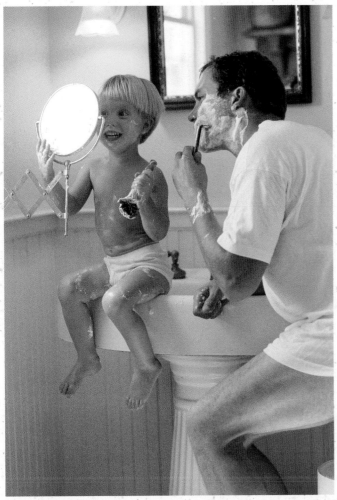

WB-P290 © Ariel Skelley

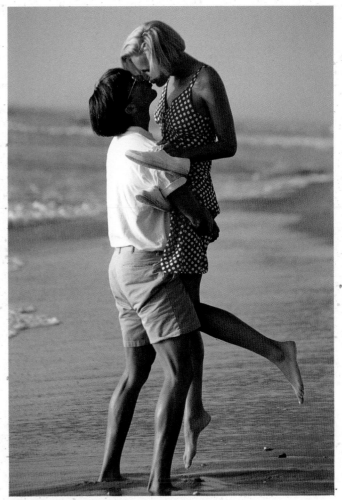

WB-P291 © Ariel Skelley

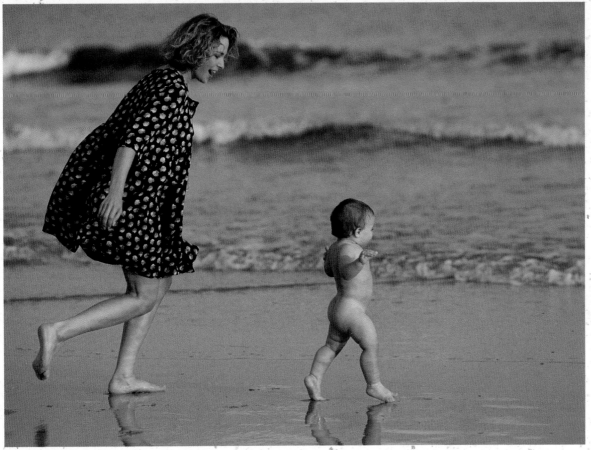

WB-P292 © Michael Keller

403

WB-P293 © Paul Barton

WB-P294 © Paul Barton

WB-P295 © Tom Stewart

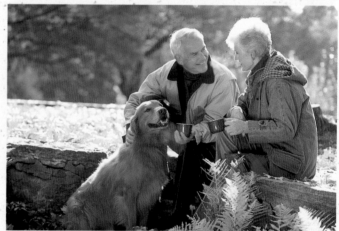

WB-P296 © Paul Barton

WB-P297 © John Curtis

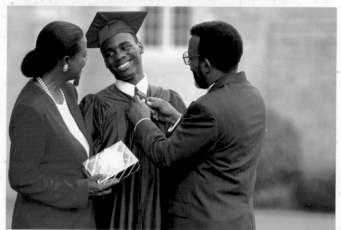

WB-P298 © Paul Barton

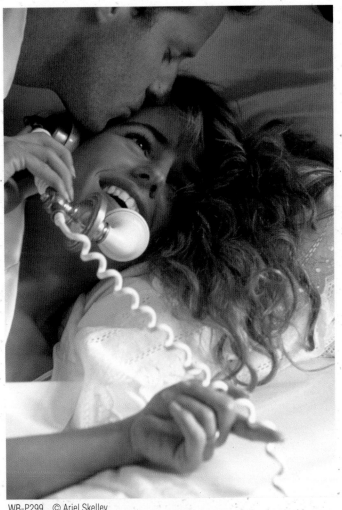

WB-P299 © Ariel Skelley

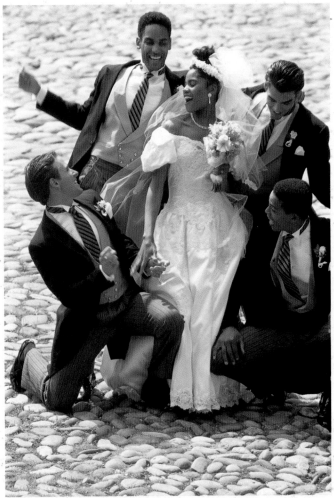

WB-P300 © Phil Kramer

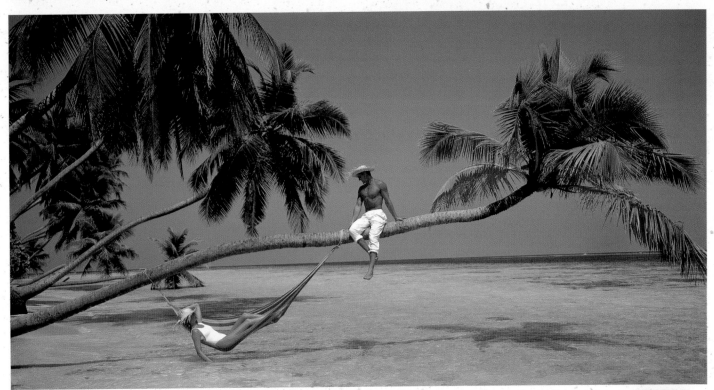

WB-P301 © Paul Steel

Send for our free 216 page color catalog

THE STOCK MARKET®

FAX 800-283-0808

800-999-0800

405

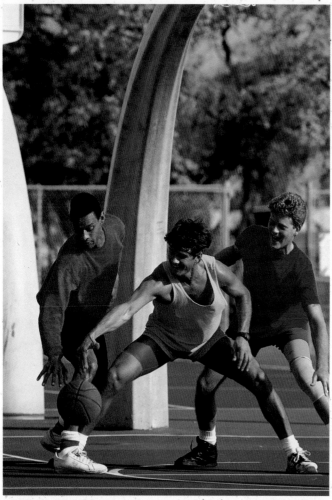

WB-SP302 © Robert Cerri

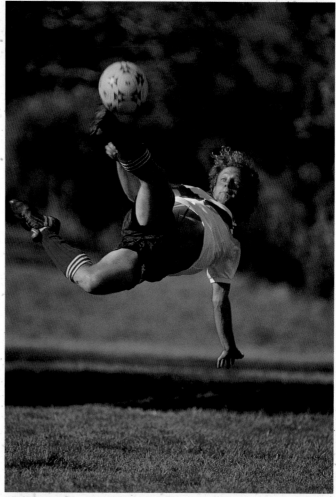

WB-SP303 © Anne-Marie Weber

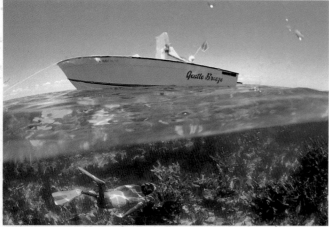

WB-SP304 © Stephen Frink

WB-SP305 © Anne-Marie Weber

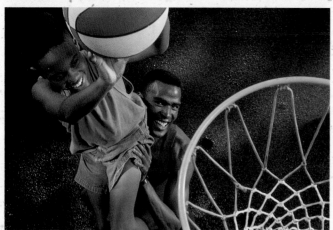

WB-SP306 © Mug Shots

WB-SP307 © Anne-Marie Weber

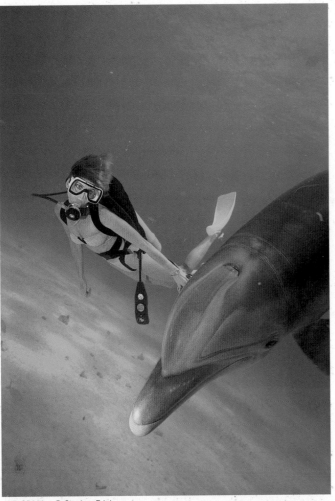

WB-SP308 © Stephen Frink

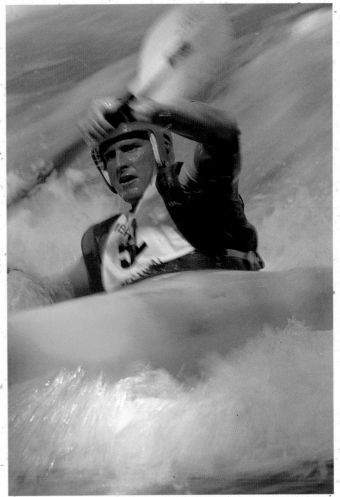

WB-SP309 © Anne-Marie Weber

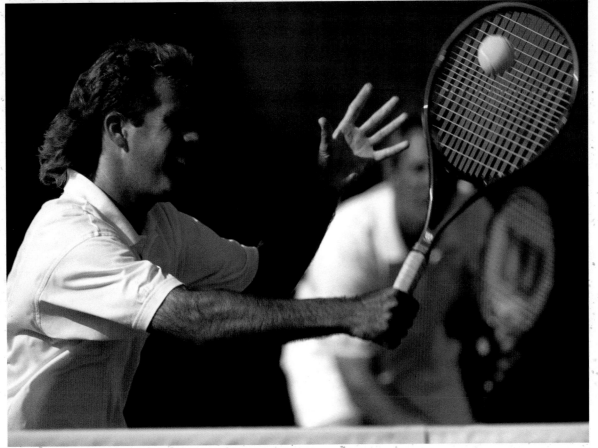

WB-SP310 © Jon Feingersh

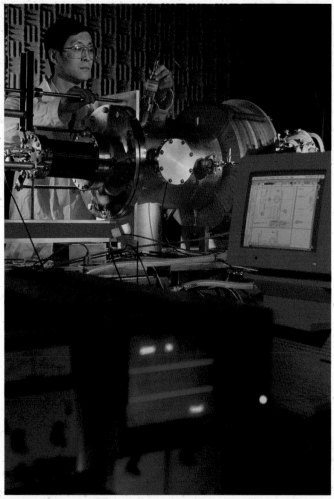

WB-S311 © Jean Miele

WB-B312 © Mug Shots

WB-B313 © Mug Shots

WB-B314 © Mug Shots

WB-B315 © Jon Feingersh

WB-B316 © Jon Feingersh

WB-CP317 © Myron J. Dorf

WB-MD318 © Bruno

WB-MD319 © David Woods

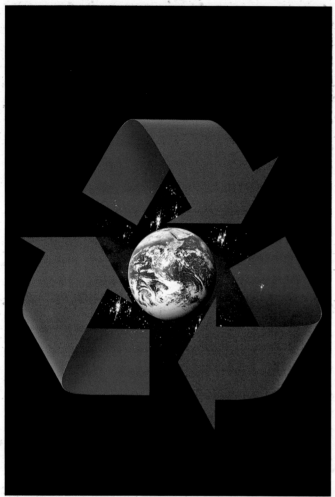

WB-CP320 © Myron J. Dorf

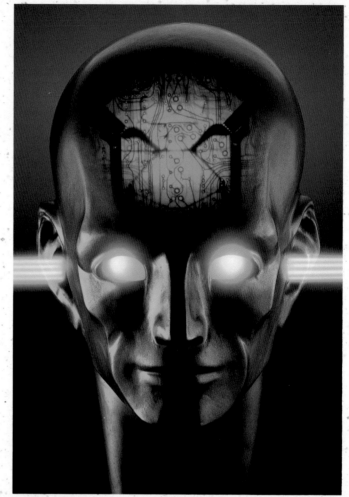

WB-CP321 © Bruno

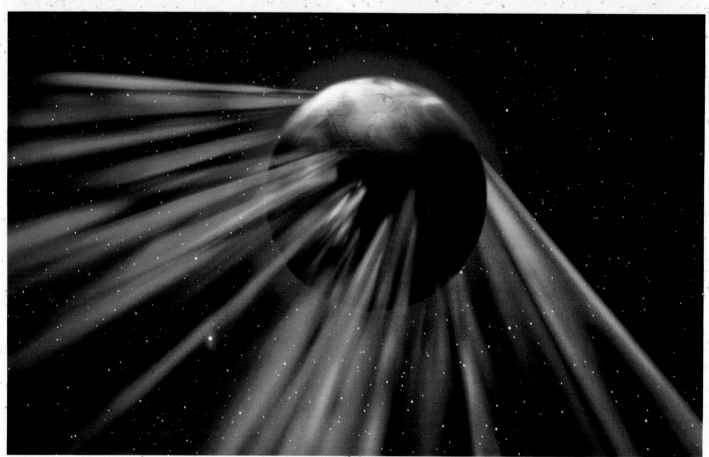

WB-CP322 © Lightscapes

WB-CP323 © Bruno

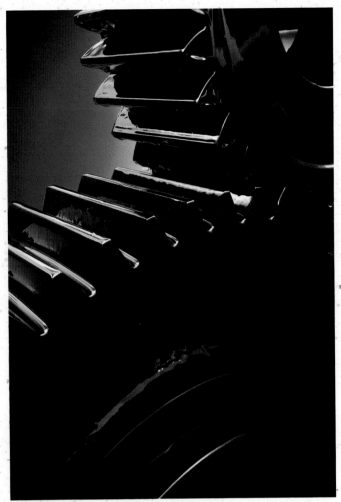

WB-CP324 © Bruno

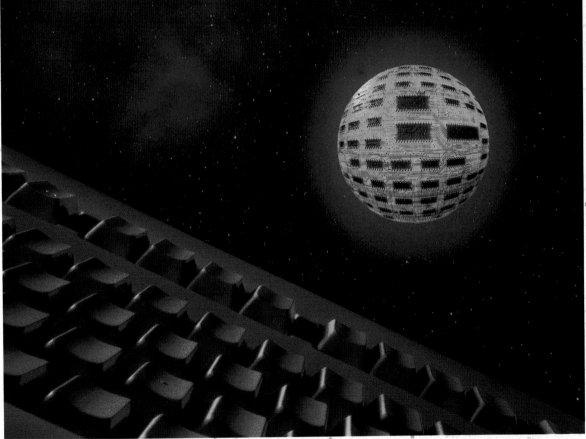

WB-CP325 © Lightscapes

411

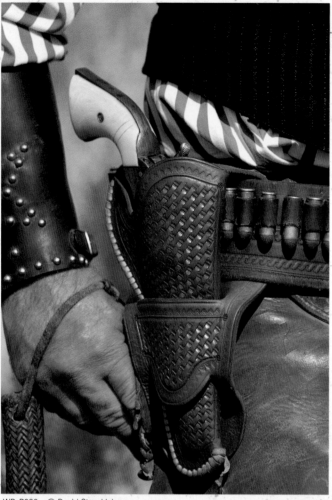
WB-P326 © David Stoecklein

WB-P327 © David Stoecklein

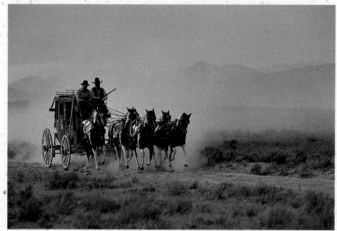
WB-P328 © David Stoecklein

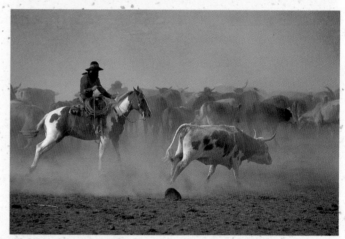
WB-P329 © David Stoecklein

WB-P330 © David Stoecklein

WB-P331 © David Stoecklein

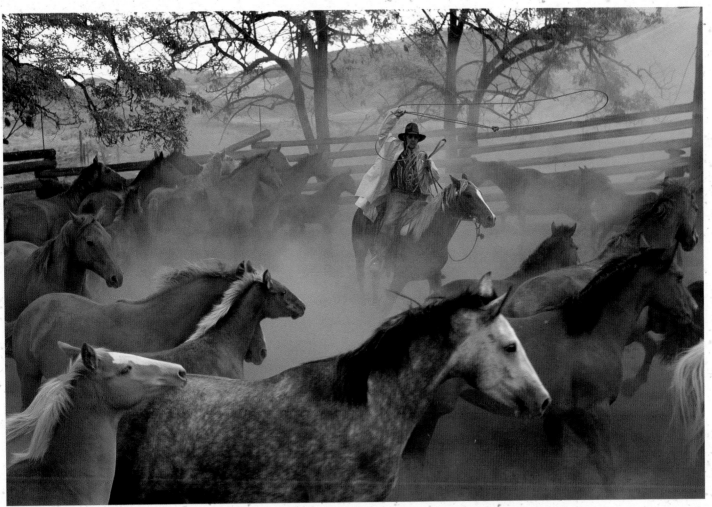

WB-P332 © David Stoecklein

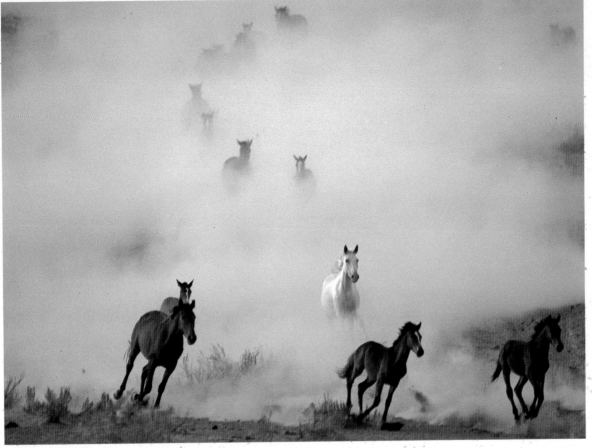

WB-A333 · © David Stoecklein

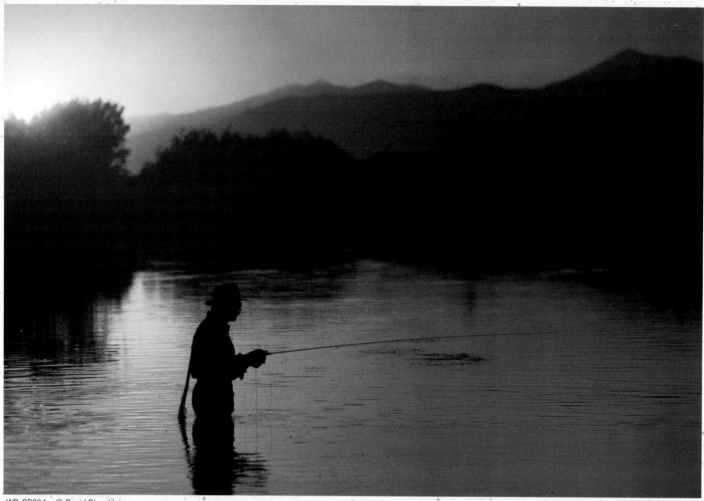

WB-SP334 © David Stoecklein

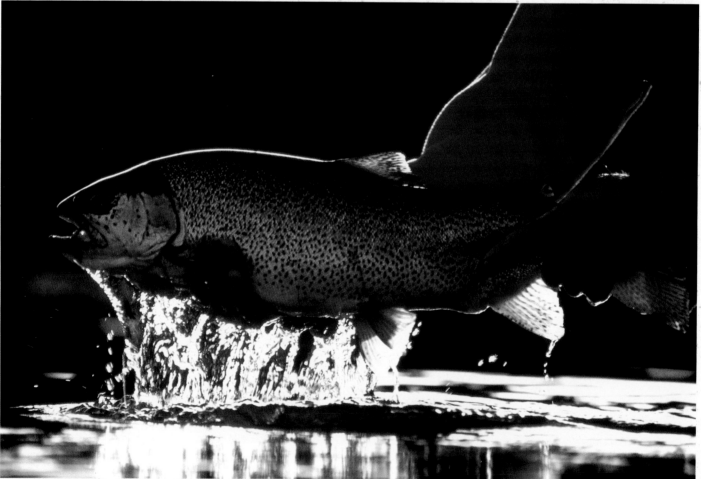

WB-SP335 © David Stoecklein

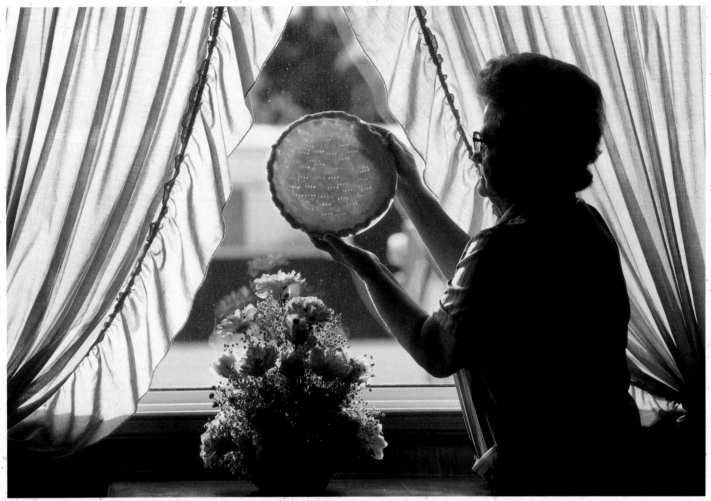

WB-P336 © David Burnett

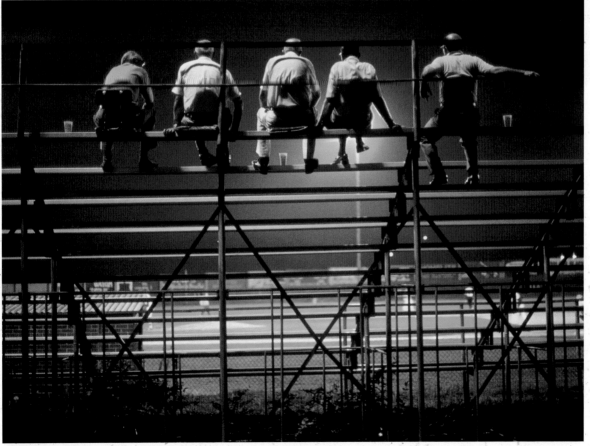

WB-SP337 © David Burnett

415

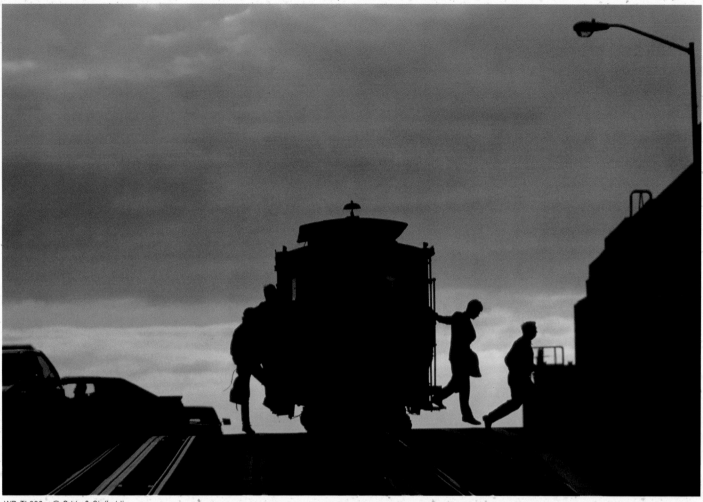

WB-TL338 © Oddo & Sinibaldi

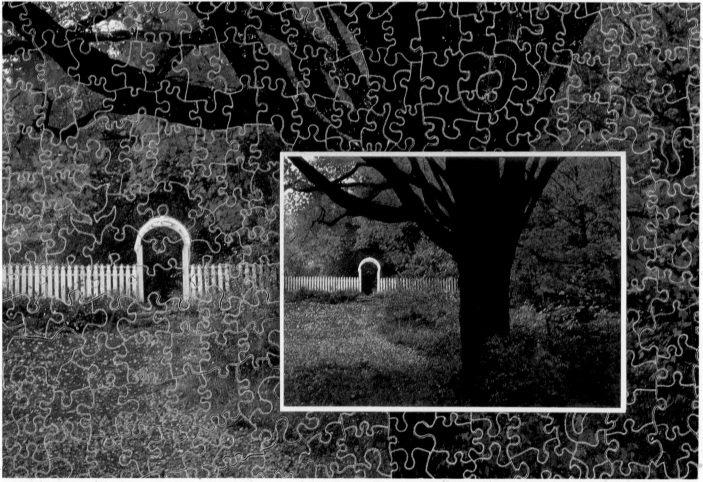

WB-CP339 © Bill Binzen

WB-T340 © Douglas T. Mesney

WB-T341 © Dilip Mehta

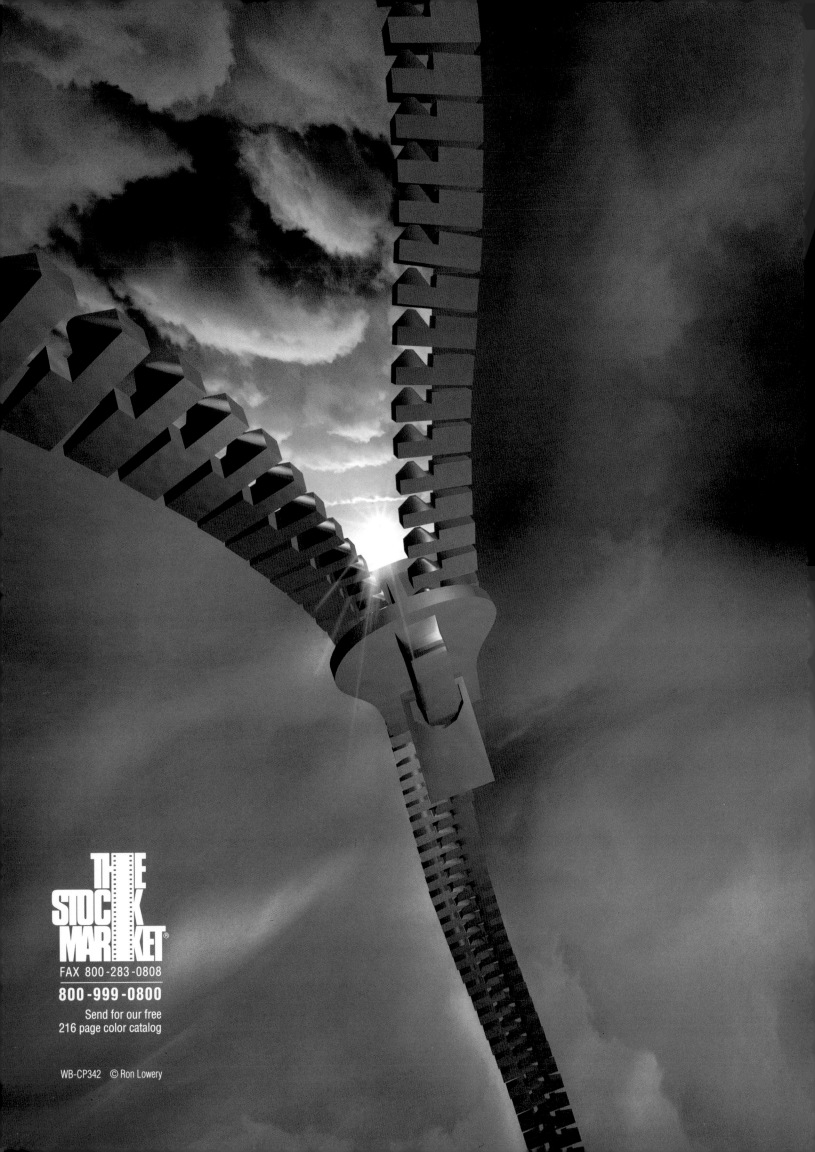

JAY MAISEL PHOTOGRAPHY

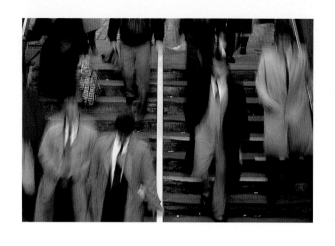
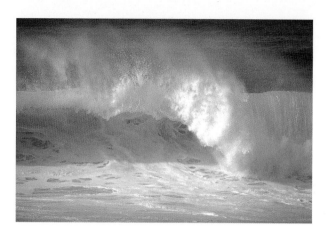
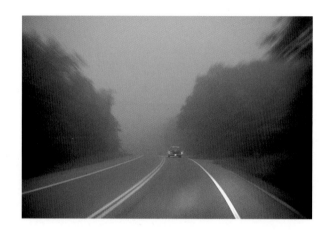
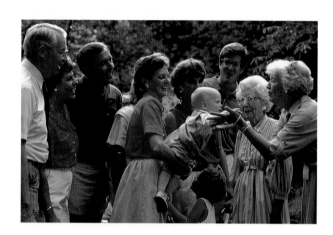

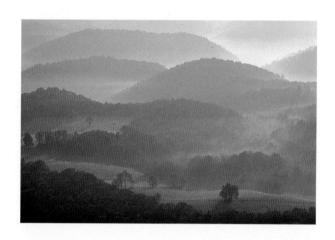

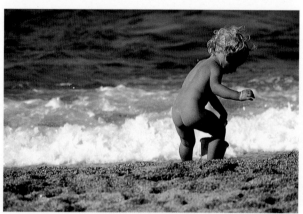

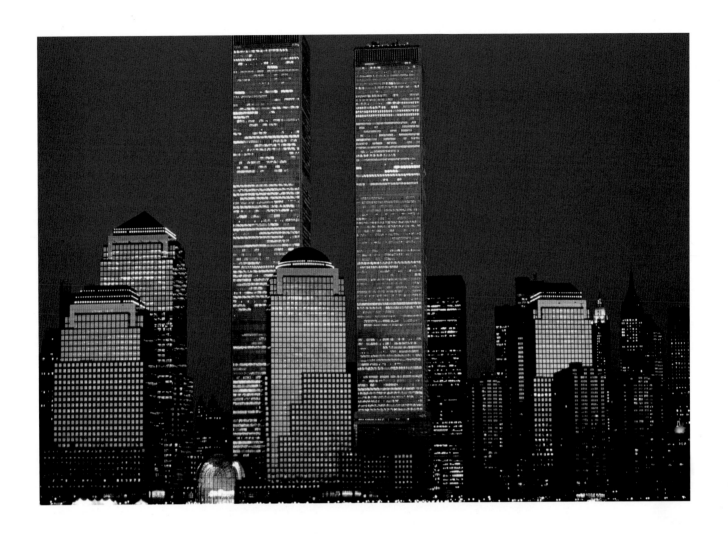

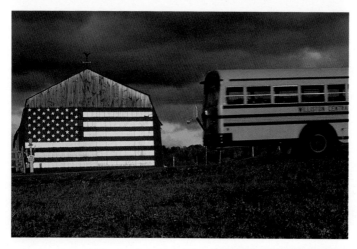

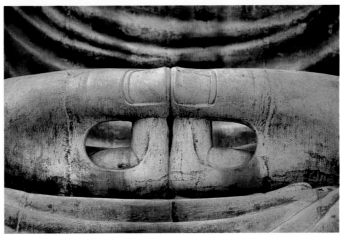

OR WRITE ON YOUR LETTERHEAD FOR OUR MAXIFOLIO. JAY MAISEL, 190 BOWERY N.Y., N.Y. 10012. FAX (212) 925-6092

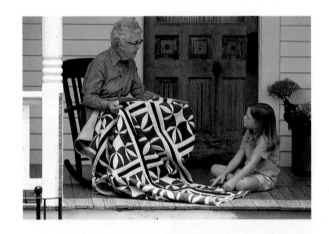
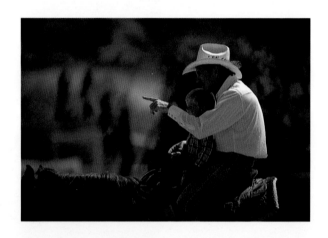
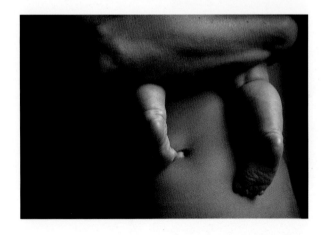

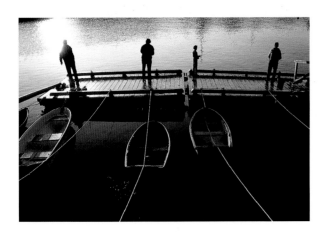
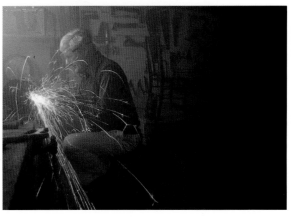

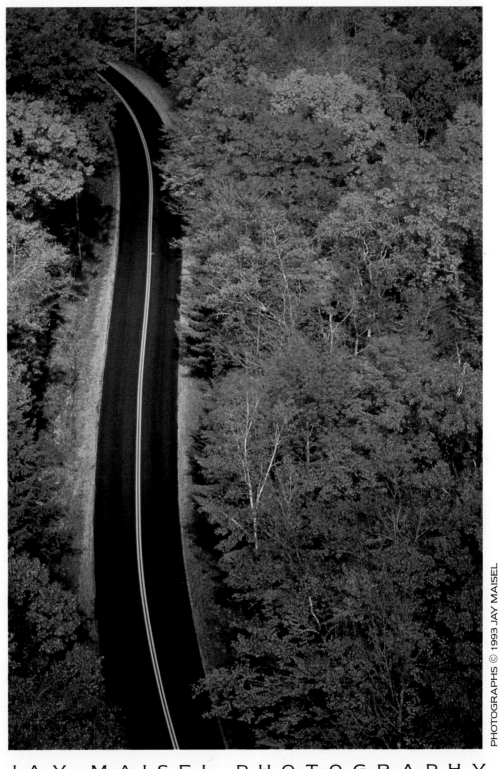

Contents

S T O C K A G E N C I E S

● Agencies with a ● have images on Stock Disk 2.

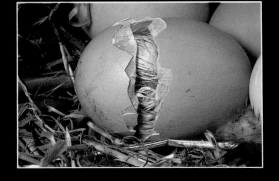 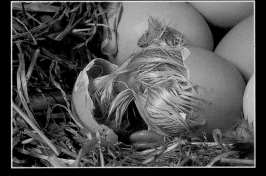 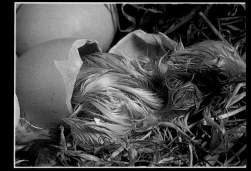

© G.I.Bernard (3)/Animals Animals

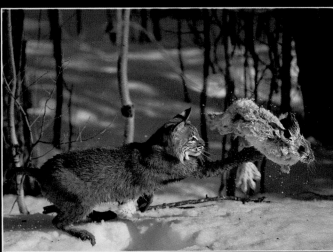

© Marty Stouffer/Animals Animals

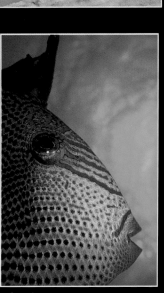

© Capt. Clay Wiseman/Animals Animals

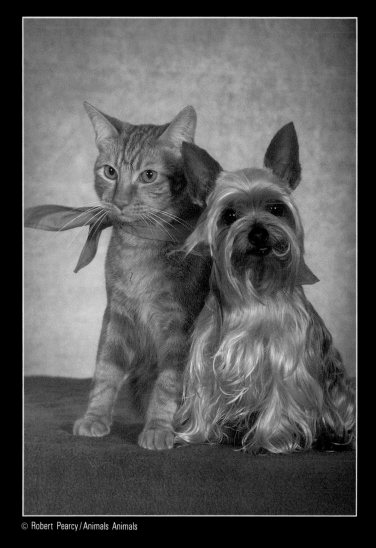

© Robert Pearcy/Animals Animals

Animals Animals/Earth Scenes
an environmental photo agency

Please call for our free catalog.

In Chatham, New York:
17 Railroad Avenue
Chatham, NY 12037 USA
518/392-5500
FAX 518/392-5550

In New York City:
580 Broadway/Suite 1111
New York, NY 10012 USA
212/925-2110
FAX 212/925-2796

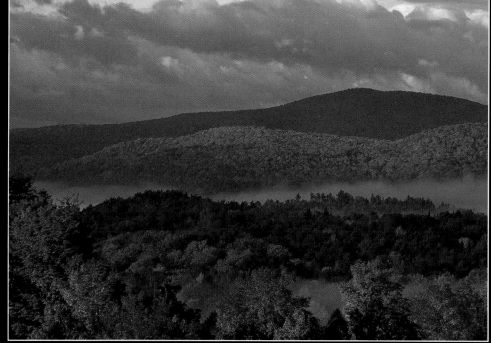
© Ted Levin / Earth Scenes

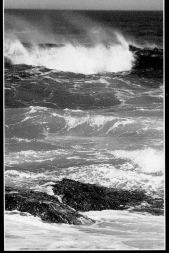
© Anne Wertheim / Earth Scenes

© John Gerlach / Earth Scenes

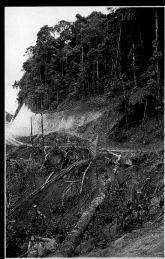
© Juan M. Renjifo / Earth Scenes

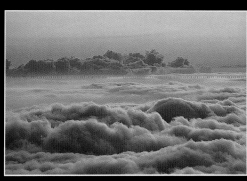
© C.C. Lockwood / Earth Scenes

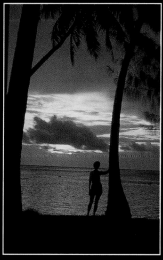
© Ken Cole / Earth Scenes

Animals Animals / Earth Scenes
an environmental photo agency

Please call for our free catalog.

In Chatham, New York:
17 Railroad Avenue
Chatham, NY 12037 USA
518/392- 5500
FAX 518/392-5550

In New York City:
580 Broadway / Suite 1111
New York, NY 10012 USA
212/925-2110
FAX 212/925-2796

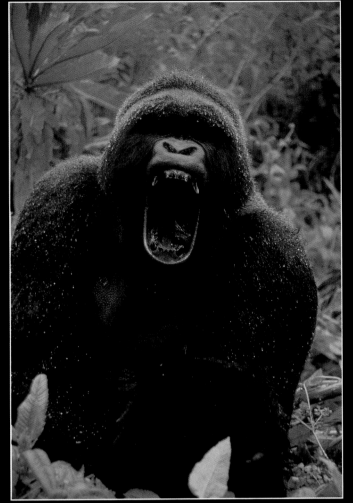
© Andrew Plumptre / OSF

© Kathie Atkinson / OSF

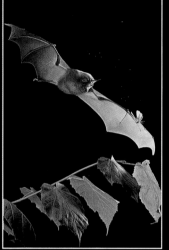
© Stephen Dalton / OSF

**We are proud
to represent
OXFORD SCIENTIFIC FILMS
of England.**

© Peter Parks / OSF

© Martyn Colbeck / OSF

Animals Animals / Earth Scenes
an environmental photo agency

**Please call for our
free catalog.**

In Chatham, New York:
17 Railroad Avenue
Chatham, NY 12037 USA
518/392- 5500
FAX 518/392-5550

In New York City:
580 Broadway/Suite 1111
New York, NY 10012 USA
212/925-2110
FAX 212/925-2796

We are proud
to represent
HOLT STUDIOS
of England.

© Nigel Cattlin/Holt Studios

© Holt Studios

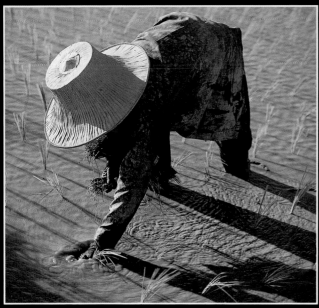

© Nigel Cattlin/Holt Studios

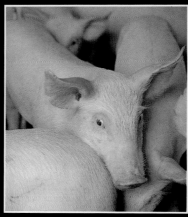

© Holt Studios

© Sue Llewellyn/Holt Studios

Animals Animals/Earth Scenes
an environmental photo agency

In Chatham, New York:
17 Railroad Avenue
Chatham, NY 12037 USA
518/392- 5500
FAX 518/392-5550

In New York City:
580 Broadway/Suite 1111
New York, NY 10012 USA
212/925-2110
FAX 212/925-2796

**Please call for our
free catalog.**

Call for the Photonica catalog.

A NEW VISUAL STANDARD FOR STOCK PHOTOGRAPHY

photonica

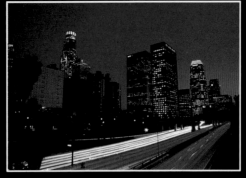
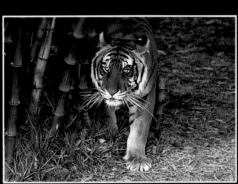
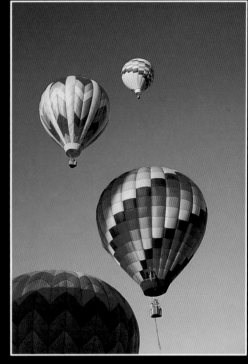
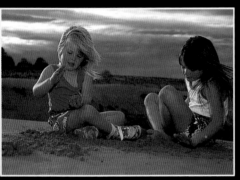
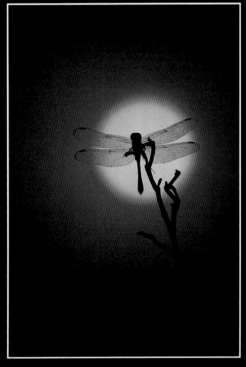
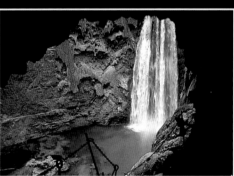

RO-MA STOCK

a new source of light

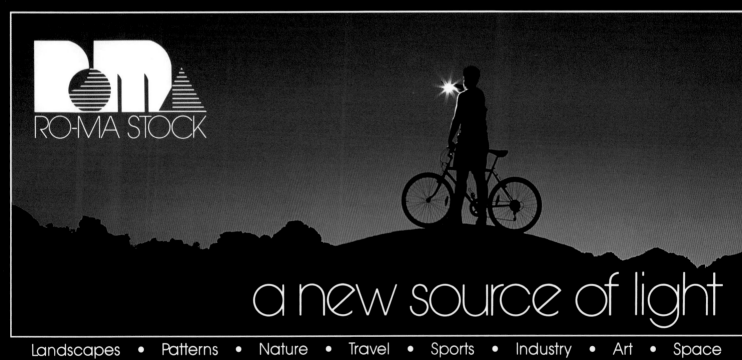

Landscapes • Patterns • Nature • Travel • Sports • Industry • Art • Space

FAX:818·566·7380

3101 RIVERSIDE DR., BURBANK, CA 91505

TEL:818·842·3777

Fundamental Photographs

THE ART OF SCIENCE

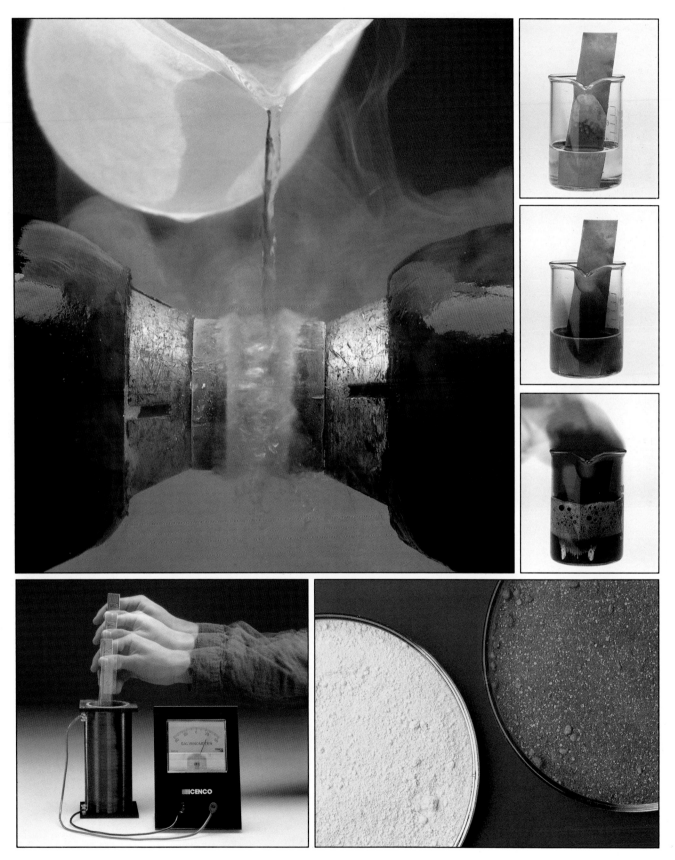

Clockwise: #3224 Paramagnetism of Oxygen, #3178 Copper reacts with Nitric Acid (sequence), #1901 Chromate Compounds, #2803 Induced EMF © Richard Megna

210 FORSYTH STREET, NEW YORK, NEW YORK 10002 (212) 473-5770 FAX (212) 228-5059

125963 01 Nepal

90165 Holland

123954 Carnival

45646 Caribbean

76426

TRAVEL

107516 Japan

EXOTIC

Leo de Wys INC.

1170 Broadway
New York, NY 10001

Tel: 212·689·5580
Fax: 212·545·1185
1·800·284·3399

126804 England Derby

56349 London

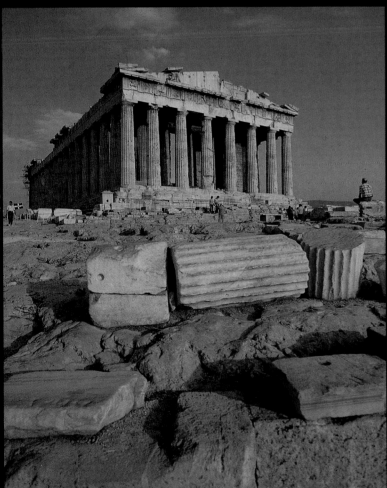

32701 Acropolis

121143 Aruba

T R A V E L

OCEAN STOCK

OS-100 Steve Sakamoto

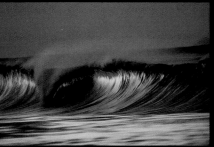

OS-112 Art Brewer

OS-101 Hank

OS-102 Aaron Chang

OS-111 Kevin Caldwell

OS-103 Eric Aeder

OS-104 Tom Servais

OS-105 Tom Servais

OS-106 Eric Aeder

OS-107 Aaron Chang

OS-108 Tom Servais

P.O. Box 3914
Dana Point,
California
92629
714-248-4324
Fax 714-248-2835

OS-110 Bob Cranston

OS-109 Bob Cranston

W I L L I A M T H O M P S O N

P H O T O G R A P H S

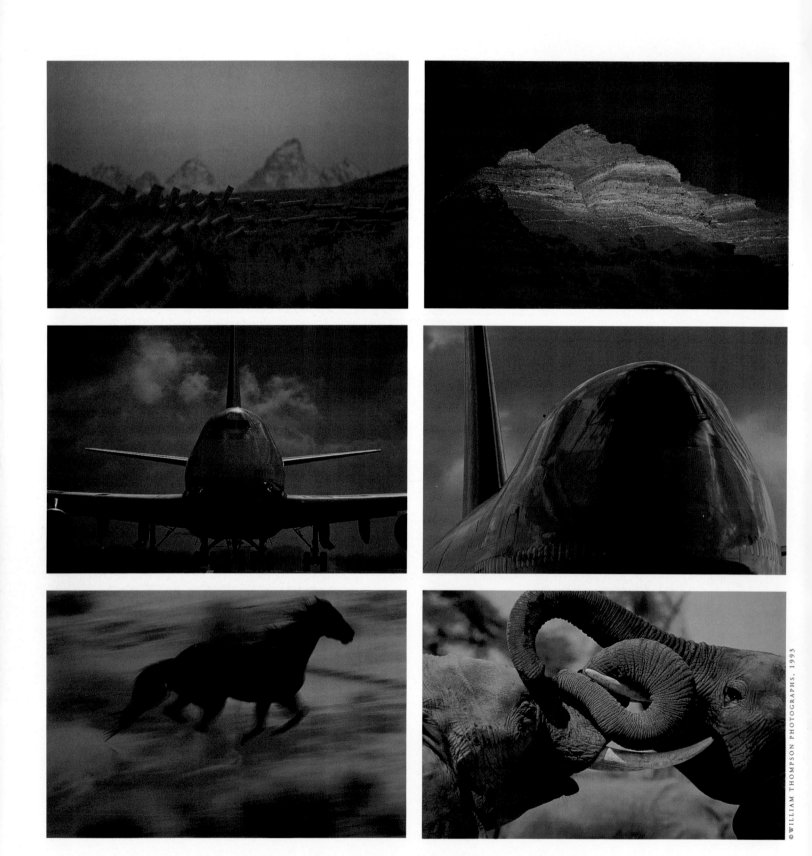

15566 SANDY HOOK ROAD POULSBO, WASHINGTON 98370

FAX 206 . 598.4902 TELEPHONE 206 . 598.4002

W I L L I A M T H O M P S O N
P H O T O G R A P H S

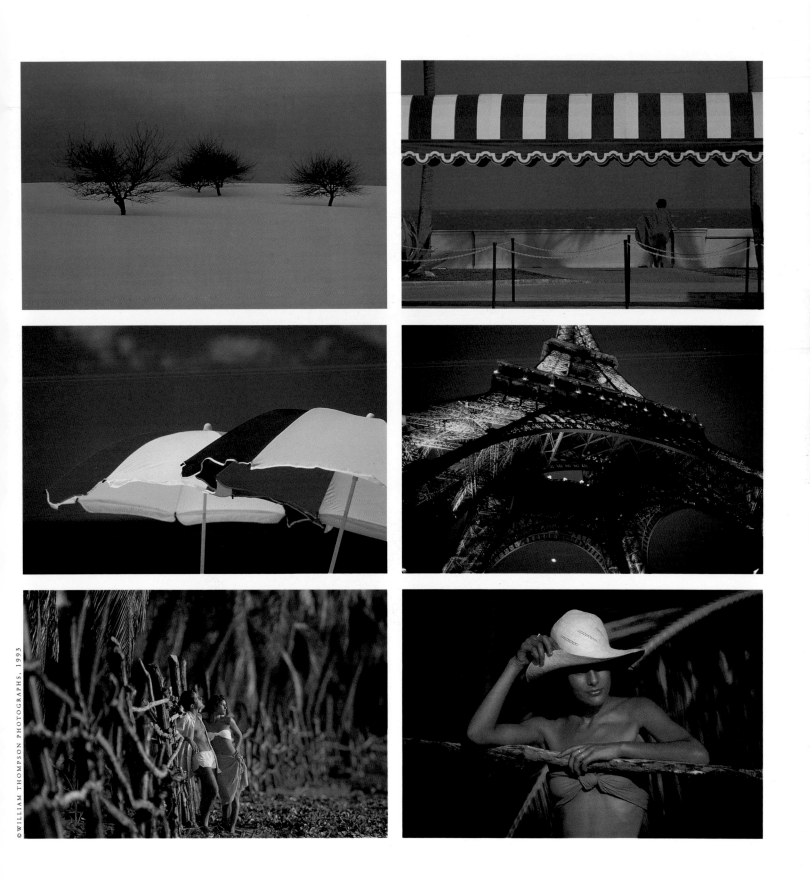

© WILLIAM THOMPSON PHOTOGRAPHS, 1993

15566 SANDY HOOK ROAD POULSBO, WASHINGTON 98370
FAX 206 . 598.4902 TELEPHONE 206 . 598.4002

447

Mark MacLaren, Inc.

Clients Include: IBM, AT&T, United, Time, 3M, Quasar, General Motors,
Conde Nast, American Express, Cole Haan, British Air, Carnation, Life,
Saatchi & Saatchi, Publicis/FCB, Schweppes, Corporate Annual Reports,
Rorer Pharmaceuticals, GTE, Sherwin Williams, Drettnel Doyle, Pentagram

430 East 20th Street,
New York, NY 10009
(212) 674-8615 & 674-0155

A Stock Agency specializing in Travel & Destination Photography, which
captures mood & moment in a highly realistic manner, for travel related
projects, as well as organizations wishing to emphasize their global presence.

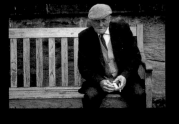
PORTRAITS/ EUROPE/ SCOTSMAN STW-701

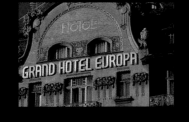
GRAND HOTEL EUROPA STW-702

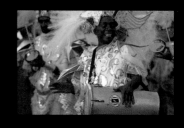
BRAZIL/ SOUTH AMERICA STW-703

FRENCH POLYNESIA/ LANDSCAPES STW-704

THE GUARDS/ LONDON STW-705

BARCELONA/ SPAIN STW-706

GRAPHIC ABSTRACTS/ COLOR STW-707

VENICE/ ITALY/ DOGE'S PALACE STW-708

ISTANBUL/ TURKEY STW-709

MOOD & MOMENT STW-710

LANGUAGES/ WINE TASTING STW-711

LATIN AMERICA/ SANTIAGO/ CHILE STW-712

BUDAPEST/ THE BLUE DANUBE STW-713

BANGKOK/ TEMPLE OF DAWN STW-714

SARA IN PINK & BLACK VEIL STW-715

SCANDINAVIA/ NORWAY/ FACADES STW-716

FRENCH RIVERIA/ COTE D'AZUR STW-717

BUENOS AIRES/ BANDONEON STW-718

VIENNA/ COFFEEHOUSES STW-719

COWBOYS/ SENIOR CITIZENS STW-720

Mark MacLaren, Inc.

Clients Include: IBM, AT&T, United, Time, 3M, Quasar, General Motors, Conde Nast, American Express, Cole Haan, British Air, Carnation, Life, Saatchi & Saatchi, Publicis/FCB, Schweppes, Corporate Annual Reports, Rorer Pharmaceuticals, GTE, Sherwin Williams, Drettnel Doyle, Pentagram

430 East 20th Street, New York, NY 10009
(212) 674-8615 & 674-0155

A Stock Agency specializing in Travel & Destination Photography, which captures mood & moment in a highly realistic manner, for travel related projects, as well as organizations wishing to emphasize their global presence.

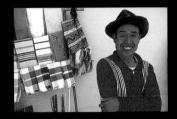

CENTRAL & SOUTH AMERICA STW-721

TAHITI/ HIBISCUS/ FLOWERS STW-722

SUPERMAN/ NEW YORK STW-723

MONTE CARLO/ COTE D'AZUR STW-724

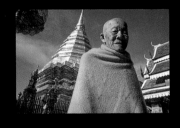

CHIANG MAI/ THAILAND/ BUDDHISM STW-725

RIO DE JAINERO/ IPANEMA BEACH STW-726

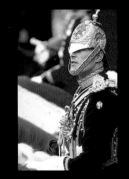

LONDON/ TROOPING THE COLOR STW-727

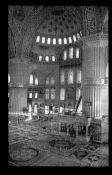

RELIGIONS/ THE BLUE MOSQUE STW-728

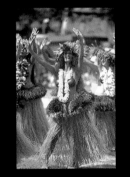

SOUTH PACIFIC/ DANCER STW-729

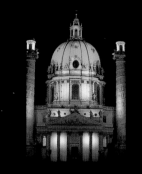

VIENNA/ AUSTRIA/ KARLSKIRCHE STW-730

PRAGUE/ EASTERN EUROPE STW-731

MUNICH/ GERMANY/ FACADES STW-732

LEISURE SPORTS/ UNDERWATER STW-733

VENICE/ ITALY/ ST.MARK'S SQUARE STW-734

BEACH CHAIRS/ PATTERNS/ LEISURE STW-735

PORTRAITS/ THE AEGEAN STW-736

FLOATING MARKET/ THAILAND STW-737

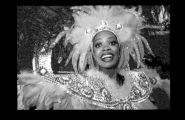

CARNEVAL/ RIO DE JAINERO STW-738

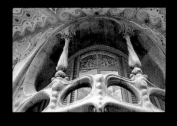

BARCELONA/ SPAIN/ ARCHITECTURE STW-739

SHADOWS & LIGHT/ THE ORIENT STW-740

Porch & Rocker, CT 13-008-171B
©1993 FRED M. DOLE

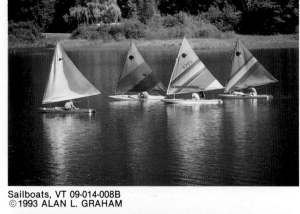

Sailboats, VT 09-014-008B
©1993 ALAN L. GRAHAM

Daffodils 19-046-001B
©1993 RON SANFORD

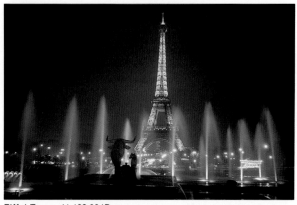

Eiffel Tower 41-189-004B
©1993 BILL BACHMANN

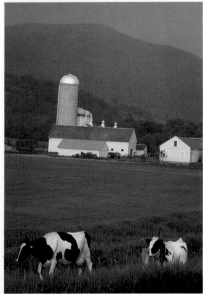

Dairy Cows, VT 27-026-004B
©1993 STEPHEN R. SWINBURNE

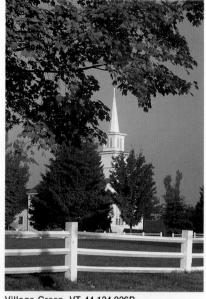

Village Green, VT 44-124-026B
©1993 ALDEN PELLETT

Road & Barn, VT 36-104-019B
©1993 LOIS MOULTON

Ice Cream 50-048-017B
©1993 HANSON CARROLL

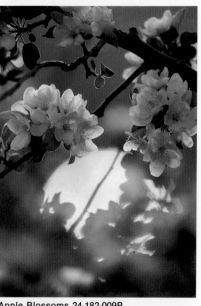

Apple Blossoms 24-182-009B
©1993 R. HAMILTON SMITH

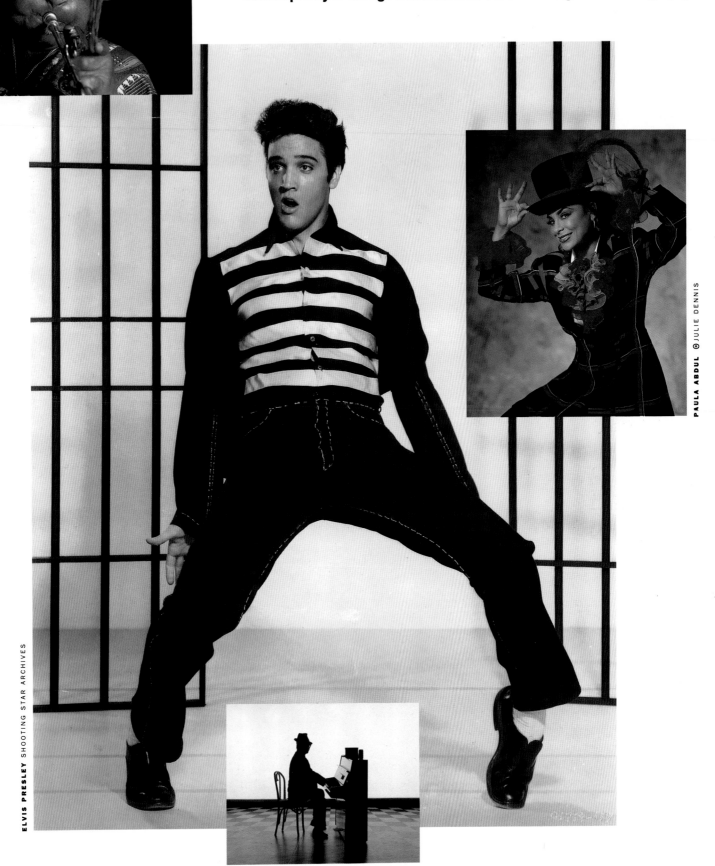

envision

212 · 243 · 0415
800 · 524 · 8238

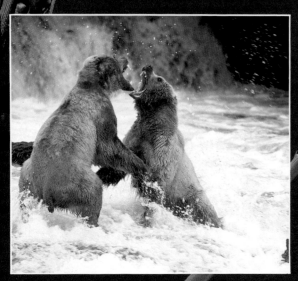

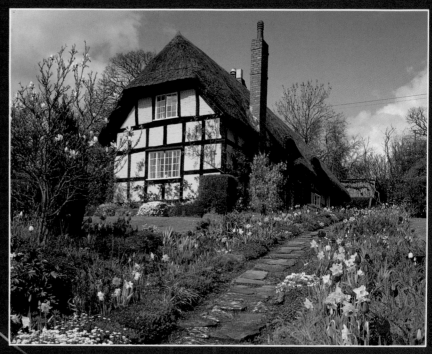

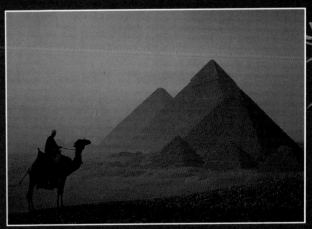

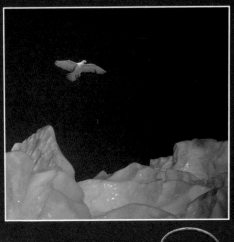

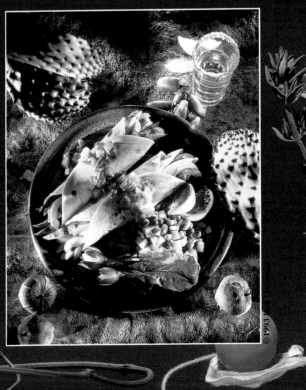

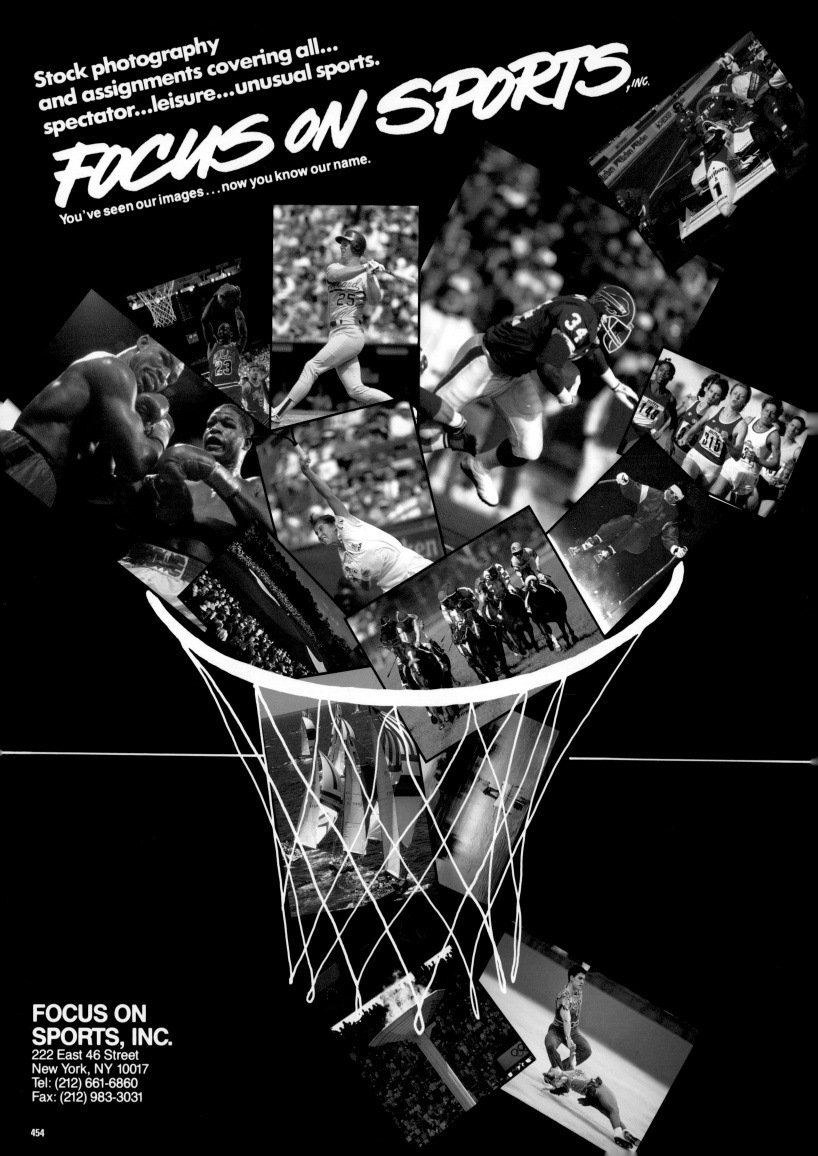

Stock photography
and assignments covering all...
spectator...leisure...unusual sports.

FOCUS ON SPORTS, INC.

You've seen our images . . . now you know our name.

LIGHT SOURCES

STOCK

A Photographic Stock Agency

23 Drydock Avenue
Marine Industrial Park
Boston, MA 02210

© Walter S. Silver

© Harold Wilion

© Frank Siteman

© Carolyn Ross

© Linc Cornell

© David White

© Tim Lynch

© Linc Cornell

© Palmer/Brilliant

© David White

© Mark Hunt

© David Shopper

© Linc Cornell

© Frank Siteman

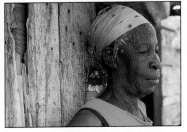

© Mark Hunt

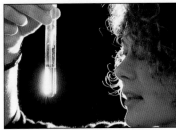

© Seth Resnick

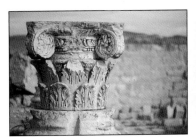

© Rebecca Marvil

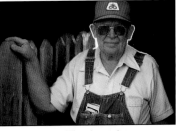

© Tim Lynch

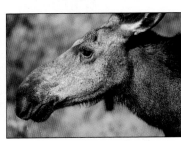

© Jeremy Barnard

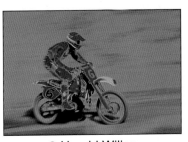

© Harold Wilion

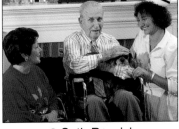

© Seth Resnick

© Seth Resnick

(617) 261-0346 • (800) 272-LITE • FAX (617) 261-0358

-PHOTOTAKE-
The Creative Link

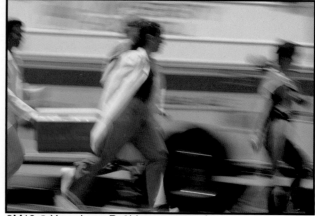
3M19 © Yoav Levy-Rushing an organ for transplant

3M37 © David Wagner-Heart Attack

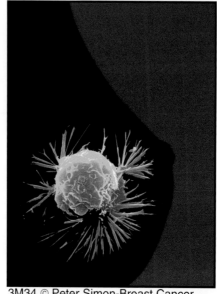
3M34 © Peter Simon-Breast Cancer

3B82 © Dr. Kunkel-Red blood cells

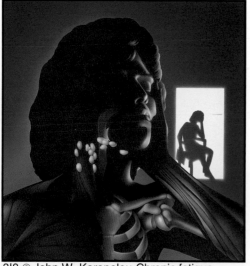
3I8 © John W. Karapelou-Chronic fatigue

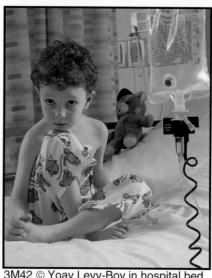
3M42 © Yoav Levy-Boy in hospital bed

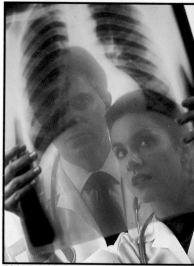
3M67 © Yoav Levy-Viewing x-ray

3B70 © Bob Schuchman-Adenovirus, cause of common cold

For a free catalog

Call: 800-542-3686

Fax: 212-942-8186

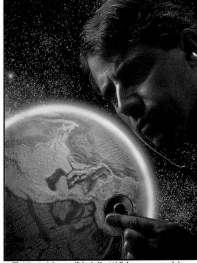

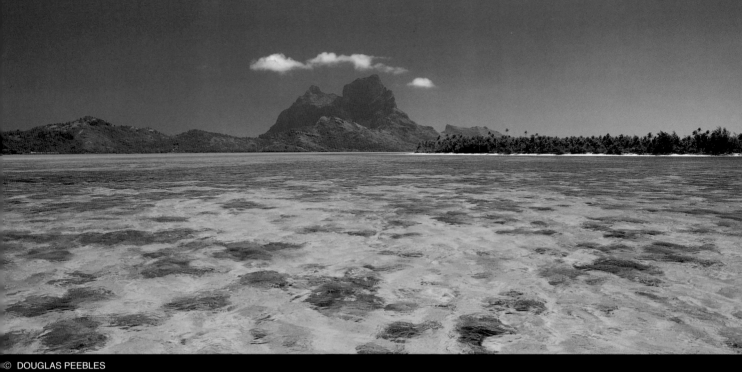

© DOUGLAS PEEBLES

© G. BRAD LEWIS

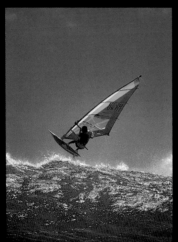

© DARRELL WONG

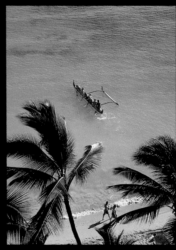

© DOUGLAS PEEBLES

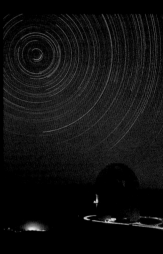

© RICHARD WAINSCOAT

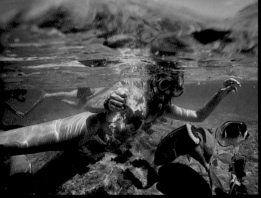

© CAT & KEVIN SWEENEY

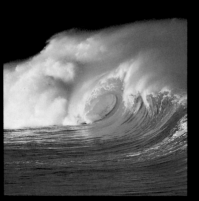

© DOUGLAS PEEBLES

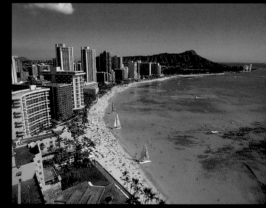

© DOUGLAS PEEBLES

OVER 150,000 TRANSPARENCIES OF HAWAII AND THE SOUTH PACIFIC

DOUGLAS PEEBLES
P H O T O G R A P H Y

145 ILIWAHI LOOP • KAILUA, HAWAII 96734 • PHONE (808) 254-1082 • FAX (808) 254-1267

Landmark
STOCK EXCHANGE

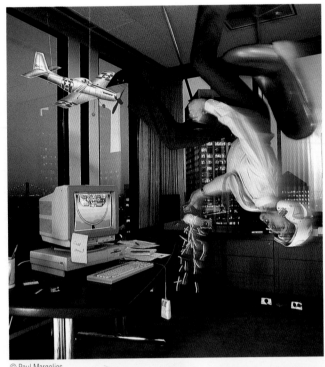

© Paul Margolies

© Walt Denson

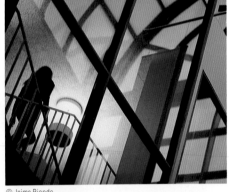

© Jaime Biondo

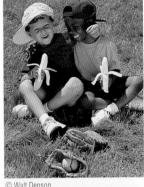

© Walt Denson

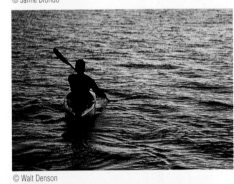

© Walt Denson

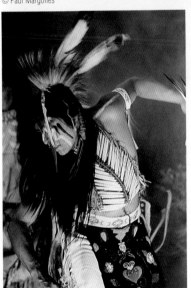

© Kris Kristoffersen

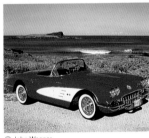

© Phil Coblentz

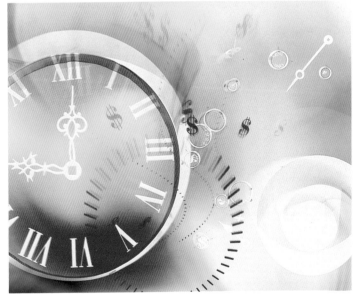

© Walt Denson

© James Randklev

© John Wagner

© Dale Higgins

© Carol Drobek

51 Digital Drive • Novato, California 94949
(415) 883-1600 • Toll Free (800) 288-5170 • FAX (415) 883-6725

SPORTS

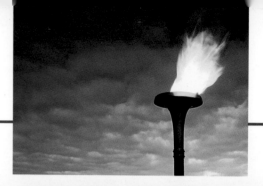

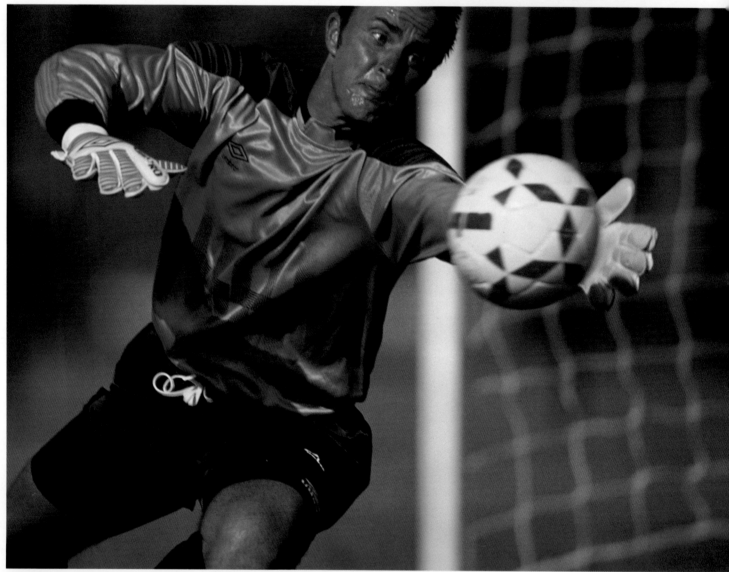

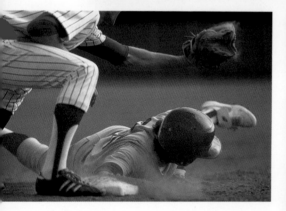

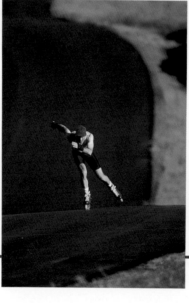

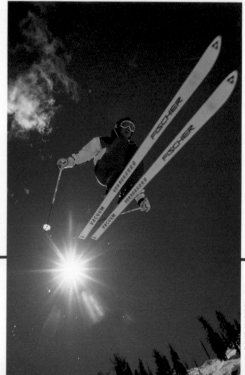

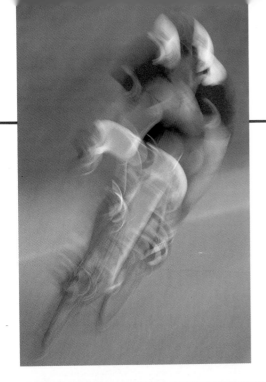

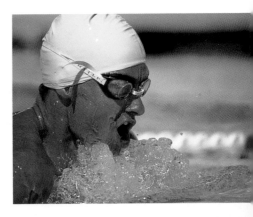

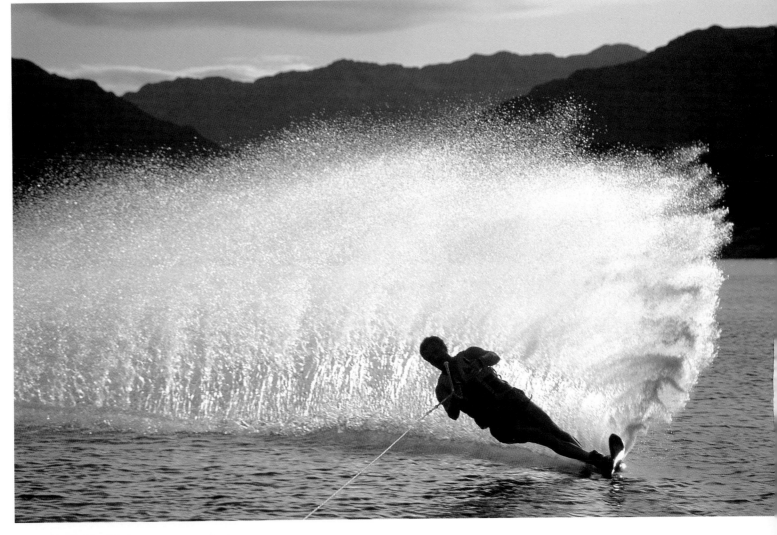

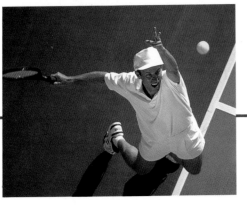

DAVID MADISON

CALIFORNIA

415·851·7324

FAX 415·851·3065

SPORTS

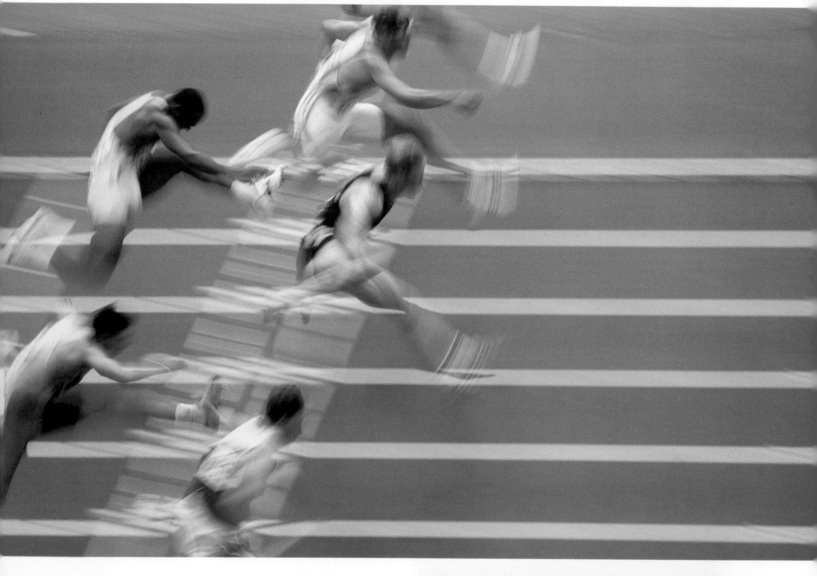

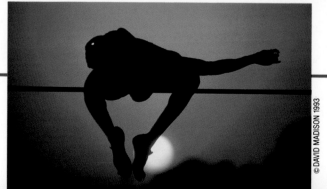

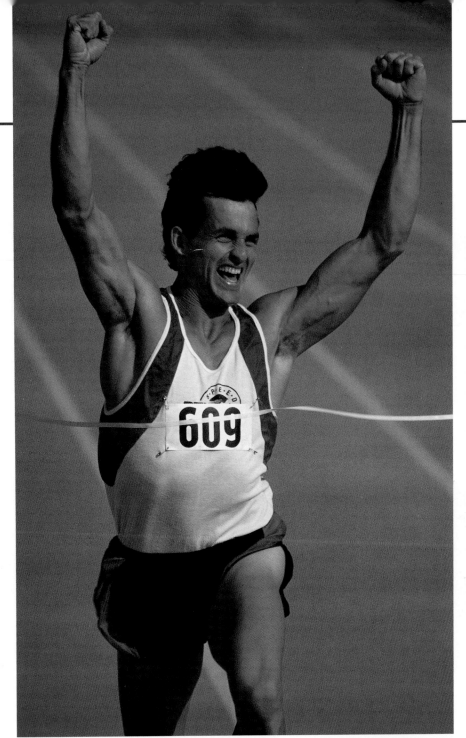

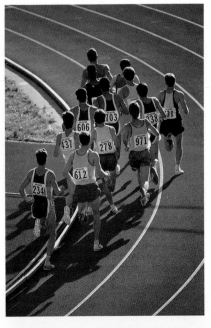

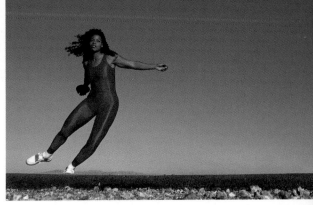

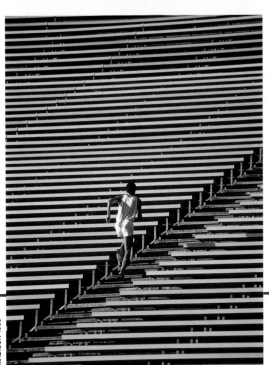

DAVID MADISON

CALIFORNIA

415·851·7324

FAX 415·851·3065

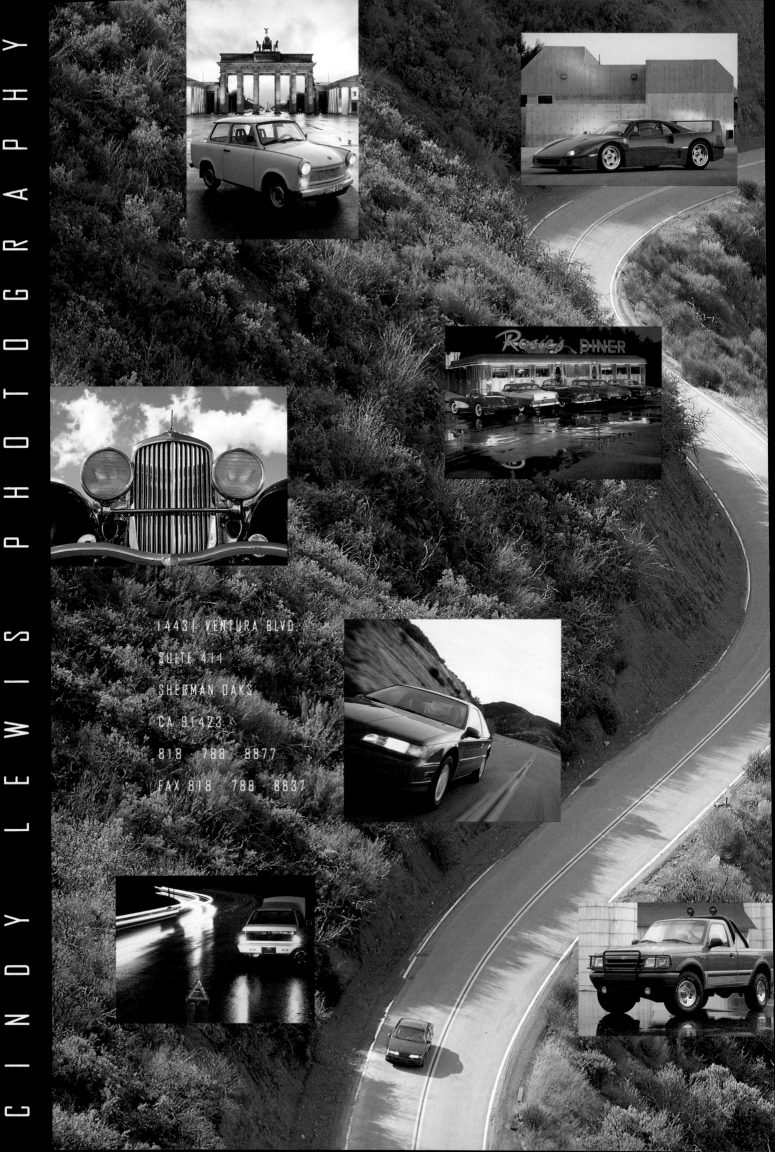

CINDY LEWIS PHOTOGRAPHY

14431 VENTURA BLVD
SUITE 411
SHERMAN OAKS
CA 91423
818 - 788 - 8877
FAX 818 - 788 - 8837

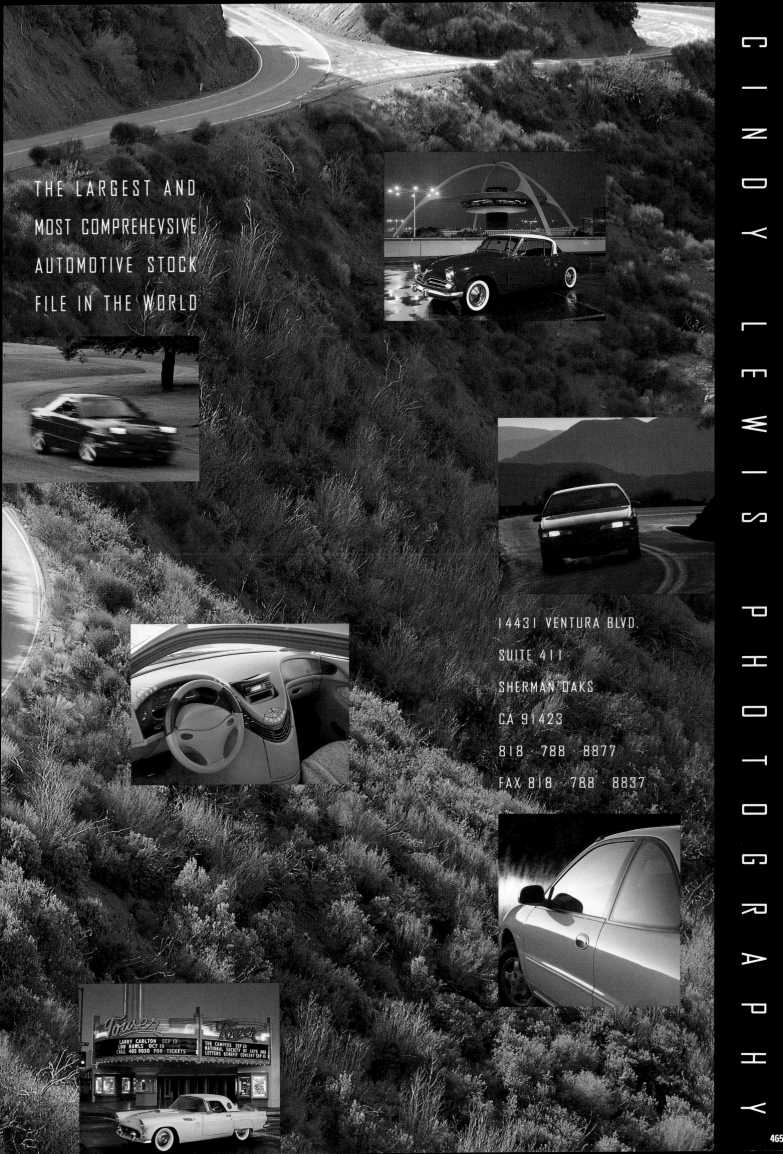

THE LARGEST AND
MOST COMPREHEVSIVE
AUTOMOTIVE STOCK
FILE IN THE WORLD

14431 VENTURA BLVD.

SUITE 411

SHERMAN OAKS

CA 91423

818 · 788 · 8877

FAX 818 · 788 · 8837

CINDY LEWIS PHOTOGRAPHY

465

Bent Photos.

The weird. The bizarre. The depraved. We've got it all. Some of the funniest historical stock money can rent. Over 160,000 photos. In almost 1700 categories.

And for those without a sense of humor, we've also got that one of a kind historical stuff you'd expect to find in museums. Serious stuff. Wars, events, etc. etc.

So if you'd like our free brochure, or you have a specific category of photo in mind, give us a call.

Underwood Photo Archives. The San Francisco stock house that's not only warped. It's old and twisted.

Underwood Photo Archives

3109 Fillmore Street, San Francisco, CA 94123 (415) 346-2292

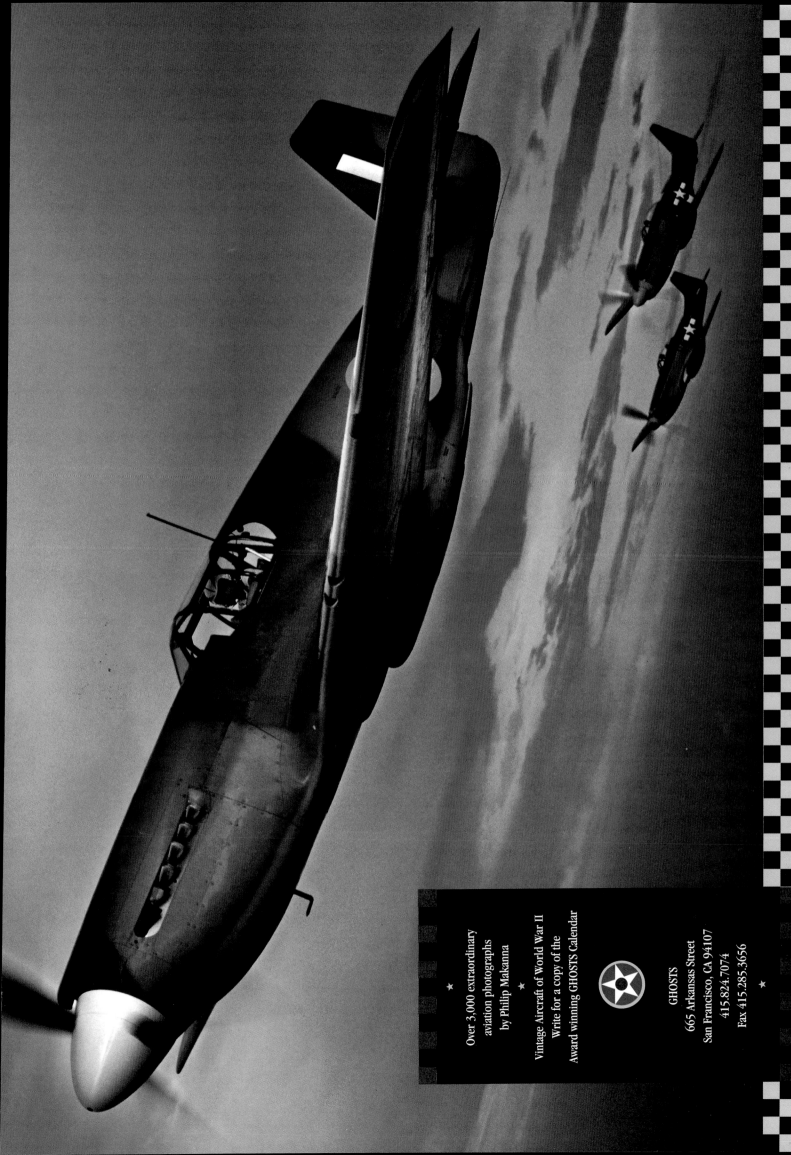

O D Y S S E Y

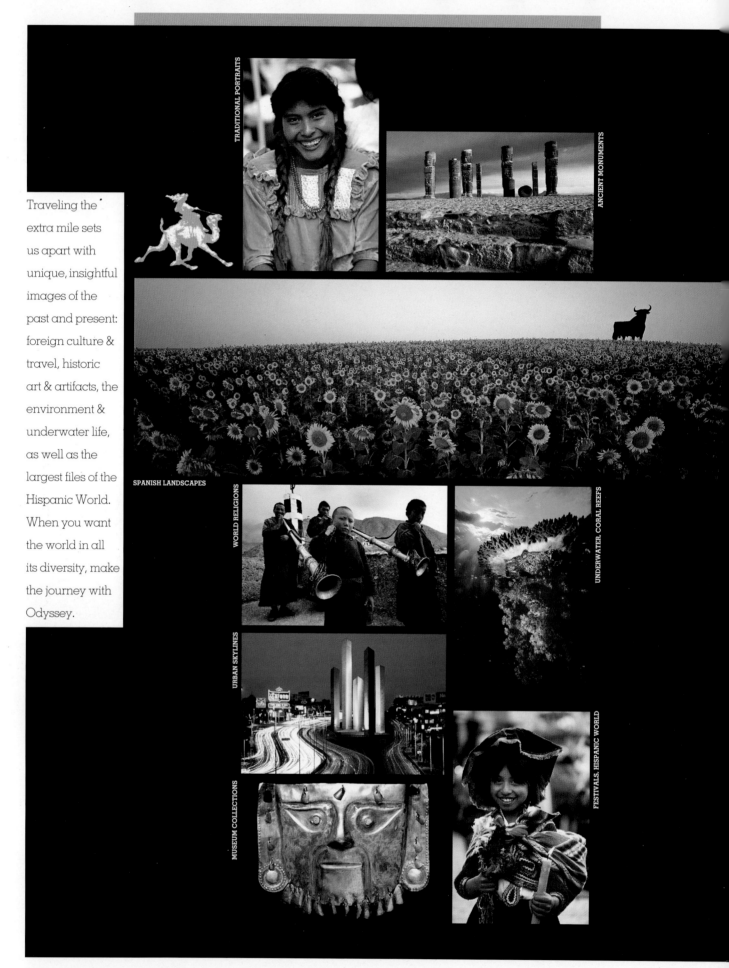

Traveling the extra mile sets us apart with unique, insightful images of the past and present: foreign culture & travel, historic art & artifacts, the environment & underwater life, as well as the largest files of the Hispanic World. When you want the world in all its diversity, make the journey with Odyssey.

TRADITIONAL PORTRAITS

ANCIENT MONUMENTS

SPANISH LANDSCAPES

WORLD RELIGIONS

UNDERWATER, CORAL REEFS

URBAN SKYLINES

FESTIVALS, HISPANIC WORLD

MUSEUM COLLECTIONS

ODYSSEY PRODUCTIONS • 2633 N. Greenview Ave. Chicago, Il. 60614 • 312 883 1965 Fax 883 0929

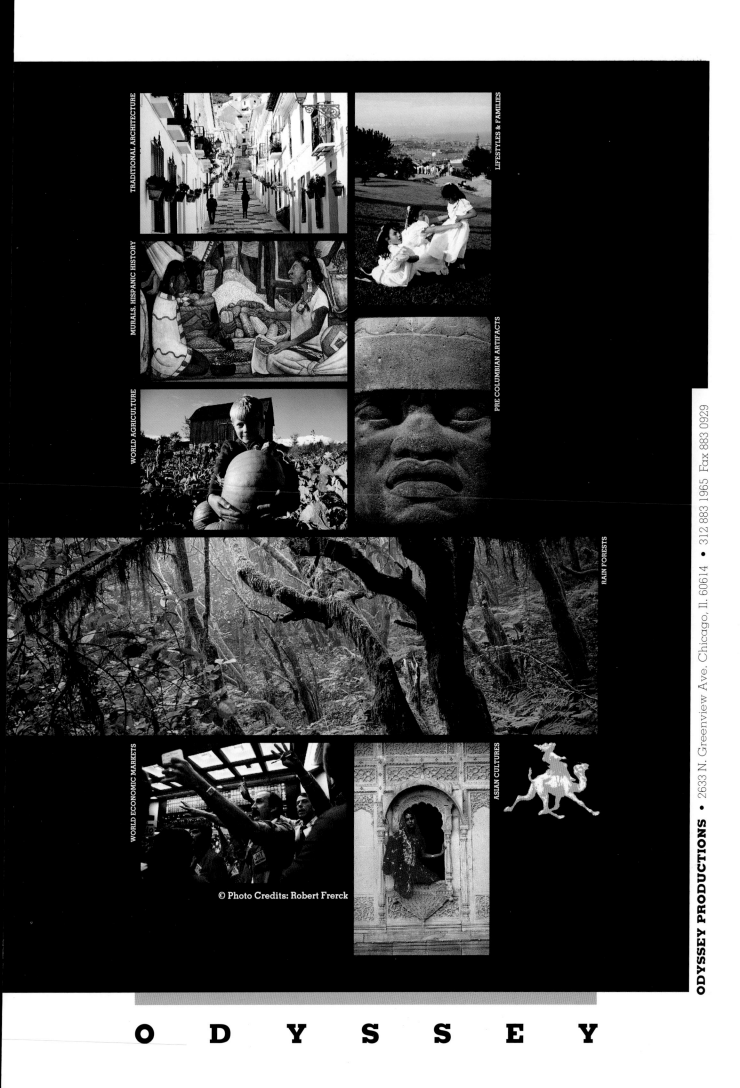

TRADITIONAL ARCHITECTURE

LIFESTYLES & FAMILIES

MURALS, HISPANIC HISTORY

PRE COLUMBIAN ARTIFACTS

WORLD AGRICULTURE

RAIN FORESTS

WORLD ECONOMIC MARKETS

ASIAN CULTURES

© Photo Credits: Robert Frerck

O D Y S S E Y

ODYSSEY PRODUCTIONS • 2633 N. Greenview Ave. Chicago, Il. 60614 • 312 883 1965 Fax 883 0929

Our copy is subliminal,
our photos sublime.

Lorem ipsum dolor sit arret, consectetur adip scing elit, Roma sed diam nonumy nibh euismod porum incidunt ut lobore et dolore mana ali quam erat volu tpat. Duis autem vel eum iriure dolor in dolor. Fax catalog requests on your company

 aliquip ex ea com modo cosequat. Fax catalog requests on your company letterhead—312-704-4077. Duis autem vel eum iriure dolor in hendrerit in vulputate velit esse molestie consequat,

letterhead—312-704-4077. Son ad minimim eniami quis nostrud ex ercitation ulla mecorpor suscipit laboris nisi ut

vel illum dolore eu feugiat nulla facilisis at vero eros et cumsan et iusto odio dign 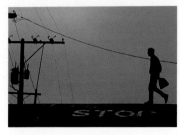 issim qui blandit praesent lupta tum zril delenit augue duis dolore te feugait nulla facilisi. Lorem ipsum dolor sit arret, cons

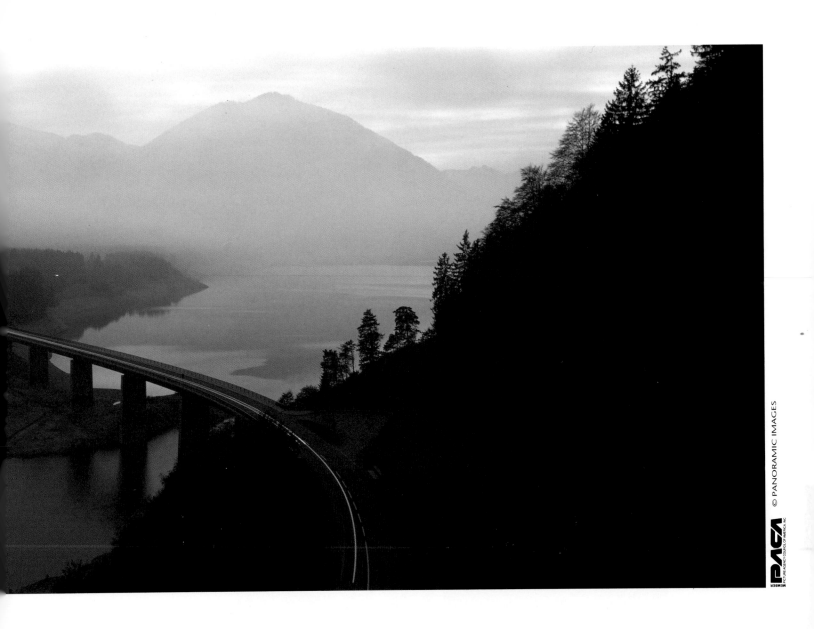

ectetur adip scing elit, Roma sed diam nonumy nibh euismod por incidunt ut

lobore et dolore mana ali quam erat

volutpat wisi te feugiat.

Fax catalog requests on your company letterhead—312-704-4077. Ut wisi enim ad minim veniam, quis nostrud exerci tation ul non provid en, simil tem pors sunt in culpa qui offica anim id est . ut er

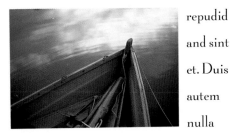

repudid and sint et. Duis autem nulla

facilisis at vero eros et cumsan et iusto odio dignissim qui blandit praesent

luptatum zril delenit augue duis dolore. Fax catalog requests on your company letterhead—312-704-4077.

PANORAMIC IMAGES & **MON·TRÉSOR**

800-543-5250 Fax 312-704-4077 312-236-8545
Chicago, Munich, Osaka, Paris, Tokyo

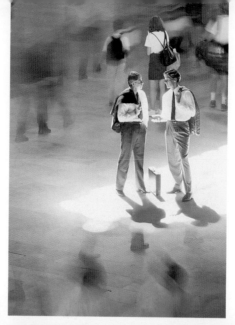

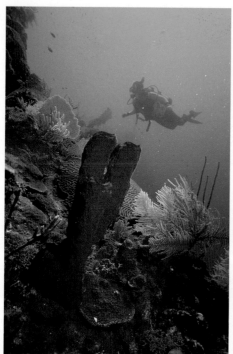

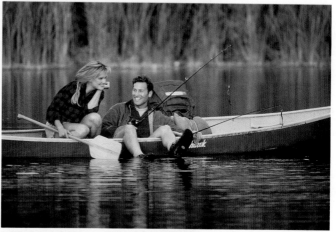

1-800-486-7118
call for our free catalog

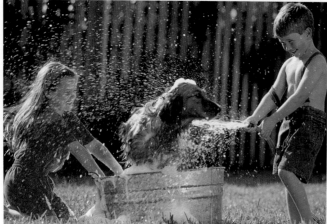

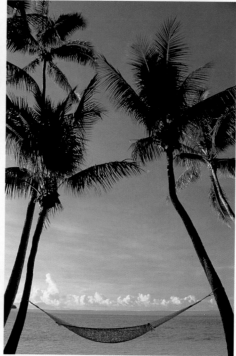

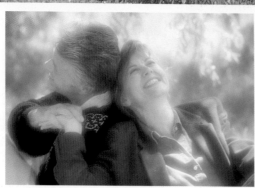

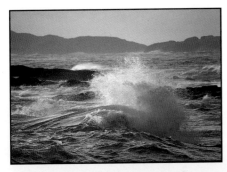
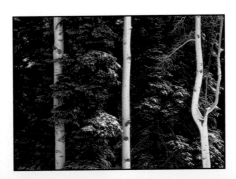
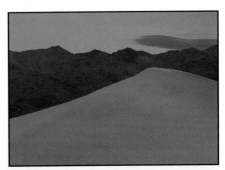
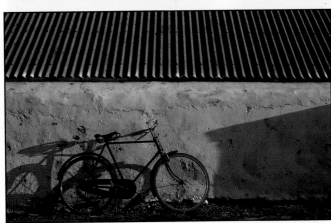
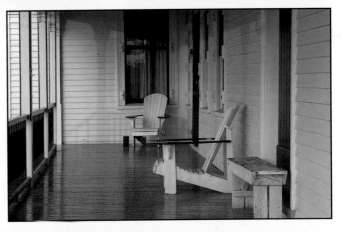
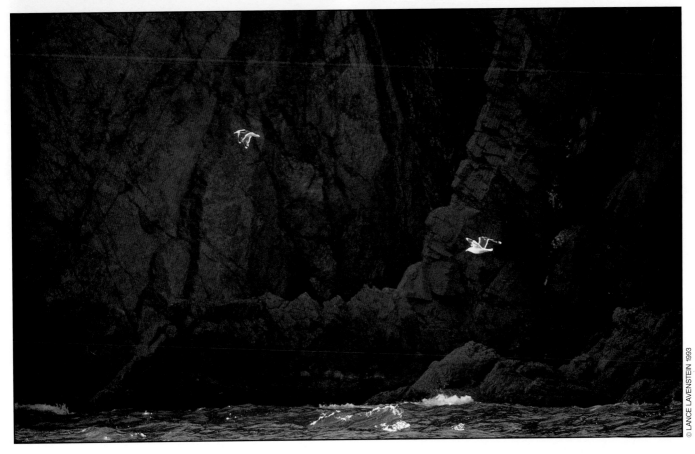

© LANCE LAVENSTEIN 1993

LavensteinStudios

PHOTOGRAPHY PRODUCTIONS & ADVERTISING

348 Southport Circle | Suite 103 | Virginia Beach, Virginia 23452 | 804.499.9959 | FAX: 804.499.9957

473

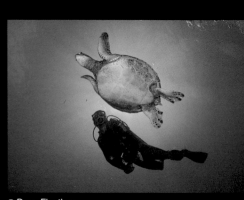
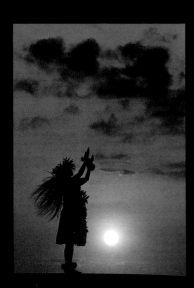

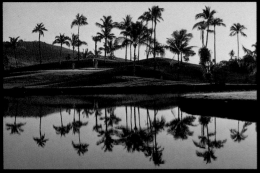

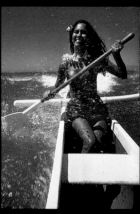

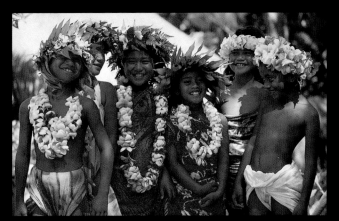
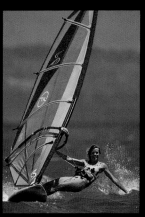

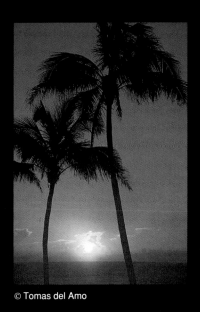
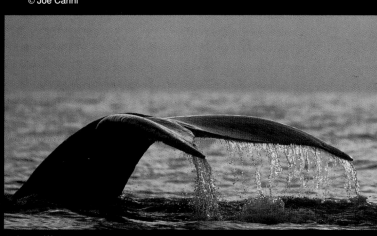

KR-78246-E A. Tovy Holland

KR-82242-E ZEFA-U.K Mont St.
Michel, France

KP-5472-E CVT

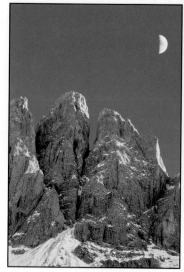

KR-67581-E M. Thonig Italy

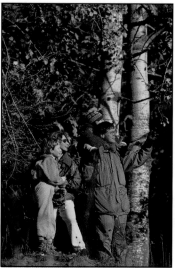

KH-11211-E P. Royer

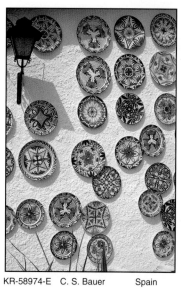

KR-58974-E C. S. Bauer Spain

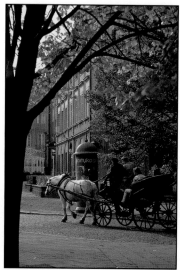

KR-84319-E ZEFA-U.K. Warsaw

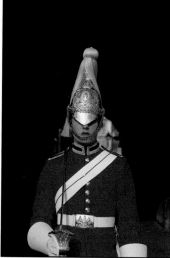

KR-58451-E Picturebank London

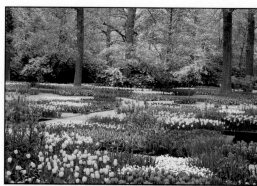

KG-11208-E M. Thonig

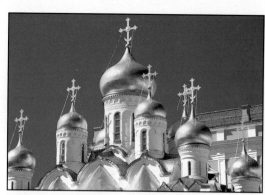

KR-95020-E G. Roessler Moscow

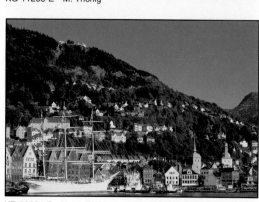

KR-50634-E Kotoh/ZEFA Bergen, Norway

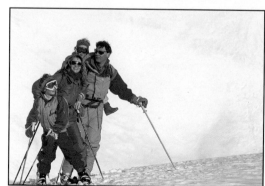

KW-12351-E P. Royer

Free catalogs upon request

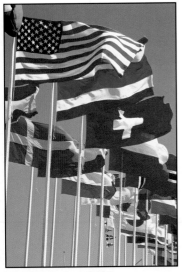

KH-10369-E Deuter/ZEFA

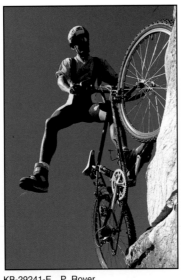

KB-29241-E P. Royer

KR-88826-E CVT Moscow

KR-77835-E A. Tovy Spain

KV-1033-E ZEFA-U.K.

KR-73228-E G. Hunter Portugal

KT-5072-E M. Thonig

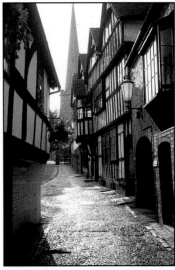

KR-58967-E C. S. Bauer England

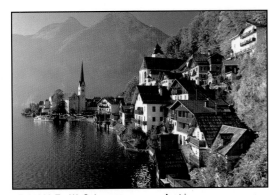

KR-81926-E W. Geiersperger Austria

KF-29749-E Blackfan

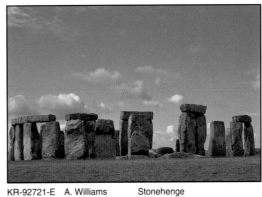

KR-92721-E A. Williams Stonehenge

KC-11778-E P. Royer

Free catalogs upon request

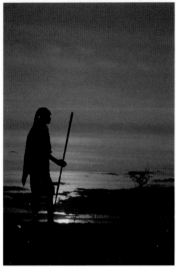

KR-95043-E ZEFA-U.K. Kenya

KR-62715-E M. Thonig Holland

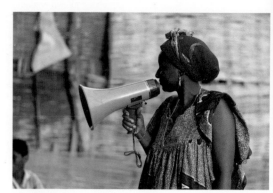

KR-95041-E M. Koene Africa

KT-4349-E M. Thonig

KA-7940-E A. Hubrich Switzerland

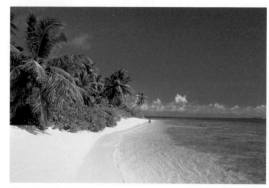

KR-76429-E A. Tovy

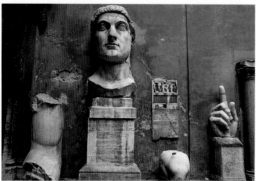

KR-89758-E C. Ursillo Rome

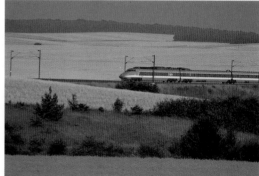

KR-95042-E C. Ursillo France

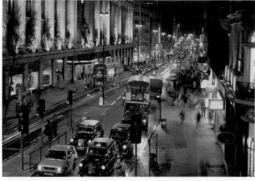

KR-87172-E ZEFA-U.K. London

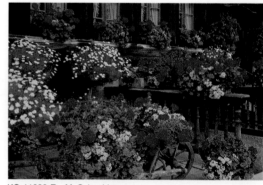

KG-11332-E M. Schneiders

KS-33442-E L. Smith

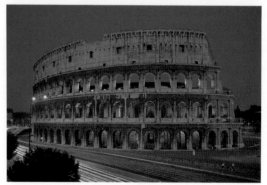

KR-78616-E ZEFA-U.K. Rome

Free catalogs upon request

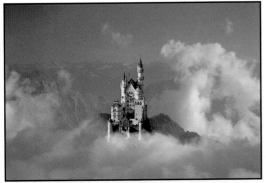

KR-81247-E Huber Germany

KF-22436-E M. Thonig

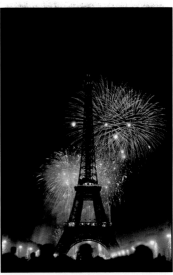

KR-91793-E Picturebank Paris

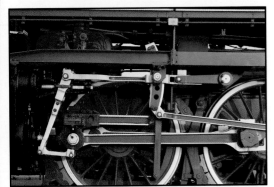

KR-51098-E M. Thonig

KR-85947-E Uselmann

KR-85052-E W. J. Scott Venice

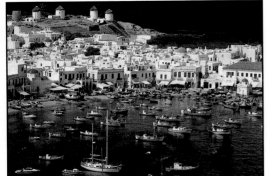

KR-73587-E M. Thonig Greece

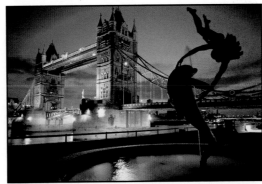

KR-92019-E ZEFA-U.K. London

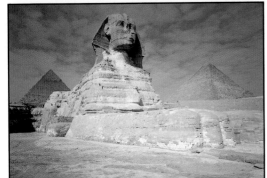

KR-45549-E K. Scholz Egypt

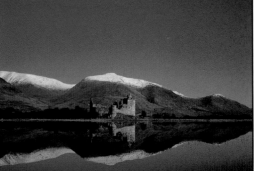

KR-84310-E ZEFA-U.K. Scotland

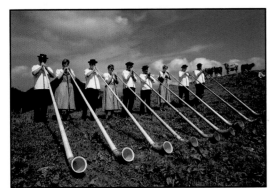

KR-94369-E Geisser Switzerland

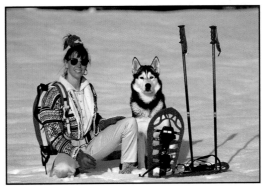

KW-12624-E P. Royer

Free catalogs upon request

40-50's Photo Archives
200,000 IMAGES FROM COAST TO COAST

 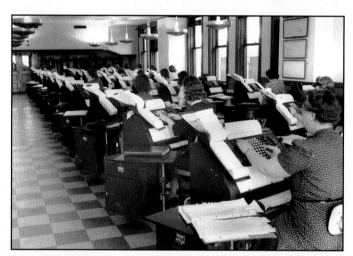

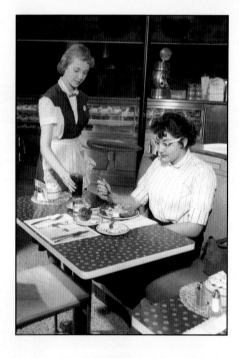 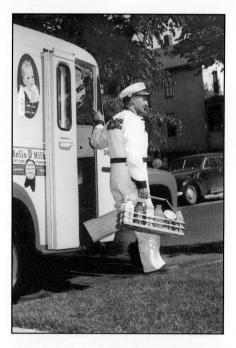 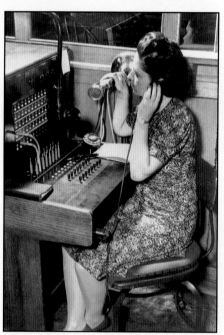

SICKLES PHOTO-REPORTING SERVICE
11 PARK ROAD • P.O. BOX 98 • MAPLEWOOD, N.J. 07040
TEL. 201-763-6355 • FAX 201-763-4473

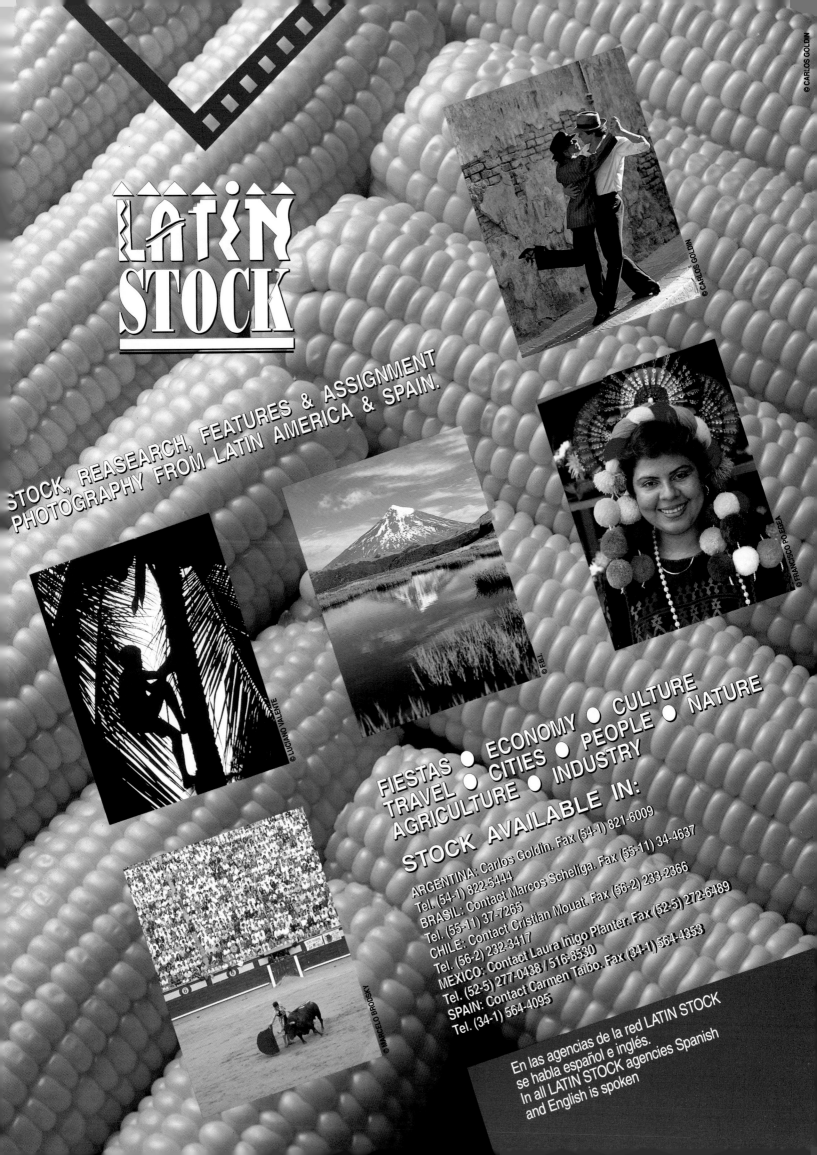

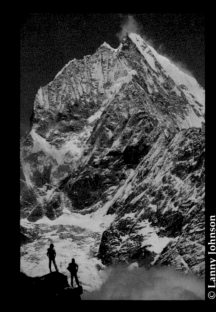
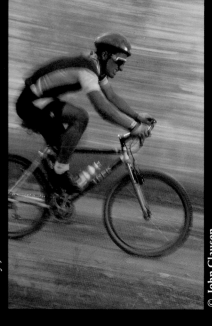
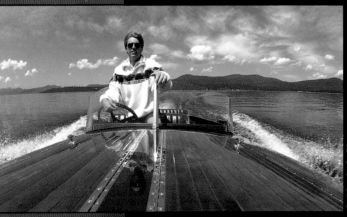
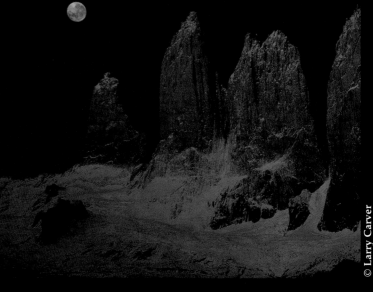
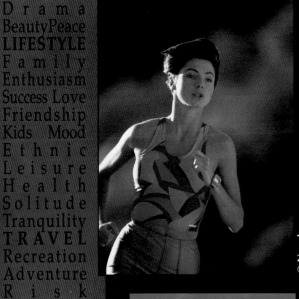

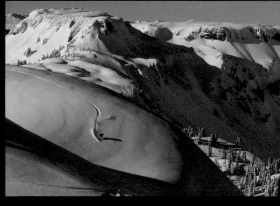

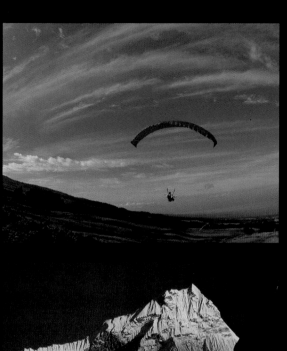

© Garry Moore

© Jim Wills

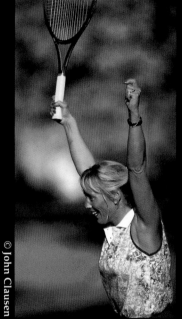

© John Clausen

© Chaco Mohler

©Simone

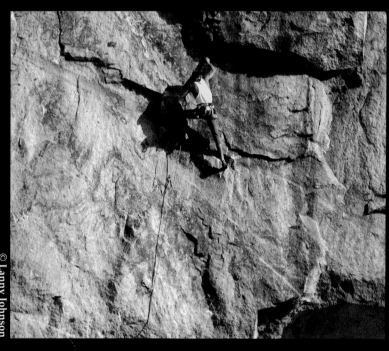

© Lanny Johnson

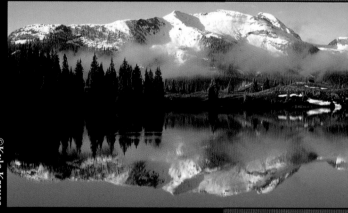

© Kyle Krause

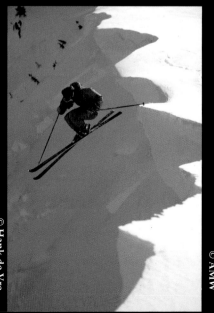

© Hank de Vre

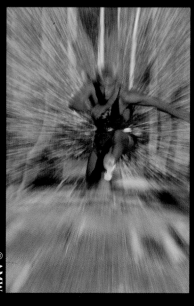

© AMW

India from India

DPA **DINODIA PICTURE AGENCY**

13, Vithoba Lane,
Vithalwadi, Kalbadevi,
Bombay - 400 002 (INDIA)
Tel : 2014126, 2014026, 2018572
Fax : 91-22-2067675.

DPA's exhaustive collection of over 3,00,000 colour transparencies and black & whites captures India in its stunning diversity. The work of over a hundred reputed photographers, DPA offers the option of several styles of representation of the same subject. All pictures are meticulously catalogued for quick retrieval. Patronised by international agencies, publishers & consulates.

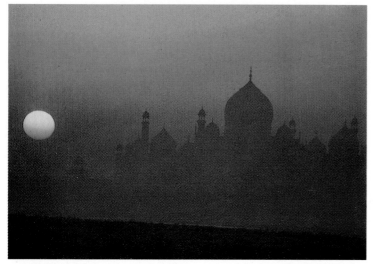

TAJ MAHAL at sunrise

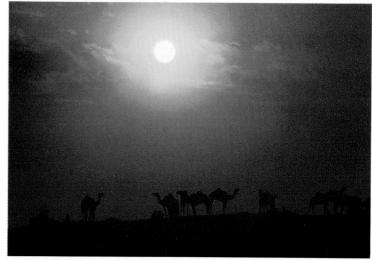

CAMELS at Pushkar Fair

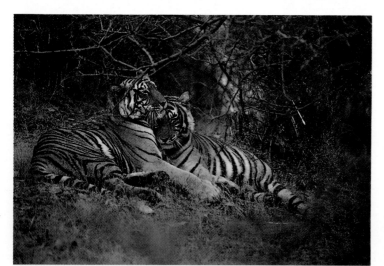

TIGERS COURTING — Kanha Wild Life Sanctuary

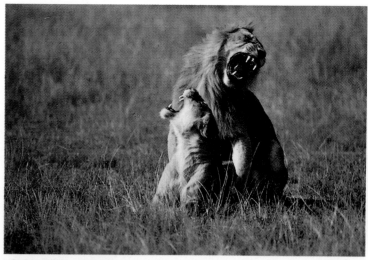

LIONS MATING — Gir Forest

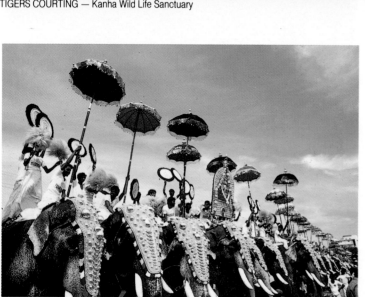

ELEPHANT MARCH FESTIVAL — Trichur

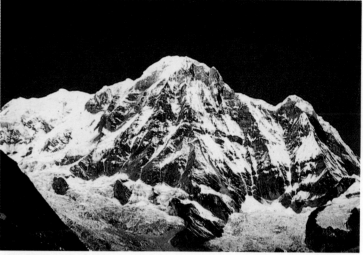

MOUNTAINS — Himalayas

Nawrocki
STOCK PHOTO
1-800-356-3066

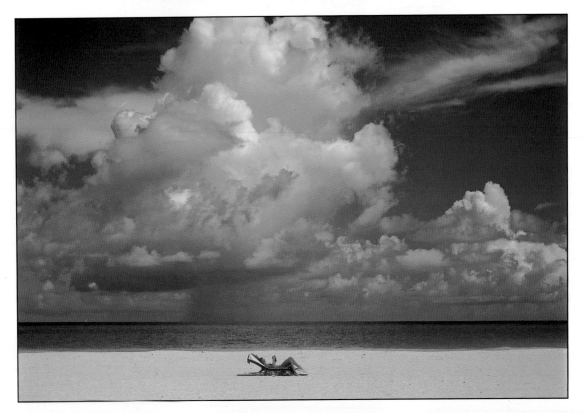

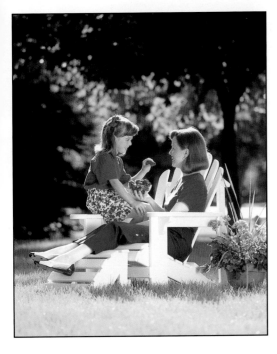

FOR AN EXTENSIVE SELECTION OF MODEL RELEASED IMAGES

CHICAGO, IL

1-312-427-8625 FAX 1-312-427-0178

MEMBER: PACA-ASPP ASMP-APA

© NSP **485**

POSITIVE IMAGES

Your Source for Nature and Human Nature

508/653-7610 Fax 508/650-4771

We donate 3% of stock sales back to the community.

Jack Foley 301

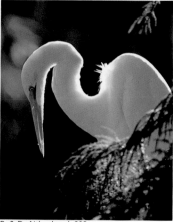

R. & D. Aitkenhead 302

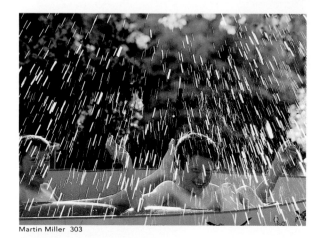

Martin Miller 303

Martin Miller 304

Ivan Massar 305

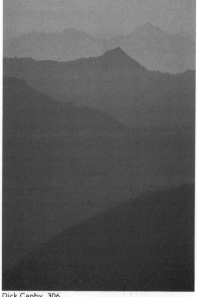

Dick Canby 306

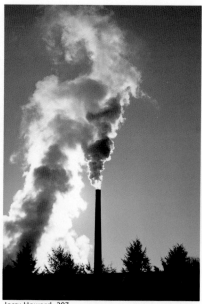

Jerry Howard 307

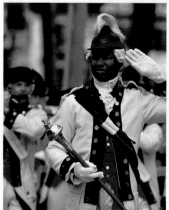

Jim Kahnweiler 308

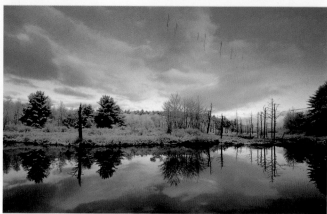

Paul Rezendes 309

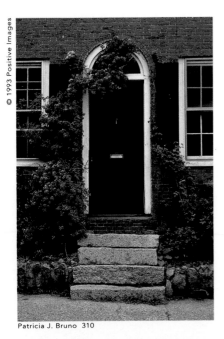

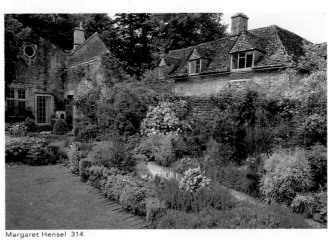
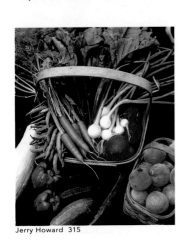
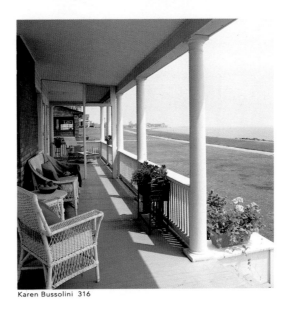
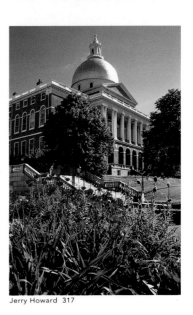

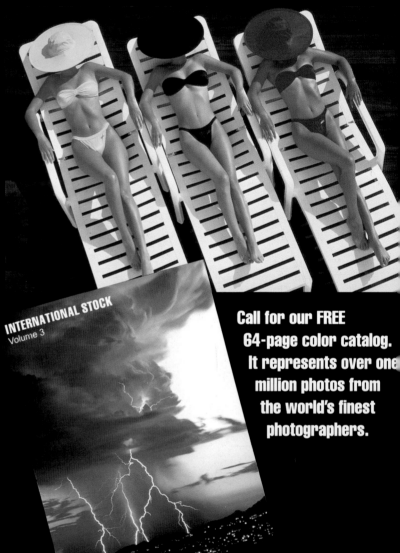

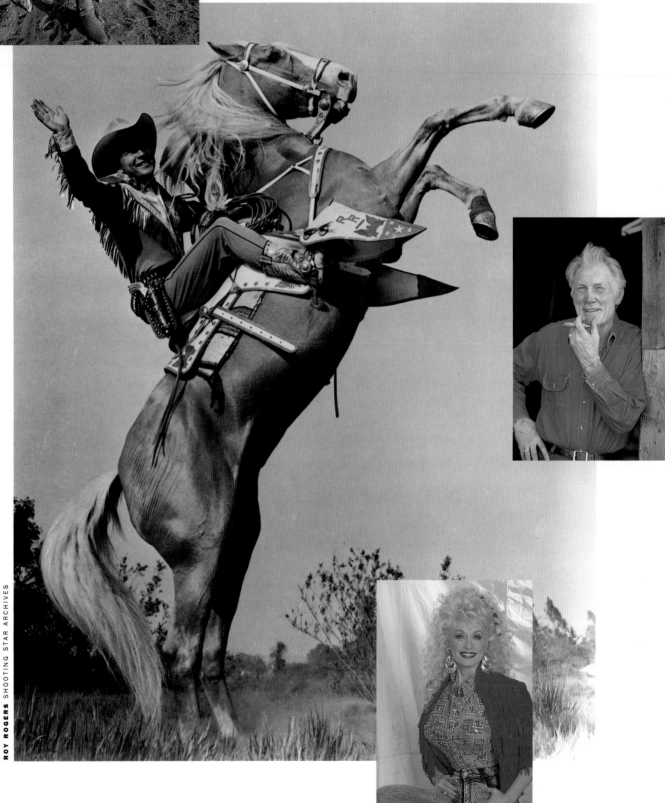

489

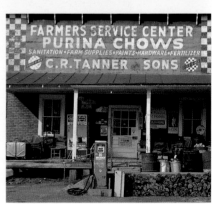

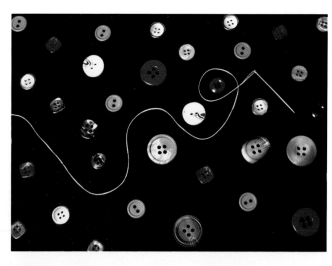

OMNI-PHOTO COMMUNICATIONS, INC.
(212) 995-0805 | FAX: (212) 995-0895
5 EAST 22nd STREET, SUITE 6N, NEW YORK, NY 10010

STOCK/RESEARCH/ASSIGNMENTS

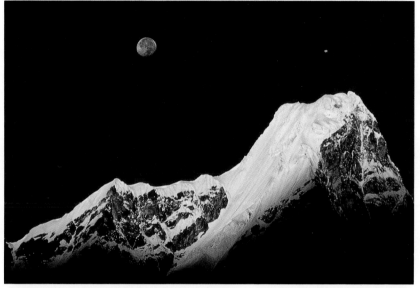

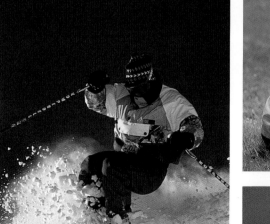

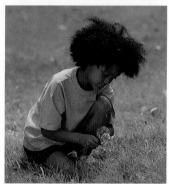

491

Fred Sieb

155 BIRCH HILL RD. - P.O. BOX 480, NORTH CONWAY, NH 03860-0480

TEL.: 603-356-587

STOCK PHOTOGRAPHY

Featuring New England scenes–all seasons as well as Southeast and Western views. Also nature photography, symbolic and seasonal still lifes– Christmas, harvest, Easter, patriotic and more. Most are large format and many are available as both verticals and horizontals.

Member –ASMP
Copyright–1993, Fred Sieb Photography

U885

A3041

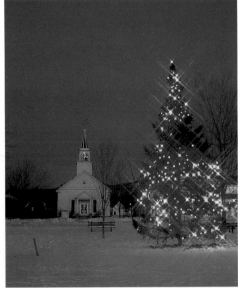

E458

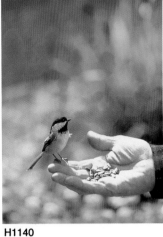
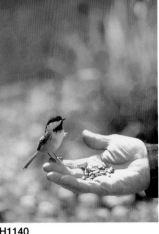

H1140

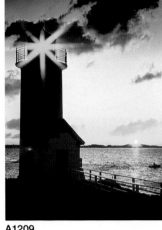

A1209

F3244

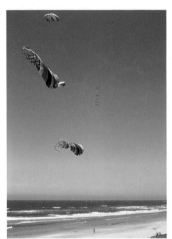

U864

H1510

A1603

E784

A2261

A3027

A2671

492

TOO BEAUTIFUL TO BE STOCK?

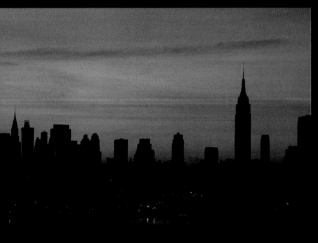

CALL JOAN KRAMER AND ASSOCIATES

**Thousands of photographs - all model released.
If you're in the market, we've got the stock.**

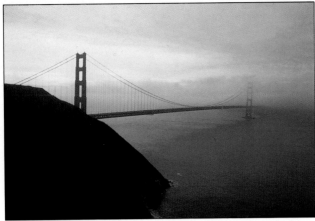

Golden Gate Bridge, San Francisco - US930083

French Window - LF930214

Pool Water - GS930191

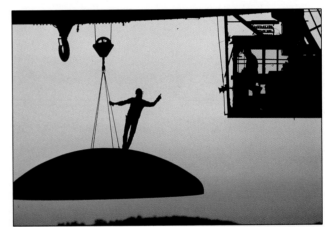

Industrial Construction - MI930049

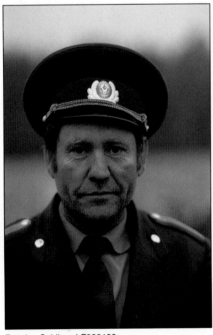

Russian Soldier - LF930199

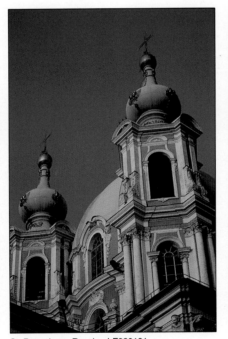

St. Petersburg, Russia - LF920181

Frost Pattern - GS910006

Streano/Havens

206/293-4525

P.O. Box 488, Anacortes, WA 98221 • Fax: 206/293-2411

In Europe call: Art Directors Photo Library, (Phone) 71 485-9325 • (Fax) 71 485-7776

A broad stock photo file with specialties in industrial, sports, locations, people, landscapes, patterns and backgrounds. Please call or write for a more complete listing.

Giant Ferris Wheel - GS910164

Industrial Pollution - MI930047

Nude in Paris - LF930219

Cattle Feed Lot - AN930066

Ancient Stone Wall - LF910092

Family - PE930031

Rivergrass in the Dordogne - GS930176

Streano/Havens

206/293-4525
P.O. Box 488, Anacortes, WA 98221 • Fax: 206/293-2411
In Europe call: Art Directors Photo Library, (Phone) 71 485-9325 • (Fax) 71 485-7776

A broad stock photo file with specialties in industrial, sports, locations, people, landscapes,
patterns and backgrounds. Please call or write for a more complete listing.

PHOTRI, INC.

A super stock library with input from ASMP photographers in many countries. We are the stock photo agency for SPACE, AEROSPACE, the MILITARY & WASHINGTON, D.C. All other subjects available including photo research.

BB-25
CIRCULAR KIDS HEADS
© PHOTRI / FOTOPIC

BB-26
SKYDIVERS IN CIRCLE
© PHOTRI / Tom Sanders

BB-27
EARTH IN SPACE
AFRICA, ARABIA

PENGUIN and YOUNG
© PHOTRI / Colin Monteath

VOLCANO ERUPTING
LAVA FLOWING

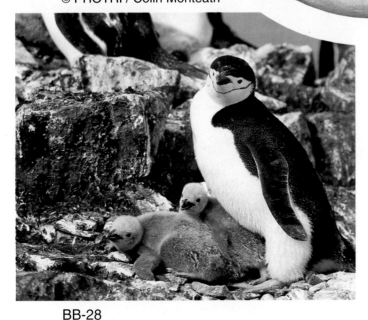

BB-28

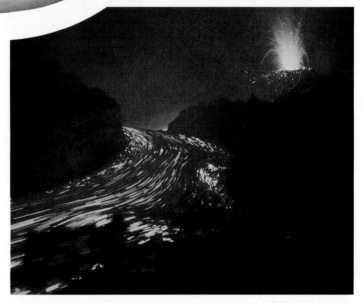

BB-29

PHOTRI, INC.
3701 South George Mason Drive
Suite C2 North
Falls Church, Virginia 22041
Phone (703) 931-8600 FAX (703) 998-8407

MGA/ PHOTRI INC.
Lakeside Loft Apartments
731 South Plymouth Court, Suite 612
Chicago, Illinois 60605
Phone (312) 987-0079 FAX (312)987-0134

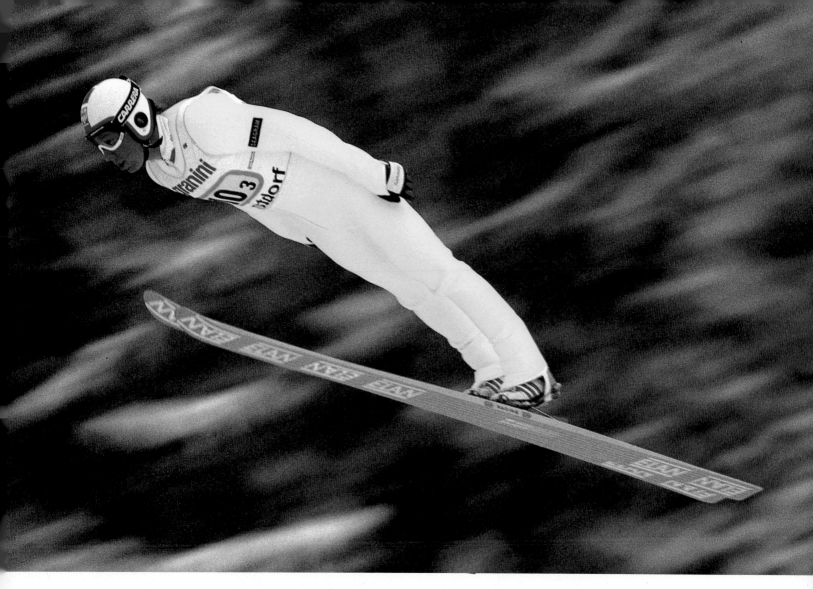

A SOURCE FOR

MODEL-RELEASED

SPORTS IMAGES,

ALONG WITH

A DIVERSE

AND

EXCITING

SPORTS COLLECTION.

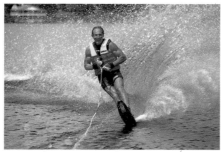

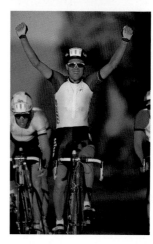

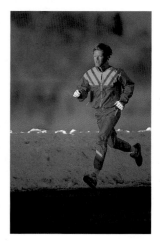

SPM
Sports Photo Masters, Inc.

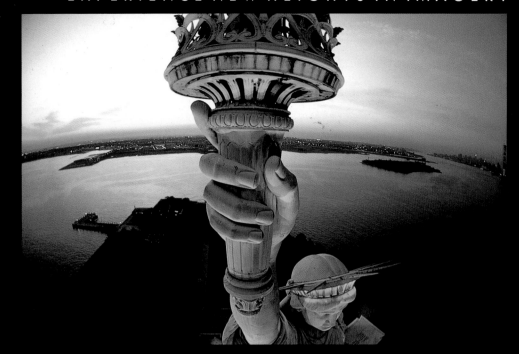

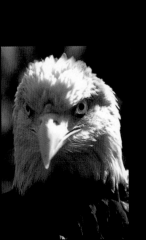
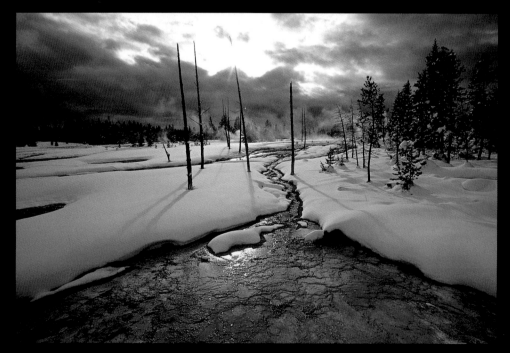

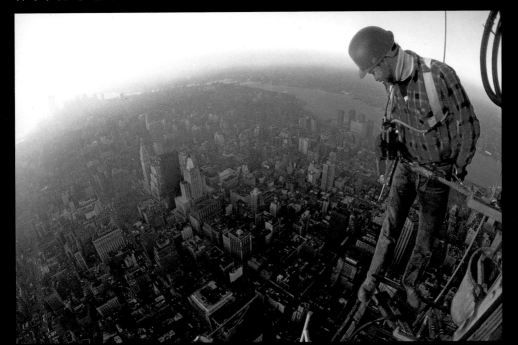
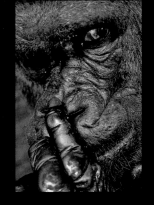
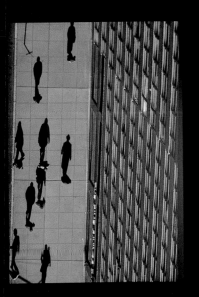
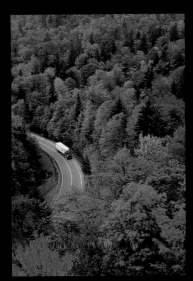
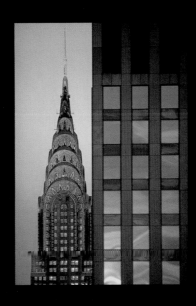
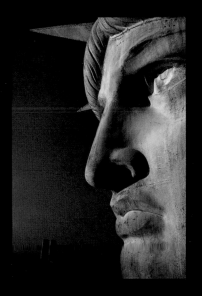
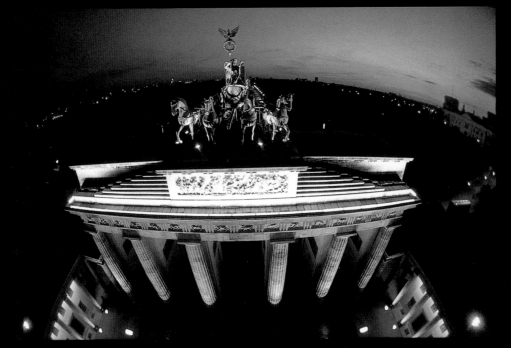

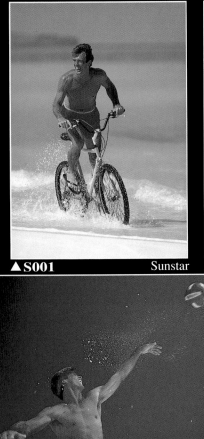
▲S001　　　Sunstar

▲S002　　　Sunstar

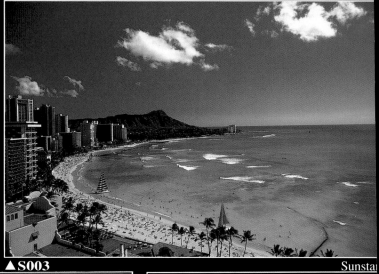
▲S003　　　Sunstar

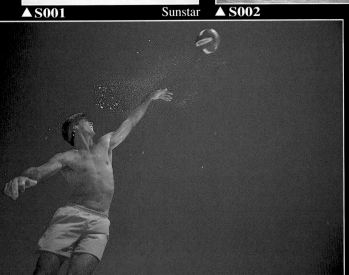
▲S004　　　Sunstar

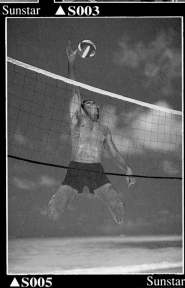
▲S005　　　Sunstar

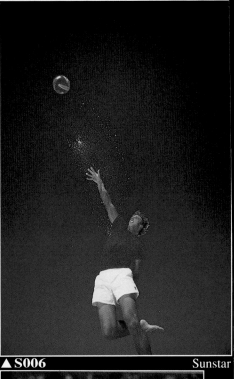
▲S006　　　Sunstar

▲S007　　　Sunstar

Magazine cover photos by Sunstar

Sun Stock
VITAL VISIONS
DYNAMIC IMAGES OF HAWAII AND THE WORLD

▲S008　　　Sunstar

P.O. BOX 1087 KAILUA HI 96734 (808)262-5546

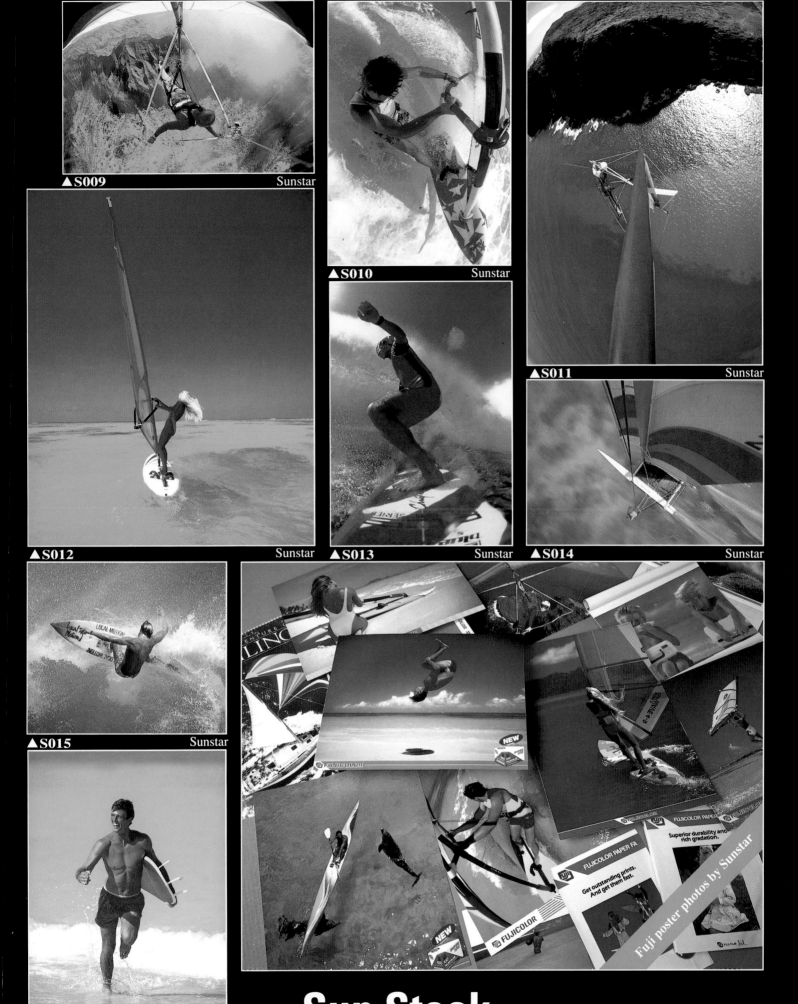

▲S009 Sunstar

▲S010 Sunstar

▲S011 Sunstar

▲S012 Sunstar

▲S013 Sunstar

▲S014 Sunstar

▲S015 Sunstar

▲S016 Sunstar

Fuji poster photos by Sunstar

Sun Stock
VITAL VISIONS
DYNAMIC IMAGES OF HAWAII AND THE WORLD

P.O.BOX 1087 KAILUA HI 96734 (808)262-5546

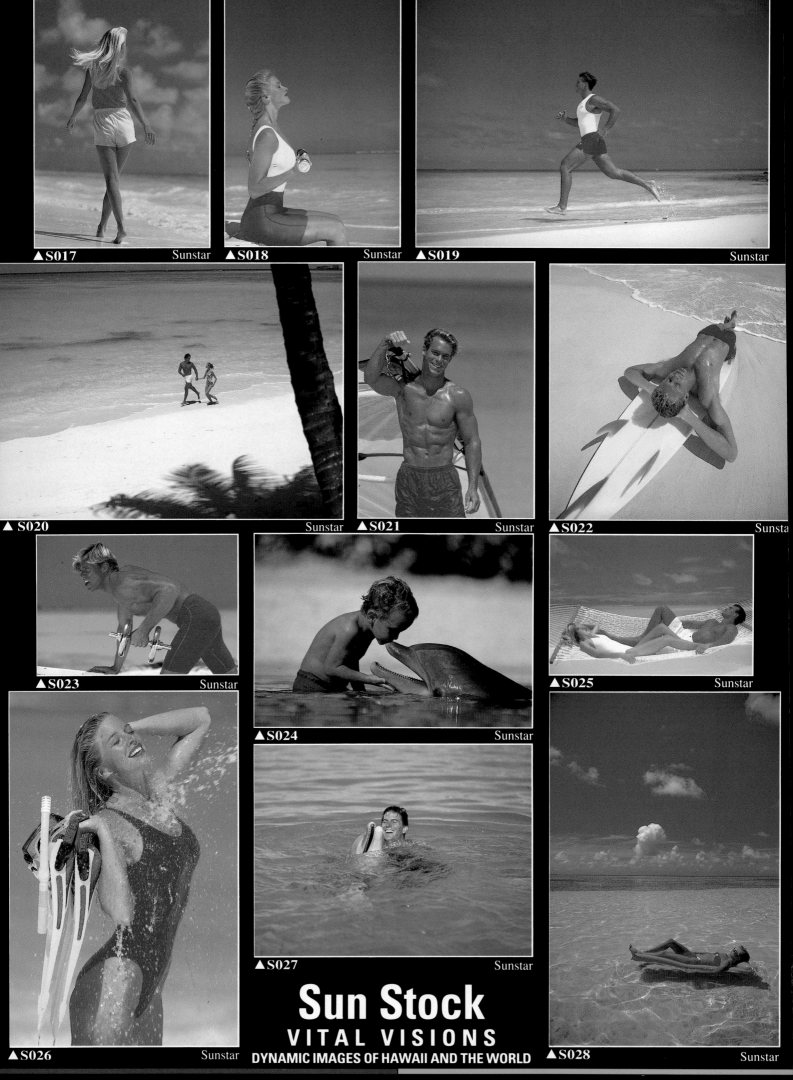

▲S017 Sunstar ▲S018 Sunstar ▲S019 Sunstar

▲ S020 Sunstar ▲S021 Sunstar ▲S022 Sunsta

▲S023 Sunstar ▲S025 Sunstar

▲S024 Sunstar

▲S027 Sunstar

Sun Stock
VITAL VISIONS
DYNAMIC IMAGES OF HAWAII AND THE WORLD

▲S026 Sunstar ▲S028 Sunstar

P.O.BOX 1087 KAILUA HI 96734 (808)262-5546

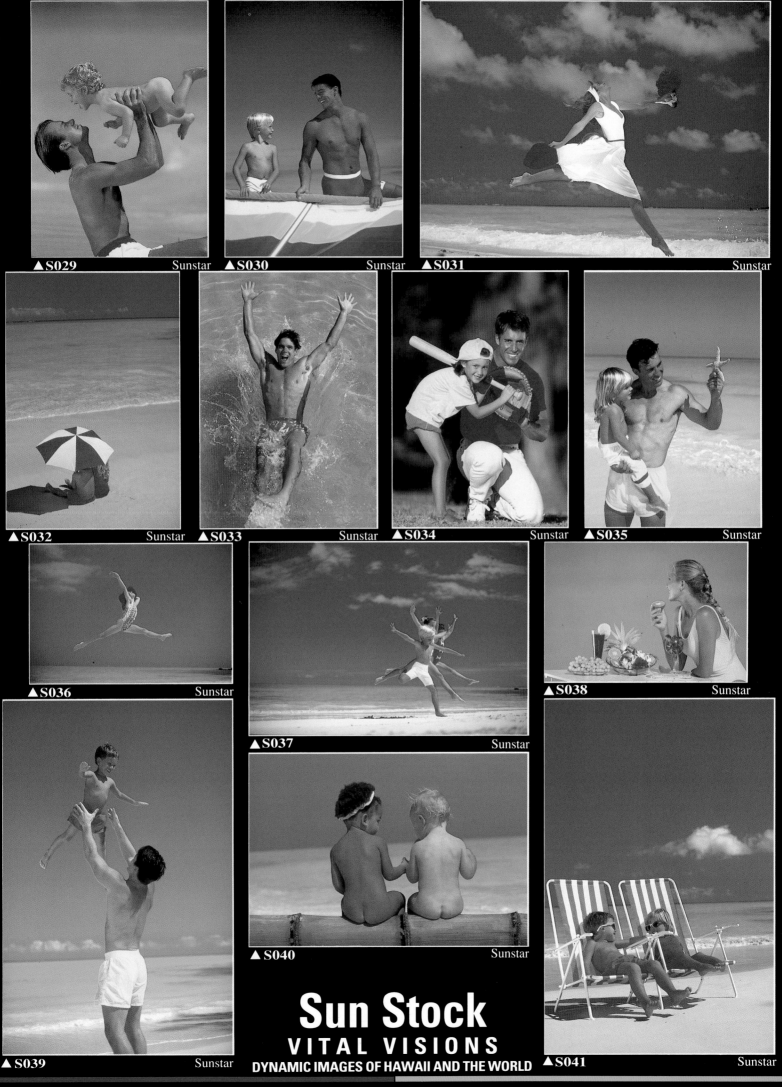

▲S029 Sunstar ▲S030 Sunstar ▲S031 Sunstar

▲S032 Sunstar ▲S033 Sunstar ▲S034 Sunstar ▲S035 Sunstar

▲S036 Sunstar ▲S038 Sunstar

▲S037 Sunstar

▲S040 Sunstar

Sun Stock
VITAL VISIONS
DYNAMIC IMAGES OF HAWAII AND THE WORLD

▲S039 Sunstar ▲S041 Sunstar

P.O. BOX 1087 KAILUA HI 96734 (808) 262-5546

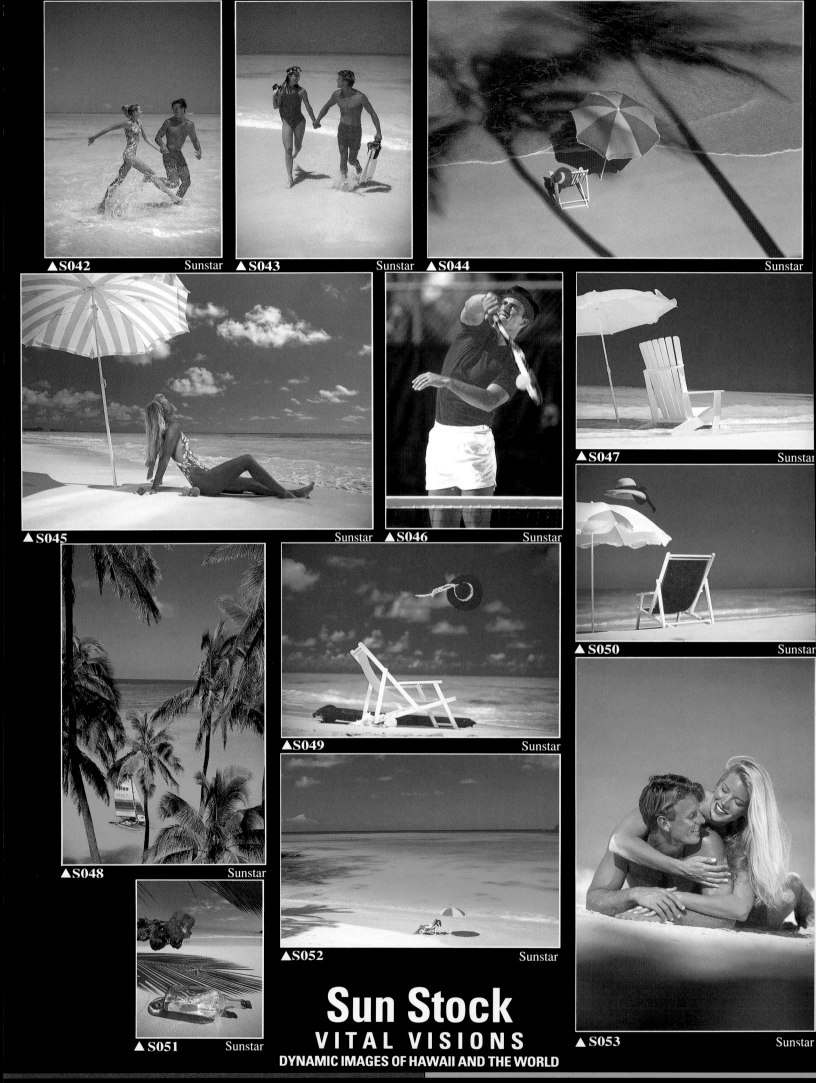

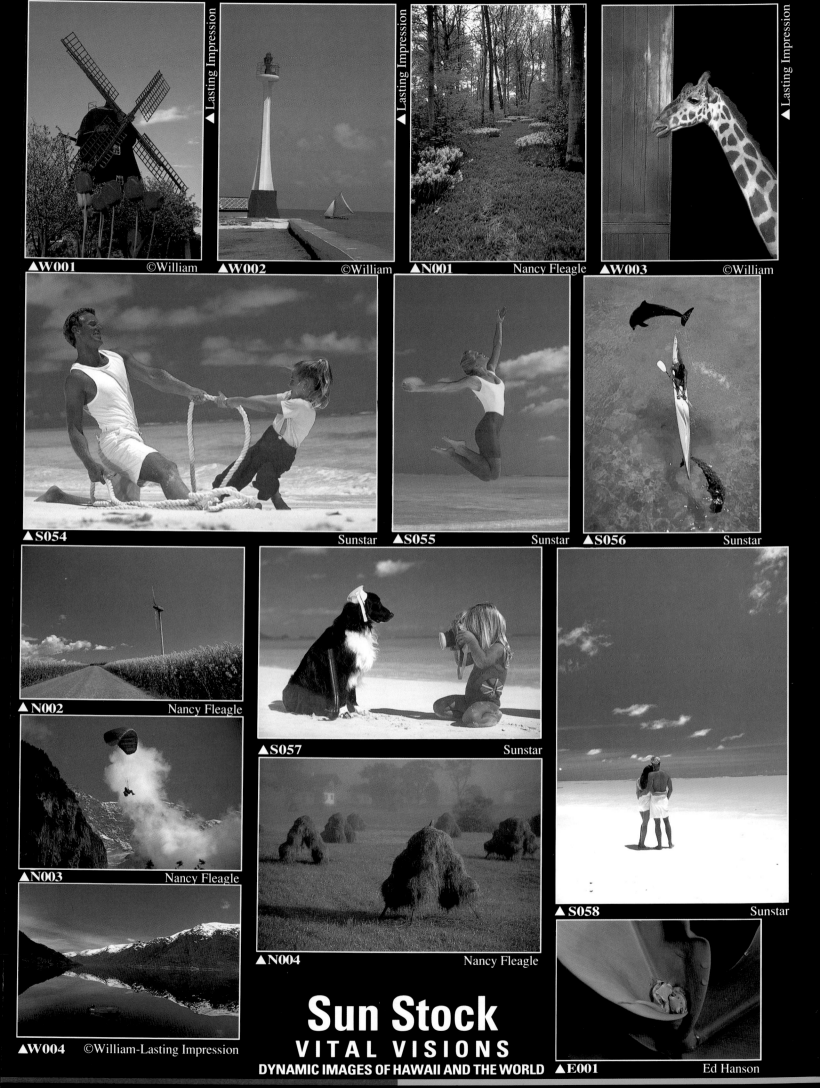

▲W001 ©William ▲W002 ©William ▲N001 Nancy Fleagle ▲W003 ©William

▲Lasting Impression ▲Lasting Impression ▲Lasting Impression

▲S054 Sunstar ▲S055 Sunstar ▲S056 Sunstar

▲N002 Nancy Fleagle

▲S057 Sunstar

▲N003 Nancy Fleagle

▲S058 Sunstar

▲N004 Nancy Fleagle

▲W004 ©William-Lasting Impression

Sun Stock
VITAL VISIONS
DYNAMIC IMAGES OF HAWAII AND THE WORLD

▲E001 Ed Hanson

P.O. BOX 1087 KAILUA HI 96734 (808) 262-5546

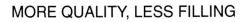

212 • 727 • 9727

FAX 212 • 633 • 2069

127 W. 26 ST., STE. 800, NEW YORK, NY 10001

MORE QUALITY, LESS FILLING

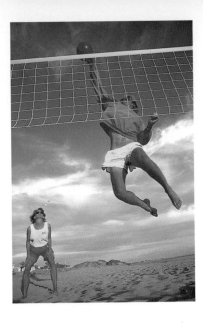

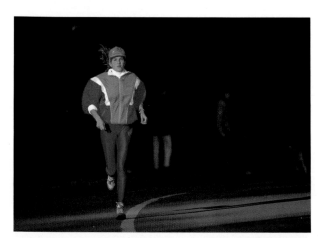

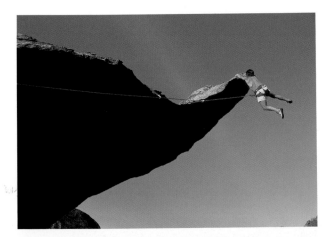

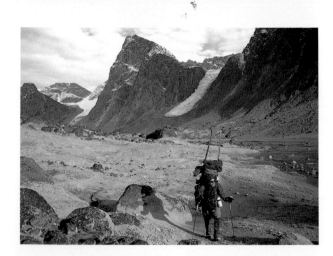

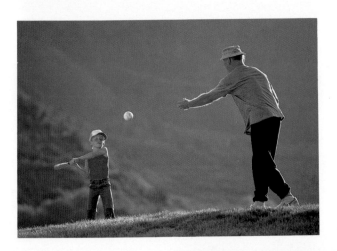

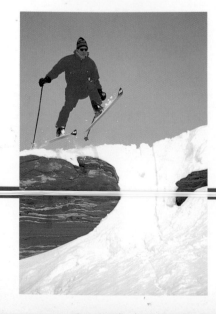

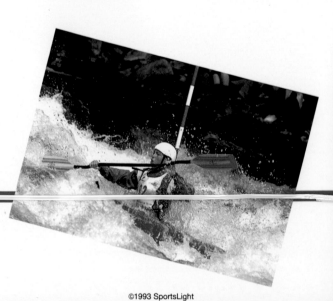

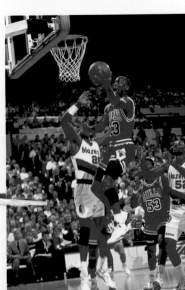

ARCHIVE PHOTOS

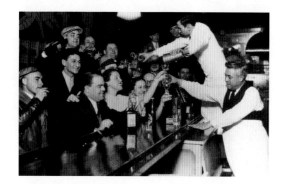 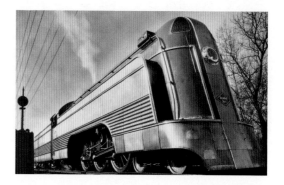

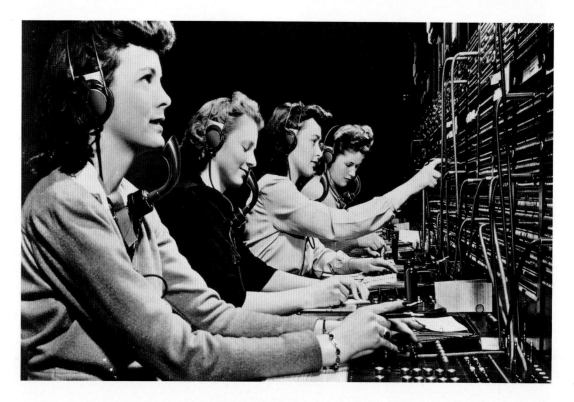

800/536/2035 OR 212/675/0115

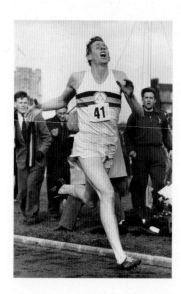 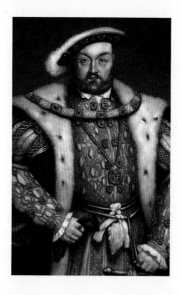

OVER 6 MILLION IMAGES. FROM FACES FAMOUS AND INFAMOUS, TO HOLLYWOOD OLD AND NEW.
MOVIE STILLS, HISTORICAL EVENTS, PLACES, LIFESTYLES, AND A COMPREHENSIVE COLLECTION OF MODEL
RELEASED STOCK COVERING AN ENCYCLOPEDIC RANGE OF SUBJECTS IN COLOR AND B&W.
530 WEST 25TH STREET NEW YORK, NEW YORK 10001 FAX 212 / 675 / 0379

ARCHIVE PHOTOS™

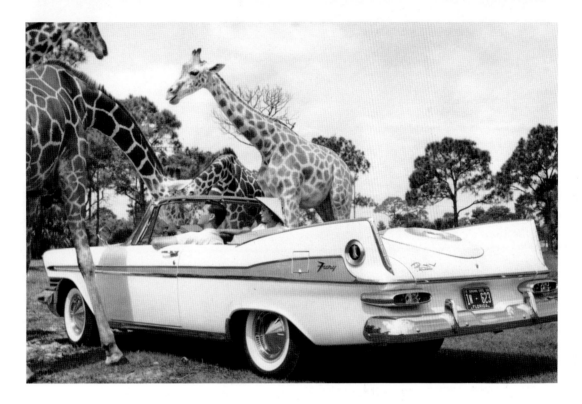

800/536/2035 OR 212/675/0115

FIRST IMAGE WEST

(Formerly VISUAL IMAGES WEST)

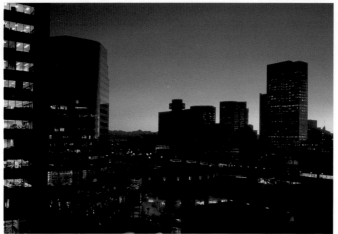

PHOENIX, ARIZONA/Jim Marshall

Bill Timmerman

Ken Akers

COWBOYS/Jim Arndt

CHICAGO, ILLINOIS/Stock Montage

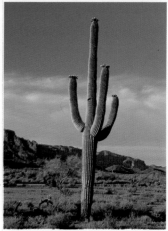

SAGUARO/Frank Biondo

FIRST IMAGE WEST, INC.
1–800–433–4765

921 West Van Buren ■ Suite 201 ■ Chicago, Illinois 60607 ■ 312/733-9875 ■ Fax 312/733-2844

© First Image West, Inc.

When You're Hot...
Show It!

VOLCANIC
RESOURCES

(808) 967-7672 VOICE/FAX
POST OFFICE BOX 884
VOLCANO, HAWAII 96785 USA

AIRBORNE

510-769-9766

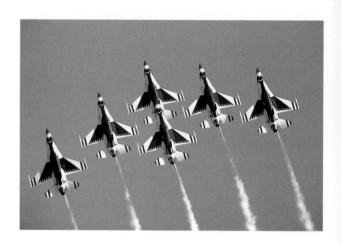

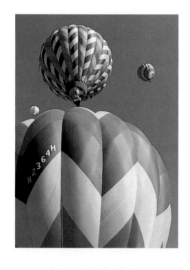

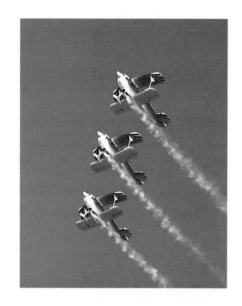

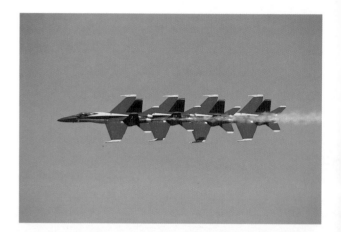

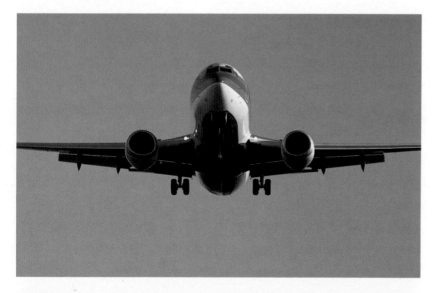

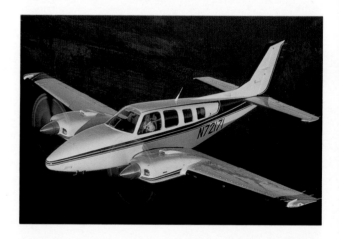

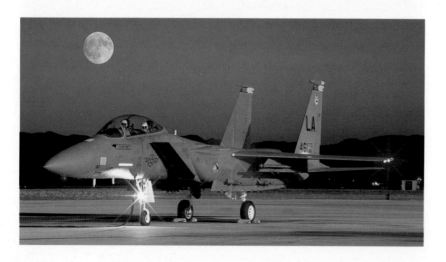

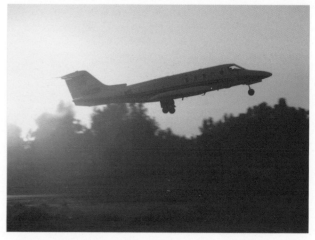

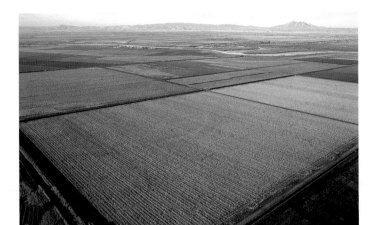

510-769-9766 FAX: 510-769-9770

P.O. Box 2878 Alameda, CA 94501

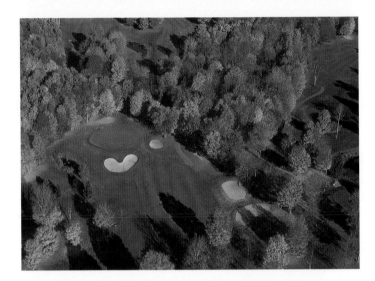

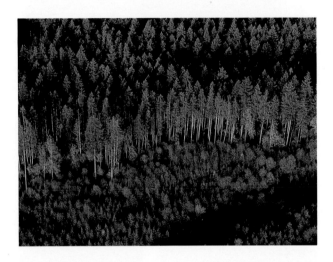

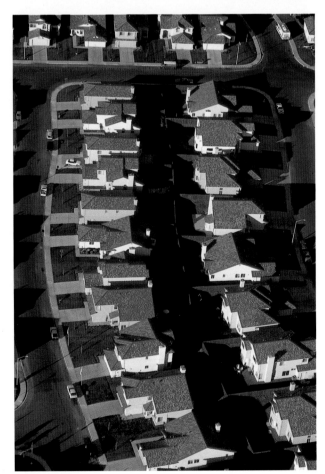

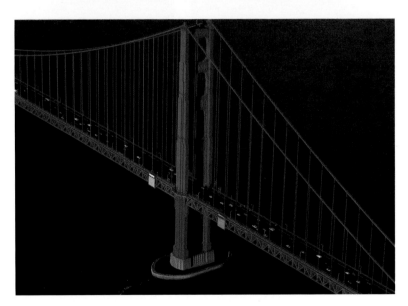

JORDAN
COONRAD

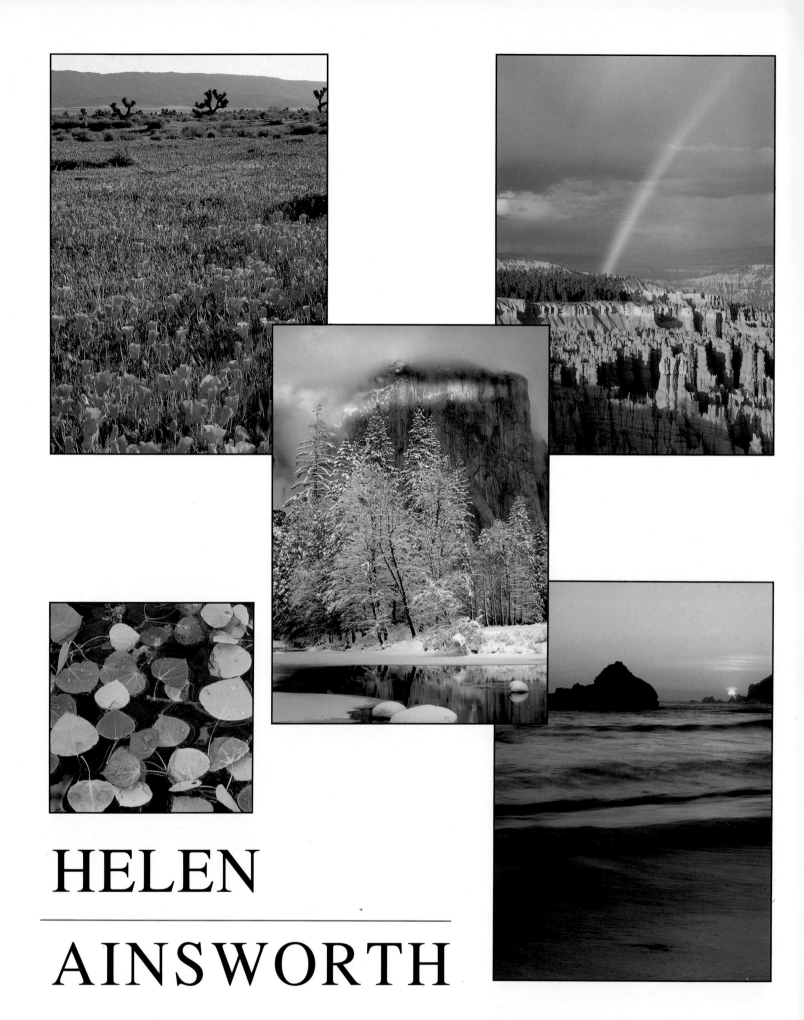

HELEN

AINSWORTH

STOCK REPRESENTED BY **JORDAN COONRAD**
510-769-9766 FAX: 510-769-9770

In Sports Photography...We're in a League by Ourselves!

PICTURE AGENCY - STOCK PHOTO LIBRARY

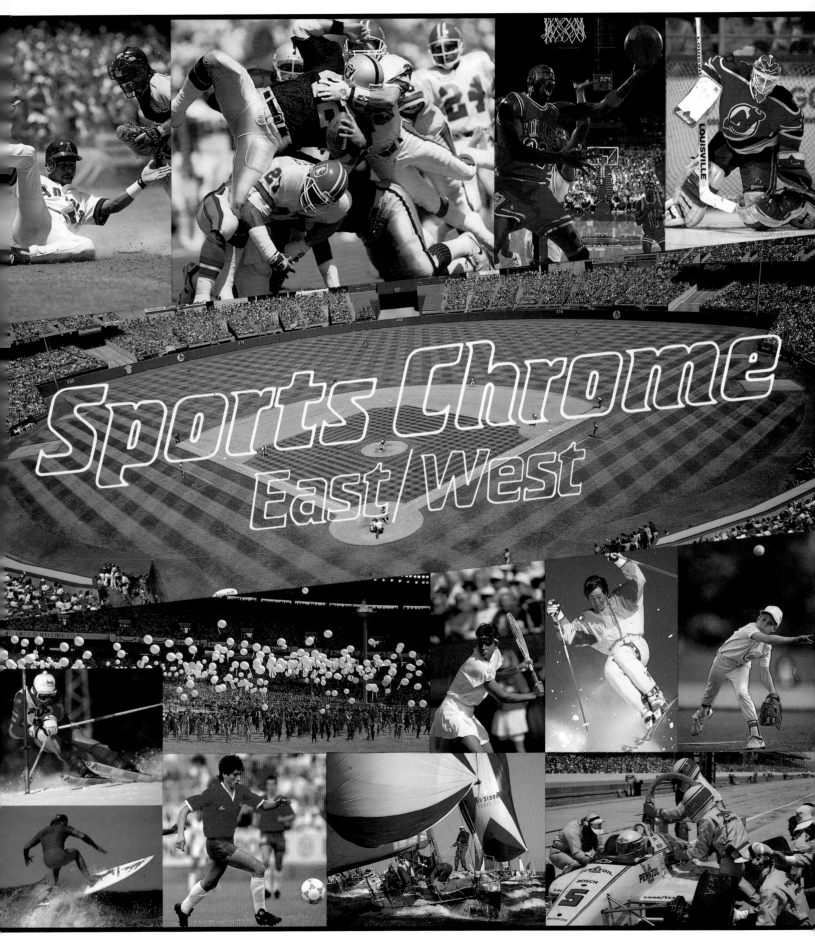

Sports Chrome
East/West

IMAGES with imagination speak for themselves. They supply the visual energy that makes an idea **WORK**. We supply **IMAGES** with imagination.

IMAGE

FINDERS

7th Floor

134 Abbott St.

Vancouver B.C.

Canada V6B 2K4

Tel: 604•688•9818

Fax: 604•684•2452

TOLL FREE

1•800•661•5609

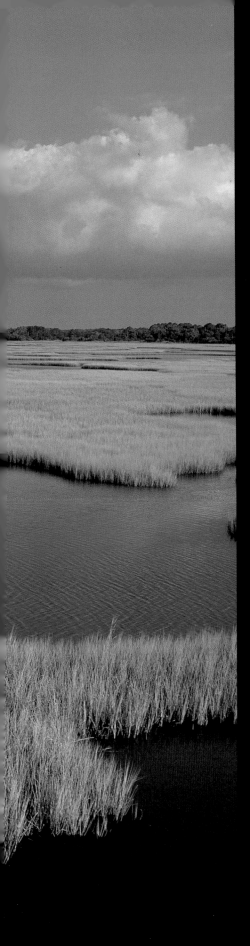

Agriculture
The Arts
Bali/Java
Bermuda
Business
Caribbean
Computers
Couples
Families
High-Tech
Industry
Medical/Health
Morocco
Nature
North Carolina
Recreation
Scenics
Seniors
Southeast
US Travel
World Travel

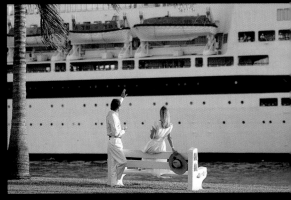

Picturesque

(919) 828-0023

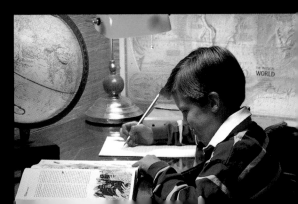

Abraham Menashe *humanistic* **phot**⊙**graphy**

306 EAST 5TH STREET, NEW YORK, NEW YORK 10003

Fax 212-505-6857 **212-254-2754**

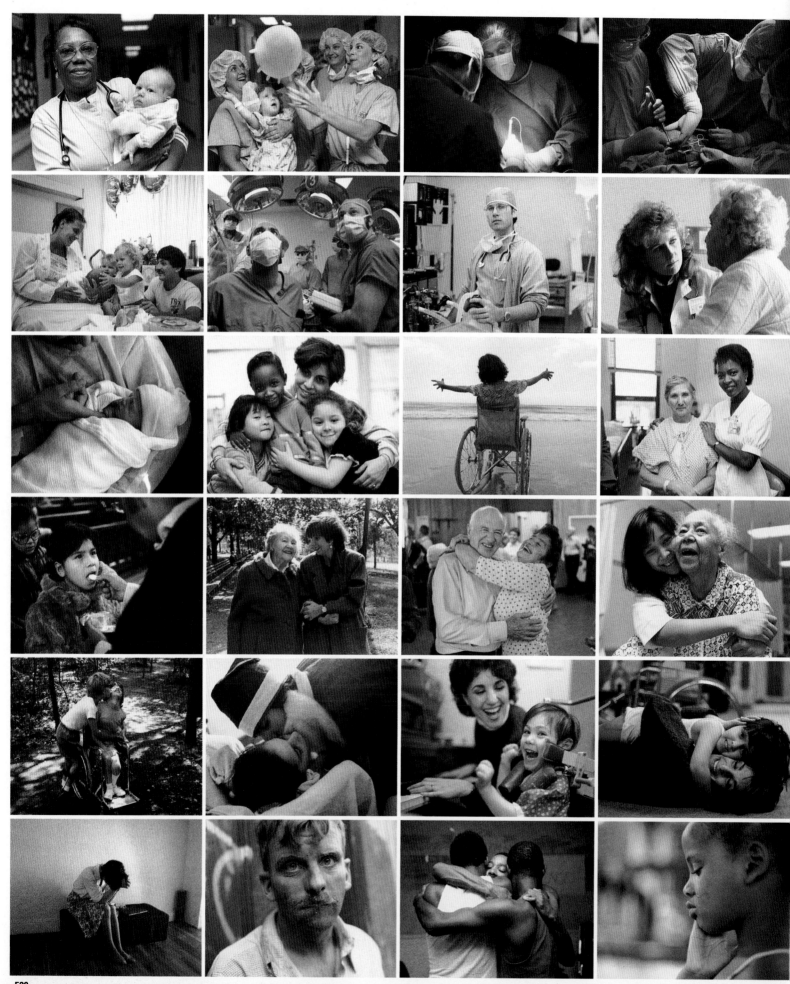

FROZEN · IMAGES

inc.

Healthy Exposures, A Division of **Frozen Images, Inc.**

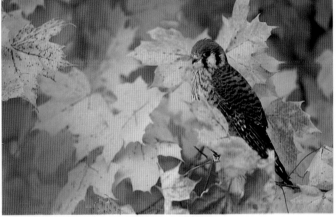

© Everett C. Johnson

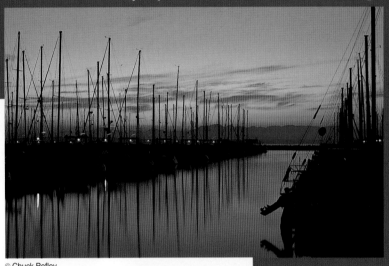

© Chuck Pefley

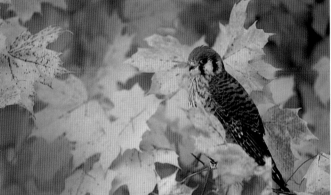

© Rich Kirchner

© Richard Hamilton Smith

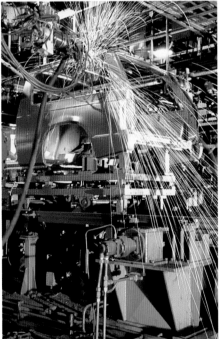

© Ken Glaser

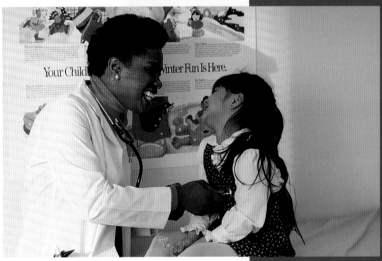

© Tom Nelson

612-339-3191
800-962-6302
FAX 612-339-3193

400 First Avenue North, Suite 512 • Minneapolis, Minnesota 55401-1723

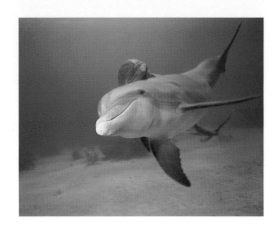

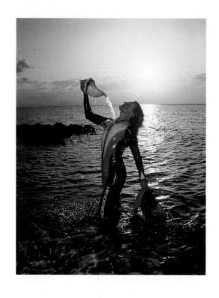

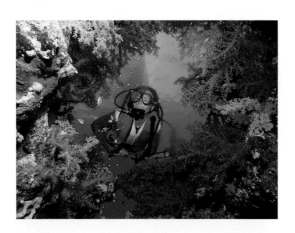

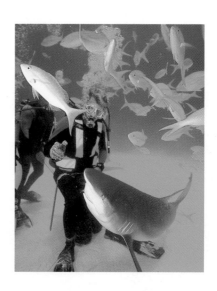

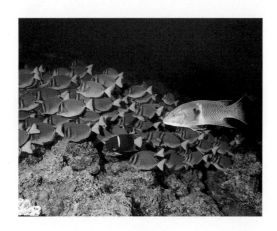

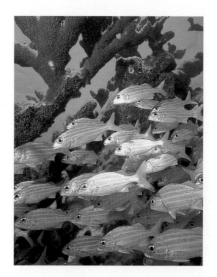

WaterHouse

STOCK PHOTOGRAPHY

800-451-3737 FAX 305-451-5147

P.O. BOX 2487 • MILE MARKER 102.5 • KEY LARGO, FLORIDA 33037

WaterHouse

STOCK PHOTOGRAPHY

800-451-3737 FAX 305-451-5147
P.O. BOX 2487 • MILE MARKER 102.5 • KEY LARGO, FLORIDA 33037

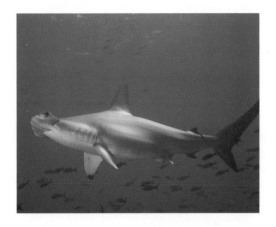

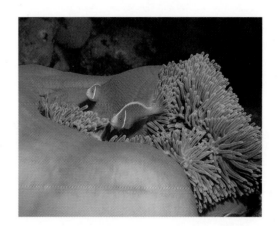

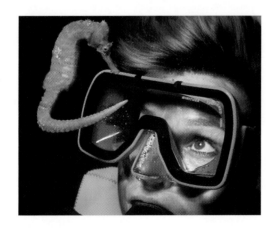

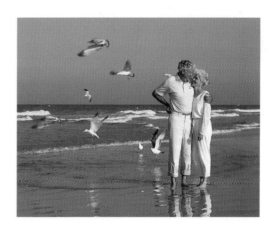

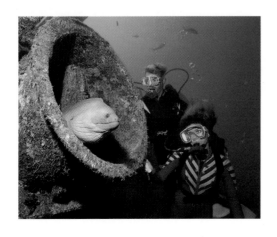

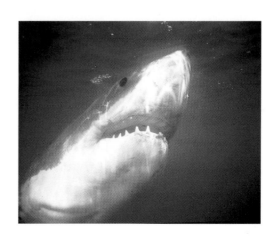

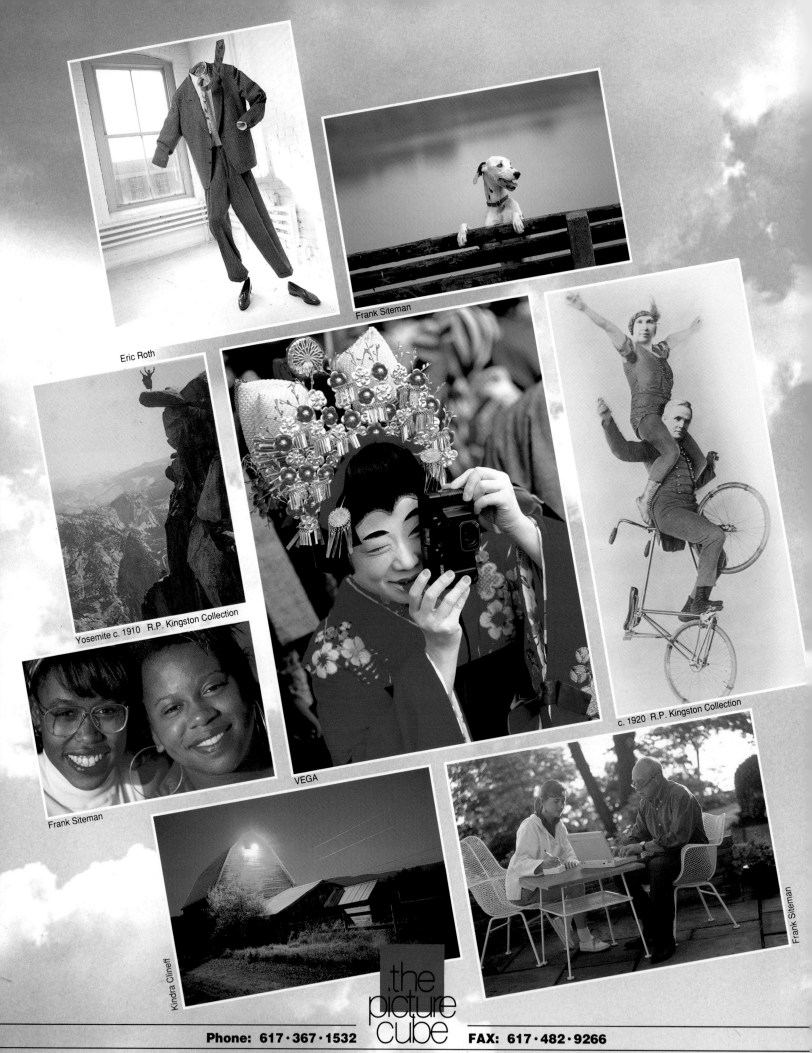

Eric Roth

Frank Siteman

Yosemite c. 1910 R.P. Kingston Collection

Frank Siteman

VEGA

c. 1920 R.P. Kingston Collection

Kindra Clineff

Frank Siteman

the
picture
Cube

Phone: 617·367·1532 **FAX: 617·482·9266**

The Picture Cube · 89 Broad Street · Boston, Massachusetts 02110

Exceptional Color and B&W Photography from New England and Around the World

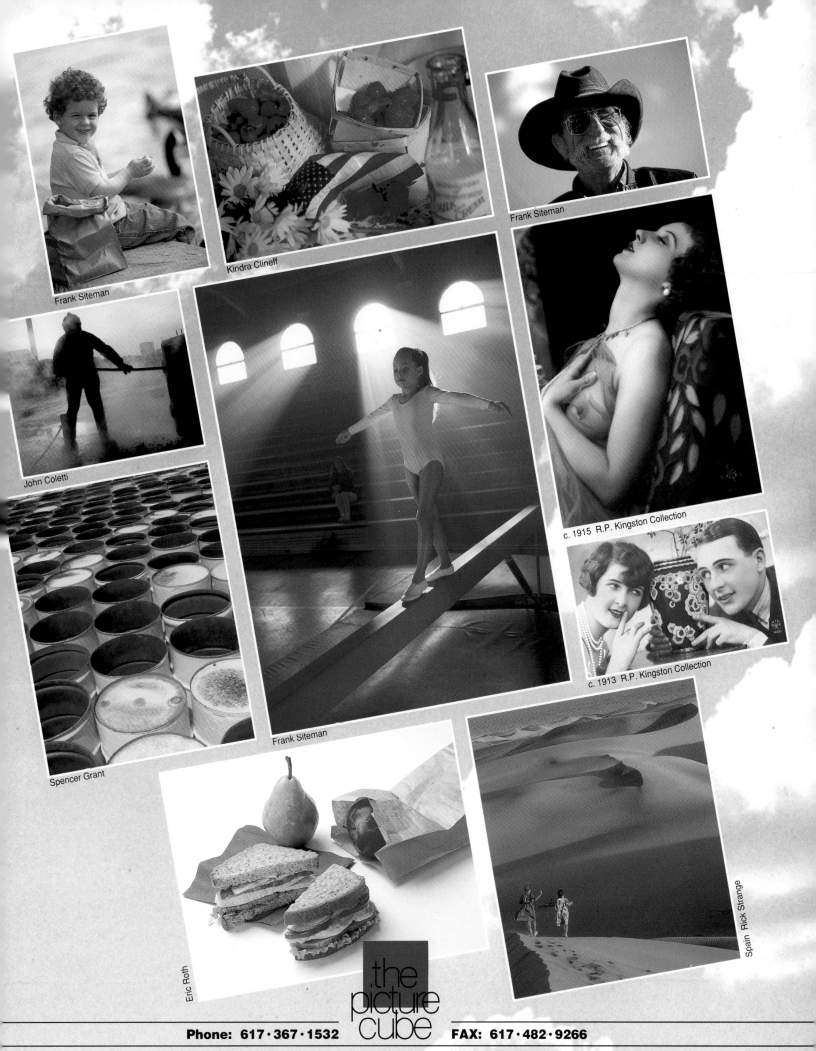

Frank Siteman

Kindra Clineff

Frank Siteman

John Coletti

c. 1915 R.P. Kingston Collection

c. 1913 R.P. Kingston Collection

Spencer Grant

Frank Siteman

Eric Roth

Spain Rick Strange

ADSTOCK PHOTOS

800-266-5903
602-277-5903
602-274-9017 FAX
Phoenix, Arizona U.S.A.

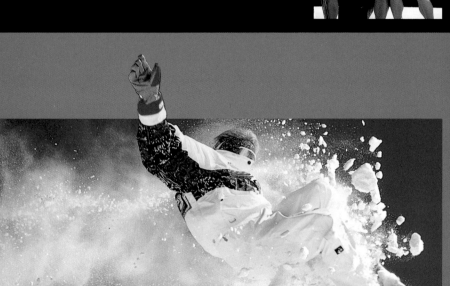

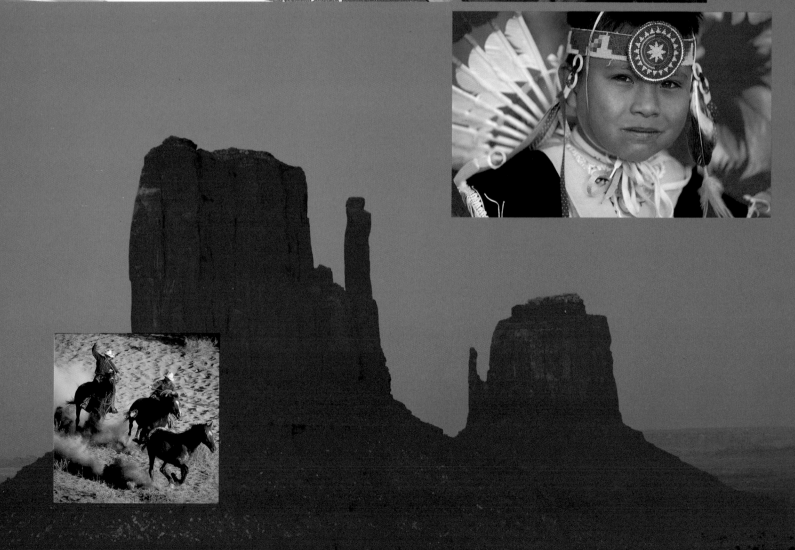

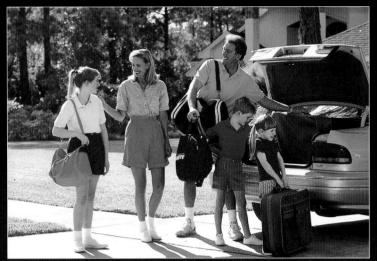

FC1001 Bill Bachmann

FC1002 Bill Bachmann

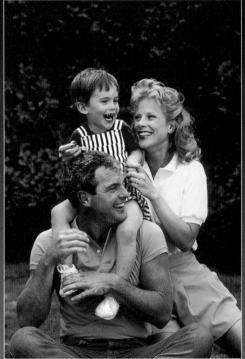

FC1003 Michael Philip Manheim

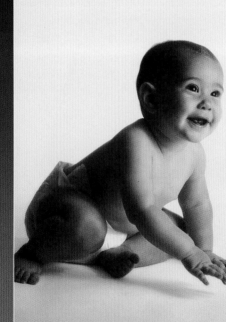

FC1004 Gerard Fritz

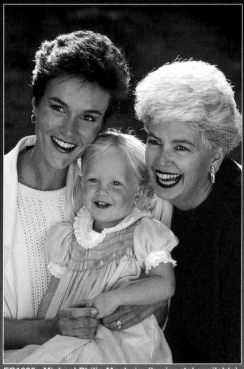

FC1005 Michael Philip Manheim (horizontal available)

FC1006 William Dean

FC1007 Bill Bachmann (horizontal available)

FC1008 Steve Tregeagle

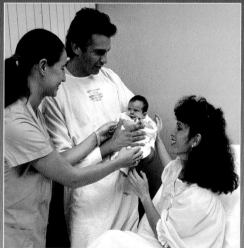
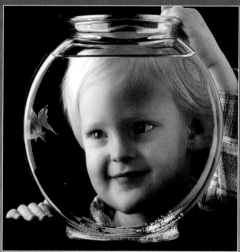
529

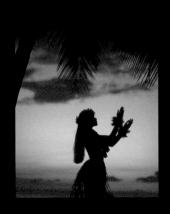
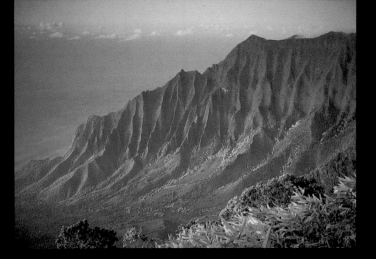
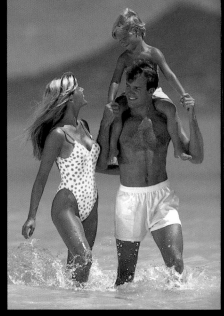
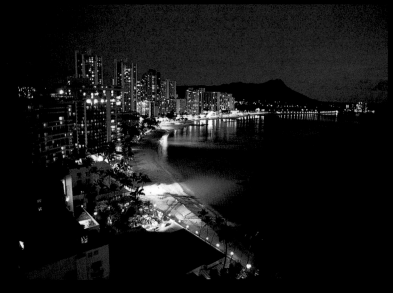
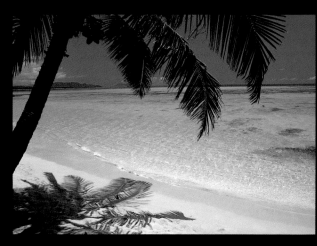
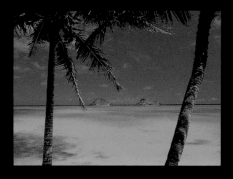
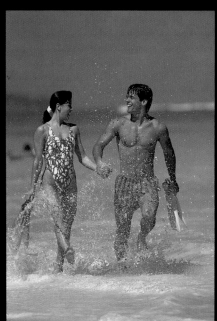
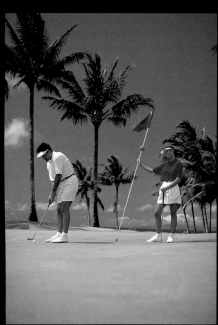

STOCK
PHOTOS
HAWAII

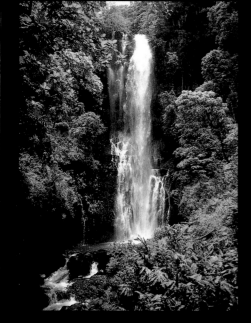
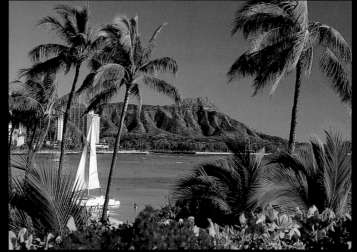
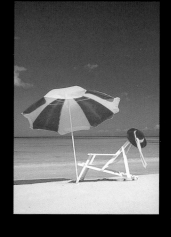

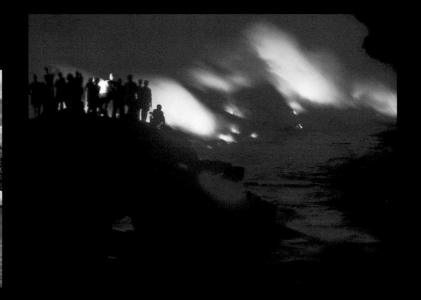

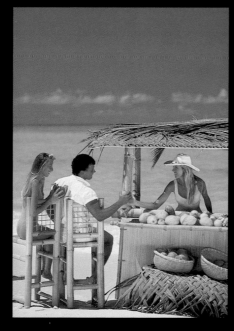
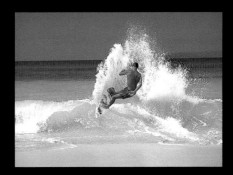

STOCK
PHOTOS
HAWAII

808·538·1389 1128 NUUANU · SUITE 250 HONOLULU · HAWAII · 96817 FAX · 808·537·9111

New York, Los Angeles, Milwaukee.*

*{All the **great** **stock** **catalogs** come from the coasts.}

Call us for your free copy.
Toll free, **1.800.323.9337**

third coast
STOCK SOURCE INC

Fotopic

FOR A FREE CATALOG, CALL 1-800-288-3686

STOCK *imagery*®

Henryk Kaiser

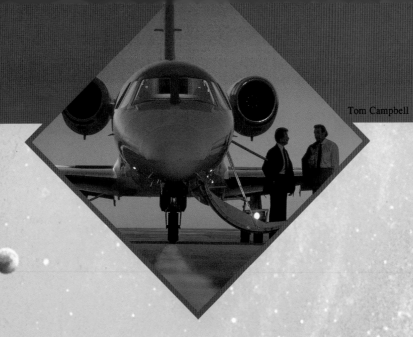

Tom Campbell

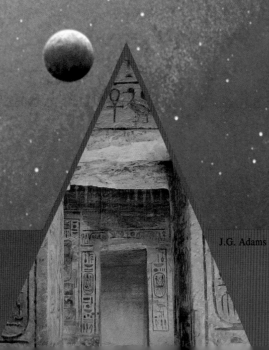

J.G. Adams

Background Illustration by Ron Russell

© Alan Oddie

© Tony Freeman

© Tony Freeman

© Tony Freeman

© Myrleen Ferguson Cate

children teens families

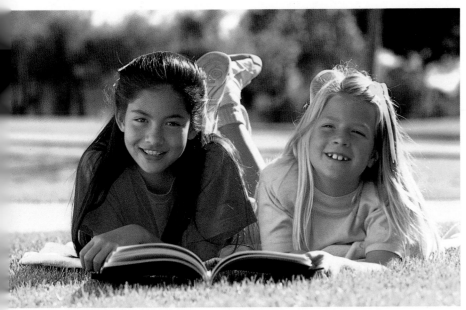

© David Young-Wolff

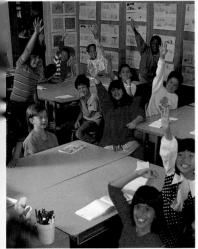

© Mary Kate Denny

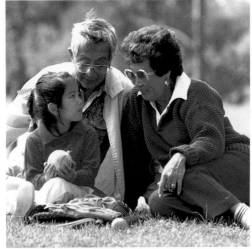

© David Young-Wolff

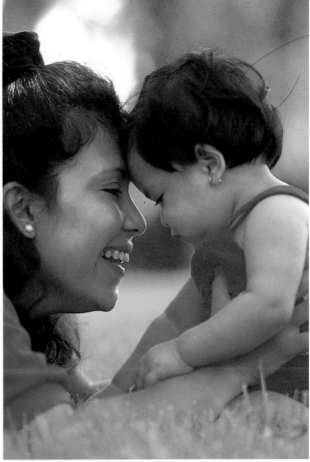

© David Young-Wolff

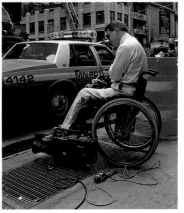

© Robert Brenner

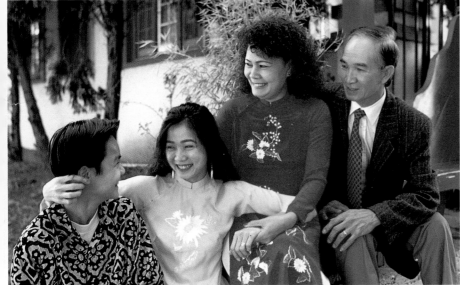

© Michael Newman

Photo
Edit

PHONE 818·342·2811 FAX 818·343·9548

IT'S NEW. IT'S FREE.

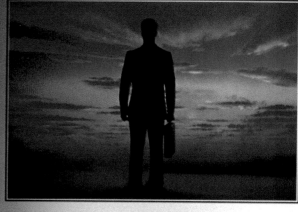

COMSTOCK
ENCYCLOPEDIA
— of —
STOCK PHOTOGRAPHY

Volume .1.
BUSINESS & INDUSTRY

COMST
ENCYCLO
— of —
STOCK PHO

Volume .3.
SPORTS, FITNESS,
MEDICINE & NUTRITION

COMS
ENCYCL
— of —
STOCK PH

Volume .4.
SCENICS & BACKGROUNDS

Now Also Available
In Digital
Format

Now Also Available
In Digital
Format

Now Also Available
In Digital
Format

CO
EN
STOC

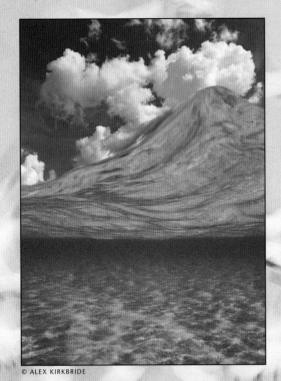
© ALEX KIRKBRIDE

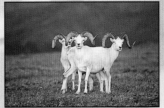
© MICHAEL FRYE

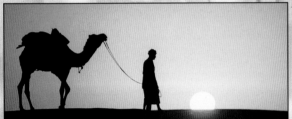
© WILLIAM NEILL

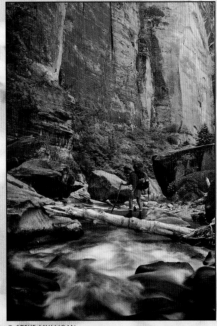
© STEVE MULLIGAN

LANDSCAPE,

WILDLIFE,

UNDERWATER AND

ADVENTURE TRAVEL

STOCK IMAGES

THAT REFLECT

THE WONDER

OF OUR PLANET.

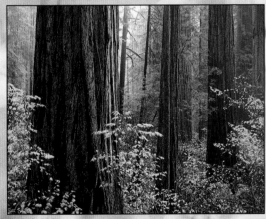
© JC LEACOCK

© JAMES GRITZ

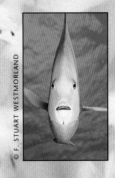
© F. STUART WESTMORLAND

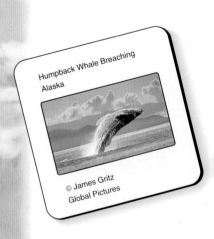
Humpback Whale Breaching
Alaska

© James Gritz
Global Pictures

1.800.766.2545 TEL 303.447.3388 FAX 303.449.3862
5595 ARAPAHOE ROAD BOULDER, CO 80303

BACKGROUND PHOTO © MICHAEL FRYE

Directory

A.S.P. PUBLISHING *68 E. Wacker Pl. #800 Chicago, IL 60601*
(312) 853-4837
Fax (312) 782-7367

ACTION SPORTS ADVENTURE/ASA *1926 Broadway New York, NY 10023*
(212) 721-2800
Fax (212) 721-0191

• **ADSTOCK PHOTOS Ad Pg 526** *6219 N. 9th Pl. Phoenix, AZ 85014*
(602) 277-5903
(800) 266-5903
Fax **(602) 274-9017**

• **ADVENTURE PHOTO Ad Pg 81-90** *56 E. Main St. #202 Ventura, CA 93001*
(805) 643-7751
(800) 524-5866
Fax **(805) 643-4423**

ADVERTISING ANIMALS *1960 Colony Mountain View, CA 94043*
(415) 969-0682
Fax (415) 969-0485

ADVERTISING AUTOMOBILES *1960 Colony Mountain View, CA 94043*
(415) 969-0682
Fax (415) 969-0485

AERIAL/TERRESTRIAL PHOTOGRAPHY *499 Vermont Ave. Berkeley, CA 94707*
(510) 527-5376
Fax (510) 527-2657

AERONAUTIC PICTURES *12021 Wilshire Blvd. #380 Los Angeles, CA 90025*
(310) 452-2376
Fax (310) 452-3515

• **AIRBORNE Ad Pg 512** *P O Box 2878 Alameda, CA 94501*
(510) 769-9766
Fax **(510) 769-9770**

AIUPPY PHOTOGRAPHS *522 W. Chinook St. P O Box 26 Livingston, MT 59047*
(406) 222-7308

ALASKA PICTORIAL SERVICE *P O Box 190144 Anchorage, AK 99519*
(907) 344-1370
Fax (907) 344-5343

• **ALASKA STOCK IMAGES Ad Pg 361-370** *800 W. 21st Ave. Anchorage, AK 99503*
(907) 276-1343
Fax **(907) 258-7848**

ALASKAPHOTO *Division of AllStock, Inc. 222 Dexter Ave. North Seattle, WA 98109*
(206) 622-6262
(800) 248-8116
Fax (206) 622-6662

J.C. ALLEN & SON, INC. *P O Box 2061 West Lafayette, IN 47906*
(317) 463-9614

JOHN E. ALLEN INC. *116 North Ave. Park Ridge, NJ 07656*
(201) 391-3299
Fax (201) 391-6335

ALLFORD/TROTMAN ASSOCIATES *4313 Dunwoody Gables Dr. Dunwoody, GA 30338*
(404) 394-9314
Fax (404) 390-0919

ALLSPORT USA, INC. *320 Wilshire Blvd. #300 Santa Monica, CA 90401*
(310) 395-2955
Fax (310) 394-6099

• **ALLSTOCK, INC. Ad Pg 381-390** *222 Dexter Ave. North Seattle, WA 98109*
(206) 622-6262
(800) 248-8116
Fax **(206) 622-6662**

• **AMERICAN STOCK PHOTOGRAPHY INC. Ad Pg 507** *6255 Sunset Blvd. #716 Hollywood, CA 90028*
Representing American Stock Photography:
Archive Photos/New York (212) 675-0115
Camerique/Florida (813) 351-5554
Camerique/Pennsylvania (215) 272-4000
Orion Press/Tokyo
(213) 469-3900
(415) 543-7220
Fax **(213) 469-3909**

• **ANATOMYWORKS INC. Ad Pg 330** *232 Madison Ave. #805 New York, NY 10016*
(212) 679-8480
(800) 233-1975
Fax **(212) 532-1934**

• **ANIMALS ANIMALS/EARTH SCENES Ad Pg 432-435** *17 Railroad Ave. Chatham, NY 12037*
(518) 392-5500
Fax **(518) 392-5550**

580 Broadway #1111 New York, NY 10012
(212) 925-2110
Fax **(212) 925-2796**

ANIMALS FOR ADVERTISING *Division of AllStock, Inc. 222 Dexter Ave. North Seattle, WA 98109*
(206) 622-6262
(800) 248-8116
Fax (206) 622-6662

ANIMALS UNLIMITED *Division of Superstock Inc. 11 W. 19th St. New York, NY 10011*
(212) 633-0200
(800) 828-4545
Fax (212) 633-0408

ANTHRO-PHOTO FILE *33 Hurlburt St. Cambridge, MA 02138*
(617) 868-4784

• **ARCHIVE PHOTOS Ad Pg 508-509** *530 W. 25th St. New York, NY 10001*
(212) 675-0115
(800) 688-5656
Fax **(212) 675-0379**

ARMS COMMUNICATIONS INC. *1517 Maurice Dr. Woodbridge, VA 22191-1922*
(703) 690-3338
Fax (703) 490-3298

• **PETER ARNOLD INC. Ad Pg 371-380** *1181 Broadway New York, NY 10001*
(212) 481-1190
(800) 289-7468
Fax **(212) 481-3409**

ART RESOURCE, INC. *65 Bleecker St. 9th Floor New York, NY 10012*
(212) 505-8700
Fax (212) 420-9286

ARTSTREET *166 E. Superior St. #212 Chicago, IL 60611*
(312) 664-3561

ASPEN PHOTO & FILM AGENCY *P O Box 4063 Aspen, CO 81612*
(303) 925-8280
Fax (303) 925-8282

ATLANTA STOCK ASSOCIATES *P O Box 723093 Atlanta, GA 31139*
(404) 434-8363
Fax (404) 435-7835

AUTHENTICATED NEWS INTERNATIONAL *34 High St. Katonah, NY 10536-1117*
(914) 232-7726
Fax (914) 232-1592

BACKGROUNDS & TEXTURES FOR ADVERTISING *2223 S. Carmelina Ave. Los Angeles, CA 90064*
(310) 820-7077
(800) 622-2028
Fax (310) 820-2687

LESTER V. BERGMAN & ASSOCIATES INC. *East Mountain Rd. South Cold Spring, NY 10516*
(914) 265-3656
Fax (914) 265-3229

BEST SHOT STOCK FILM & VIDEO *4726 N. Lois Ave. #A Tampa, FL 33614*
(813) 877-2118
Fax (813) 874-3655

THE BETHEL AGENCY *641 W. 59th St. #16 New York, NY 10019*
(212) 664-0455

BETTMANN *902 Broadway 5th Floor New York, NY 10010*
(212) 777-6200
Fax (212) 533-4034

BIOLOGICAL PHOTO SERVICE/TERRAPHOTOGRAPHICS *P O Box 490 Moss Beach, CA 94038*
(415) 726-6244

BIRD PHOTOGRAPHS, INC. *254 Sapsucker Woods Rd. Ithaca, NY 14850*
(607) 257-1263

BLACK BOX *Division of Index Stock Photography 126 5th Ave. 7th Floor New York, NY 10011*
(212) 929-4644
(800) 729-7466
Fax (212) 633-1914

6500 Wilshire Blvd. #500 Los Angeles, CA 90048
(213) 658-7707
(800) 729-7477
Fax (213) 651-4975

BLACK STAR PUBLISHING COMPANY INC. *116 E. 27th St. New York, NY 10016*
(212) 679-3288
Fax (212) 889-2052

BROWN BROTHERS *100 Bortree Rd. Sterling, PA 18463*
(717) 689-9688
Fax (717) 689-7873

D. DONNE BRYANT STOCK PHOTOGRAPHY *P O Box 80155 Baton Rouge, LA 70898-0155*
(504) 387-1620
Fax (504) 383-2951

CAMERA 5 *6 W. 20th St. 8th Floor New York, NY 10011*
(212) 989-2004
Fax (212) 727-1858

CAMERA GRAPHICS *2001 Bomar Rd. #4 North Palm Beach, FL 33408*
(407) 775-3399
Fax (407) 622-2727

CAMERA HAWAII, INC. *875 Waimanu St. #110 Honolulu, HI 96813*
(808) 536-2302
Fax (808) 538-7417

CAMERAMANN INTERNATIONAL, LTD. *P O Box 1199 Park Ridge, IL 60068-7199*
(708) 825-4141
Fax (708) 825-4455

• **CAMERIQUE INC. INTERNATIONAL Ad Pg 507** *1701 Skippack Pike P O Box 175 Blue Bell, PA 19422*
(215) 272-4000
(800) 272-4749
Fax **(215) 272-7651**

Representing Camerique Inc. International:
American Stock Photography/Los Angeles (213) 469-3900
Don Hall Productions/Sarasota (813) 365-6161
E.P. Jones Company/Boston (617) 267-6450
H. Armstrong Roberts/Chicago (312) 938-4466
H. Armstrong Roberts/New York (212) 685-3870
Reflextion Photo Theque/Montreal (514) 876-1620
Orion Press/Tokyo

WOODFIN CAMP & ASSOCIATES, INC. *116 E. 27th St. 8th Floor New York, NY 10016*
(212) 481-6900
(800) 541-2267
Fax (212) 481-6909

2025 Pennsylvania Ave. N.W. #1011 Washington, DC 20006
(202) 223-8442
Fax (202) 223-0034

CANAPRESS PHOTO SERVICE *36 King St. East #402 Toronto, Ontario M5C 2L9 Canada*
(416) 364-0321
Fax (416) 364-9283

WALTER CHANDOHA *50 Spring Hill Rd. Annandale, NJ 08801*
(908) 782-3666

CINENET CINEMA NETWORK *2235 1st St. #111 Simi Valley, CA 93065*
(805) 527-0093
Fax (805) 527-0305

CLASSIC IMAGES *1041 N. Formosa Ave. Los Angeles, CA 90046*
(213) 850-2980
Fax (213) 850-2981

BRUCE COLEMAN INC. *117 E. 24th St. 5th Floor New York, NY 10010*
(212) 979-6252
Fax (212) 979-5468

COLLECTORS SERIES *7350 Croname Niles, IL 60648-3932*
(708) 647-7285
Fax (708) 647-2238

COLOR-PIC, INC. *P O Box 186 Convent Station, NJ 07961*
(201) 267-4165
Fax (201) 984-1336

• **COMSTOCK, INC. Ad Pg 538-539** *30 Irving Pl. New York, NY 10003*
(212) 353-8600
(800) 225-2727
Fax **(212) 353-3383**

Comstock overseas:
Comstock Photofile Ltd./London (071) 351-4448
Comstock S.A.R.L./Paris (1) 46-99-07-77
Comstock, GmbH/Berlin (030) 462-9090

COMSTOCK PHOTOFILE LTD. *Division of Comstock, Inc. 49 Bathurst St. #401 Toronto, Ontario M5V 2P2 Canada*
(416) 601-9177
In Canada (800) 387-0640
Fax (416) 777-0619

CONSOLIDATED NEWS PICTURES *209 Pennsylvania Ave. S.E. Washington, DC 20003*	(202) 543-3203 *Fax* (202) 543-8122
• **JORDAN COONRAD/IMAGERY UNLIMITED Ad Pg 513-514** *P O Box 2878 Alameda, CA 94501*	**(510) 769-9766** *Fax* **(510) 769-9770**
COSMO TONE BACKGROUNDS *24422 S. Main St. #503 Carson, CA 90745*	(310) 513-6096 (800) 995-6229 *Fax* (310) 513-6298
CREATIVE PHOTOGRAPHY *1927 Lee Blvd. North Mankato, MN 56003-2506*	(507) 345-4208
CREATIVE VIDEO *1465 Northside Dr. #110 Atlanta, GA 30318*	(404) 355-5800 *Fax* (404) 350-9823
CULVER PICTURES INC. *150 W. 22nd St. 3rd Floor New York, NY 10011*	(212) 645-1672 *Fax* (212) 627-9112
CURTIS ARCHIVES *Division of Curtis Publishing 1000 Waterway Blvd. Indianapolis, IN 46202*	(317) 633-2070 *Fax* (317) 634-1791
• **CUSTOM MEDICAL STOCK PHOTO, INC. Ad Pg 179-188** *3819 N. Southport Ave. Chicago, IL 60613-2823*	**(312) 248-3200** **(800) 373-2677** *Fax* **(312) 248-7427**
CYR COLOR PHOTO AGENCY *P O Box 2148 Norwalk, CT 06852*	(203) 838-8230
DMI *David McGough Inc. R.R. 1 Box 167 Morris, NY 13808*	(607) 263-2090 *Fax* (607) 263-2477
DRK PHOTO *265 Verde Valley School Rd. Sedona, AZ 86336*	(602) 284-9808 *Fax* (602) 284-9096
DESIGN CONCEPTIONS *112 4th Ave. 4th Floor New York, NY 10003*	(212) 254-1688
DEVANEY STOCK PHOTOS INC. *755 New York Ave. #306 Huntington, NY 11743*	(516) 673-4477 *Fax* (516) 673-4440
• **LEO DE WYS INC. Ad Pg 440-443** *1170 Broadway #906 New York, NY 10001*	**(800) 284-3399** **(212) 689-5580** *Fax* **(212) 545-1185**
• **DINODIA PICTURE AGENCY Ad Pg 484** *13, Vithoba Lane Vithal Wadi, Kalbadevi Bombay, India 400 002*	**(91) (22) 201-4026** *Fax* **(91) (22) 206-7675**
LARRY DORN ASSOCIATES *5820 Wilshire Blvd. 3rd Floor Los Angeles, CA 90036*	(213) 935-6266 *Fax* (213) 935-9523
DREAMLIGHT IMAGES *Stock Footage 932 N. La Brea Ave. #C Hollywood, CA 90038*	(213) 850-1996 *Fax* (213) 850-5318
DREAMLIGHT IMAGES EAST *Stock Footage 163 E. 36th St. #1-B New York, NY 10016*	(212) 686-4900 *Fax* (212) 686-4998
• **DUOMO PHOTOGRAPHY INC. Ad Pg 217-226** *133 W. 19th St. 6th Floor New York, NY 10011*	**(212) 243-1150** *Fax* **(212) 633-1279**
ECHO IMAGE *1317 N.W. Prospect Ave. Grants Pass, OR 97526*	(503) 474-9649
ECLIPSE & SUNS *P O Box 689 Haines, AK 99827-0689*	(907) 766-2670 *Fax* (907) 766-2778
THE 11TH HOUR *1313 W. Randolph #326 Chicago, IL 60607-1526*	(312) 226-2661 *Fax* (312) 226-3125
ENERGY PRODUCTIONS TIMESCAPE IMAGE LIBRARY *12700 Ventura Blvd. 4th Floor Studio City, CA 91604*	(818) 508-1444 (800) 462-4379 *Fax* (818) 508-1293
• **ENVISION Ad Pg 452-453** *220 W. 19th St. 5th Floor New York, NY 10011*	**(212) 243-0415** **(800) 524-8238** *Fax* **(212) 243-3957**
RIC ERGENBRIGHT PHOTOGRAPHY *60380 Arnold Market Rd. P O Box 1067 Bend, OR 97709*	(503) 389-7662 *Fax* (503) 389-9917
• **EUROSTOCK Ad Pg 476-479** *4203 Locust St. Philadelphia, PA 19104*	**(800) 786-6300** *Fax* **(800) 786-1920**
EVERETT COLLECTION, INC. *117 W. 26th St. 3rd Floor New York, NY 10001*	(212) 255-8610 *Fax* (212) 255-8612
EWING GALLOWAY, INC. *100 Merrick Rd. #LL22 Rockville Centre, NY 11570* *Representing Ewing Galloway, Inc.:* *E.P. Jones Company/Boston (617) 267-6450* *Spectrum Photo/Detroit (313) 398-3630* *American Stock Photography/Los Angeles (213) 469-3900* *Atlanta Stock Associates/Atlanta (404) 434-8363*	(516) 764-8620 (212) 719-4720 (312) 368-0026 (214) 651-7553 (612) 340-0622 *Fax* (516) 764-1196
• **F-STOCK PHOTOGRAPHY, INC. Ad Pg 267-276** *323 Lewis St. #P P O Box 3956 Ketchum, ID 83340*	**(208) 726-1378** *Fax* **(208) 726-8456**
• **F/STOP PICTURES, INC. Ad Pg 450** *P O Box 359 Springfield, VT 05156*	**(802) 885-5261** *Fax* **(802) 885-2625**
• **FPG INTERNATIONAL Ad Pg 51-60** *32 Union Square East New York, NY 10003-3295*	**(212) 777-4210** *Fax* **(212) 995-9652**
FABULOUS FOOTAGE *19 Mercer St. Toronto, Ontario M5V 1H2 Canada*	(416) 591-6955 (800) 361-3456 *Fax* (416) 591-1666
121 Brayton Rd. Brighton, MA 02135	(617) 783-4897 *Fax* (617) 783-0355
FASHIONS IN STOCK *23-68 Steinway St. Astoria, NY 11105*	(718) 721-1373
FILM & VIDEO STOCK SHOTS, INC. *10700 Ventura Blvd. #E Studio City, CA 91604*	(818) 760-2098 *Fax* (818) 760-3294

- **FIRST IMAGE WEST, INC.** Ad Pg 510 *921 W. Van Buren #201 Chicago, IL 60607* **(312) 733-9875**
 Representing First Image West: **(800) 433-4765**
 Take Stock Photo/Calgary (403) 233-7487 Fax **(312) 733-2844**
 Ace Photo Agency/London
 Auschrome Pety, Ltd./South Melbourne
 Fotex/Hamburg
 Marka S.R.L./Milan
 Megapress Agency/Tokyo
 Stock Image/Paris
 Stock Photos/Madrid

FIRST LIGHT STOCK *204-1 Atlantic Ave. Toronto, Ontario M6K 3E7 Canada* (416) 532-6108
 (800) 661-2001
 Fax (416) 532-7499

FISH FILMS FOOTAGE WORLD *4548 Van Noord Ave. Studio City, CA 91604* (818) 905-1071
 Fax (818) 905-0301

FLORIDA IMAGE FILE, INC. *506 11th Ave. N.E. St. Petersburg, FL 33701* (813) 894-8433

- **FOCUS ON SPORTS, INC.** Ad Pg 454 *222 E. 46th St. New York, NY 10017* **(212) 661-6860**
 Fax **(212) 983-3031**

- **FOLIO INC.** Ad Pg 169-178 *The Image Agency 3417½ M St. N.W. Washington, DC 20007* **(202) 965-2410**
 (800) 662-1992
 Fax **(202) 625-1577**

FOTOCONCEPT *18020 S.W. 66th St. Fort Lauderdale, FL 33331* (305) 680-1771
 (800) 348-3680
 Fax (305) 680-8996

FOTOLEX ASSOCIATES *804 Coach Bluff Crescent S.W. Calgary, Alberta T3H 1A8 Canada* (403) 246-2994

FOTOS INTERNATIONAL *530 W. 25th St. New York, NY 10001* (212) 675-0115
 (800) 688-5656
 Fax (212) 675-0379

FOUR BY FIVE *Division of Superstock Inc. 11 W. 19th St. New York, NY 10011* (212) 633-0300
 (800) 828-4545
 Fax (212) 633-0408

99 Osgood Pl. Penthouse San Francisco, CA 94133 (415) 781-4433
 (800) 828-4545
 Fax (415) 781-8985

417 St. Pierre #500 Montreal, Quebec H2Y 2M4 Canada (514) 849-2181
 Fax (514) 849-5577

FRONTLINE VIDEO & FILM *243 12th St. Del Mar, CA 92014* (619) 481-5566
 Fax (619) 481-4189

- **FROZEN IMAGES, INC.** Ad Pg 521 *400 1st Ave. North Minneapolis, MN 55401* **(612) 339-3191**
 (800) 962-6302
 Fax **(612) 339-3193**

- **FUNDAMENTAL PHOTOGRAPHS** Ad Pg 439 *210 Forsyth St. New York, NY 10002* **(212) 473-5770**
 Fax **(212) 228-5059**

GAMMA-LIAISON NETWORK *11 E. 26th St. 17th Floor New York, NY 10010* (212) 447-2500
 Fax (212) 447-2534

GET REAL *2223 S. Carmelina Ave. Los Angeles, CA 90064* (310) 820-7077
 (800) 872-7872
 Fax (310) 820-2687

- **GHOSTS** Ad Pg 467 *665 Arkansas St. San Francisco, CA 94107* **(415) 824-7074**
 Fax **(415) 285-3656**

- **GLOBAL PICTURES** Ad Pg 540 *5595 Arapahoe Rd. Boulder, CO 80303* **(303) 447-3388**
 (800) 766-2545
 Fax **(303) 449-3862**

GLOBE PHOTOS, INC. *275 7th Ave. New York, NY 10001* (212) 689-1340
 Fax (212) 627-8932

8400 Sunset Blvd. #2-B Los Angeles, CA 90069 (213) 654-3350
 Fax (213) 654-9732

THE GRANGER COLLECTION *381 Park Ave. South #901 New York, NY 10016* (212) 447-1789
 Fax (212) 447-1492

GREAT AMERICAN STOCK FOOD PHOTOGRAPHY *521 Quantum Rd. Rio Rancho, NM 87124-4507* (505) 892-7747
 (800) 624-5834
 Fax (505) 892-7713

GREEN STOCK *Division of First Light Stock 204-1 Atlantic Ave. Toronto, Ontario M6K 3E7 Canada* (416) 532-6108
 (800) 661-2001

SHERMAN GRINBERG FILM LIBRARIES *1040 N. McCadden Pl. Hollywood, CA 90038* (213) 464-7491
 Fax (213) 462-5352

630 9th Ave. New York, NY 10036 (212) 765-5170
 Fax (212) 262-1532

LEE GROSS ASSOCIATES INC. *366 Madison Ave. #1603 New York, NY 10017* (212) 682-5240
 Fax (212) 682-6829

AL GROTELL UNDERWATER PHOTOGRAPHY *170 Park Row #15-D New York, NY 10038* (212) 349-3165
 Fax (212) 349-4363

DON HALL PRODUCTIONS *2922 Hyde Park St. Sarasota, FL 34239* (813) 365-6161

GEORGE HALL/CHECK SIX *P O Box 144 Mill Valley, CA 94942* (415) 381-6363
 Fax (415) 383-4935

WALLY HAMPTON PHOTOGRAPHY/TRAVEL STOCK *4190 Rockaway Beach Bainbridge Island, WA 98110* (206) 842-9900
 Fax (206) 842-0900

HEADHUNTERS *2619 Lovegrove St. Baltimore, MD 21218-4532* (410) 338-1820
 Fax (410) 366-1257

HEDRICH-BLESSING *11 W. Illinois St. Chicago, IL 60610* (312) 321-1151
 Fax (312) 321-1165

- **GRANT HEILMAN PHOTOGRAPHY, INC.** **Ad Pg 277-290** *506 W. Lincoln Ave. P O Box 317 Lititz, PA 17543* **(717) 626-0296** **(800) 622-2046** Fax **(717) 626-0971**

FRAN HEYL ASSOCIATES *230 Park Ave. #2525 New York, NY 10169* (212) 439-5600 (800) 327-0333

HILLSTROM STOCK PHOTO, INC. *5483 N. Northwest Hwy. P O Box 31100 Chicago, IL 60631* (312) 775-4090 (312) 775-3557 Fax (312) 774-2929

HOT SHOTS & COOL CUTS, INC. *1926 Broadway 5th Floor New York, NY 10023* (212) 799-9100 Fax (212) 799-9258

HOT SHOTS STOCK SHOTS, INC. *341 Lesmill Rd. Toronto, Ontario M3B 2V1 Canada* (416) 441-3281 Fax (416) 441-1468

ID&A IMAGERY *91 5th Ave. New York, NY 10003* (212) 633-2388 Fax (212) 989-9079

IBID, INC. *935 W. Chestnut St. #415 Chicago, IL 60622* (312) 733-8000 Fax (312) 733-1005

- **THE IMAGE BANK** **Ad Pg 341-350** *Riverchon Plaza 3500 Maple Ave. #1150 Dallas, TX 75219* **(214) 528-3888** Fax **(214) 528-3878**

5811 Pelican Bay Blvd. #302 Naples, FL 33963 (813) 262-1227 Fax (813) 262-6272

430 1st Ave. North #600 Minneapolis, MN 55401 (612) 332-8935 Fax (612) 344-1717

500 Boylston St. #260 Boston, MA 02116 (617) 267-8866 Fax (617) 267-4682

10351 Stella Link Rd. Houston, TX 77025 (713) 668-0066 Fax (713) 664-4441

4526 Wilshire Blvd. Los Angeles, CA 90010 (213) 930-0797 Fax (213) 930-1089

101 Yesler Way #206 Seattle, WA 98104 (206) 343-9319 Fax (206) 343-9317

3490 Piedmont Rd. N.E. #1106 Atlanta, GA 30305 (404) 233-9920 Fax (404) 231-9389

3150 Livernois #150 Detroit, MI 48083 (313) 524-1850 Fax (313) 524-3243

40 Eglinton Ave. East #307 Toronto, Ontario M4P 3A8 Canada (416) 322-8840 Fax (416) 322-8855

111 5th Ave. 12th Floor New York, NY 10003 (212) 529-6700 Fax (212) 529-7024

22 Battery St. #202 San Francisco, CA 94111 (415) 788-2208 Fax (415) 392-6637

444 N. Wabash Ave. #200 Chicago, IL 60611-3538 (312) 329-1817 Fax (312) 329-1029

- **IMAGE FINDERS PHOTO AGENCY INC.** **Ad Pg 516-517** *134 Abbott St. 7th Floor Vancouver, BC V6B 2K4 Canada* **(604) 688-9818** **(800) 661-5609** Fax **(604) 684-2452**

IMAGE RESOURCES *224 W. 29th St. 15th Floor New York, NY 10001* (212) 736-2523 Fax (212) 736-2562

THE IMAGE WORKS *367-B Glascow Turnpike P O Box 443 Woodstock, NY 12498* (914) 246-8800 Fax (914) 246-0383

IMAGES PRESS SERVICE *7 E. 17th St. 8th Floor New York, NY 10003* (212) 675-3707 (800) 367-4854 Fax (212) 243-2308

IMAGEWAYS, INC. *412 W. 48th St. New York, NY 10036* (212) 265-1287 Fax (212) 586-0339

INDEX STOCK PHOTOGRAPHY, INC. *126 5th Ave. 7th Floor New York, NY 10011* (212) 929-4644 (800) 729-7466 Fax (212) 633-1914

6500 Wilshire Blvd. #500 Los Angeles, CA 90048 (213) 658-7707 (800) 729-7477 Fax (213) 651-4975

INSTOCK PHOTOGRAPHY *2401 S. Santa Fe Ave. #B-00 Los Angeles, CA 90058* (213) 582-6883 (800) 310-6224

INTERNATIONAL COLOR STOCK, INC. *555 N.E. 34th St. #1502 Miami, FL 33137* (305) 573-5200

INTERNATIONAL HISTORIC FILMS *3533 S. Archer Ave. P O Box 29035 Chicago, IL 60609* (312) 927-2900 Fax (312) 927-9211

- **INTERNATIONAL STOCK** **Ad Pg 488** *130 Madison Ave. New York, NY 10016* **(212) 696-4666** Fax **(212) 725-1241**

BRUCE IVERSON PHOTOMICROGRAPHY *7 Tucker St. #65 Pepperell, MA 01463* (508) 433-8429

JETON *513 Harrington Ave. N.E. Renton, WA 98056* (206) 226-1408

E.P. JONES COMPANY *45 Newbury St. Boston, MA 02116* (617) 267-6450 Fax (617) 247-6476

- **PETER B. KAPLAN PHOTOGRAPHY INC.** **Ad Pg 498-499** *7 E. 20th St. #4-R New York, NY 10003* **(212) 995-5000** Fax **(212) 995-5698**

KESSER STOCK FOOTAGE LIBRARY *21 S.W. 15th Rd. Miami, FL 33129* (305) 358-7900 Fax (305) 358-2209

KEYSTONE PRESS AGENCY, INC. *202 E. 42nd St. 4th Floor New York, NY 10017* (212) 924-8123

KILLIAM SHOWS, INC. *6 E. 39th St. #502 New York, NY 10016* (212) 679-8230 Fax (212) 686-0801

- **RON KIMBALL STOCK** **Ad Pg 351-360** *1960 Colony Mountain View, CA 94043* **(415) 969-0682** Fax **(415) 969-0485**

THE KOBAL COLLECTION *133 5th Ave. 9th Floor New York, NY 10003* — (212) 673-5600 / Fax (212) 673-1667

- **JOAN KRAMER & ASSOCIATES Ad Pg 493** *10490 Wilshire Blvd. #605 Los Angeles, CA 90024* — **(310) 446-1866** / In New York **(212) 567-5545** / Fax **(310) 446-1856**

KYODO PHOTO SERVICE (JAPAN) *250 E. 1st St. #1107 Los Angeles, CA 90012* — (213) 680-9448 / Fax (213) 680-3547

50 Rockefeller Plaza #815 New York, NY 10020 — (212) 397-3723 / Fax (212) 397-3721

LGI PHOTO AGENCY *241 W. 36th St. 7th Floor New York, NY 10018* — (212) 736-4602 / Fax (212) 643-2916

HAROLD M. LAMBERT STUDIOS INC. *2801 W. Cheltenham Ave. P O Box 27310 Philadelphia, PA 19150* — (215) 885-3355

- **LANDMARK STOCK EXCHANGE Ad Pg 459** *51 Digital Dr. Novato, CA 94949* — **(415) 883-1600** / **(800) 288-5170** / Fax **(415) 883-6725**

- **LATIN STOCK Ad Pg 481** *Carbonero y Sol, 30 28006 Madrid Spain* — **(34-1) 564-40-95** / Fax **(34-1) 564-43-53**
 Representing Latin Stock:
 Carlos Goldin/Argentina (54-1) 822-5444
 Marcos Scheliga/Brazil (55-11) 37-7265
 Christian Mouat/Chile (56-2) 232-3417
 Laura Iñigo Planter/Mexico City (52-5) 277-0438

- **LAVENSTEIN STUDIOS Ad Pg 473** *348 Southport Circle #103 Virginia Beach, VA 23452* — **(804) 499-9959** / Fax **(804) 499-9957**

TOM & PAT LEESON *P O Box 2498 Vancouver, WA 98668* — (206) 256-0436

LEVITON-ATLANTA INC. *1271 Roxboro Dr. N.E. Atlanta, GA 30324* — (404) 237-7766 / Fax (404) 237-8882

- **CINDY LEWIS PHOTOGRAPHY Ad Pg 464-465** *14431 Ventura Blvd. #411 Sherman Oaks, CA 91423* — **(818) 788-8877** / Fax **(818) 788-8837**

- **LIAISON INTERNATIONAL Ad Pg 159-168** *11 E. 26th St. 17th Floor New York, NY 10010* — **(212) 447-2500** / **(800) 488-0484** / Fax **(212) 447-2534**

LIFE PICTURE SALES *1271 Avenue of the Americas Time Life Bldg. #28-58 New York, NY 10020* — (212) 522-4800 / Fax (212) 522-0328

LIFESTYLES LIBRARY *250 W. Main St. Branford, CT 06405* — (203) 481-0068 / Fax (203) 481-4164

- **LIGHT SOURCES STOCK Ad Pg 455** *23 Drydock Ave. Boston, MA 02210* — **(617) 261-0346** / **(800) 272-5483** / Fax **(617) 261-0358**

LIGHTWAVE *1430 Massachusetts Ave. Cambridge, MA 02138* — (617) 628-1052 / (800) 628-6809 / Fax (617) 628-1052

LONDON FEATURES *405 W. 14th St. 4th Floor New York, NY 10014* — (212) 929-7007 / Fax (212) 929-3600

MGA/PHOTRI, INC. *40 E. 9th St. #1109 Chicago, IL 60605* — (312) 987-0078 / Fax (312) 987-0134

THE MACH 2 STOCK EXCHANGE LTD. *204-1409 Edmonton Trail N.E. Calgary, Alberta T2E 3K8 Canada* — (403) 230-9363 / Fax (403) 230-5855

- **MARK MacLAREN, INC. Ad Pg 448-449** *430 E. 20th St. New York, NY 10009* — **(212) 674-0155** / **(212) 674-8615**

- **DAVID MADISON Ad Pg 460-463** *3 Tynan Way Portola Valley, CA 94028* — **(415) 851-7324** / Fax **(415) 851-3065**

MAGNUM PHOTOS INC. *72 Spring St. 12th Floor New York, NY 10012* — (212) 966-9200 / Fax (212) 941-9325

- **JAY MAISEL PHOTOGRAPHY Ad Pg 419-428** *190 The Bowery New York, NY 10012* — **(212) 431-5013** / Fax **(212) 925-6092**

MARINE MAMMAL IMAGES *732 Cloyden Rd. Palos Verdes Estates, CA 90274* — (310) 378-4084

MASTERFILE *415 Yonge St. #200 Toronto, Ontario M5B 2E7 Canada* — (416) 977-7267 / (800) 387-9010 / Fax (416) 977-8162

MEDICAL IMAGES, INC. *26 W. Shore Pl. Salisbury, CT 06068* — (203) 824-7858 / Fax (203) 824-7864

- **MEDICHROME Ad Pg 321-329** *232 Madison Ave. #805 New York, NY 10016* — **(212) 679-8480** / **(800) 233-1975** / Fax **(212) 532-1934**

MEGA PRODUCTIONS, INC. *1714 N. Wilton Pl. Hollywood, CA 90028* — (213) 462-6342 / Fax (213) 462-7572

- **ABRAHAM MENASHE HUMANISTIC PHOTOGRAPHY Ad Pg 520** *306 E. 5th St. New York, NY 10003* — **(212) 254-2754** / Fax **(212) 505-6857**

MIDWESTOCK *218 Delaware #309 Kansas City, MO 64105* — (816) 474-0229

MINDEN PICTURES *24 Seascape Village Aptos, CA 95003* — (408) 685-1911 / Fax (408) 685-1913

- **MON-TRESOR Ad Pg 470-471** *230 N. Michigan Ave. #3700 Chicago, IL 60601* — **(312) 236-8545** / **(800) 543-5250** / Fax **(312) 704-4077**

MONKMEYER PRESS PHOTO SERVICE *118 E. 28th St. New York, NY 10016* — (212) 689-2242 / Fax (212) 779-2549

MOTION PICTURE & TELEVISION PHOTO ARCHIVE *11821 Mississippi Ave. Los Angeles, CA 90025* — (310) 478-2379 / Fax (310) 477-4864

- **MOUNTAIN STOCK PHOTOGRAPHY & FILM INC. Ad Pg 482-483** *P O Box 1910 Tahoe City, CA 96145* — **(916) 583-6646** / Fax **(916) 583-5935**

MOVIECRAFT INC. *P O Box 438 Orland Park, IL 60462*	(708) 460-9082	*Fax* (708) 460-9099
DAVID MUENCH PHOTOGRAPHY, INC. *P O Box 30500 Santa Barbara, CA 93130*	(805) 967-4488	*Fax* (805) 967-4268
NBC-NEWS ARCHIVE *30 Rockefeller Plaza #922 New York, NY 10112*	(212) 664-3797	*Fax* (212) 957-8917
NFL PHOTOS *6701 Center Dr. West #1111 Los Angeles, CA 90045*	(310) 215-1606	*Fax* (310) 215-3813
NYT PICTURES *New York Times News Service 229 W. 43rd St. 9th Floor New York, NY 10036*	(212) 556-1243	*Fax* (212) 556-3535
NATIONAL GEOGRAPHIC SOCIETY *Picture Syndication Office 1600 M St. N.W. Washington, DC 20036*	(202) 857-7537	*Fax* (202) 429-5776
Stock Footage Library 1600 M St. N.W. Washington, DC 20036	(202) 857-7659	*Fax* (202) 429-5755
• **NATURAL SELECTION STOCK PHOTOGRAPHY, INC. Ad Pg 149-158** *183 St. Paul St. Rochester, NY 14604*	**(716) 232-1502**	*Fax* **(716) 232-6325**
• **NATURE SOURCE Ad Pg 115-124** *Division of Photo Researchers, Inc. 60 E. 56th St. New York, NY 10022*	**(212) 758-3420** **(800) 833-9033**	*Fax* **(212) 355-0731**
• **NAWROCKI STOCK PHOTO Ad Pg 485** *20-L W. 15th St. Chicago, IL 60605* *Representing Nawrocki Stock Photo:* *Photo Network/Irvine (714) 259-1244* *Stock Imagery/Denver (303) 592-1091* *Take Stock/Calgary (403) 233-7487* *Zephyr Pictures/San Diego (619) 755-1200* *Ace Photo Agency/London* *Auschromes/Melbourne* *Focus/Madrid* *Fotex/Hamburg* *Imapresse/Paris* *Key Photos/Tokyo*	**(312) 427-8625** **(800) 356-3066**	*Fax* **(312) 427-0178**
NAWROCKI STOCK PHOTO HISTORICAL *20-L W. 15th St. Chicago, IL 60605*	(312) 427-8625 (800) 356-3066	*Fax* (312) 427-0178
NEW ENGLAND STOCK PHOTO *P O Box 815 Old Saybrook, CT 06475*	(203) 388-1741	*Fax* (203) 388-6999
THE NEW IMAGE STOCK PHOTO AGENCY, INC. *38 Quail Ct. #200 Walnut Creek, CA 94596*	(510) 934-2405 (800) 788-8818	*Fax* (510) 256-7754
NEW YORK DAILY NEWS PHOTO SALES *220 E. 42nd St. New York, NY 10017*	(212) 210-1620	*Fax* (212) 661-3317
NEWSTOCK AGENCY INTERNATIONAL, INC. *5520 Cherokee Ave. Alexandria, VA 22312*	(703) 642-3700 (800) 955-7468	*Fax* (703) 642-3703
NORTH WIND PICTURE ARCHIVES *R.R. 1, Box 172 Federal St. Alfred, ME 04002*	(207) 490-1940 (800) 952-0703	*Fax* (207) 490-3627
• **OCEAN STOCK Ad Pg 445** *25262 Mainsail P O Box 3914 Dana Point, CA 92629*	**(714) 248-4324**	*Fax* **(714) 248-2835**
MICHAEL OCHS ARCHIVES *524 Victoria Ave. Venice, CA 90291*	(310) 306-6111	*Fax* (310) 821-1168
• **ODYSSEY PRODUCTIONS Ad Pg 468-469** *2633 N. Greenview Ave. Chicago, IL 60614*	**(312) 883-1965**	*Fax* **(312) 883-0929**
OFFSHOOT *5-A Pirates Lane Gloucester, MA 01930*	(508) 281-5118	*Fax* (508) 281-8807
• **OMNI-PHOTO COMMUNICATIONS, INC. Ad Pg 490-491** *5 E. 22nd St. #6-N New York, NY 10010*	**(212) 995-0805**	*Fax* **(212) 995-0895**
ONEWORLD PHOTOGRAPHIC *4607 N.W. 6th St. #H Gainesville, FL 32609*	(904) 373-3486	*Fax* (904) 338-9215
ONYX ENTERPRISES, INC. *7515 Beverly Blvd. Los Angeles, CA 90036*	(213) 965-0899	*Fax* (213) 965-0364
OUTLINE PRESS SYNDICATE, INC. *596 Broadway 11th Floor New York, NY 10012*	(212) 226-8790	*Fax* (212) 226-8944
5757 Wilshire Blvd. Penthouse 20 Los Angeles, CA 90036	(213) 954-9422	*Fax* (213) 954-9455
PACIFIC RIM STOCK *2223 S. Carmelina Ave. Los Angeles, CA 90064*	(310) 820-7077 (800) 872-7872	*Fax* (310) 820-2687
• **PACIFIC STOCK Ad Pg 474-475** *758 Kapahulu Ave. #250 Honolulu, HI 96816*	**(808) 735-5665** **(800) 321-3239**	*Fax* **(808) 735-7801**
• **PANORAMIC IMAGES Ad Pg 470-471** *230 N. Michigan Ave. #3700 Chicago, IL 60601* *Representing Panoramic Images:* *Bavaria/Munich* *Mon-Tresor/Osaka* *Stock Image/Paris*	**(312) 236-8545** **(800) 543-5250**	*Fax* **(312) 704-4077**
PARAMOUNT STOCK FOOTAGE LIBRARY *5555 Melrose Ave. Hollywood, CA 90038*	(213) 956-5510	*Fax* (213) 956-1833
• **DOUGLAS PEEBLES PHOTOGRAPHY Ad Pg 458** *445 Iliwahi Loop Kailua, HI 96734*	**(808) 254-1082**	*Fax* **(808) 254-1267**
PETRIFIED FILMS, INC. *430 W. 14th St. #204 New York, NY 10014*	(212) 242-5461	*Fax* (212) 691-8347

- **PHOTO EDIT Ad Pg 536-537** *6056 Corbin Ave. Tarzana, CA 91356* **(818) 342-2811**
 Fax **(818) 343-9548**

THE PHOTO FILE *4855 E. Warner #24-183 Phoenix, AZ 85044* (602) 759-5200
(800) 334-5222
Fax (602) 759-3271

PHOTO FINDERS INTERNATIONAL *P O Box 5600 Scottsdale, AZ 85261* (602) 483-8968

PHOTO/NATS INC. *33 Aspen Ave. Auburndale, MA 02166* (617) 969-9531
Fax (617) 964-9456

PHOTO NETWORK *1541 Parkway Loop #J Tustin, CA 92680* (714) 259-1244
(800) 548-0199
Fax (714) 259-0645

PHOTO OPTIONS *1432 Linda Vista Dr. Birmingham, AL 35226* (205) 979-8412

- **PHOTO RESEARCHERS, INC. Ad Pg 125-134** *60 E. 56th St. New York, NY 10022* **(212) 758-3420**
 (800) 833-9033
 Fax **(212) 355-0731**

PHOTO RESOURCE HAWAII *1146 Fort St. #207 Honolulu, HI 96813* (808) 599-7773
Fax (808) 599-7754

PHOTO 20-20 *50 Kenyon Ave. Kensington, CA 94708* (510) 526-0921
Fax (510) 527-7740

PHOTOBANK *17952 Sky Park Circle #B Irvine, CA 92714* (714) 250-4480
Fax (714) 752-5495

PHOTOFEST *47 W. 13th St. 2nd Floor New York, NY 10011* (212) 633-6330
Fax (212) 366-9062

PHOTOGRAPHERS/ASPEN *1280 Ute Ave. Aspen, CO 81611* (303) 925-2317
Fax (303) 925-2420

- **PHOTOGRAPHIC RESOURCES Ad Pg 391-400** *6633 Del Mar St. Louis, MO 63130* **(314) 721-5838**
 (800) 933-5838
 Fax **(314) 721-0301**

PHOTOGRAPHY FOR INDUSTRY *29 Rick Lane Route 4 Peekskill, NY 10566* (914) 736-7693
Fax (914) 736-7694

- **PHOTONICA Ad Pg 436-437** *141 5th Ave. #8 South New York, NY 10010* **(212) 505-9000**
 Fax **(212) 505-2200**

PHOTOPHILE *6150 Lusk Blvd. #B-203 San Diego, CA 92121* (619) 453-3050
Fax (619) 452-0994

PHOTOREPORTERS INC. *875 Avenue of the Americas #1003 New York, NY 10001* (212) 736-7602
Fax (212) 465-0651

PHOTOSEARCH *P O Box 92656 Milwaukee, WI 53202* (414) 271-5777
Fax (414) 272-5329

- **PHOTOTAKE Ad Pg 456-457** *4523 Broadway New York, NY 10040* **(212) 942-8185**
 (800) 542-3686
 Fax **(212) 942-8186**

PHOTOVAULT *1045 17th St. San Francisco, CA 94107* (415) 552-9682
Fax (415) 431-5647

- **PHOTRI-PHOTO RESEARCH INTERNATIONAL Ad Pg 496** *3701 S. George Mason Dr. #C-2N Falls Church, VA 22041* **(703) 931-8600**
 (800) 544-0385
 Fax **(703) 998-8407**

- **THE PICTURE CUBE Ad Pg 524-525** *89 Broad St. Boston, MA 02110* **(617) 367-1532**
 Fax **(617) 482-9266**

PICTURE GROUP, INC. *830 Eddy St. Providence, RI 02905* (401) 461-9333
Fax (401) 461-9060

PICTURE PERFECT U.S.A., INC. *P O Box 20058 New York, NY 10023-1482* (212) 765-1212
Fax (212) 765-1163

PICTURE THAT INC. *880 Briarwood Rd. Newtown Square, PA 19073* (215) 353-8833
Fax (215) 353-8553

- **PICTURESQUE Ad Pg 518-519** *1520 Brookside Dr. #3 Raleigh, NC 27604* **(919) 828-0023**
 Fax **(919) 828-8635**

PIX INTERNATIONAL *P O Box 642351 Chicago, IL 60664-2351* (312) 321-9071

PLESSNER INTERNATIONAL *121 W. 27th St. #502 New York, NY 10001* (212) 645-2121
Fax (212) 633-8629

PONOPRESS INTERNATIONAL INC. *2177 Masson #202 Montreal, Quebec H2H 1B1 Canada* (514) 528-9825
Fax (514) 528-9826

- **POSITIVE IMAGES Ad Pg 486-487** *35 Main St. #5 Wayland, MA 01778* **(508) 653-7610**
 Fax **(508) 650-4771**

PRELINGER ARCHIVES *430 W. 14th St. #403 New York, NY 10014* (212) 633-2020
(800) 243-2252
Fax (212) 255-5139

- **PROFILES WEST Ad Pg 91-100** *210 E. Main St. P O Box 1199 Buena Vista, CO 81211* **(719) 395-8671**
 Fax **(719) 395-8840**

PROTELE *2121 Avenue of the Stars #2300 Los Angeles, CA 90067* (310) 286-0124
Fax (310) 286-0125

PYRAMID FILMS *2801 Colorado Ave. Santa Monica, CA 90404* (310) 828-7577

RAINBOW *1079 Main St. P O Box 573 Housatonic, MA 01236* (413) 274-6211
Fax (413) 274-6689

RANGEFINDER CORP. *275 7th Ave. 28th Floor New York, NY 10001* (212) 689-1340
Fax (212) 627-8932

REFERENCE PICTURES *900 Broadway #802 New York, NY 10003* (212) 254-0008
Fax (212) 353-9152

REFLEXTION PHOTO THEQUE *1255 Phillips Square #1000 Montreal, Quebec H3B 3G1 Canada* (514) 876-1620
Fax (514) 876-3957

RELIGIOUS NEWS SERVICE *P O Box 1015 Radio City Station New York, NY 10101* (212) 315-0870
Fax (212) 315-5850

RETNA LTD. *18 E. 17th St. 3rd Floor New York, NY 10003*	(212) 255-0622 Fax (212) 255-1224
REX USA LTD. *351 W. 54th St. New York, NY 10019*	(212) 586-4432 Fax (212) 541-5724
• **RO-MA STOCK** **Ad Pg 438** *The Image Source 3101 W. Riverside Dr. Burbank, CA 91505*	**(818) 842-3777** **Fax (818) 566-7380**
• **H. ARMSTRONG ROBERTS STOCK PHOTOGRAPHY** **Ad Pg 189-206** *4203 Locust St. Philadelphia, PA 19104*	**(215) 386-6300** **(800) 786-6300** **Fax (800) 786-1920**
• **H. ARMSTRONG ROBERTS STOCK PHOTOGRAPHY/CHICAGO** **Ad Pg 189-206** *233 E. Wacker Dr. #4305 Chicago, IL 60601*	**(312) 938-4466** **(800) 786-6300** **Fax (800) 786-1920**
• **H. ARMSTRONG ROBERTS STOCK PHOTOGRAPHY/NEW YORK** **Ad Pg 189-206** *1178 Broadway 4th Floor New York, NY 10001*	**(212) 685-3870** **(800) 786-6300** **Fax (800) 786-1920**
SF.V INTERNATIONAL *11219 Bloomington Dr. Tampa, FL 33635*	(813) 884-5963 Fax (813) 888-6713
SAGA AGENCY INC. *116 E. 27th St. 8th Floor New York, NY 10016*	(212) 481-6900 Fax (212) 481-6909
SCENIC PHOTO *9208 32nd Ave. North New Hope, MN 55427*	(612) 542-8740
SCENICS OF AMERICA *1110 Red Maple Dr. Chula Vista, CA 91910*	(619) 421-0611
• **SCIENCE SOURCE** **Ad Pg 101-114** *Division of Photo Researchers, Inc. 60 E. 56th St. New York, NY 10022*	**(212) 758-3420** **(800) 833-9033** **Fax (212) 355-0731**
SHARKBAIT PRODUCTIONS HAWAII *Kalaoa St. P O Box 3263 Kailua-Kona, HI 96745-3263*	(808) 325-6327 Fax (808) 325-6979
• **SHARPSHOOTERS PREMIUM STOCK PHOTOGRAPHY** **Ad Pg 291-320** *4950 S.W. 72nd Ave. #114 Miami, FL 33155*	**(305) 666-1266** **(800) 666-1266** **Fax (305) 666-5485**
• **SHOOTING STAR** **Ad Pg 451, 489, 527** *P O Box 93368 Los Angeles, CA 90093*	**(213) 469-2020** **Fax (213) 464-0880**
1441 N. McCadden Pl. Hollywood, CA 90028	
SHOSTAL ASSOCIATES, INC. *Division of Superstock Inc. 11 W. 19th St. New York, NY 10011*	(212) 633-0101 (800) 828-4545 Fax (212) 633-0409
• **SICKLES PHOTO-REPORTING SERVICE ARCHIVES** **Ad Pg 480** *40-50's Photo Archives P O Box 98 11 Park Rd. Maplewood, NJ 07040*	**(201) 763-6355** **Fax (201) 763-4473**
• **FRED SIEB PHOTOGRAPHY** **Ad Pg 492** *155 Birch Hill Rd. P O Box 480 North Conway, NH 03860-0480*	**(603) 356-5879**
SIPA IMAGE *30 W. 21st St. 6th Floor New York, NY 10010*	(212) 463-0150 Fax (212) 463-0160
SITEMAN STUDIOS *136 Pond St. Winchester, MA 01890*	(617) 729-3747 Fax (617) 729-2549
SKY KING *R.R. 1 Box 45 Elroy, WI 53929*	(608) 462-8999
• **SOUTHERN STOCK PHOTO AGENCY** **Ad Pg 472** *3601 W. Commercial Blvd. #33 Fort Lauderdale, FL 33309*	**(305) 486-7117** **(800) 486-7118** **Fax (305) 486-7118**
SOVFOTO/EASTFOTO AGENCY *48 W. 21st St. 11th Floor New York, NY 10010*	(212) 564-5485 Fax (212) 564-4249
SPECTRA-ACTION, INC. *5 Carole Lane St. Louis, MO 63131*	(314) 567-5700 Fax (314) 567-5704
SPORTS ILLUSTRATED PICTURE SALES *1271 Avenue of the Americas Time Life Bldg. 20th Floor New York, NY 10020*	(212) 522-2803 Fax (212) 522-0102
• **SPORTS PHOTO MASTERS, INC.** **Ad Pg 497** *476 Bergen Blvd. Ridgefield, NJ 07657*	**(201) 943-0028** **Fax (201) 943-0284**
• **SPORTSCHROME EAST/WEST** **Ad Pg 515** *10 Brinkerhoff Ave. Palisades Park, NJ 07650*	**(201) 568-1412** **Fax (201) 944-1045**
38 Quail Ct. #200 Walnut Creek, CA 94596	**(510) 256-1340** **Fax (510) 256-7754**
453 Sunnyside Ave. Ottawa, Ontario K1S 0S8 Canada	**(613) 730-3488**
• **SPORTSLIGHT PHOTOGRAPHY** **Ad Pg 506** *127 W. 26th St. #800 New York, NY 10001*	**(212) 727-9727** **Fax (212) 633-2069**
TOM STACK & ASSOCIATES *3645 Jeannine Dr. #212 Colorado Springs, CO 80917*	(719) 570-1000 (800) 648-7740 Fax (719) 570-7290
STAR FILE PHOTO AGENCY LTD. *1501 Broadway #1405 New York, NY 10036*	(212) 869-4901 Fax (212) 354-8376
STILL LIFE STOCK *286 5th Ave. New York, NY 10001*	(212) 971-9178 (800) 982-9178 Fax (212) 563-0402
THE STOCK ADVANTAGE *213 N. 12th St. Allentown, PA 18102*	(215) 776-7381 Fax (215) 776-1831
STOCK, BOSTON *36 Gloucester St. Boston, MA 02115*	(617) 266-2300 (800) 678-7468 Fax (617) 353-1262
• **THE STOCK BROKER** **Ad Pg 135-148** *450 Lincoln St. #110 Denver, CO 80203*	**(303) 698-1734** **Fax (303) 698-1964**
STOCK CANADA *Division of First Light Stock 204-1 Atlantic Ave. Toronto, Ontario M6K 3E7 Canada*	(416) 532-6108 (800) 661-2001 Fax (416) 532-7499
STOCK CHICAGO *111 E. Chestnut #25-G Chicago, IL 60611*	(312) 787-8834 Fax (312) 787-8172

STOCK EDITIONS *11026 Ventura Blvd. Studio City, CA 91604*

(818) 762-0001
(800) 445-4495
Fax (818) 762-3468

THE STOCK FILE, INC. *1322 W. Broad St. Richmond, VA 23220*

(804) 358-6364
Fax (804) 358-6373

STOCK FOOTAGE CONNECTION *7321 W. Breen St. Niles, IL 60714*

(708) 966-0496

THE STOCK HOUSE *6922 Hollywood Blvd. #621 Hollywood, CA 90028*

(213) 461-0061
Fax (213) 461-2457

THE STOCK ILLUSTRATION SOURCE, INC. *20 Waterside Plaza #A New York, NY 10010*

(212) 679-8070
Fax (212) 679-8107

• **STOCK IMAGERY, INC. Ad Pg 534-535** *711 Kalamath St. Denver, CO 80204*

(303) 592-1091
(800) 288-3686
Fax **(303) 592-1278**

• **THE STOCK MARKET Ad Pg 401-418** *360 Park Ave. South New York, NY 10010*

(212) 684-7878
(800) 999-0800
Fax **(800) 283-0808**

THE STOCK MARKET INC. *275 King St. East #72 Toronto, Ontario M5A 1K2 Canada*

(416) 362-7767
Fax (416) 362-9417

STOCK MONTAGE *921 W. Van Buren St. #201 Chicago, IL 60607*

(312) 733-3239
Fax (312) 733-2844

STOCK NEWPORT *15 W. Marlborough St. Newport, RI 02840*

(401) 846-8484
Fax (401) 848-5187

STOCK OPTIONS *4602 East Side Ave. Dallas, TX 75226*

(214) 826-6262
Fax (214) 826-6263

• **STOCK PHOTOS HAWAII Ad Pg 530-531** *1128 Nuuanu Ave. #250 Honolulu, HI 96817*

(808) 538-1389
Fax **(808) 537-9111**

STOCK PILE, INC. *2404 N. Charles St. Baltimore, MD 21218*
P O Box 1403 Grand Junction, CO 81501

(410) 889-4243

• **THE STOCK SHOP INC. Ad Pg 321-329** *232 Madison Ave. #805 New York, NY 10016*

(212) 679-8480
(800) 233-1975
Fax **(212) 532-1934**

STOCK SHOTS, INC. *17962 Sky Park Circle #J Irvine, CA 92714*

(714) 261-0577
Fax (714) 261-0141

• **THE STOCK SOLUTION Ad Pg 528-529** *307 W. 200 South #3004 Salt Lake City, UT 84101*

(801) 363-9700
Fax **(801) 363-9707**

STOCK SOUTH *75 Bennett St. N.W. #K-2 Atlanta, GA 30309*

(404) 352-0538
Fax (404) 352-0653

STOCK STOCK *7041 E. Orange Blossom Lane Scottsdale, AZ 85253*

(602) 941-2903
Fax (602) 941-5561

THE STOCKHOUSE, INC. *3301 W. Alabama Houston, TX 77098*

(713) 942-8400

STOCKTREK *10 E. 2nd St. Westfield, NY 14787*

(716) 326-2792
Fax (716) 326-3792

• **STOCKWORKS STOCK ILLUSTRATION Ad Pg 61-70** *4445 Overland Ave. Culver City, CA 90230*

(310) 204-1774
Fax **(310) 204-4598**

• **TONY STONE IMAGES/CHICAGO Ad Pg 71-80** *233 E. Ontario St. #1201 Chicago, IL 60611*

(312) 787-7880
(800) 234-7880
Fax **(312) 787-8798**

• **TONY STONE IMAGES/NEW YORK Ad Pg 71-80** *475 Park Ave. South 28th Floor New York, NY 10016*

(212) 545-8220
(800) 234-7880
Fax **(212) 545-9797**

• **TONY STONE IMAGES/LOS ANGELES Ad Pg 71-80** *6100 Wilshire Blvd. #1250 Los Angeles, CA 90048*

(213) 938-1700
(800) 234-7880
Fax **(213) 938-0731**

• **TONY STONE IMAGES/CANADA Ad Pg 71-80** *161 Eglington Ave. East #501 Toronto, Ontario M4P 1J5 Canada*

(416) 488-9495
Fax **(416) 488-9448**

• **TONY STONE IMAGES/LONDON Ad Pg 71-80** *116 Bayham St. London NW1 0BA England*

(071) 267-7166

Tony Stone Images overseas:
Fotogram-Stone/Paris
Tony Stone Bilderwelden/Munich
Worldview-Tony Stone/Amsterdam
Worldview-Tony Stone/Brussels
Fototeca Stone/Barcelona
Laura Ronchi Tony Stone/Milan
Tony Stone Images/Stockholm
Color Library (PTY)/Johannesburg
Profile Photolibrary PTE/Hong Kong
Profile Photolibrary PTE/Singapore

STREAMLINE FILM ARCHIVES *432 Park Ave. South #1314 New York, NY 10016*

(212) 696-2616
Fax (212) 696-0021

• **STREANO/HAVENS Ad Pg 494-495** *P O Box 488 Anacortes, WA 98221*

(206) 293-4525
Fax **(206) 293-2411**

• **SUNSTOCK Ad Pg 500-505** *1750 Kalakaua Ave. #1506 Honolulu, HI 96826*

(808) 949-3484
(800) 949-9810
Fax **(808) 949-4098**

SUPERSTOCK INC. *11 W. 19th St. New York, NY 10011*

(212) 633-0300
(800) 828-4545
Fax (212) 633-0408

99 Osgood Pl. Penthouse San Francisco, CA 94133

(415) 781-4433
(800) 828-4545
Fax (415) 781-8985

417 St. Pierre #500 Montreal, Quebec H2Y 2M4 Canada

(514) 849-2181
Fax (514) 849-5577

	
SWANSTOCK *135 S. 6th Ave. P O Box 2350 Tucson, AZ 85701*	(602) 622-7133 *Fax* (602) 622-7180
SYGMA PHOTO NEWS *322 8th Ave. New York, NY 10001*	(212) 675-7900 *Fax* (212) 675-2433
TAKE STOCK, INC. *516 15th Ave. S.W. Calgary, Alberta T2R 0R2 Canada*	(403) 229-3458 *Fax* (403) 541-9104
TELEPHOTO STOCK AGENCY *Division of Index Stock Photography 126 5th Ave. 7th Floor New York, NY 10011*	(212) 929-4644 (800) 729-7466 *Fax* (212) 633-1914
6500 Wilshire Blvd. #500 Los Angeles, CA 90048	(213) 658-7707 (800) 729-7477 *Fax* (213) 651-4975
• **THIRD COAST STOCK SOURCE Ad Pg 532-533** *P O Box 92397 Milwaukee, WI 53202*	**(414) 765-9442** **(800) 323-9337** *Fax* **(414) 765-9342**
• **WILLIAM THOMPSON PHOTOGRAPHS Ad Pg 446-447** *15566 Sandy Hook Rd. Poulsbo, WA 98370*	**(206) 598-4002** *Fax* **(206) 598-4902**
TIME PICTURE SYNDICATION *Time Magazine 1271 Avenue of the Americas New York, NY 10020*	(212) 522-3593 (212) 522-3866 (212) 522-3352 *Fax* (212) 522-0150
TOM TRACY PHOTOGRAPHY *1 Maritime Plaza #1300 San Francisco, CA 94111*	(415) 340-9811 *Fax* (415) 348-9016
TRANSPARENCIES, INC. *1008 East Blvd. Charlotte, NC 28203*	(704) 333-5330 *Fax* (704) 332-3431
THE TRAVEL IMAGE *5335 McConnell Ave. Los Angeles, CA 90066*	(310) 823-3439 *Fax* (310) 578-5990
• **UNDERWOOD PHOTO ARCHIVES Ad Pg 466** *3109 Fillmore St. San Francisco, CA 94123*	**(415) 346-2292** *Fax* **(415) 346-0552**
UNIPHOTO PICTURE AGENCY *Uniphoto New York 19 W. 21st St. #901 New York, NY 10010*	(212) 627-4060 (800) 225-4060 *Fax* (212) 645-9619
UNIPHOTO PICTURE AGENCY *Uniphoto Washington 3307 M St. Washington, DC 20007* *Representing Uniphoto Picture Agency:* *Pictor International Ltd./London* *Pictor International Ltd./Paris* *Pictor International Ltd./Munich* *Pictor International Ltd./Italy*	(202) 333-0500 (800) 345-0546 *Fax* (202) 338-5578
VALAN PHOTOS *Clayton Lake Rd. R.R. 2 Clayton, Ontario K0A 1P0 Canada*	(613) 256-5294 *Fax* (613) 256-5296
VIDEO TAPE LIBRARY LTD. *1509 N. Crescent Heights Blvd. #2 Los Angeles, CA 90046*	(213) 656-4330 *Fax* (213) 656-8746
VIESTI ASSOCIATES *P O Box 20424 Cherokee Station New York, NY 10028*	(212) 787-6500 *Fax* (212) 595-6303
VIEWFINDER STOCK *435 Brannan St. #203 San Francisco, CA 94107*	(415) 543-8983 *Fax* (415) 543-2199
VIEWFINDERS, INC. *126 N. 3rd St. #406 Minneapolis, MN 55401*	(612) 333-8170 (800) 776-8171 *Fax* (612) 333-8179
VINTAGE IMAGES *P O Box 228 Lorton, VA 22199*	(703) 550-1881 *Fax* (703) 550-7992
VISAGES *8748 Holloway Dr. West Hollywood, CA 90069*	(213) 650-8880 *Fax* (310) 652-0934
VISIONS PHOTO, INC. *220 W. 19th St. #500 New York, NY 10011*	(212) 255-4047 *Fax* (212) 691-1177
VISUAL IMPACT HAWAII *836 Ocean View Dr. Honolulu, HI 96816-3606*	(808) 737-2885 *Fax* (808) 737-3744
VISUALS UNLIMITED *78 Hale Hill Rd. P O Box 146 East Swanzey, NH 03446*	(603) 352-6436 *Fax* (603) 357-7931
• **VOLCANIC RESOURCES Ad Pg 511** *P O Box 884 Volcano, HI 96785*	**(808) 967-7672**
THE WPA FILM LIBRARY *Division of MPI 5525 W. 159th St. Oak Forest, IL 60452*	(708) 535-1540 (800) 777-2223 *Fax* (708) 535-1541
• **WASHINGTON STOCK PHOTO, INC. Ad Pg 444** *5520 Cherokee Ave. Alexandria, VA 22312*	**(703) 642-3700** **(800) 955-7468** *Fax* **(703) 642-3703**
• **WATERHOUSE STOCK PHOTOGRAPHY Ad Pg 522-523** *P O Box 2487 Key Largo, FL 33037*	**(305) 451-3737** **(800) 451-3737** *Fax* **(305) 451-5147**
WEATHERSTOCK *P O Box 31808 Tucson, AZ 85751*	(602) 751-9964 *Fax* (602) 751-1185
• **WEST STOCK Ad Pg 331-340** *2013 4th Ave. 4th Floor Seattle, WA 98121*	**(206) 728-7726** **(800) 821-9600** *Fax* **(206) 728-7638**
• **WESTLIGHT Ad Pg 227-266** *2223 S. Carmelina Ave. Los Angeles, CA 90064*	**(310) 820-7077** **(800) 872-7872** *Fax* **(310) 820-2687**
WIDE WORLD PHOTOS, INC. *50 Rockefeller Plaza New York, NY 10020*	(212) 621-1930 *Fax* (212) 621-1955
THE WILDLIFE COLLECTION *69 Cranberry St. Brooklyn Heights, NY 11201*	(718) 935-9600 (800) 373-5151 *Fax* (718) 935-9031

WILDLIFE FILM LIBRARY *24233 Old Rd. Newhall, CA 91321* (805) 255-7969

WILDSTOCK *P O Box 987 Livingston, MT 59047* (406) 222-7100
Fax (406) 222-8216

THE WINGSTOCK COLLECTION *Division of Comstock, Inc. 30 Irving Pl. New York, NY 10003* (212) 353-8600
(800) 225-2727
Fax (212) 353-3383

WORLDWIDE TELEVISION NEWS CORP. *1995 Broadway New York, NY 10023* (212) 362-4440

• **ZEPHYR PICTURES Ad Pg 207-216** *339 N. Highway 101 Solana Beach, CA 92075* **(619) 755-1200**
(800) 537-3794
Fax **(619) 755-3723**